Adobe Photoshop CS4 for Photographers:
The Ultimate Workshop

Martin Evening and Jeff Schewe

ELSEVIER

AMSTERDAM • BOSTON • HEIDELBERG • LONDON • NEW YORK • OXFORD
PARIS • SAN DIEGO • SAN FRANCISCO • SINGAPORE • SYDNEY • TOKYO
Focal Press is an imprint of Elsevier

Focal Press is an imprint of Elsevier

Linacre House, Jordan Hill, Oxford OX2 8DP, UK

30 Corporate Drive, Suite 400, Burlington, MA 01803, USA

First published 2009

British Library Cataloguing in Publication Data

Evening, Martin.
 Adobe Photoshop CS4 for photographers : the ultimate
 workshop.
 1. Adobe Photoshop. 2. Photography–Digital techniques.
 I. Title II. Schewe, Jeff.
 006.6'86-dc22

Library of Congress Control Number: 2008944317

ISBN: 978-0-240-81118-5

For information on all Focal Press publications visit our website at:
www.focalpress.com

Trademarks/Registered Trademarks
Brand names mentioned in this book are protected by their respective trademarks and are acknowledged

Printed and bound in Canada

09 10 11 12 12 11 10 9 8 7 6 5 4 3 2 1

Chapter 3: Mending and blending 73

Chapter 7: Minding your own business 367

Index 383

Introduction

One of the problems with Adobe Photoshop is that the engineers always keep adding stuff to the program and, as Photoshop has got bigger, there has been that much more to write about. This brand new addition to the Photoshop for Photographers series is intended as a companion to the main *Adobe Photoshop CS4 for Photographers* book. Rather than teach you all the basics of Photoshop, Camera Raw and Bridge, we wanted to concentrate more on what you can actually do with Photoshop. This book is therefore very much tutorial-based and packed with photographic examples shot by Martin Evening and Jeff Schewe. This book is unique in that it doesn't just show you how to use Photoshop, but explains the planning process leading up to the point where Photoshop is used and discusses some of the photographic techniques used, which are also illustrated throughout the book. You could call this edition '*Photoshop Unleashed*', since this book has offered us both a welcome opportunity to talk about the Photoshop techniques that interest us most.

It's also rather ironic for this book to be co-authored by Jeff and Martin. Jeff was under contract to write a book tentatively titled *Photoshop for Photographers* back in the mid 1990s that for many reasons got scrapped. Martin had heard about Jeff's book project and had the good graces to ask permission to use the title – which Jeff gladly agreed to. Therein started a friendship between the two authors that now has them collaborating on this new *Photoshop for Photographers* title.

Acknowledgements

This book project began thanks to the support of Ben Denne, Marie Hooper, Hayley Salter and David Albon at Focal Press. Our thanks also go to the other people who helped directly with the production of the book: Rod Wynne-Powell for the tech editing, Soo Hamilton who took care of the proofreading, Chris Murphy who supplied the press profiles and Matt Wreford for doing the CMYK conversion work.

Quite a number of the photographs that appear in this book were shot in our London and Chicago studios. We would like to thank the following people for their assistance: our photographic assistants Harry Dutton and Mel Hill, Camilla Pascucci for makeup and hair, Harriet Cotterill for clothes styling, our models Courtney Hopper at Storm, Natasha DeRuyter at Take 2 and Alex Kordek and Lidia at MOT models, Stuart Weston at LH2 Studios, London, plus Art Director, David Willett and Propabilities, Chicago for supply of the studio props. We thank Kevin Raber of Phase One for the use of the P45+ digital back. We would also like to acknowledge the additional support in the early stages of the book production from Greg Gorman, Peter Krogh, Ian Lyons (the 'Leprish Iricon') and Marc Pawliger.

Thanks also go to all our friends at Adobe: Russell Brown, John Nack, Chris Cox, and co-architects Scott Byer and Russell Williams on Photoshop and Thomas Knoll, Eric Chan, Zalman Stern and Tom Hogarty on Camera Raw. Obviously we owe a great debt of gratitude to Thomas and his brother John Knoll for authoring Photoshop in the first place and Adobe for having the brilliance to buy it. We also wish to thank Mark Hamburg for the years of 'useful' dialog (and for putting so many of our wishes into Photoshop).

Thanks also to the Pixel Genius crew: Mac Holbert, Mike Keppel, Seth Resnick and Andrew Rodney and our gone but not forgotten members Mike Skurski and Bruce Fraser. We miss them and so does the industry. We also give a nod to the Pixel Mafia, you know who you are...

Lastly, Martin would like to thank Camilla for all her love, support and understanding and Jeff would like to thank his wife Becky and daughter Erica for their support and willingness to accept and love him (it isn't easy). And to Max, the dog who will be remembered.

We also wish to thank you, our reader, and hope you get what we are trying to do and enjoy the learning process – we do, and it never ends...

Photograph: Martin Evening.
Client: Altered Image | Model: Lydia @ MOT | Fuji GX 68 MkII Camera | 110 mm | 100 ISO Ektachrome Film | Imacon 848 Scanner

Chapter 1

Before you shoot

Concepts and planning before you use Photoshop

This book may be all about Photoshop and what you can do with the program, but we thought we would start by looking at where exactly does Photoshop fit in to a photography workflow? While it is possible to do an enormous amount of work on the computer using Photoshop, just because you can doesn't mean you should. There is much to be said for taking a step back before you shoot an assignment and pre-plan how you might end up using Photoshop, then shoot accordingly with that purpose in mind. Over the next few pages we have used a few studio shoot examples to illustrate this point.

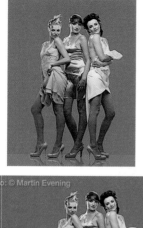

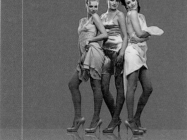

Figure 1.1 Here is a simple example of where it makes more sense to extend the width of an image using Photoshop, rather than create the full width scene 'in-camera'.

Before you shoot that picture!

In the days of film photography, we would often use Polaroids as a way to test the lighting and show clients a preview of how the image would look. Photographers would often use the excuse that the quality of the Polaroid wasn't up to standard and that it would look OK once they saw the film (by which time it would be too late!). Now, in the age of digital photography, photographers are tempted to say 'we'll fix it in Photoshop'. Of course, Photoshop can be used to fix almost anything, but the trick to becoming a successful and productive photographer is to be able to work out when it is appropriate to use Photoshop and when it's better to get this right 'in-camera' first.

For commissioned shoots this is something that should be worked out before you pick up the camera, or earlier still at the layout stage. It all boils down to making the best use of your time. In Figure 1.1 you can see how Martin easily added extra width to a studio-shot picture using the content-aware scaling feature. It took a matter of a few seconds to do this in Photoshop, whereas it would have required a lot of extra space (and expense) in the studio to have shot the photo like this. For example, most seamless background rolls are only nine feet wide and Martin would have had to paint the cove by hand to get the full backdrop width in camera.

Some people will call this cheating, while others will look at the economic necessities and conclude that using Photoshop in the post-production stage makes the most sense. These days a lot of movies and TV dramas are filmed on studio sets where many of the props and exterior details are missing and added in later. This kind of post-production work is so successfully done that you'll hardly be aware of the artifice that's involved.

Interpreting a brief

'Briefs' (normally called 'layouts' in the US) run the gamut om a highly detailed and exact rendering of what will be executed by the photographer, to a rough guide as simple as telling you whether the image is vertical or

horizontal – and even that can sometimes evolve. Ideally, the relationship the photographer has with the art director or designer will determine how flexible the layout will be. The better art directors tend to be open to opportunities to improve the project with the input and creative ideas of the photographer. It's incumbent on the creative team to know the limits and expectations of the ultimate client. The best photographers are always on the lookout for ways to enhance and extend the original concept and execution, while diligent in maintaining the needs of the client.

All that said, it's not at all unusual for the layout to evolve (and hopefully improve) during the course of a project. When a layout is originally drawn, the reality of the final photograph is unknown – unless the layout has been created with stock photography, which can be a dual-edged sword. Ethically, a photographer should not merely copy another photographer's work and create a derivative work of the original. It's one thing to use another's work as inspiration, it's another thing entirely to infringe on the work of others.

Figure 1.2 is a prime example of a tight layout with room for flexibility in execution and evolution. Even the headline was changed after the photographic image was completed. The art director remained open to taking advantage of opportunities and the end client was not so rigid as to ignore the possibilities.

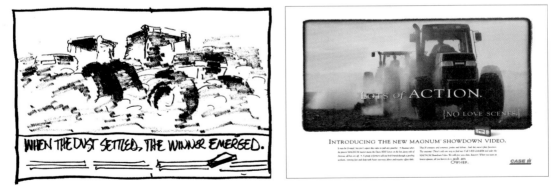

Figure 1.2 Here is a simple example of an evolution of a layout to final printed ad.

Shooting multiple elements – intelligently

There's no question that a really good photographer can create a compelling image in a single shot and not have to rely on Photoshop to make it great. But given the limitations of time and budget, it's often easier (and just as productive) to break down a final image into its essential parts before shooting anything; then shoot those parts and assemble them in Photoshop. This is a prime example of such a shot.

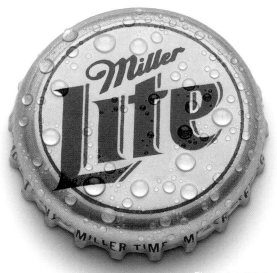

Photo: © Jeff Schewe

Figure 1.3 This is the final composite of two shots with retouching.

The shot of the Miller Lite bottle cap (Figure 1.3) was an assignment shot by myself. Having experience of shooting liquid droplets, I knew that shooting the bottle cap with the droplets placed exactly correct would be tedious and involve lots of very detailed work up close. It would be a pain... So rather than even try to accomplish the final result in a single shot, I chose to shoot two shots: one with the bottle cap completely dry, with the lighting finessed and the image optimized for the logo text, and a second shot where the water droplets were allowed to go where they wanted (Figure 1.4). I made no special effort to keep the background dry.

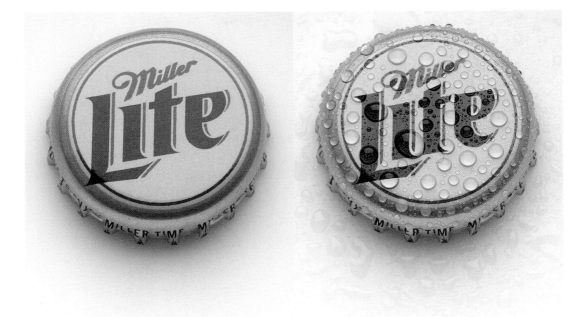

Figure 1.4 These are the two raw shots before layering and masking.

By planning in advance to shoot the assignment in two shots, I was able to simplify the individual shots to the point where the image assembly was quite simple. Also, by telling the art director that two shots would be better from the very start of the assignment, doing the two shots was not seen as a failure to 'get it' in one shot but a better way to accomplish the goals of the assignment. It also gave the art director the opportunity that art directors love so much: the chance to direct. But instead of looking through the ground glass of a view camera (whose image is upside down) and trying to direct the precise placement of water droplets, he could direct me sitting at the computer and add, delete or move them in Photoshop. To be honest, it didn't necessarily take less time but it was certainly less tedious dealing with a layer mask rather than the difficult task of placing the real water droplets. Using the separate elements approach was also much more efficient and precise, which led to a better result – the goal of both the art director and myself.

Multi light blending technique

Shooting in the studio with controlled lighting can lead to wonderfully lit still-life images. But you are often faced with the realities of optics and physics, and the difficulties of getting light exactly where you want it. As a result, I have become adept at shooting subjects under varied lighting conditions and directions and then compositing the resulting elements in Photoshop. Figure 1.5 shows the two original captures. The only real difference is that the light was moved from the upper left to the lower right of the image between shots. Both captures were processed in the same way and were maintained in exact registration between the exposures. The trick then was to 'paint with light' by using the second layer's layer mask to determine the precise visibility of that layer.

This approach – locking the camera down and shooting multiple exposures with different qualities of light (such as a Hard Light mixed with a Soft Light) or, as in this example, with the same light from different directions – is a creative approach that marries the best of photography with the efficiency of Photoshop. Sure, you could labor the long time it would take to finesse the lighting using two separate light sources, but why when this alternative is so simple (and easy)?

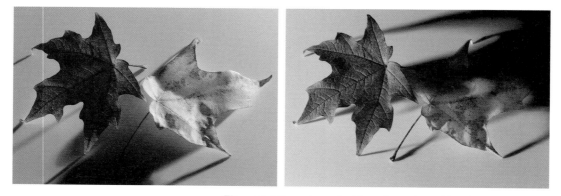

Figure 1.5 The capture on the left was the starting position of the light. After capturing and evaluating the first shot, the light was moved 180° and the second capture was made.

There are some caveats: you really should have a very stable shooting platform and it's ideal to keep the lighting rather simple. However, with Photoshop CS4's auto-align function this has become less mission critical. Ironically, for this book I did test the Auto-align command on these layers and received the warning shown in Figure 1.6. It seems that the lighting was so different that the auto-align logic was fooled. This wasn't a problem in this case since the registration was already excellent.

Figure 1.7 shows the final layer stack with the layer mask on the 'lower left' layer that modulated the visibility of that layer. Some areas were completely opaque while other areas were blended in partial opacity. The white areas of the layer mask allowed all of the lower left layer to show through. Figure 1.8 shows the final result 'painted by light'. There weren't a lot of tone and color adjustments made. The primary adjustment was a Hue/Saturation increase and a midtone contrast bump to pop some of the detail. More about those types of adjustments later in the book.

Figure 1.6 The Auto-align command prompted this warning when trying to align the two leaf layers.

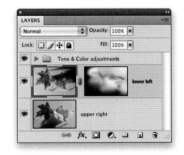

Figure 1.7 The final layer stack (with the adjustments grouped for brevity).

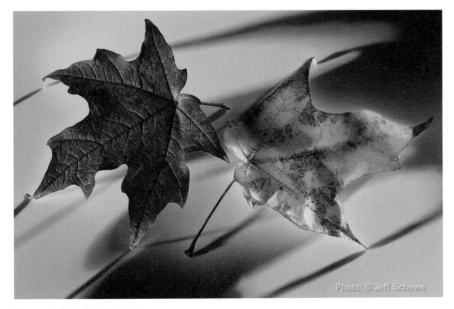

Figure 1.8 The final blended image.

Complex composite work

The previous examples were simple to composite because
of the nature of the images. However, Figure 1.9 was not
in the least bit easy to assemble. All of the individual
elements had to be shot separately. However, the nature of
the assembly dictated that each element shot had to have
matching lighting that would enable the final assembly to
look convincing. The element shots (see Figure 1.10) were
set up so that the lighting would cast a shadow in the correct
direction and provide realistic clues as to how to make the
synthetic shadows that would be made in Photoshop. The
additional challenge was to rig each shot so the model's
action would be real. This required tieing off the pickax
fellow's suit to make the action look more real. For the
shot with the two people with the saw, they did actually

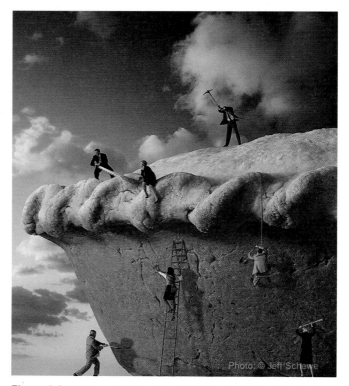

Figure 1.9 Left is the original layout provided by the client. Above is the final
retouched composite.

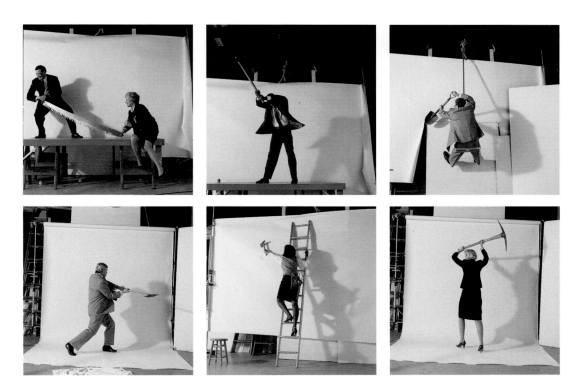

Figure 1.10 The images above were shot with 120 mm color transparency in the studio. The two pie shots were done on 4 x 5 film. The sky background was studio stock. All of the element shots were outlined using the pen tool to create paths. Separate paths were made from the real shadows and then remade in Photoshop.

have to engage with each other so their expressions would be real. The hatchet girl needed to be on a ladder and even though I rigged a line for the lady with the pickax (she couldn't actually hold it over her head), it was important that the lighting and the shadow were correct. Even the 70-year-old fellow with the shovel (I didn't know the gentleman was 70 at the time – but the model did actually have fun on the shoot) had to be suspended by real rope to look realistic.

The shot that actually dictated lighting direction and quality was the background image. Since the sunset had a low side light angle, the rest of the elements had to be shot to match. Try as he did, the food stylist couldn't get 'the perfect pie' so I took parts from two different pies for the final composite.

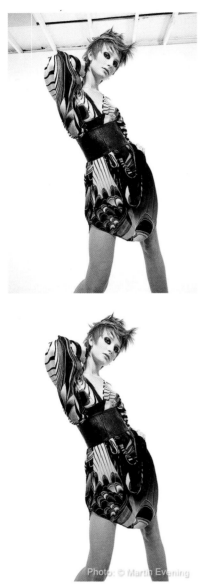

Figure 1.11 Knowing the end photograph will be edited in Photoshop does mean that one can take shots such as the one here, using an extreme wide-angle lens, and not have to worry if the model's head happens to overlap the edge of the backdrop. This kind of problem is easy to fix in Photoshop and you don't lose the shot.

Fashion and beauty retouching

Where would the fashion and beauty industry be without retouching? It's been used for many years now and has had quite an impact on the way fashion images look in magazines.

A Scottish hairdresser I worked with once told me how the clean hair lines and cuts shown in the photographs created for Vidal Sassoon in the sixties made a huge impression on other Scottish hairdressers, and how as a result they refined their cutting techniques to match the precision in the photographs that they had seen. Little did they realize that the pictures had actually been retouched, but ever since Scottish hairdressing has become world famous for it's technical precision!

One might argue that the ridiculous levels of retouching used on some photographs has become too much, but we reckon that good retouching work should be retouching that you don't notice. Figure 1.12 shows an image that is featured later in this book to demonstrate a Photoshop hair coloring technique. There have been several occasions where I have worked on a series of hair coloring shots to demonstrate a range of hair colors and it has been necessary to color a models hair different shades of color (matching a sample color). You have to bear in mind here that to dye the hair for real, the models would be required to undertake a skin patch test to check for chemical sensitivity and the coloring process itself can take up to several hours to complete. So although doing it in Photoshop may not be so truthful, it is the only way many clients can afford to get the exact hair color look they are after, especially at the rates models will charge.

I also believe one can now afford to be somewhat looser about the way you shoot. In the past, it was critical that the models kept within the bounds of the backdrop, whereas now it doesn't matter quite so much (as I have shown in Figure 1.11). I quite like having the freedom to shoot to capture movement and gesture, knowing that Photoshop can be used to extend the backdrop if necessary. In this respect, Photoshop offers more ways to be creative because you have fewer restrictions.

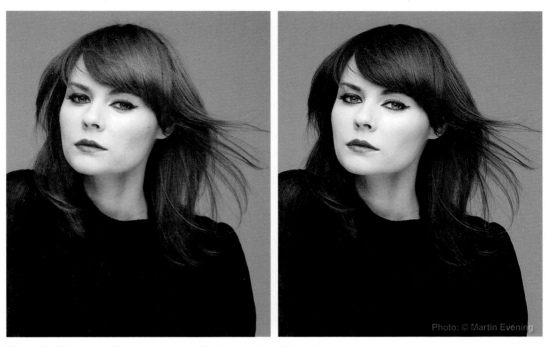

Photo: © Martin Evening

Figure 1.12 Here is a before and after example of a photograph in which I carried out basic retouching to remove stray hairs, smooth the skin texture and adjust the color of the model's hair.

When it comes to lighting for beauty and fashion photography, there is also more opportunity to shoot without limits. After a long career learning how to light precisely I certainly know how to control my lighting, yet I do now appreciate the freedom Photoshop gives me to break the rules and shoot without regard to the precise balance of lighting or optimal contrast. For example, I find that I now tend to light that much harder. I have always liked the drama that you get with strong, directional light, but at the same time been wary of the problems you get with strong harsh shadows on the face. However, it is now relatively easy to smooth these out in Photoshop and have the best of all worlds. Some might consider this a lazy approach to photography, but if Photoshop occasionally allows you to break the normal rules of lighting, why not allow yourself to experiment?

When not to use Photoshop

I recall that the client had originally contacted me because I am thought of as some sort of 'computer expert', so the idea was to make an image of a melted phone on the computer (Figure 1.13). I quickly realized that the client was both overestimating the ease of doing something like that in CGI and vastly underestimating what the costs would be. It would be far better and less costly just to put a phone in the oven and melt the darn thing.

The first test melt wasn't a huge success. The resulting mass of bubbling and blackened plastic looked like a

Figure 1.13 This figure shows the final image as it appeared in the ad. The background was shot separately and the layered phone (with shadows) dropped on top.

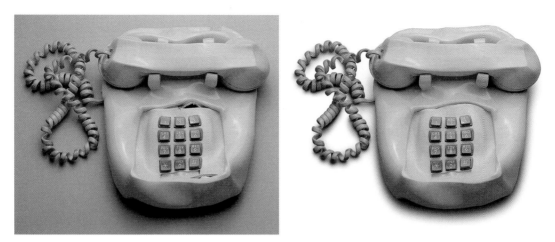

Figure 1.14 The melted phone on the left was shot on a medium gray background to minimize the reflections in the plastic. The image on the right is the retouched and layered phone with synthetic shadows.

biological experiment run amuck. But subsequent tests led to the technique of a longer time in the oven at a lower heat.

The key was to remove as much metal as possible and simply let gravity do its work. The longer time in lower heat also enabled me to prod certain areas and angle the base (a cookie sheet) while still in the oven. Clearly, as shown in Figure 1.14, there would be the need for some pretty heavy retouching after the melted phone was cooled. But the amount of work was minimal compared with trying to melt the phone in Photoshop.

Which really is the thrust of the main point we are trying to get across in this first chapter. There are things you can do very easily in front of the camera that would be very difficult after the fact in Photoshop. Yet knowing how to shoot for digital imaging can greatly ease the post-production burden and substantially improve the final result. If you have skills as a photographer and skills as a digital imaging artist, you can improve the final result (and make your life easier) by carefully choosing when to do what and by which means: photographic or Photoshop.

Chapter 2

Raising your IQ

How to improve your image quality

We naturally all want our photographs to look their very best when they are printed on the page. In this chapter we wanted to start by looking at some of the ways you can help guarantee getting the best digital results from your camera. As you will read later, we carried out a few tests to show how different ways of shooting and the choice of lens can affect sharpness. More importantly, we wanted to show some of the key benefits of using Camera Raw to carry out the initial image processing. You'll also find tips in this chapter on ways to curb noise and add midtone contrast.

Camera Raw's history

Thomas Knoll, the co-author of Photoshop, is the founder and principal engineer of Camera Raw. Camera Raw 1.0 was released as a stand-alone product for Photoshop 7 and sold for $99. Camera Raw 2 was bundled with Photoshop CS which was released in October 2003. Contributing engineers are Zalman Stern and Eric Chan. Mark Hamburg has also contributed to the Camera Raw processing pipeline and was the founder of Adobe Photoshop Lightroom, which built upon and added to Camera Raw's processing.

Optimizing images

Camera Raw or Photoshop?

When Adobe launched Camera Raw it was designed as a raw file format import plug-in that allowed Photoshop to access raw digital captures. It can now be argued that Camera Raw has been turned into it's own editing domain called 'parametric editing' and, in some ways, challenges Photoshop for image editing of digital photographs. But don't lose sight of the fact that Camera Raw's main role is still to open images into Photoshop.

Inevitably, there will be a degree of confusion about what to do to images in which domain: parametric or pixel editing. The answer is really rather simple – use the best tool for the task at hand. Using Camera Raw is optimal for raw capture tone curve adjustments because you are working with the entire linear tone range of the raw capture. Waiting to do that in Photoshop would mean leaving image quality

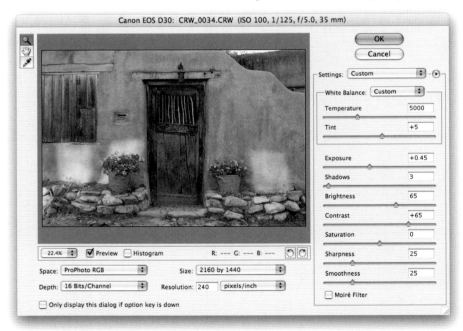

Figure 2.1 Camera Raw version 1.0 in Photoshop 7 released February 19th, 2003.

on the table. The same holds true for adjusting the white balance of a raw capture. Nothing in Photoshop can rival the accuracy and efficiency of Camera Raw's white balance tool. If your camera sensor has a dust spot, you can use the spot removal tool to remove a spot on one or one hundred captures. Doing these tasks in Camera Raw is more efficient than in Photoshop. Yet for all of its strengths, Camera Raw is not a pixel editor (the adjustment brush and gradient filter not withstanding). When you need pixel accurate masks or image composites, you need Photoshop.

The best approach is to devise a strategy and employ the correct tactics to achieve it. The strategy we like to use is the 80–20 rule (also called the Pareto principle) where the majority of the work can be done with the least amount of effort. So, Camera Raw is tactically employed to make mass adjustments accurately, quickly and efficiently while Photoshop is tactically employed on only a few select images that are truly worthy of the extra effort.

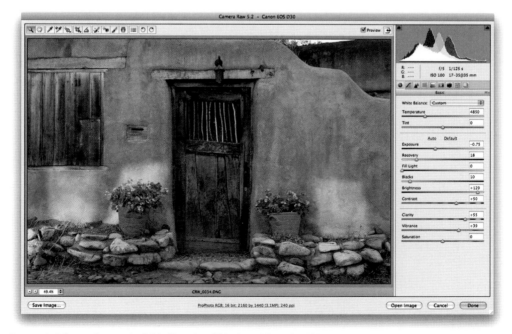

Figure 2.2 Camera Raw version 5.2 in Photoshop CS4 released November 25th, 2008.

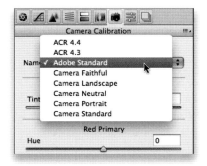

Figure 2.3 The Camera Raw Camera Calibration panel showing the drop-down menu of available profiles.

Camera Profiles in Camera Raw

When Camera Raw was introduced, one of the more controversial aspects of image quality was the Camera Raw default color rendering. Many thought the color was inaccurate (or at least didn't match the color produced by the camera JPEG or camera software). Adobe took heed and introduced the DNG Profile addition to the DNG specification with DNG version 1.2. When Camera Raw version 5.2 shipped, the final versions of the DNG Profiles were also released. Whether you were in the camp that thought Camera Raw's color rendering was fine or the camp that thought it sucked is moot – the DNG Profiles have now changed the Camera Raw rendering. If you want the same color rendering as your camera JPEG, you can pretty much match it. Figure 2.3 shows the Camera Calibration panel of Camera Raw (version 5.2 and above). The new default color profile is the Adobe Standard profile. This profile is designed to be colorimetrically accurate and an improvement on the previous table-based profiles (shown as ACR 4.4 and 4.3). The profiles starting with the name 'Camera' are designed to emulate the in-camera settings available as designed by the camera maker (although the actual names will vary). The drop-down menu in Figure 2.3 is for a Canon EOS1DS Mk III. Other cameras will have names that align with their own camera 'looks'.

For comparison, Figure 2.4 shows a synthetic Macbeth ColorChecker card. The bottom figure shows shots of a mini ColorChecker card shot in daylight. The far left image

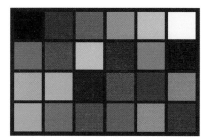

Figure 2.4 A synthetic ColorChecker card made in ProPhoto RGB.

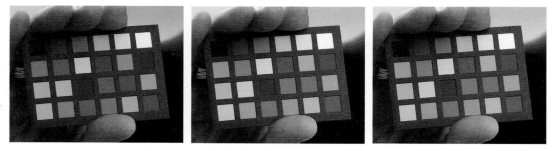

Figure 2.5 Comparisons of the Adobe Standard profile (left), the Camera Standard profile (middle) and a camera-produced JPEG file (right).

of Figure 2.5 was rendered using the Adobe Standard DNG Profile. The middle image was rendered using the Camera Standard profile and the image on the right was a camera JPEG with the camera set to sRGB. As you can see, the Camera Standard and JPEG are a close match. However, in terms of accuracy, the Adobe Standard rendering is a closer match to what the ColorChecker colors are supposed to produce. What does this prove? That color rendering from raw files is open for interpretation – there really is no single 'right' answer but there may be more accurate answers.

It doesn't really end here either. Adobe has released a free software utility called DNG Profile Editor which enables users to create their own DNG Profiles through manual editing or by using shots of ColorChecker charts. The documentation available is extensive so if you are interested we suggest you download the DNG Profile Editor from http://labs.adobe.com and try it yourself (be sure to read the documentation). For real world examples of the different renderings using the vender matching profiles see Figure 2.6 below.

Color accuracy

Whether you spell it color or colour, photographers often think accurate is best. Not really. One of the most successful film launches ever was Fuji Velvia which was anything but accurate. What photographers usually want is pleasing color and Camera Raw 5 has 37 controls dedicated to color adjustments (not including the adjustment brush). But try not to think of the DNG Profiles as color correction tools but more of a color rendering tool that offers options for the start of your color editing needs.

Figure 2.6 This shows comparisons of the DNG Profile rendering. Note: the naming convention will vary by camera manufacturer and not all cameras will have all variations.

Adobe Standard

Camera Faithful

Camera Landscape

Camera Neutral

Camera Portrait

Camera Standard

Highlight checking

In Camera Raw there are several ways you can check that the important highlight information is preserved. One way is to click the highlight clipping warning in the Camera Raw histogram (circled in Figure 2.7). Alternatively, if you hold down the ⌥ *alt* key as you drag the Exposure or Recovery sliders, you will see the preview image change to show a threshold mode display, in which the clipped areas will appear colored (indicating which colors are clipped), or white (to indicate that all colors are clipped). You can use this as a guide to make sure important detail isn't clipped. Lastly, you can move the cursor over the highlight areas of the image and check the RGB values to see if these fall within an acceptable range for print output. Here, you usually want to make sure that the brightest areas of highlight detail don't go lighter than, say, 245, 245, 245.

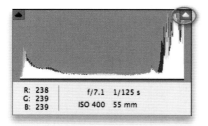

Figure 2.7 The Camera Raw histogram.

Optimizing the image tones

This section deals with a few of the ways you can fine-tune images in Photoshop to improve their appearance. If you want to learn more about the basics of Photoshop image editing, then we do recommend you read the Image editing essentials chapter in *Adobe Photoshop CS4 for Photographers*. To start with though, we thought it worth making a few points about how to optimize the shadows and highlights and dispel a few myths.

Optimizing an image in Camera Raw

A lot of people have got confused about how you are supposed to set the shadow and highlight points in Camera Raw and Lightroom, and why you don't have the same type of Levels controls as you do in Photoshop. Basically, you will sometimes read that the black point output levels should be set to an RGB value like 12, 12, 12, and the white output levels should be set to, say, 245, 245, 245. There are sound, historical reasons for such advice, because you don't want the blacks to clip to 0, 0, 0, when you send a file to be printed, since any blacks that are darker than a certain value will all clip to black. Likewise, you need to ensure that essential highlight information doesn't all burn out to paper white when printed. Yet in Camera Raw there are no output levels settings. This is because they are not needed when editing images for RGB output and we'll explain why here.

When it comes to optimizing the highlights, you only need to worry about the non-specular highlights, which are basically the brightest whites that contain important tonal detail. With specular, or shiny whites, you can safely let these clip. So although you do have to be careful, in practice most pictures contain specular highlights and if you set the highlight clipping to clip these the important detail highlight information will usually be safely preserved within a margin of safety. Where there are bright areas in a picture that contain important detail, we first make sure that the threshold clipping display confirms that these areas are not significantly clipped and then use the Recovery slider in Camera Raw to make sure the highlight detail is preserved in these areas.

Optimizing the highlights

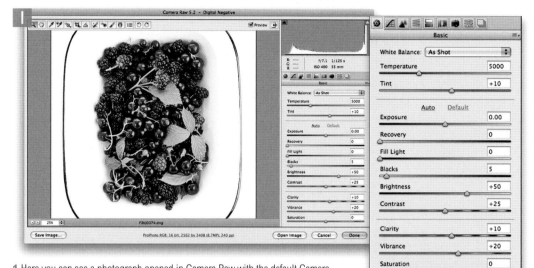

1 Here you can see a photograph opened in Camera Raw with the default Camera Raw settings. Although the photograph appears rather bright, I would say that it has been captured at an optimum exposure from which to process a tone corrected image.

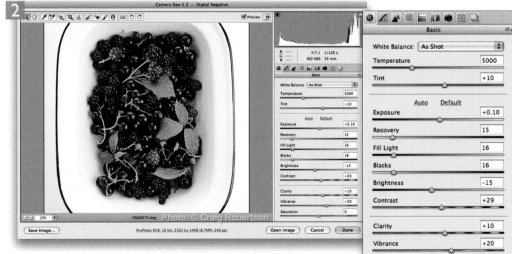

2 This shows the tone corrected version in which I adjusted the Exposure, Recovery, Fill Light, Blacks, Brightness and Contrast sliders to apply the best combination of settings to achieve a nice level of contrast without blowing out the highlights. The important thing to note here is that I was extremely careful to make sure that the highlight detail in the white bowl was well within range to print OK. It mattered less to me that the white backdrop tone values were in this case clipped.

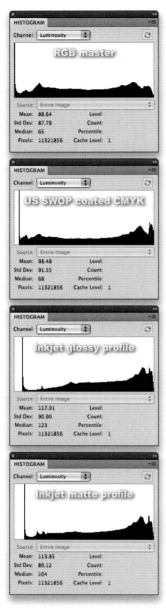

Figure 2.8 This shows, from top to bottom, the histogram for a Camera Raw processed RGB image, a conversion to CMYK, a conversion to a glossy inkjet paper profile and a conversion to a matte inkjet paper profile.

Optimizing the blacks

When it comes to adjusting the Blacks slider, the choice is simple: where are the blackest blacks and how much do you wish to clip them? Just as there is no one CMYK space that fits all, there is no one setting for the black point that will correctly set the blacks for every type of print output. Where you read advice to set the blacks lighter than 0, 0, 0, this dates back to the time before Photoshop 5, when there was no other way to ensure that the blacks in a photograph would print correctly without clipping. With the advent of ICC-based color management now being built into Photoshop, this preparation step is no longer required and it is fairly easy to prove why.

The photograph on the page opposite is of my daughter Angelica, and was shot against a black velour backdrop. In the accompanying steps I describe how I adjusted the settings in Camera Raw to deliberately clip the blacks so that the backdrop detail went completely to black. Some people have expressed concern that Camera Raw only allows you to adjust the input levels in this way (to set the input clipping levels) and that you don't have a Levels-type control for setting the output levels to something higher than 0, 0, 0. In reality, an output levels control is not necessary these days, since the profile conversion takes care of this for you and does it all automatically. For example, in Figure 2.8 I opened the Camera Raw processed photograph of Angelica in Photoshop and set the histogram display to Luminosity. The top histogram shows the Photoshop histogram for the Camera Raw processed RGB image. Below that you can see the luminosity histogram for a CMYK converted image and below that a conversion to a glossy inkjet profile, followed by a matte inkjet paper profile. In these screen shots of the output converted histograms you can see that the black point has been automatically indented. This shows how the profile conversion takes the guesswork out of setting the blacks, as well as how the amount of black point compensation will actually vary for each different type of print output.

1 Here is a photograph shot against a black background shown here with the default Camera Raw settings. As with the previous example, the slight over-exposure did not bother me, as I could easily address this in the following step.

2 In this version you can see that I reduced the Exposure slightly and added some Recovery, but the main thing I did was to increase the Blacks amount until I had successfully clipped all of the shadow detail in the backdrop. In cases like this it does not really matter if you clip the blacks a lot, since it is not always important that you preserve every bit of shadow detail.

Optimizing both the highlights and blacks

1 To complete this section on optimizing images in Camera Raw I have selected here a photograph where, as in the previous example, the blacks needed to be clipped, but it was OK to clip the highlights as well.

2 In this corrected version, I raised the amount for the Blacks slider to darken the backdrop to black. I also dragged the Exposure slider to the left to darken the image and used the Recovery slider to help preserve some of the highlight detail. In this particular image it was not necessary to preserve the extreme highlights, since I wanted to let the bright reflections clip and burn out to white.

Cut-outs against a white background

Subjects that are photographed against a white background deserve careful treatment. Ideally you want the white background to print as pure white on the paper, but not at the expense of losing image detail in important highlight areas elsewhere in the photograph. When preparing cut-out images against white, the levels should first be adjusted with consideration for the subject only and the background should then be adjusted separately without compromising the tonal range of the subject. The following steps suggest one way that you might like to add a pure white backdrop to a photograph, while ensuring that you preserve the fine detail in the edges of the subject.

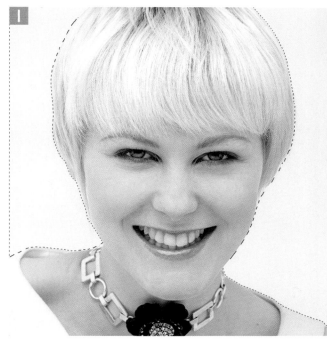

1 Whenever I need to cut out the background to white in a photograph, I'll often start by creating a mask for the background. This doesn't necessarily have to be a super-accurate mask, just so long as it adequately selects the areas that I want to turn white. With subjects like this the trick was to make sure that the cut-out did not begin and end abruptly, and the goal was to achieve a smooth transition along the edges of the subject. In this first step, I went to the Channels panel and loaded an alpha channel mask of the backdrop area as a selection.

Clipping paths

Graphic designers may sometimes use a clipping path to create the cut-out. A clipping path is a designated pen path saved in an EPS, TIFF or PSD file format that is used to mask an image when placed in a page layout program. If I was preparing a clipping path of the model in the following step-by-step I would do everything the same, but make the clipping path extend a few pixels beyond the model's outline so that the tonal transition to pure white is preserved.

Figure 2.9 This shows the lighting setup used to shoot the photograph shown here.

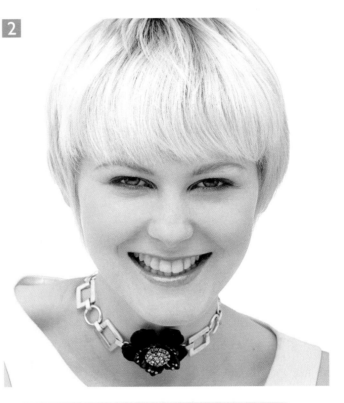

2 With the mask selection active, I clicked on the adjustment layer menu in the Layers panel and selected Solid Color... This opened the Color Picker dialog shown here, where I selected a pure white color with which to fill the unmasked area.

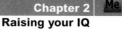

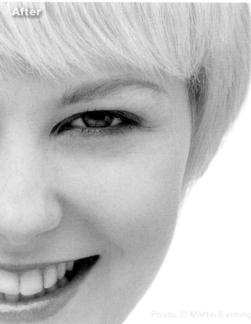

3 The only problem now is that the edge of the Solid Color fill layer mask was too harsh. To address this, I made sure that the pixel layer mask was selected still, then went to the Masks panel and clicked on the Mask Edge... button (circled). This opened the Refine Mask dialog shown on the right, where I adjusted the settings to achieve a softer edge for the Solid Color fill layer mask. I adjusted the Contract/Expand slider so that the mask was slightly wider than the subject, plus I used the Radius and Feather sliders to achieve the desired softening of the mask. The key thing here was to make sure there was a gentle transition at the edges between the light areas and the pure white backdrop. The left image shows the before version with the sharp edge, and the right image shows what it looked like with the modified mask edge.

Essential image editing steps

With so many tools and ways to edit photographs, it is easy to get confused when working out what is the best way to edit an image in Photoshop. This book offers advice and tips on how to improve the look of your pictures, but at the end of the day we find that 90% of the photographs we take can mostly be improved by applying a simple six-stage image editing routine, namely: crop, color, tone, finesse, capture sharpen and noise reduction. We do this all in Camera Raw when processing our raw photos, because we find it to be the most efficient workflow available. We know some people have been put off shooting raw because they think it makes things complicated, but when you study the Basic controls in Camera Raw and Lightroom, they really aren't that difficult to master. In fact it seems to us quite odd that people are happy to shoot JPEG because it's 'simpler', yet they then end up jumping through all sorts of complicated hoops in Photoshop to perfect their images.

Camera Raw allows you to work both smarter and faster so you can spend more time taking pictures rather than getting bogged down in making endless photo adjustments. Plus you don't just save time editing single photographs. Get one photograph to look good and it's easy to synchronize all the adjustments across other images taken in the same sequence. Essentially, our message is this. Why make things more difficult for yourself? The controls in Camera Raw are expressly designed to make the photo editing process easier to understand, while offering the ultimate in image quality as well as flexibility. Simple doesn't mean you have to compromise on quality. Adobe have devoted the best part of six years to enhancing the Camera Raw editing process because in this day and age it makes more sense to carry out the color and tone editing working from the raw capture data. As Camera Raw has got better we have ended up doing all our major tone and color corrections in Camera Raw or Lightroom, leaving Photoshop as the program we use for the major retouching work.

As we say, nine times out of ten we can edit a photograph completely in Camera Raw using the following steps. For the remaining 10% of images we either make fuller use of the other Camera Raw tools such as the Tone Curve, HSL and Lens Corrections panels or the special techniques that we use in Photoshop such as the Midtone contrast techniques featured at the end of this chapter which, while similar to the Clarity adjustment in Camera Raw, allow you to carry out more precise types of localized contrast adjustments.

To help explain our approach, we'll show the complete process used for editing a single image in Camera Raw. Figure 2.10 isn't a particularly special photograph – it's a snapshot that was taken in Rome that can adequately be used to demonstrate how you can edit a typical image in six simple stages. You can access this image from the DVD, but you should be able to apply the steps shown here to almost any raw photograph you choose to edit in Camera Raw.

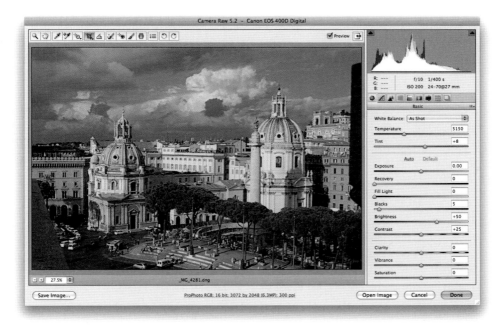

Figure 2.10 This shows the uncropped before version using the default Basic panel settings.

Crop

When you work in Camera Raw, there is no particular order that you must follow. That's the beauty of Camera Raw, it's a non-destructive process and you can undo and redo the adjustments as many times as you like. You can start with the tone and color editing and end with a crop, although we reckon it is always best to carry out the tone and color editing first before you decide how to capture sharpen.

We simply suggest you crop the photograph first because once you have cropped an image you get a better feel for how the final image can look before you make the tone and color adjustments. It doesn't matter if you crop last, but generally you'll find the crop can sometimes change the whole feel of an image and you may end up having to revise your earlier adjustment settings.

In Figure 2.11 we cropped the photograph more tightly to remove some of the objects in the foreground. We also rotated the crop very slightly so the cropped photo was more level with the horizon.

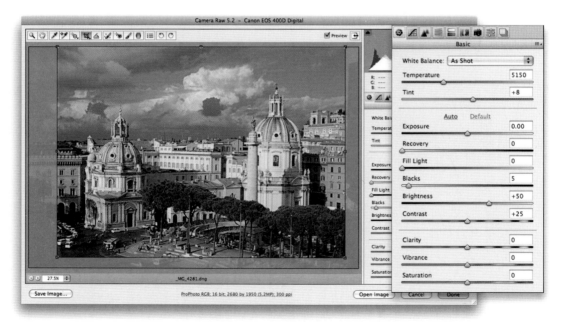

Figure 2.11 Cropping the image.

Color

Next, we come to the color adjustment stage. The white balance controls are placed first at the top of the list of Basic controls, so we'll start here first. In Figure 2.12 the photograph was shot with the camera using a set daylight white balance setting. The 'As Shot' white balance didn't look too bad, but by selecting the white balance tool we were able to click on the white marble of one of the buildings in the photograph and thereby choose an improved white balance setting for the whole photograph. That's just one way you can do this. Other methods include selecting a preset white balance setting from the Color Temperature menu, or choosing the Auto option to let Camera Raw work out the optimum setting, or you can manually drag the Temperature and Tint sliders to create a manual white balance setting. Usually, once you have got the white balance right, all the other colors will easily fall into place.

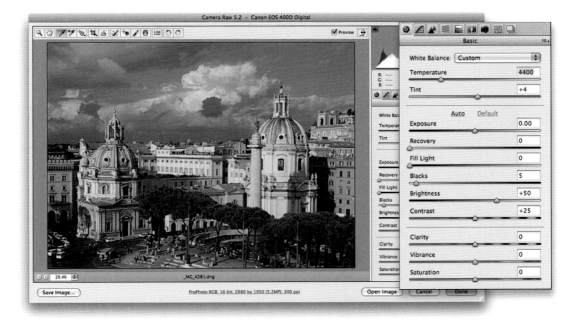

Figure 2.12 Setting the white balance.

Tone

We were now ready to tone adjust the image. There are four main sliders that you can use here: Exposure, Recovery, Fill Light and Blacks.

Exposure

We recommend that you start with the Exposure slider first and use this to gauge how much you wish to lighten or darken the picture. The one rule we would apply here is to always adjust the Exposure first before you adjust the Brightness (which we'll come onto shortly). In Figure 2.13 you can see an Exposure adjustment being applied. As you adjust the Exposure you can also use the Histogram to be your guide here to make sure that you don't push the Exposure slider too far so that you clip the highlights. You can also use the highlight clip warning here as well, or hold down the ⎇ *alt* key as you drag the Exposure slider and check the appearance of the Threshold preview shown on the screen.

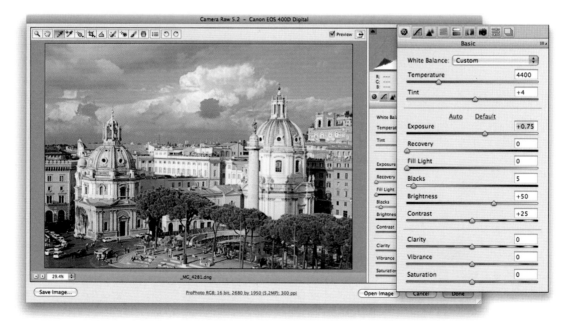

Figure 2.13 Setting the overall Exposure and highlight clipping point.

Recovery

The next step is to make sure that there is no significant clipping in important areas of highlight detail. This is something that we touched on earlier in the optimizing image tones section. When it comes to making Camera Raw adjustments the best advice is to use the Exposure slider first to adjust the overall brightness. As you do so, you will want to check the appearance of the extreme highlight detail as well as the RGB numbers to make sure these don't go too high. Quite often you'll find that as you set the Exposure, you can get both the brightness and highlight clipping right in one go. However, you shouldn't have to restrict the Exposure adjustment, because the Recovery slider can be used to preserve detail in the highlights, but without altering the effect of the Exposure adjustment (see Figure 2.14). So basically, you should adjust Exposure to expand the tones, making the image brighter or darker. Where you see signs of highlight detail clipping, use Recovery to bring back detail.

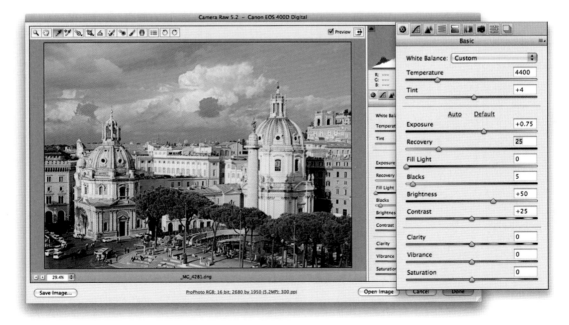

Figure 2.14 Adjusting the Recovery to protect the highlight details from clipping.

Blacks

We'll skip the Fill Light slider and look at setting the Blacks next. If you refer to the section earlier on setting the black clipping point, you will recall how we advise you to simply clip the blackest blacks in the picture as you see fit. There is no need to concern yourself with setting the output levels for the black point, since this can all be handled automatically in Photoshop when you send a file to print or make a CMYK conversion.

Because of the way Camera Raw calculates its tone adjustments, small incremental Blacks adjustments will produce a much more noticeable shift in tone adjustment compared to corresponding Exposure adjustments. The default Blacks setting in Camera Raw is 5, which is usually about right for a lot of photographs, and our advice is to not take the Blacks slider any lower than 2 or 3. Or, you can increase the Blacks clipping if you feel it would be useful to hide some of the shadow detail and make these tones all clip to solid black. In the Figure 2.15 example, we raised the Blacks clipping to 10.

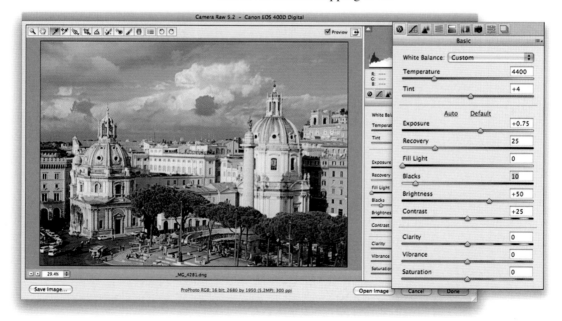

Figure 2.15 Setting the Blacks clipping point.

Fill Light

It is usually best to add Fill Light after you have set the Blacks. Fill Light can be used to lighten the shadows and reveal more detail. As with Recovery, it's not necessary for every picture, but for this example we added +15 Fill Light.

Brightness

The one rule we do urge here is to adjust the Exposure first before you adjust the Brightness. In the steps shown so far, we used the Exposure and Recovery to expand the tones in the photograph and fine-tune to avoid clipping. In the Figure 2.16 step you'll notice how the Brightness adjustment was applied last to adjust the 'relative brightness' of the photograph. In this instance, the Brightness adjustment had little effect on the highlight clipping, but essentially shifted the midtone levels point left or right. You can think of the Brightness slider as behaving just like the Gamma slider in Photoshop Levels.

Don't overdo Fill Light

The Fill Light adjustment can work wonders at lightening the shadow areas while preserving the black clipping point. Take care not to overdo things with the Fill Light adjustment, because if you add too much Fill Light you'll get very unnatural looking shadows. If you need to dramatically lighten the shadows, it is better to use Tone Curve adjustments in conjunction with Fill Light.

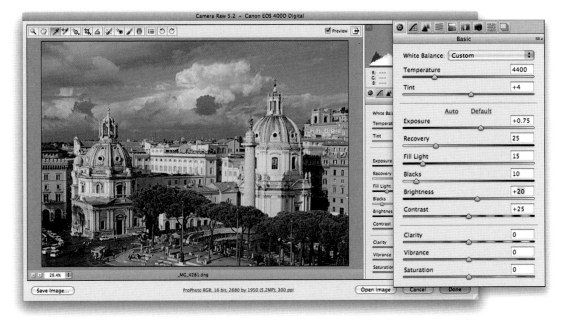

Figure 2.16 Setting the Fill Light and Brightness.

Contrast

The preceding steps all essentially affect the image's global contrast, with the Exposure and Blacks sliders in particular having the greatest effect. The Contrast slider in the Basic panel can therefore be used at this stage to modify the contrast. Basically, after you have set the highlights and blacks and adjusted the brightness, what do you think of the image? Does it look too flat at this stage or too contrasty? The Contrast slider provides a simple, yet effective means to adjust the global contrast. In the Figure 2.17 example we reckoned the photograph could have done with a little added contrast. The default setting is +25, but here we chose to raise this to +55.

Of course, you can also go to the Camera Raw Tone Curve panel and adjust the contrast. While we both like using the Tone Curve there is a lot to be said for the simplicity of the Contrast slider. You don't have to switch panels to carry on editing the image and a simple slider adjustment is often all you need to get the contrast right initially.

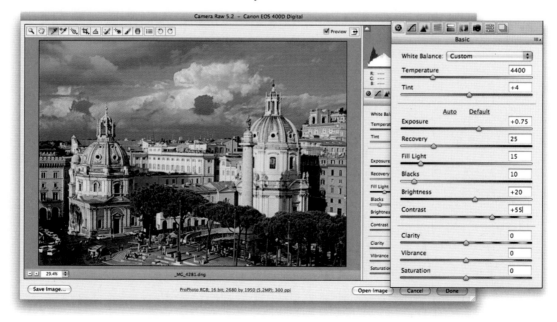

Figure 2.17 Setting the Contrast.

Finesse

This step is about adding polish to the image. It's not obligatory, but something that we do to quite a number of our images. You could extend what's done in this step to include things like HSL panel adjustments or use of the gradient filter to selectively darken a portion of the picture. We wanted to keep this section simple, so we'll focus on just the Clarity and Vibrance sliders in the Basic panel.

Clarity

The Clarity slider provides a nice, easy to use adjustment for adding midtone contrast to an image. A little later on in this chapter we'll be showing two different Photoshop techniques that can be used to add variable midtone contrast. The Clarity slider combines a bit of both of these techniques and is an effective tool for enhancing detail contrast (as opposed to sharpness) in areas of flat tone. Most photographs can benefit from adding at least +10 Clarity; in the Figure 2.18 example we set the Clarity to +25.

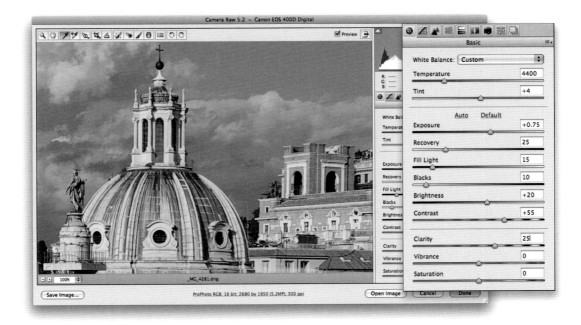

Figure 2.18 The Clarity adjustment step.

Vibrance

Just below Clarity we have the Vibrance and Saturation sliders. Saturation has been around since version 1 of Camera Raw and provides a basic method for boosting saturation in a photograph as it applies a 'linear' type saturation adjustment to every image. This means that it boosts the saturation of all colors evenly, including those colors that are already quite saturated. The downside of this is that it is very easy to clip some of the already saturated colors when applying even just a modest saturation boost. The Vibrance control, on the other hand, applies a non-linear saturation adjustment in which the least saturated colors get the biggest saturation boost, while the already saturated colors receive less of a saturation boost. Vibrance also tends to filter out skin tone colors so that these are more protected as you increase the Vibrance. In Figure 2.19 we applied a +20 Vibrance which enriched the colors in the scene, but without clipping the richer colors such as the treetops in the foreground.

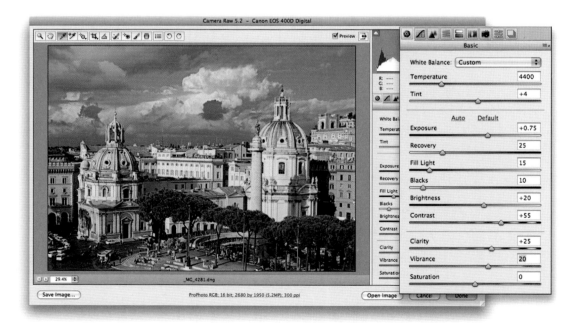

Figure 2.19 The Vibrance adjustment step.

Capture sharpening

Finally, we come to the capture sharpening step in which we go to the Detail panel in Camera Raw and fine-tune the four Sharpening sliders according to the sharpening needs of the image. When you first go to the Detail panel you'll see the default settings of 25 Amount, 1.0 Radius, 25 Detail and 0 Masking. These settings offer a reasonable starting point for most images, so even if you do nothing Camera Raw applies an appropriate level of capture sharpening.

Amount and Radius

The Amount and Radius need to be adjusted in tandem. The Amount determines how much sharpening is applied, while the Radius lets you decide how wide you want the halo edges to be. Basically, a Radius of 1.0 will work well for most edges. Fine detailed subjects will benefit from a smaller Radius setting and soft detailed subjects such as portraits can use a wider radius of, say, 1.1–1.3. In the Figure 2.20 example we applied an Amount of 45 with a small Radius of 0.8 pixels.

Sharpen for content

It is important to adjust the capture sharpening for the needs of the individual image. Once you have got the capture sharpening tailored to the requirements of each photo, the output sharpening that is applied at the end will be the same for every image. We'll be looking at the sharpening workflow a little later in this chapter.

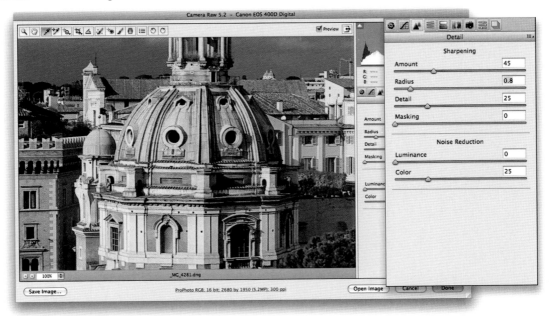

Figure 2.20 The Amount and Radius sharpening step.

Maximum detail

If Detail is set at 100, the sharpening effect is similar to that achieved when using the Unsharp Mask filter in Photoshop.

Detail and Masking

The Detail and Masking sliders act like suppression controls for the sharpening. Setting the Detail slider to an amount lower than 100 allows you to suppress the halo artifacts. With soft detailed subjects (such as portrait photographs) it is preferable to use a low Detail setting. With detailed photographs such as this it was OK to increase the Detail setting and not suppress the halos quite so much, which allowed us to apply a stronger sharpening effect. The Masking slider can be used to apply a mask based on the image content that filters the capture sharpening effect. With detailed subjects we leave the Masking set to zero, but for other types of images it is worth raising the masking, as this can help protect some of the soft detailed areas from being over-sharpened. In Figure 2.21 we applied a Detail of 60 and left the Masking set to 0.

Noise reduction

The noise reduction consists of a Luminance slider to suppress the grain-like effects of extreme camera noise,

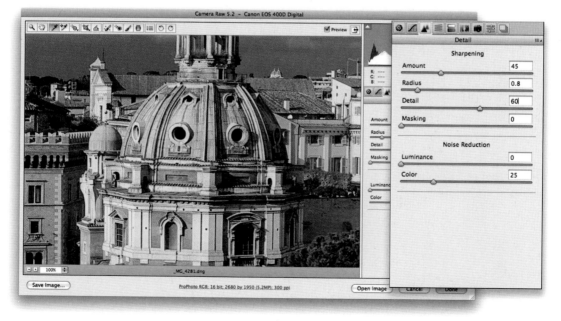

Figure 2.21 The Detail sharpening step

as well as a Color slider for suppressing the color speckle artifacts that are also a consequence of high ISO capture with some digital cameras. For most low to medium ISO captures we tend to stick with the default settings, but for high ISO captures, where more noise is usually visible, we tend to increase the Color slider first to remove the color speckles and then see if it is necessary to increase the Luminance noise reduction to smooth out noise artifacts. We'll be looking at other ways to reduce noise a little later in this chapter, but for now Figure 2.22 compares the finished photograph with the version we started out with.

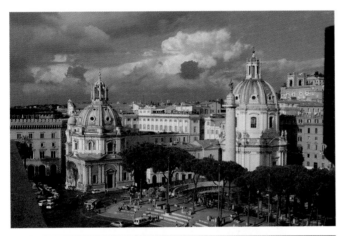

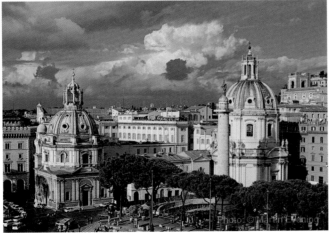

Figure 2.22 Here you can compare the before version (top) and the edited version below.

Lightroom perspective corrections

You can easily adapt the technique shown here to working in Lightroom. Go to the Photo menu and choose Edit in ⇨ Open as Smart Object in Photoshop.

Perspective corrections with Camera Raw

One of the top requests for Camera Raw and Lightroom has been to include perspective corrections, so that users can apply perspective corrections to raw images. There is no doubt that this would be a neat feature to have; the only downside is that perspective correction adjustments would be memory-intensive and such a feature could potentially slow down the preview redraw times. This might not always be such a problem for Camera Raw users, but it could slow things down in Lightroom if you had synchronized a perspective correction setting across a hundred images or more.

Leaving all this aside, it so happens there is already a method in Camera Raw and Photoshop that will allow you to correct the perspective of a raw photograph while keeping the image in its original raw file state. Here's how it can be done.

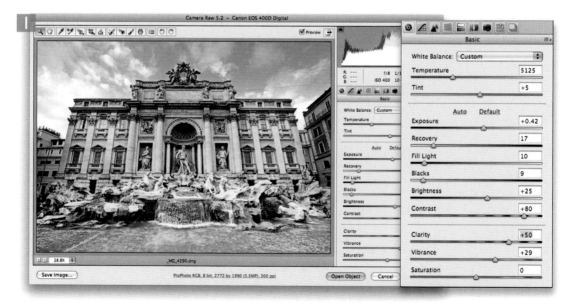

1 To correct the perspective in a raw image, I opened it in Camera Raw and held the *Shift* key down so that the Open Image button switched to display Open Object. I then clicked on this button to open the raw image as a Smart Object in Photoshop.

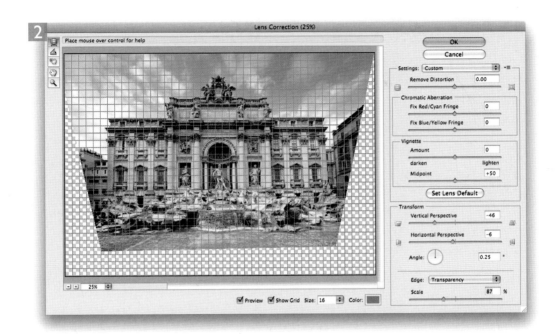

2 Once the Smart Object image had opened in Photoshop, I went to the Filter menu and chose Distort ⇨ Lens Correction... I applied the corrective settings shown here and clicked OK to apply the filter.

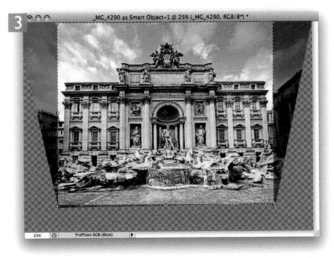

3 In the layers panel you can see the Lens Correction has been applied as a Smart Filter to the raw Smart Image layer. Next, I selected the crop tool so that I could crop the lens corrected image.

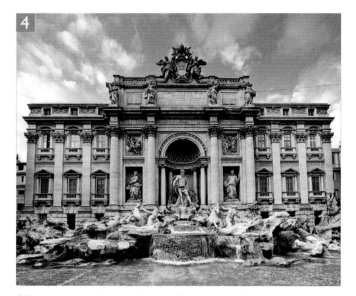

4 Here you can see the cropped version of the image. Let's suppose I now wanted to change the original Camera Raw settings. That's not a problem. All I had to do was to double-click the Smart Object thumbnail to reopen in Camera Raw.

5 As you can see, I still had access to the raw original without the Lens Correction filter and crop that I had applied in Photoshop. I was now able to adjust the Camera Raw settings and update the Smart Object accordingly.

6 Here you can see how the finished image looked after I had updated the settings in Camera Raw. As you will have gathered by now, the Smart Object layer references an embedded raw version of the image and this allows you to edit not only the Camera Raw settings but the Lens Correction filter settings, as many times as are needed. You can of course use the Lens Correction filter to compensate for barrel/pin cushion distortions as well as perspective control. There are just a few caveats to bear in mind here. Firstly, although you can add extra filters to this Smart Object layer you shouldn't attempt to edit the Smart Filter opacity of blending mode settings, since this is a filter adjustment that should either be on or off. Secondly, once you start adding retouch layers in Photoshop, you will want to lock down the Smart Object settings so that you don't accidentally re-edit them. Perhaps the best policy is to save this as a master version and create a flattened duplicate copy to retouch on.

45

PhotoKit Sharpener

PhotoKit Sharpener's sharpening workflow has proven to be successful – so much so that Adobe wanted Bruce Fraser to work with Thomas Knoll to incorporate the capture sharpening principles into Camera Raw and, later, output sharpening directly into both Camera Raw (5.2 and above) as well as Adobe Photoshop Lightroom. Unfortunately, Bruce passed away before seeing the results of the collaboration but I filled in for Bruce and helped complete the project. We're sure he would have been pleased.

Capture sharpening workflow

In the 'old days' the common wisdom was to only sharpen images at the end prior to printing. That worked 'OK' but was far from optimal. Our good friend and colleague Bruce Fraser had devised a two-stage sharpening approach back in Photoshop 3.0 days, but updated his thinking while working on PixelGenius' PhotoKit Sharpener™. The scheme was to break down the sharpening into three phases: 'Capture Sharpening' upon first opening an image, 'Creative Sharpening' for addressing local sharpening or smoothing, and 'Output Sharpening' at the last stage when the final size and resolution of an image is known.

The creative and output stages are well covered by PhotoKit Sharpener, but it's the capture stage that still mystifies some people. Capture sharpening depends on both the source of the image as well as the content. The content part of the equation is critical. For optimum sharpening, you need to adjust for the edge frequency – a higher radius for low frequency and a lower radius for high frequency edges. Figure 2.23 is an example of a low edge frequency image and shows the Detail settings used. While

Figure 2.23 With the image at a 100% zoom, the aim is to adjust the image till it looks 'good' at that zoom. The Radius was set to 1.5 which is appropriate for a portrait containing low edge frequency.

setting the Radius correctly is the first big step, it's really deploying the edge Masking that allows proper sharpening to be applied to those areas that need it, such as the eyes, lips and hair. Figure 2.24 shows the result of the masking preview. The white areas represent the edges which we want to sharpen and the black areas the surface areas which we don't. Setting the Radius and Masking properly allows using a more aggressive amount, which will optimize the detail in the image.

For a portrait, it's also useful to lower the Detail slider to kick in the halo suppression it provides while reducing the emphasis on high frequency detail (the other thing the Detail slider does). The higher the Detail settings the more the sharpening concentrates on detail and allows stronger halos – which are not 'bad' as long as they are invisible when zoomed to 100%. The other thing to pay attention to is while there are four sliders called 'Sharpening', there's really a fifth slider that comes into play and needs to be properly set: Luminance noise reduction. Most images need at least some slight noise reduction even though it's off by default.

Determining edge frequency

An easy way to determine an image's edge frequency is to imagine a horizontal line across the image. Images with low frequency tend to have fewer alternating strong lights and darks, such as this portrait. Landscape images often have high frequency edges and need a lower radius setting. Of course, sometimes an image has a mix and for that you need to take some extra steps.

Figure 2.24 This shows the Figure 2.23 image with the Masking preview (hold down the ⌥ *alt* key while moving the slider) showing the edges and surfaces of the image. The Masking slider is set here to 70, which is a common setting for portraits.

Figure 2.25 An example of an image with high frequency edges. Lots of alternating lights and darks and small detail. Here the Radius is lowered to 0.6 and the Detail slider set to 65. Notice the Masking is still being used at a low setting and Luminance noise reduction has been applied.

For images with high frequency edges – which are common for landscapes – the radius should be lowered and often the Detail slider increased. Figure 2.25 shows the result of aggressive Detail and Amount settings. The image is sharp, but without halos that would interfere with subsequent sharpening rounds in later phases (although the odds of needing creative sharpening are not high).

So that's all well and good if your image falls neatly into one of these two categories, but what about an image that has a mix of frequencies that puts it squarely in between? Well, you could compromise and adjust the settings to the middle ground but that's not really optimal. For cases where capture sharpening needs a blend of two types of sharpening – high and low frequencies – the best option is to optimize for both and blend the results. Creating two differently capture-sharpened copies of the raw file as Smart Objects allows us to blend between them. (See Figure 2.26). Figure 2.27 shows the two different settings used: one optimized for low frequency edges and the second for high frequencies. Figure 2.28 shows the combined result.

Figure 2.26 The image has been opened in Photoshop as a Smart Object. The bottom layer has been duplicated using Layer ⇨ Smart Objects ⇨ New Smart Object via Copy and a layer mask has been applied so the copy layer will only be blended in the center.

Figure 2.27 Within each Smart Object different Sharpening settings have been made to deal with low frequency detail, shown on the left (and placed at the bottom of the layer stack), and high frequency (finer) detail on the right, and placed above. Note that the Radius was higher and the Detail slider lower for the low frequency image with masking set to 30. Also note that the Luminance noise reduction was set to 40 to kill noise in the sky and water. The top layer needed a lower Radius, a higher Detail setting, and less Masking and Luminance noise reduction.

Figure 2.28 The final result of the Smart Object capture sharpen blend. The original image was shot at dusk with a Canon EOS 1Ds MII with a 24–70mm F2.8 lens.

Improving camera capture sharpness

It is all very well devising a sharpening workflow that includes capture sharpening, but it's also important to ensure that the images you capture are as sharp as they can be.

Choice of camera lens

The most obvious factor that affects sharpness will be the quality of the image optics used on the camera. In the past, camera lenses have been designed to meet the specific needs of film. This is not to say that film-designed lenses are no longer any good. Many of the classic lenses are indeed well suited for digital photography, but there are certain limitations you need to be aware of.

First of all, the lenses for 35 mm film cameras were designed to resolve well enough so as to capture a sharp image on a 24 mm x 36 mm area of film emulsion. Even when using the finest grain film emulsion processed under ideal conditions, the ultimate resolving power of 35 mm film cannot even begin to compare to the amount of detail that can be captured by the sensors found in some of today's digital SLR cameras. So, lenses that might have been great or OK ten years ago are not going to allow you to get the most out of the resolving power of, say, a 16 or 22 megapixel camera. Even if you use a good quality zoom lens, there may not be any point capturing anything more than 16 megapixels of data. However, if you use a modern prime lens, you should certainly see a definite improvement in capture sharpness. At the end of the day, 11 megapixels of data captured on an average zoom lens is plenty enough pixels for most reproduction quality work, but if you need extra detail, and want to make the most of what the sensor can offer, then you do need to think carefully about the lenses you shoot with.

Another consideration is the fact that film lenses were designed to resolve a color image to three separate (red, green and blue sensitive) film emulsion layers which overlaid each other. Consequently, film lenses were designed to focus the red, green and blue wavelengths at fractionally different distances and at even further distances

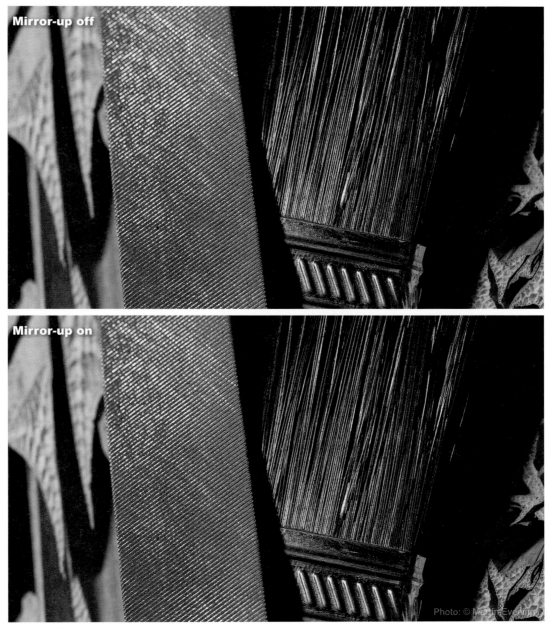

Figure 2.29 This shows a close-up view of a detailed subject where the top picture was shot with the mirror-up option switched off and the bottom picture was shot with the mirror-up option switched on. Canon EOS 1Ds MkIII with a Canon EF 100 mm f2.8 Macro lens, shot at 1/60th, f 7.1, 200 ISO.

Image stabilizing lenses

Image stabilization can be achieved in two main ways. Image stabilizing lenses use gyroscopic motors to move the lens elements in an effort to keep the image steady. If you look through the camera and move the lens about quickly, you'll hear the motors whirring as they compensate for camera shake type movement and you'll sometimes notice how the image jumps every now and then as you do so. Some cameras can stabilize the image by using motors to move the sensor instead and the advantage of this is that you are not limited to working with specific image stabilizing lenses only. In either case, image stabilization can help you shoot sharp pictures at slower shutter speeds and this can effectively buy you a couple stops of exposure, where without image stabilization you would be forced to shoot at a higher ISO setting in order to get sharp pictures.

Setting the camera to mirror-up mode

This can be tricky with some cameras, as it is often a custom user setting that is buried deep in the camera settings menus. With the latest Canon EOS cameras it is now possible to make the mirror-up mode a custom favorite setting that you can access more easily when out on location shooting.

apart towards the corner edges of the film emulsion area. Since the red, green and blue photosites are all in the same plane of focus on a digital sensor, lenses that are specifically designed for digital capture will now focus the red, green and blue wavelengths to a single plane of focus.

Shooting with a tripod vs. hand-held

There are some obvious benefits to shooting with the camera fixed to a tripod, especially when shooting in low light conditions where you would otherwise be forced to use a slower shutter speed or higher ISO setting. One thing you do have to be careful of is to not use image stabilization when shooting on a tripod since with some older lenses, the image stabilization can end up actually destabilizing the image.

Improved sharpness using mirror-up mode

The action of the mirror flipping up on a digital SLR or medium format camera will cause a small amount of internal vibration. This can be a problem when shooting with continuous light and where the time duration in which the camera body vibrates slightly makes up a significant proportion of the overall exposure. We therefore reckon this is more of an issue when using shutter speeds of around, say, a 1/15th to 1/125th of a second and when photographing close-up subjects, as opposed to landscape scenes shot with a wide-angle lens (see Figures 2.29 and 2.30). Ironically, the problem can be made worse when the camera is mounted on a tripod. This is because the vibration movement originates within the camera itself, whereas when you hand-hold a camera the mirror vibration can be absorbed through your hands. You could say that the photographer holding the camera is acting like a giant shock absorber!

Whenever we shoot non-moving exterior shots on a tripod or studio subjects lit with continuous lighting, we often use the camera in mirror-up mode when shooting close-up details. One of the nice features of the latest Canon EOS cameras is that it is now much easier to set up and access the mirror-up mode as a favorite camera setting.

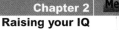

Figure 2.30 This shows the same subject that was shot in Figure 2.29, this time showing the difference between four methods of shooting, using the Canon EOS 1Ds MkIII at a 200 ISO setting with an exposure of 1/60th second at f7.1. The top left example was shot on a tripod using an EF 70–200 mm lens in mirror-up mode. Next to it, on the right, is a hand-held version shot with the lens image stabilization switched on and, bottom left, a shot taken with the image stabilization switched off. The bottom right picture shows the same subject photographed on a tripod, but with a less expensive Canon zoom lens.

Noise reduction

Noise is something that affects all digital images. If you shoot at the optimum ISO rating the chances are you won't even see any noise, but as you increase the ISO rating the noise will soon become noticeable. The presence of noise in an image is due to the fact that when you increase the ISO setting, this increases the gain sensitivity of the sensor (which bear in mind is actually an analog device). The amplification of the signal coming from the sensor increases its sensitivity (and therefore its ISO rating), but it also amplifies the random background noise and this is where we start to see more noise in our captures. There are two problems to address here. One is the random color speckles and the other is the clumpy grain-like pattern that you see when you inspect an image in close-up.

Photoshop noise reduction

There are two ways to address noise inside Photoshop. Firstly, there are the Detail panel noise reduction sliders in Camera Raw. These can remove noise from most types of images (the noise reduction algorithm has been much improved since Camera Raw 4.1). The other option is to process images in Photoshop directly using the Reduce Noise filter, which offers some extra fine-tuning controls to help combat noise. Overall, we reckon the Camera Raw Detail panel is the more appropriate tool to use as your first port of call. The Reduce Noise filter is suitable for treating any particularly noisy digital captures that Camera Raw can't fix. We also recommend the extra steps described over the next few pages which show how the Reduce Noise filter can be targeted more precisely to affect those areas that need noise reduction the most.

Third-party noise reduction

Although the tools in Photoshop are pretty good, they are still not a match for some of the third-plug-ins out there, such as Noiseware™ by Imagenomic® and Noise Ninja™ by PictureCode®. Most of our experience has been with using Noiseware, which is excellent at removing really tricky noise as well as reducing film grain.

Targeted noise reduction

The following steps are derived from a technique described by Bruce Fraser in his book *Real World Sharpening with Adobe Photoshop CS2*, published by Peachpit. These steps show you how to mask a Reduce Noise filter layer so that the edge detail is preserved and does not suffer from the softening effect of the noise reduction process.

Record as an action

To save repeating all the steps shown here, each time you want to reduce the noise in a photograph we suggest you record the following steps as a Photoshop action.

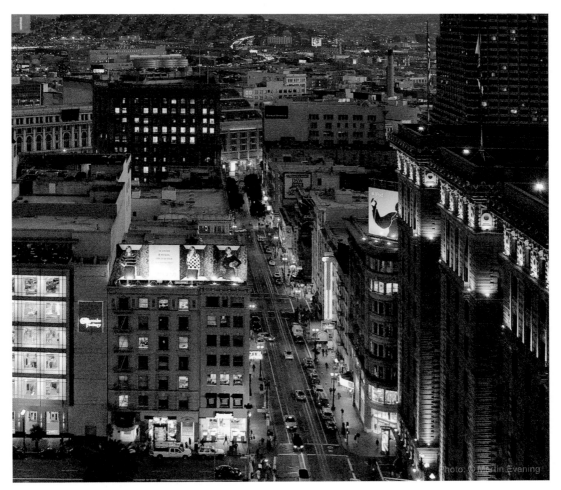

Photo: © Martin Evening

1 Here is a close-up view of an underexposed and unsharpened digital capture that was shot at 1250 ISO. You can clearly see a lot of luminance and color noise in this picture.

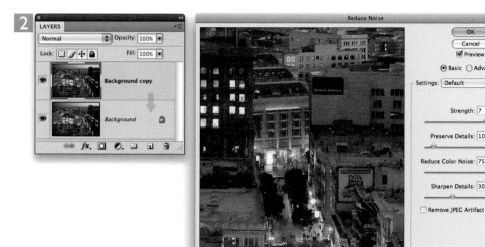

2 The first step was to make a duplicate copy of the Background layer (you can do this by dragging the Background layer down to the New Layer button). I then applied the Reduce Noise filter, adjusting the settings to remove as much of the luminance and color noise as possible. You have to be careful to not set the Reduce Color Noise setting too high, as this can cause strong colors to bleed slightly.

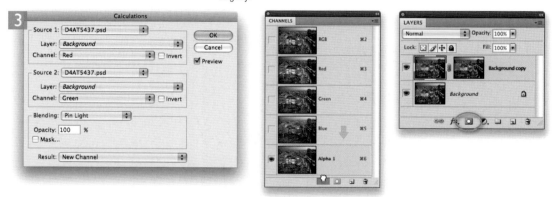

3 I now wanted to create a protection mask for the Background copy layer that would help preserve more of the edge detail. I chose Image ⇒ Calculations and configured the dialog as shown here. Basically, I created a new Alpha channel that was a blend of the Red and Green channels, using the Pin Light blend mode. The Alpha 1 channel appeared in the Channels panel and I dragged this to the Make New Selection button to load as a selection, and clicked on the Add Layer Mask button (circled) in the Layers panel to convert this active selection into a layer mask for the Background copy layer.

4 The mask was now ready for editing. I went to the Filter ⇨ Stylize menu and chose Find Edges. This was then followed by a Gaussian Blur filter of between 3–5 pixels plus a Curves adjustment, which lightened the mask slightly. The idea here is that darker shades of gray in the layer mask hide the layer contents and the lighter areas of the mask allow more of the layer to be revealed.

5 Here is the final result, in which the Background copy layer that had been processed using the Reduce Noise filter was masked by a layer mask that hid the edges more and kept these from being filtered.

More about Stacks

Stacks is one of my favorite features for photographers. Unfortunately it is only available as part of the extended version of Photoshop. Check out the tutorial on pages 82–85 in which we demonstrate how to remove tourists from a busy scene.

Removing noise using multiple exposures

Here is an alternative technique for reducing noise that makes use of the Stacks feature in Photoshop, where you can blend a series of identically shot photographs to produce a single image where all the noise artifacts are smoothed out. Note: you can only use the following technique if you have the extended version of Photoshop CS3 or CS4 and this technique works best for those situations where you are shooting pictures of still-life subjects in low light conditions but don't have access to a tripod.

Here's how it works. Once you have aligned the photos using the auto-align method described here, the Median Stacks rendering method averages out the pixels at each point in the image. What you end up with is an image that will not only be noise-free, but may well appear to be smoother and sharper than the individual captures. This is because the rendering process will also smooth out those shots where there was a slight amount of blur. There is also another Stacks processing technique described later in Chapter 3, but this too can only work if you have the extended version of Photoshop.

1 To begin with, I made a selection of nine photographs in Bridge that I wished to process as a Stacked layer image. These pictures were all shot at night where I had simply hand-held the camera and fired off a short sequence of captures.

2 The first step was to open these photographs up in Camera Raw (using ⌘ R ctrl R). I adjusted the White Balance plus other Basic panel adjustments and synchronized these settings with the other selected photos by choosing 'Select All' in the Camera Raw dialog, before clicking on the Synchronize... button. I then clicked the Done button to close the Camera Raw dialog and apply the settings.

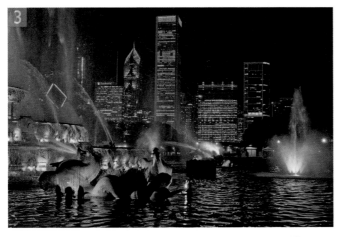

3 I then went to the Tools menu in Bridge and chose Photoshop ⇨ Load files into Photoshop Layers... This opened the selected photos in Photoshop and added them as layers to a single image document. How the images were opened depended on the workflow settings I had set in Step 2 (circled). In this instance the photographs were all processed at their native resolution using ProPhoto RGB at a bit depth of 16-bits per channel.

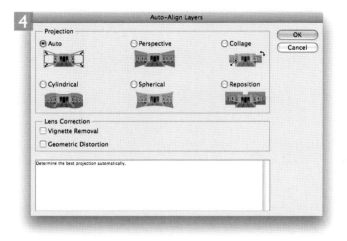

4 Since the photographs had all been captured using the camera hand-held, it was important to make sure that the layers were aligned correctly. I selected all the layers in the Layers panel, went to the Edit menu and chose Auto-Align Layers... This opened the dialog shown here, where I checked the Auto option and clicked OK.

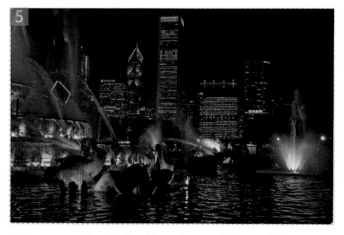

5 Here you can see the auto-aligned image. I now needed to go to the Layer menu and choose Smart Objects ⇨ Convert to Smart Object. This created the single Smart Object layer you can see here on the left, but if I were to double-click the layer thumbnail I would see all the original layers that comprised my Smart Object.

I then went to the Layer menu again and chose Smart Objects ⇨ Stack Mode ⇨ Median. If you try this out for yourself, you may find the Stacks rendering will take a while to complete. How long it takes to apply the processing will depend of course on the size and number of layers, plus the bit depth of the image.

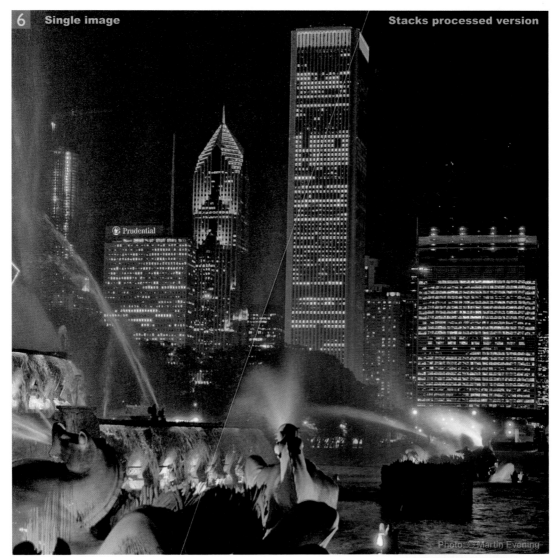

6 Once the processing was complete, you will notice how the Smart Object layer had a Stacks icon (circled) indicating that the Smart Object had been rendered using the Stacks feature. Here is a close-up view that shows a single exposure on the left and the Stacks rendered version on the right where the nine separate exposures were merged to produce a smoother, noise-free image. The Median rendering was used here because it analyzed the pixel values from the lowest to the highest that occurred at any one point and picked the middle value, thereby eliminating nearly all of the noisy pixels that were present on each of the separate layers.

Nash Editions

Nash Editions is based in California and was founded in 1990 by Mac Holbert and Graham Nash to provide a specialist fine-art digital printing service. They were the original pioneers of fine-art inkjet printing. Mac uses this technique to bring out the depth and give more shape to many of the images he prints for customers. Mac is also the newest member of Pixel Genius and will be working on a revision to PhotoKit Sharpener.

Sculpting photos

Photography has always sought to represent three-dimensional scenes and objects in a two-dimensional medium. The most successful images tend to have an enhanced sense of shape and volume but mother nature doesn't always cooperate and provide the perfect light. Then it's up to the photographer to bring out the shape and volume using Photoshop. There are a lot of tools in Photoshop to help with that task, but sometimes it's best to use an alternative approach. Mac Holbert has perfected this technique (although others have used variations) to bring out the three-dimensional shape to images he prints for customers. It does employ a certain degree of brush work by hand (which always make me nervous since I can't draw) but if I can do it, pretty much anybody can. You're always able to use Photoshop's extensive array of selection techniques to help in the painting.

The sculpting technique uses a layer set to Overlay blend mode and filled with a 50% gray to start. Since overlay is a procedural blend, it screens when above 50% gray and multiplies below 50% gray. The starting gray layer does nothing until you paint with black or white. The key is to do so very gently in order to enhance the natural shape and forms already in the image. See Figure 2.31 for a before and after.

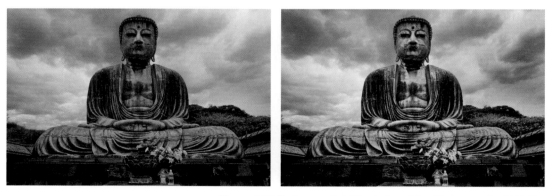

Figure 2.31 The image on the left is prior to sculpting. The image on the right is the result. The result of sculpting cannot be exactly duplicated using adjustment layers – it's really a unique solution for adding shape and volume to an image.

1 To begin with, I made a new empty layer on top of the Smart Object layer. The fact that the raw image was a Smart Object meant that I would always be free to go back to the raw image to tweak it (although I didn't need to here). The empty layer was filled with a 50% gray and the blend mode was set to Overlay. Thereafter, when I painted with white into the Overlay layer it would lighten by screening and darken when painting with black by multiplying the image data underneath.

2 To allay my natural fear of painting, I started the process by making a luminance selection of the darker areas I wanted to enhance (to load the luminance as a selection hold the ⌘ *ctrl* key and click on the RGB channel). Since the 50% gray layer was set to 100% opacity, I needed to work gently and set the brush flow to only 5%. Much of the subsequent work was actually done with the flow set to 1–3%. I started painting into the selection using white as the foreground color. I also inverted this selection and painted with black to increase the separation between the areas. I used the **X** key to toggle back and forth between painting with black or white as shown in Figure 2.32. Lightening an area tends to visually make it move closer while darkening makes it recede. Thus by lightening and darkening adjacent areas I could increase the appearance of dimensionality.

Figure 2.32 Setting the foreground color to black will darken the image while white will lighten. To toggle back and forth between the colors be sure to reset the colors then simply press the **X** key to toggle back and forth.

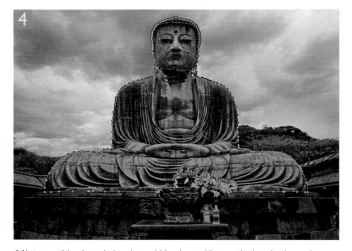

3 In this step I zoomed into the image and painted white into the chin area and black under the lips to give a greater sense of depth and separation. As long as you work with a very low flow and build up the strokes, you don't need to worry about being too accurate with each stroke.

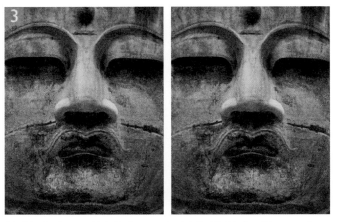

4 Not everything I needed to do could be done with a synthetic selection or by freehand painting. In this step I created a path to outline the Buddha and then made a selection from the path. The 1.2 feather radius was used to approximate the resolution of the edges in the image. If the selection was too sharp it would look like a cut-out and if too soft it would bleed the effects. A 1.2 feather radius matched the sharpness of the natural edge. By inverting the selection I could work on the sky or, by inverting again, work on the Buddha.

5 In the top figure I had inverted the selection to paint black to darken the sky beyond the Buddha's head. In the bottom figure I had reinverted the selection (to reselect the Buddha) and painted with white to lighten the shoulder.

6 One of the inherent problems with using an Overlay blend mode to sculpt an image is that when increasing the contrast of an image, you may also get a boost in the color saturation. To control that I created a merged layer set to Color blend inside of a layer group. I deselected the Overlay layer and held the ⌥ alt key when selecting the Merge Visible option in the Layers panel. Placing the Color Control layer above the Overlay layer essentially removed the color saturation boost. I didn't bother with a layer mask for the Sculpting layer because it was really easy to get rid of the black and white in the layer by changing the foreground color to a 50% gray and painting or filling to reduce the effect of the layer.

7 This step shows the result of painting white and black in the various areas to alter the dimensionality of the final image. You'll see that the effect of adding black and white to the Sculpting layer is fairly subtle – as it should be.

8 Here is the final result. The original image of the Diabusu Buddha in Kamakura, Japan, was shot with a Canon EOS 1Ds with a 16–35mm F2.8 lens.

Improving midtone contrast

Normal image contrast adjustments affect the image globally, but if you wish to improve the contrast in the midtone areas you can use the following two techniques in Photoshop to add more presence to your images.

The first one is designed to specifically target the midtone areas by applying a small, soft halo edge to the midtones only. The second technique allows you to apply a wider, softer halo edge, which can help improve the contrast in areas that have soft detail. The Clarity slider in Camera Raw basically offers a hybrid of these two types of adjustment. By showing here the individual Photoshop methods that make up Clarity, you can learn how to apply more controlled Clarity type enhancements to your photographs. So instead of having just one slider to improve clarity, you can effectively have three slider controls at your disposal. We don't suggest you need to do this with every image, but you may find with subjects such as softly-lit landscape subjects that these steps give you added control to help make the detail stand out more.

Smart Object limitations

You'll notice here that rather than convert the Background layer to a Smart Object directly, we had to make a duplicate of the Background layer and convert the copy layer into a Smart Object. It shouldn't always be necessary to do this in order to use Smart Filter layers, but in this instance we had to because the Smart Filter options don't yet include Blend If sliders (although we wish they did).

1 Here we wanted to demonstrate how the medium contrast technique could be applied to a photograph as a Smart Filter. To begin with, we dragged the Background layer to the New layer button in the Layers panel. We then went to the Filter menu and chose Convert for Smart Filters.

2 With the Background copy layer selected (which is now a Smart Object), we went to the Filter menu and chose Other ⇨ High Pass. It does not matter too much at this stage what value was used here since we were able to re-edit this setting later in Step 4.

3 Now that we had applied the High Pass filter, we needed to change the layer blend mode setting to Overlay. To do this we double-clicked on the Background copy layer, targeting the blank space area (this is the area within the green box and not the thumbnail or the layer name itself). We set the blend mode to Overlay and, at the same time, went to the Blend If options at the bottom and adjusted the 'This Layer' sliders so that they were split as shown above: 50/100 150/200 (to set the sliders like this you have to hold down the ⟆ *alt* key to split them apart).

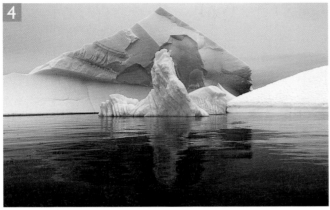

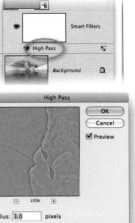

4 The layer blend changes made in Step 3 meant that the halo effect created in Step 2 was applied to the midtone areas only. At this stage you might want to double-click the High Pass filter layer in the Layers panel (circled) to reopen the High Pass filter dialog and fine-tune the Radius setting.

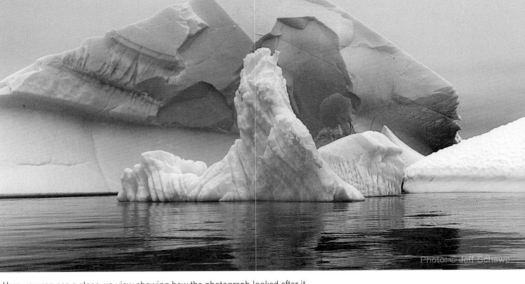

5 Here you can see a close-up view showing how the photograph looked after it had been processed using this technique, compared with how it looked before. The difference is quite subtle, but you should be able to see how it has enhanced the contrast in the midtone areas. Note how the ripples in the water are also better defined in the right half of the picture.

High radius Unsharp Mask technique

We know from experience that if we add contrast to a photograph we can make it stand out more. However, bumping up the contrast or adding an 'S' shaped curve can only do so much to improve the 'global' appearance of a photograph. If you add too much contrast, you can all too easily destroy the delicate tonal balance and ruin a perfectly good picture. The technique described here is one that will allow you to add contrast at a localized level.

It so happens that the human eye is more attuned to localized changes in contrast and it was knowledge of this phenomenon that led Thomas Knoll at Adobe to propose a localized contrast enhancement technique based around the formula of using a high Radius and low Amount setting in the Unsharp Mask filter dialog. This in turn led Thomas to devise the new Clarity control for Adobe Camera Raw 4.1 and Lightroom 1.1 (incidentally, Michael Reichmann has written an excellent article outlining this technique, and Thomas Knoll's thinking behind it, on the Luminous-Landscape.com website). As I mentioned on page 37, the Clarity adjustment combines the technique shown here with the midtone contrast technique described on pages 67–69. Even so, the 'high Radius/low Amount' is so effective when it's applied on its own that I thought it would be useful to share, especially since it is only in Photoshop that you have the ability to selectively apply the effect. In the following examples you can apply these as a Smart Filter and use the Smart Filter layer mask to hide or show the effect.

In the example shown opposite, I chose a photograph where the atmospheric haze had softened the detail on the shore and hillside in the distance. Here, you will notice how the low Amount setting combined with a high Radius created a soft shadow halo around the edges of the picture, which helped remove a lot of the haze.

1 The first step was to choose Filter ⇨ Sharpen ⇨ Unsharp Mask and set the Radius to a really high value, such as between 30 and 70. This is a much higher Radius value than you would use normally and the trick is to keep the Amount slider to a low setting so that you don't end up applying too strong an effect.

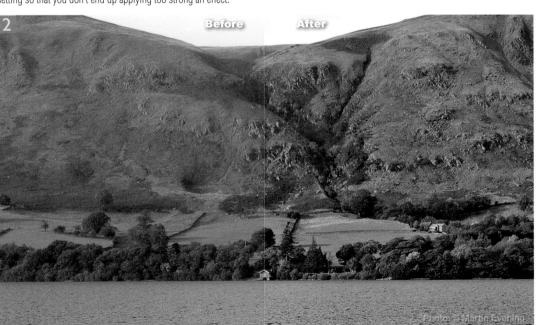

2 This shows a 100% view, where you can see on the left the before version and on the right how the photograph looked after I had applied the Unsharp Mask filter. The difference can be quite dramatic. In this particular example the end result was like lifting a veil from in front of the lens.

JAY PRITZKER PAVILION

Photograph: Martin Evening.
Canon EOS 1Ds Mk III | 15 mm | 125 ISO | f11.0 @ 1/60th: 1/1000th. Blended using PhotoMatrix Pro.

Chapter 3

Mending and blending

Photoshop repair work

Most people tend to think of Photoshop as a program for retouching photographs. Photoshop can do a lot more than that these days, but retouching is what it's best known for. In this chapter we wanted to focus on a few of our favorite retouching techniques, some of which have never before been demonstrated or published. Some of these techniques are quite involved and require a certain level of expertise, while others are actually quite simple and suggest some interesting shortcuts for correcting photos.

Healing brush modes

The healing brush offers a choice of blending modes. The Replace mode is identical to the clone stamp tool, except it allows you to merge film grain more reliably and smoothly around the edges of your brush strokes. The other healing brush blending modes can produce different results but in my opinion they won't actually improve upon the ability of the healing brush in Normal mode, since the healing brush is already utilizing a special form of image blending to perform its magic.

General retouching

Healing brush strategies

Those of you who have not used versions of Photoshop prior to version 7 must forgive us for thinking that the healing brush is a magical wonder – but it can't do everything. The clone stamp tool still has its usefulness as does copying and pasting pixels. When to use what can be tricky – healing is best done away from strong contrast perimeters and where texture needs to be preserved (or added to). It's best used at full opacity and with a hard brush (just about the opposite of the clone stamp tool). Sometimes you need to seed an area with pixels before the healing brush can be made to work, other times it's better to use the patch tool where you can make an accurate selection prior to using the tool. Sometimes it is easier to simply grab pixels from some other source and blend them in. Figure 3.1 shows Jeff's Harley shot in the studio. There are issues: too narrow a background, wrinkles and a foreshortened foreground due to needing a front fill card. Figure 3.2 shows using the healing brush as well as the patch tool to fix the background issues. The Layers panel shows the addition of a pasted layer from a separate image shot on the same background. There are additional layers for tone adjustment and a fix for the Harley logo. The final retouched image is shown in Figure 3.3.

Figure 3.1 This is the before shot of Jeff's FLSTS Harley (he's sold that and rides a BMW now). You can see that the muslin background didn't cover the full width and is short in the foreground due to a required fill card. You can also see seams that need removal.

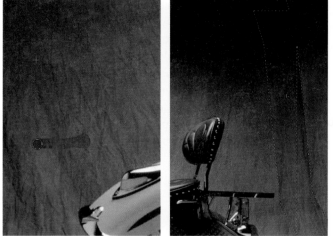

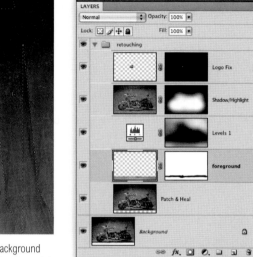

Figure 3.2 On the left, the healing brush is being used to eliminate background seams – a function perfect for this tool. On the near right the patch tool makes quick work of extending the background. On the far right is the final layer stack showing a foreground addition added from a separate shot to cover up the fill reflector card.

Figure 3.3 The final retouched image.

Adding lens flare

The Lens Flare filter is ideal for adding realistic-looking lens flare effects to photographs or computer rendered images, as this filter allows you to apply the ghosting type patterns that are normally associated with camera lens flare. Now that we have Smart Filters it makes sense to convert an image to a Smart Object layer first before you apply the filter. This way you have the ability to re-edit the filter settings and reposition the source point for the lens flare effect.

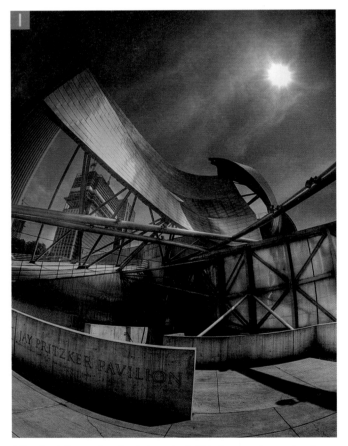

1 Here is a before version of a photograph, shot into the sun using a series of bracketed exposures and blended together using Photomatrix Pro. The first step was to select the Background layer, go to the Filter menu and choose Convert to Smart Filters. This converts the layer to a Smart Object – you can see the Smart Object badge circled in the layers panel.

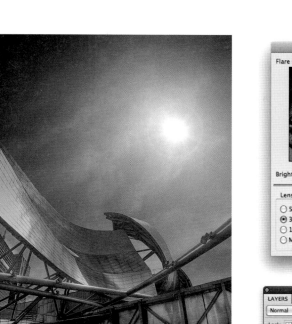

Photo: © Martin Evening

2 I then went to the Filter menu and chose Render ⇨ Lens Flare... This opened the dialog shown top right, where you will notice there are several different types of lens flare patterns that you can choose from. Since this photograph was originally shot using a 15 mm fisheye lens, I selected the 35 mm Prime option. I then clicked on the sun in the small dialog preview to set this as the flare center point. One can then adjust the Brightness slider to create a weak or strong lens flare effect. Since I was applying the effect as a Smart Filter I chose to set the brightness quite high at 150%. This allowed me to later edit the Lens Flare Smart Filter settings by double-clicking on the options icon (circled in yellow) next to the Lens Flare effect to open the Blending Options dialog shown here, where I could quickly fade the filter effect strength. The other advantage of applying as a Smart Filter is that I could double-click the Lens Flare effect (circled in red) to reopen the Lens Flare dialog and re-edit the filter settings (this is true for any filter that you are able to apply as a Smart Filter).

Alien Skin™ Exposure®

If you are after a good range of film simulation effects for digitally shot images, then check out the following link: www.alienskin.com/exposure/ This Photoshop plug-in can be used to apply film grain effects that match a variety of traditional film emulsions.

Simulating film grain

Most Photoshop users will be aware that you can use the Add Noise filter to get images to look more grainy, but the Add Noise filter will always tend to look rather 'electronic' if it's applied as a single filter. The following steps show one way you can modify the Add Noise filter effect to achieve a result that looks more like real film grain. For example, this technique might be used to simulate a grainy film look or to disguise retouching work that's been carried out on a scanned grainy film image.

1 The first step was to ⌥ alt click the Add New Layer button in the Layers panel (circled). This popped the New Layer dialog shown here where I set the blend mode to Overlay and checked the 'Fill with Soft-Light-neutral color (50% gray)' box.

2 With this new layer selected, I went to the Filter menu and chose Noise ➪ Add Noise. Here, I selected the Gaussian mode, checked the Monochromatic box and applied an Amount of 45%. I followed this by going to the Filter menu again, selected Blur ➪ Gaussian Blur and applied a 1.5 pixels Radius Blur.

3 I then applied a further dose of the Add Noise filter but this time added a lesser Amount of 10%, using the Uniform option, but still in Monochromatic mode. Lastly, I chose Filter ⇨ Sharpen ⇨ Unsharp Mask using the settings shown here.

4 In this final step you can see on the left an untreated image and on the right the same image with the film grain layer active. As you can see, the film grain steps described here can produce a very pronounced film grain effect, which can be made softer by either reducing the opacity of the film grain effect layer or by modifying the filter settings that were applied in the previous steps.

Removing foreground objects

Don't you hate it when street signs or overhead cables get in the way of a great view? Here is an easy way to get rid of offending foreground objects, although to use this technique you will need to shoot several frames of your subject and step slightly to the left or right between each exposure. You don't need to shoot using a tripod, just try to keep the background subject more or less in the same position in the frame. To process these photographs in Photoshop, all you have to do is choose the two best frames. All you will need is enough displacement between the two shots to achieve a clear view of the main subject behind whatever objects are in front of it.

1 Here are two photographs shot of the same subject, but captured from two slightly different angles. In this example, I shot the frieze on this wall from across the street and sidestepped just a few feet to the right to capture the second exposure. The view of the frieze was more or less consistent, but this slight shift of camera perspective was enough to displace the street sign in both photographs.

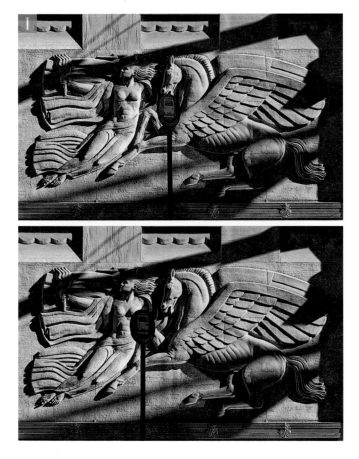

2 I opened the two photographs shown in Step 1 and used the move tool to drag one on top of the other as a new layer. I held down the shift key as I did so that the second image was placed above the other, keeping the frame positions in exact registration.

3 To align the picture content, I needed to hold down the Shift key to select both layers and choose Edit ⇨ Auto-Align Layers... This opened the dialog shown here, where I clicked on the Auto option to automatically align the two layers.

4 The retouching part was really simple. For this final step, I selected the uppermost layer and clicked on the Add layer mask button to add a new empty layer mask. I then selected the paint brush and used black as the foreground color to paint over the street sign. This technique worked well here because the auto-alignment in Photoshop had done a perfect job of aligning the two layers.

Photo © Martin Evening

Specialist applications

There are various types of specialist users who will find the Stacks rendering feature useful. Scientists can use this as a tool for detecting small differences between images. Forensics users can use certain types of Stacks renderings to amplify minute changes in a series of images, while astronomers can use the Mean rendering to remove extraneous noise when combining a series of astronomy photographs. Some of us have argued that the Median rendering method should be made accessible in the standard version of Photoshop as well but, for now at least, this technique is only going to be available to those Photoshop users who have the extended version of Photoshop CS3 or CS4.

Layer blending to remove tourists

The Stacks feature lets you use special formulas to determine how layered images are blended together. To summarize how this works, you can take a multi layered image, select two or more layers, convert these to a Smart Object and apply a Stacks rendering. This feature was really designed as a tool for analytical work in areas such as forensics, medical imaging and astronomy photography (see sidebar). It is because of these rather specialist applications that the Stacks feature has so far been limited to the Extended version only of Photoshop, which is a shame really because the Median Stacks rendering mode can also be applied to creative tasks such as removing tourists from a busy location scene.

Median rendering

Of all the different rendering methods you can apply to a series of layers in a Smart Object, the Median rendering is probably the most interesting. This is because it works by analyzing each and every pixel location in a stack of images and selects whatever is the most common pixel value to all the layers at a given point. A Median rendering can therefore be used to smooth out the differences found between individual exposures in a Stack and is most useful for processing a sequence of photographs that have been shot from the same angle. This technique will allow you do things like smooth out high ISO noise or, as shown here, remove people that have been captured moving through the scene in front of the camera. The following technique will therefore work best for photographs that have been taken using a tripod. Having said that, on the day we shot this a young photographer approached us; we got chatting and explained the technique. Later on that day he emailed us with the result he had got from hand-holding the camera using just a few frames that had been shot over a much shorter period of time. The picture he created was actually pretty good for what was a quick, first experiment using this technique. Basically, you can make this work hand-holding the camera, but for best results use a tripod.

1 This shows just a few of the photographs that we shot of a sculpture in Chicago that is popularly known as the Bean. We took these pictures early afternoon over a period of an hour, at a time when a large number of people were visiting. The most crowded area was right underneath the Bean itself, which was why we took it in turns to capture well over a hundred frames. This ensured that we had enough pictures so that a Median Stacks rendering would allow us to remove all of the people from this scene.

Figure 3.4 The Median stacks rendering technique works best if you do what we did here and shoot the pictures using a tripod with a cable release.

2 The first step was to go to the File ⇨ Scripts menu and choose 'Load Files into Stack'. This opened the dialog shown here, where we clicked on the Browse... button to locate the folder containing all the images that had been shot that afternoon. We also checked the Create Smart Object after Loading Layers option (although you could do this separately in Photoshop afterwards). If these shots had been taken hand-held, we would also have checked the Attempt to Automatically Align Source Images option, but since these had all been shot using a tripod (see Figure 3.4) there was no need to do so. We clicked OK to start loading the layers.

3 It may take a while for Photoshop to open all the images, add them as layers and create a Smart Object. 128 images were added here and, as you might expect, the time this takes will all depend on the size of the individual images and how many there are. What we ended up with was a new document with a Smart Object layer that contained all the selected image documents grouped as layers within a Smart Object. When we double-clicked the Smart Object layer we were able to see the full expanded list of layers contained in the Smart Object.

4 Now for the clever part. First we needed to make sure that the Smart Object (that I showed open in Step 3) was closed, so that the Layers panel looks like the example shown here (showing a single Smart Object layer). We went to the Layers menu and choose Smart Objects ➪ Image Stack Mode ➪ Median. Again, the Stacks rendering took a little while to complete, but once it was finished the Median rendering managed to blend the layers such that nearly all of the people in the merged picture had disappeared completely.

5 Although the Image Stack Median rendering did a pretty good job of removing the people from the scene, it ended up smoothing out the sky to the point where we lost any cloud detail. We selected one of the original images where there were some interesting clouds, added this as a new layer and applied a linear gradient to the layer mask to replace the top half of the photograph.

Displacement maps

The Displace filter requires a separate displacement map image that it can reference when calculating the displacement. Black (0) will produce the maximum negative displacement shift and white (255) will produce the maximum positive shift, while gray (128) will produce no displacement. A displacement map must be saved as a grayscale image using the native Photoshop file format, but if you add a second channel the first channel determines the horizontal displacement and the second channel controls the vertical displacement.

Merging objects with displace distortion

The Displace filter is not the most intuitive of filters but is still quite invaluable if you need to distort a layer so that it appears to match the shape or texture of the underlying layers. The effect works well where the displacement map you use has been softened beforehand, plus you will find a large number of displacement maps are contained on the Adobe Photoshop disk and these can be loaded to create other types of texture displacements.

1 Here you can see the graffiti graphic and a brick wall image. To begin with I used ⌘ C ctrl C to copy the graffiti logo pixels. I then went to the brick wall image, created a new channel and pasted the logo into the channel (⌘ V ctrl V). I duplicated the new channel and edited them both so that I ended up with an 'Elvis Rules' and a 'Tiny' alpha channel.

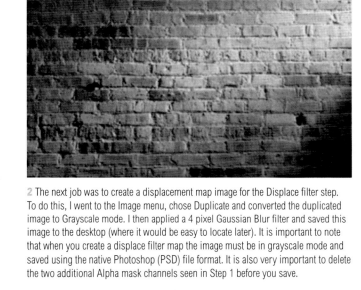

2 The next job was to create a displacement map image for the Displace filter step. To do this, I went to the Image menu, chose Duplicate and converted the duplicated image to Grayscale mode. I then applied a 4 pixel Gaussian Blur filter and saved this image to the desktop (where it would be easy to locate later). It is important to note that when you create a displace filter map the image must be in grayscale mode and saved using the native Photoshop (PSD) file format. It is also very important to delete the two additional Alpha mask channels seen in Step 1 before you save.

3 I was now ready to blend the two elements together. Here I created a new layer group and added two solid color fill layers inside it. One used black as the fill color, where I set the layer blend mode to Multiply at a 50% opacity. I used a dark brown for the other color layer and set the layer blend mode to Overlay and the opacity to 85%. Next, I ⌘ *ctrl*-clicked on the Elvis Rules alpha channel in the Channels panel (see Step 1) to load this as a selection. I then selected the layer group shown here and clicked on the Add layer mask button at the bottom of the Layers panel (circled) to convert this to a pixel layer mask for the layer group. As you can see, I now had a single layer mask that masked the two Solid Color fill layers The graffiti didn't look particularly realistic yet, but I was about to work on that next.

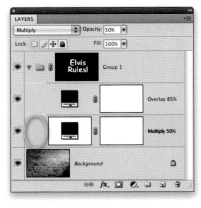

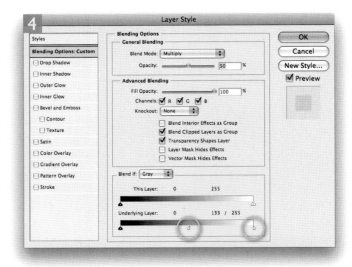

4 To get the lettering to look more graffiti-like, I needed to edit the Blending options for one or more of the Solid Color fill layers. For this particular image, I selected the black Solid Color fill layer that's highlighted in the Layers panel and double-clicked the layer, targeting the area you see circled here. This opened the Layer Style dialog, where I adjusted the Underlying Layer 'Blend If' sliders (circled) to allow some of the mid to highlight tones to show through from below.

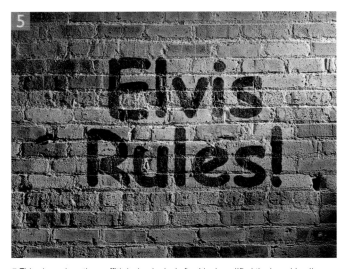

5 This shows how the graffiti design looked after I had modified the layer blending sliders for the underlying brick wall layer. All I needed to do now was to distort the lettering so that it appeared to merge more realistically with the bricks layer.

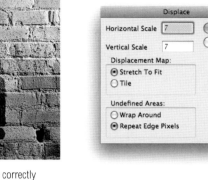

6 I selected the layer mask for the layer group and made sure it was correctly targeted. I then went to the Filter menu and chose Distort ⇨ Displace... The Displace dialog allowed me to set the displacement amount for the horizontal and vertical axes. You don't always want to enter too high amounts here. Start off with 10 and try redoing the displacement again using higher or lower values. In this instance the Displacement Map settings didn't make any difference because the pixel dimensions of the map I was about to use matched the image exactly. After I clicked OK in the Displace dialog, I was asked to locate a displacement map image file. This is where the saved grayscale image came in. I located the grayscale map that had been saved earlier to the desktop and clicked Open to use this as the displacement source image.

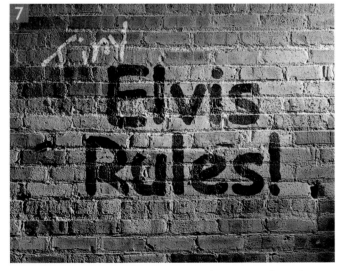

7 Here is the finished image, where the Elvis Rules logo was now distorted to match the shape and texture of the wall. You'll also notice how I added two yellow solid color fill layers and placed these in a new group, masked by the 'Tiny' alpha channel mask. I set one color fill layer to Overlay at 85% and the other to Soft Light at 55%, and applied the same Displace filter settings and displacement map to this layer mask too.

How to create a spotlight effect

As we pointed out at the beginning of this book, although there is a lot you can do in Photoshop to retouch pictures and generate realistic-looking effects, it can still be useful to do extra work in-camera before you take the photographs into Photoshop. In the example shown here, I anticipated needing to light the wall in two different ways so that I could later combine these two captures to create a dramatic spotlight effect. The following steps show how I added a final twist to the 'Tiny Elvis Rules' image.

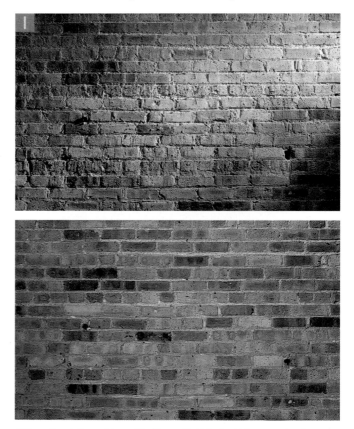

1 Shown here is the wall image lit with a spotlight (top), which was used as the backdrop image for the previous steps (as well as to create the displacement map image), and below that another shot taken of the same wall, but lit using soft diffuse lights that were filtered with blue gels to produce a soft shadow lighting look.

2 I dragged the soft lit wall image across to the layered master image, with the *Shift* key held down, so as to place it in register with the spot lit layer below. I then added a layer mask and painted with black on the mask to create a focused spotlight effect. I also added a darkening Curves adjustment which was clipped to the soft lit wall layer.

3 Here, I've made all the other layers visible to show the completed image, where you'll notice I also added an extra logo layer in the bottom right corner (this offers a small clue as to Tiny Elvis's true identity!)

Fashion and beauty retouching

Adding lightness and contrast to the eyes

If you lighten the eyes too much they will look unnatural. Worse still, if you make them too white, the whites of the eyes will appear without any detail on the page and print as paper white. I use a fairly simple method for lightening the eyes, which is shown here. Of course, you could just select the whites of the eyes and lighten these areas on their own. That works too, but I find that by applying a Curves adjustment to the whole of the eye areas, I can use the curve to anchor the brightness of the iris and tweak the curve to make the whites of the eyes lighter. This is just as effective as selecting the whites only but I find I have simultaneous control over the lightness of the pupils as well as the whites of the eyes.

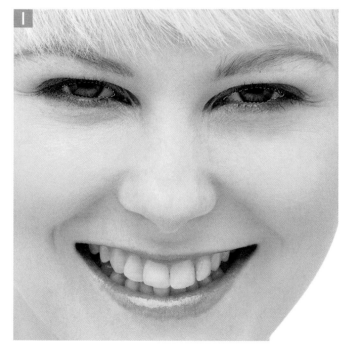

1 To add more contrast to the eyes in this photograph, I selected the lasso tool and drew a selection around the outline of the left eye. I then held down the *Shift* key to draw around the right eye and added this to the lasso selection.

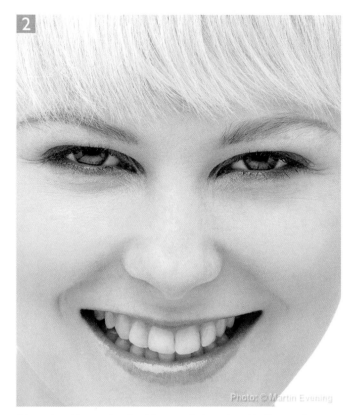

Photo: © Martin Evening

2 I was then able to apply a direct Curves adjustment (or add a Curves adjustment layer) and draw a lightening curve to add lightness to the eyes but keep the tone in the dark areas of the pupils the same. If you look at the curve shown here you can see how I placed an anchor point near the bottom of the curve to anchor the brightness for the pupils and then added extra points to lighten the pupils and whites of the eyes. Once I had done this I needed to feather the selection area, which I did by going to the Masks panel and set the Feather amount to 2 pixels.

Brush painting and adding noise

As well as removing noise you sometimes need to actually add noise instead. When you use Photoshop to retouch a photograph you may at times find yourself painting with what might be called 'pure pixels'. If you are cloning pieces from one part of the picture to another then you are probably not going to run into too many problems but if you use the paint brush tool and apply gradients or blurs to parts of a photograph, there can be a mismatch. This is where the smoothness of the pixels painted using Photoshop do not match the inherent texture of the rest of the image. You should therefore consider selectively adding noise whenever you add a gradient or paint with Photoshop. Note that Add Noise options are already included in a lot of Photoshop features such as the Brush options, Gradient Fill layers and the Lens Blur filter.

Repair work using a copied selection

We typically use the clone stamp and healing brush to carry out most repair work but there is another approach you can use, which is to copy a selection of pixels that have been sampled from another part of the picture (or a separate image even). Back in the mists of time before there were layers in Photoshop, you could duplicate a selection to make it a temporary layer by ⌥ *alt* dragging inside a selection with the move tool. Well, you can still do this in Photoshop, but you will usually find it more practical to copy the selection contents as a new layer. To do this make a selection and then use Layer ⇨ New ⇨ Layer via Copy, or use the keyboard shortcut ⌘ *J* *ctrl* *J* . This will copy the selection contents as a new layer. Once you have duplicated the selection contents as a new layer you can use the copied layer to cover up another portion of the image by dragging it across with the move tool and transforming the layer as necessary.

In the step-by-step example shown here, I wanted to cover up the burst blood vessels in the model's right eye. To do this I made a simple rectangular selection over the good eye, copied the contents to a new layer and transformed the new layer by flipping it horizontally. The Add layer mask step was important because when you add a layer mask and fill or paint with black, you are not deleting the image data but merely hiding the layer contents. In this example the layer mask allowed me to initially hide all of the copied layer and (with white as the foreground color) selectively paint back the bits that I wanted to reveal. This allowed me to paint with the brush tool to replace the bloodshot areas of the eye with the copied selection from the good eye. One of the things you have to be careful of when retouching the eyes in this way is to make sure that you preserve the catch light reflections in the eyes, because if you were to flip the catch lights as well your subject could end up looking cross-eyed!

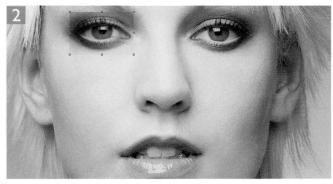

1 In this close-up view you can see that the model's right eye has some burst blood vessels. Fortunately the model is looking straight to camera and I was easily able to make a repair by copying across pixel data from the good eye.

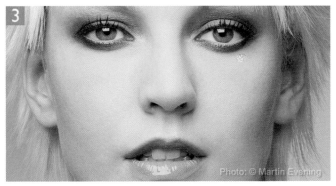

2 I made a selection of the other eye and used the `⌘ J` `ctrl J` shortcut to copy as a new layer, and then used Edit ⇨ Transform ⇨ Flip Horizontal to match it to the other eye (with the opacity temporarily lowered to 70%).

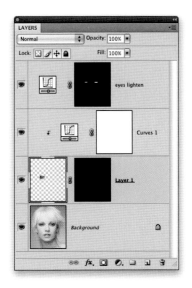

3 I then `⌥` `alt`-clicked the Add Layer Mask button to add a filled layer mask to 'hide all' on the layer. I selected the paint brush and with white as the foreground color gradually painted back in the good eye layer to repair the bloodshot area. Finally, I added an eye lightening Curves layer as described on pages 92–93)

Locking brush attributes

If you click on the lock icons in the Brushes panel next to the brush attributes such as 'Shape Dynamics', you can lock these brush attribute settings so that these stay fixed whenever you choose new brush presets.

Removing stray hairs

When I shoot for fashion and beauty clients I do all I can to make sure the hair is looking good at the capture stage. Even so, there will always be some stray hairs that need tidying later in Photoshop. The healing brush is great for most retouching, but is not ideal when painting up against areas where there is a sudden change in tone. Therefore, in most instances I find it preferable to retouch loose hairs using the clone stamp or brush tool. I always use a Wacom pen stylus and use a custom brush setting where the brush size is a round brush with a size of around 10 pixels, with the brush opacity and brush size linked to the amount of pressure that's applied. I have found this to be a useful brush setting for cloning hair strands and painting new strands of hair (see Figure 3.5). The brush size can then be modified and made larger or smaller using the square bracket keys on the keyboard. Using the clone stamp or brush tool in this way I can clone out cross-hairs, remove intricate strands of hair and paint new strands that match the texture and color of the existing hair.

If you are retouching fine strands of hair, pay careful attention to where the strands of hair originate, the direction they are flowing in and where they meet up with or cross over other strands of hair. A clumsy retoucher may simply lop off loose strands and such retouching always stands out as looking retouched (see Figure 3.6). Hair retouching can sometimes be like sorting through a mass of electric cable, making sure that you don't cut the hair off at the root and leave the rest of the hair just floating there! When I am asked to tidy up fluffy loose hairs, I usually approach this type of task in gradual stages – gradually thinning out the hair rather than cutting it all off at once. This is because it would look unnatural to see a soft textured hairstyle suddenly change into a perfectly smooth outline. To keep the hair looking real I'll often leave some stray hairs in the picture. Sometimes I will begin by erasing the loose hairs around the hair outline and actually paint in some loose stray hairs afterwards (using the clone stamp tool configuration shown in Figure 3.5). Doing so enables me to achieve a more natural look to the hair.

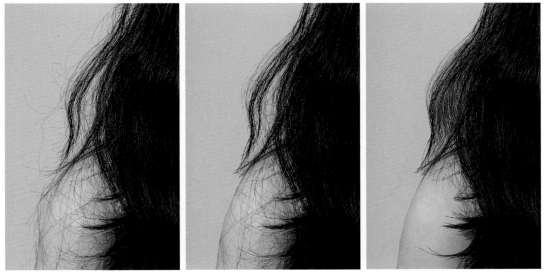

Figure 3.5 When using the clone stamp tool to retouch hair strands, I use a special preset setting. The brush size is around 10 pixels and the Shape Dynamics and Other Dynamics (Opacity) are linked to the pen pressure of the Wacom pen. I then save this combination of settings for both the clone stamp and the brush tool as a 'hair retouch' brush setting.

Figure 3.6 On the left here we have the original unretouched image and in the middle a crudely retouched version where all I did was to clean up the outer edge of the hairline. The version on the right shows the result of a more detailed hair retouch where I carefully removed every loose strand of hair and filled in some of the gaps, all using the brush and clone stamp tool and the settings shown in Figure 3.5.

Tidying hair against a busy backdrop

Here is an interesting challenge that I was presented with recently. I shot the model shown on these pages for an advertising job and was asked by the client to make sure that the skin tone and nails looked flawless. After they had seen the initial retouch work they also asked if I could clean up the hair outline. At first it looked like this would be impossible to achieve. After all, how on earth can one use the clone stamp or healing brush to tidy up the fine hair strands against a background which consisted of a busy wallpaper pattern? As it turned out, the solution to this problem was staring me in the face!

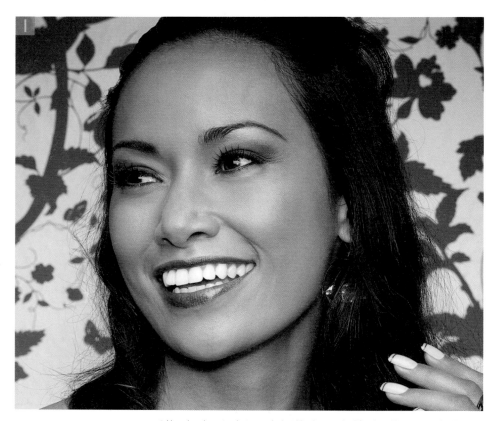

1 Here is a beauty photograph that I had retouched for the skin, eyes and nails, but where the client requested that I tidy the hair outline more. As you can see, there were a lot of loose stray hairs that overlapped the wallpaper backdrop.

2 In search of an answer, I went to Bridge and checked out some of the other shots that I had taken of that same setup. Fortunately, I had not discarded the original test shots that were taken at the beginning of the shoot and found a photograph of the wallpaper without the model in front of it. The moral here is that you never know when a shot may prove useful, which is why I recommend you never delete anything.

3 I opened the two images that I had selected in Bridge and dragged the wallpaper image across to the main model photograph image to add this as a new layer.

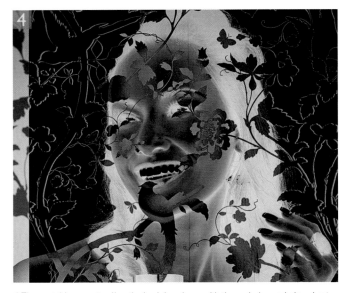

Difference blend mode registration

As you can see here, the Difference blend mode is invaluable when it comes to positioning layers in register with each other. You can also use the Difference blend mode to carry out analysis work, such as when you wish to highlight minute differences between the way an image has been processed. For example, you can use this technique to compare the results when using JPEG compression settings.

4 The next thing was to align the backdrop layer with the main image below. I set the wallpaper layer blend mode to Difference, which made it easier to see when the wallpaper layer was in pin register (see sidebar) as I used the move tool.

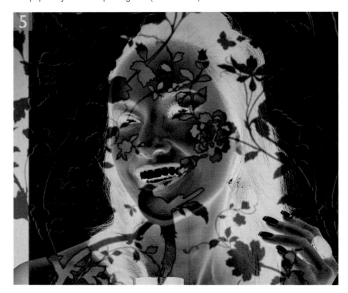

5 As you can see in Step 4, I was first able to roughly align the two layers. The problem here though was that the wallpaper in the model image was blurred and the wallpaper in Layer 1 was sharp. In order to get the two layers to match, I kept the Layer 1 wallpaper layer in Difference mode and applied a Gaussian Blur filter until the Difference blend mode showed that the two layers matched more closely.

6 I returned the wallpaper layer blend mode to Normal again and ⬦ *alt*-clicked the Add new layer mask button in the Layers panel (circled) to add a layer mask to the layer, filled with black. I then used a hard edged paint brush to paint with white on the layer mask. This allowed me to paint on the photograph from the wallpaper layer and clean up some of the stray hairs.

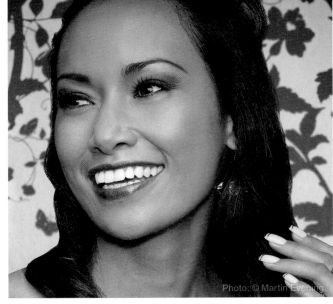

Photo: © Martin Evening

7 Here is the finished version where you can see a close-up view of the hair outline. If I hadn't taken a picture of the backdrop on its own, I could always have sampled bits of backdrop detail in other shots from the same sequence, but in this instance having access to the out-take backdrop image made my life a lot easier.

Coloring hair roots

As a beauty photographer who specializes in hair work, I often get asked to lighten the hair roots so that the hair looks like it has a more even color. Here is a fairly simple two-step process that can be used to help lighten dark roots.

For this technique I basically add two empty layers and set one to Soft Light blend mode and the other to Color. Painting on the Soft Light layer then allows me to selectively add a fill light to the dark areas of the hair, while painting on the Color layer allows me to colorize the hair to make the hair color look more even. When I paint with the brush tool, I use the ⌥ *alt* keys to switch to Eyedropper mode and sample a new lighter hair color from the image and use this as the foreground color to paint with. The trick here is to use a low opacity, soft-edged brush and to keep resampling new colors as you paint. The Soft Light mode worked well here at lightening the hair, but you may want to use the Overlay blend mode instead when retouching some hair shots.

1 To disguise the hair roots that were showing here in this photograph I added a new empty layer, set this to the Soft Light blend mode and placed this layer inside a layer group.

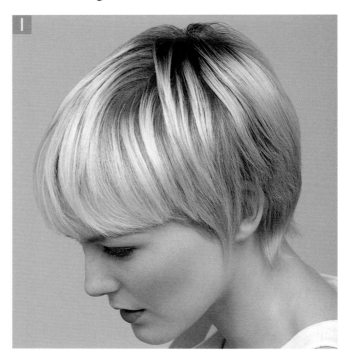

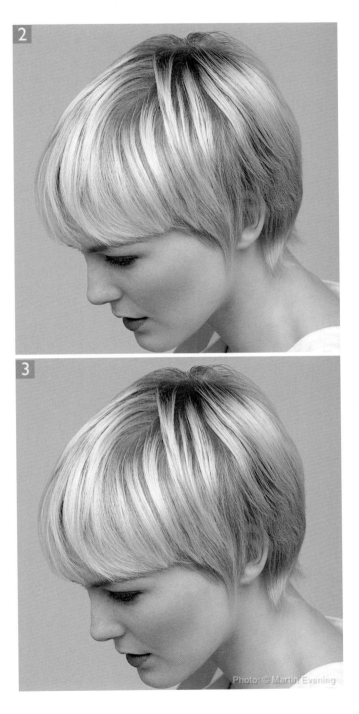

2 I selected the brush tool and held down the ⌥ *alt* key to sample a color from the lighter hair color area and gently painted over the dark hair areas where the roots were showing most. This step colorized the hair yet also lightened the darker areas, but without destroying the detail in the shadows. This was kind of like a 'filling in the shadow areas' step.

3 I added a new layer within the layer group and set the blending mode to Color. I then used the paint brush to sample more colors (holding down the ⌥ *alt* key) to paint on the Color layer. I found when editing both this and the Soft Light layer that it helped to use the eraser tool (rather than add a layer mask) to remove paint from these two layers. I was therefore able to work quite quickly by toggling between the brush tool and the eraser.

Pressure-sensitive pen and pad

I do much of my beauty retouching using the brush tool on this copied layer. I prefer to use a pressure-sensitive stylus and pad, such as the Wacom™ Intuos™, because this allows me a much finer degree of control than I can get with a normal mouse. Whenever you select any of the painting tools you can select from a number of options from the Brushes panel that will enable you to determine what aspects of the brush behavior will be governed by the way you use the pressure-sensitive stylus. Photoshop will not just be aware of the amount of pressure you apply with the stylus. If you are using the Wacom™ Intuos™, Photoshop is now able to respond to input information such as the barrel rotation of the stylus, the angle of tilt or the movement of the thumb wheel (if you have one).

Beauty skin retouching

There are many different types of skin and the skin texture varies a lot on different parts of the body. For example, with a young woman the skin under the eyes will usually have a coarse goose bump texture and the cheeks may be slightly pitted with larger-sized pores. The skin on the forehead will generally be quite smooth, but with minute horizontal lines, and the smoothest skin texture of all will be on the temples and sides of the nose. As you move down towards the neck area the texture of the skin changes to become coarser still. In addition to this you may notice a very fine downy hair on the face, especially just above the lips. I mention this because it is important to pay close attention to these changes in skin texture as you retouch a beauty image. When you use the clone stamp or healing brush tools you need to carefully choose the source point you sample from when cloning skin texture to another part of the face or body.

Disguise your retouching

The basic rule when retouching is to disguise your work so that whatever corrections you make to a photograph, it is not immediately apparent that the picture has been retouched. If you are working for a fashion client they will usually be looking for image perfection. Although I may sometimes employ a lot of Photoshop wizardry in order to satisfy the client, I feel it is important to fade out the retouching without hiding the underlying skin texture so I let some of the original blemishes show through.

My preferred approach is to retouch the skin using the clone stamp and healing brush tools to clean up all the blemishes. I then add a painting layer in which I use a large brush to paint over the skin to soften the details and unwanted shadows. As you will see in the beauty retouching example that's coming up, I always reduce the opacity of the layer that contains the brush paint retouching work to let much of the original, unpainted skin texture show through. The net result is a more natural-looking finish, where the model's skin looks perfect but without looking too artificial.

Brush blending modes

The painting and editing tools can be applied using a variety of blending modes and these are the same as the ones available in the Layers panel, Apply Image and Calculations dialogs. Of the numerous blend modes available, I reckon that the following modes are probably the most useful when used with the brush or gradient tools.

The Screen blend mode can be used to lighten, so you could use this as a brush blend mode to lighten areas such as the eyes, or add highlight sparkles, as shown on pages 122–123. The Multiply blend mode basically darkens and this can be used to selectively darken specific features, sampling colors from the photograph as you paint. For example, I sometimes use a large, soft-edged brush with a low opacity to gently build up density in the eyebrows.

As an assistant, I used to work for a photographer called James Wedge who was well known at the time for his hand-colored black and white photography. He produced some rather beautiful work in which he would carefully mask areas of a picture and paint directly on the print using translucent colored inks. If you are working in Photoshop, the Color blend mode can be used to achieve similar types of results. More often, I find the Color blend mode is ideal for color correcting small color casts. For example, I sometimes use the brush tool in color mode to get the skin tones to match the colors on other areas of the face or body.

The Overlay and Hard Light blend modes can be used to paint in contrast, while the Soft Light blend mode can be used (as was shown in the 'Coloring hair roots' example) to paint in a soft contrast effect. In the Masking and Compositing chapter I show how the brush tool can be used in Overlay blend mode to clean up a silhouette mask while preserving important edge detail.

As you will see in the beauty retouching steps on the following pages, I use the Lighten and Darken blend modes all the time whenever I use the brush tool to smooth out the skin tones on a beauty photograph.

Beauty/fashion retouching

Fashion and beauty retouching is usually driven by the commercial requirements of clients, who in today's market will normally want every photograph that appears in print to have some level of retouching done to it. Photoshop has played a huge role in giving photographers the digital tools they need to retouch their own pictures. Yet, in the wrong hands this can lead to some truly dreadful photography! Over the next few pages I have shown all the steps I would use in a typical retouching session, where the objective was to clean up all the stray hairs and blemishes yet leave the model still looking human at the end of the process.

1 This shows the before version image without any retouching. As you can see, there were a lot of stray hairs to tidy, some spotting required on the black outfit and the skin tones needed to be made smoother.

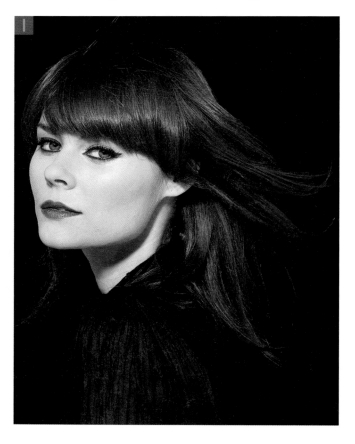

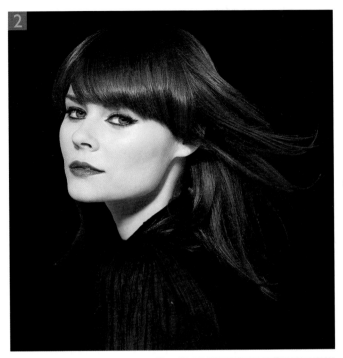

2 Before carrying out any retouching I added an empty new layer above the Background layer and set the tool options for the clone stamp and healing brush tools to Current Layer & Below. I was then able to carry out all the main spotting work on a separate layer. This meant that should I need to undo any of the retouching it would be easy enough to erase the bits that I didn't want included. There is also another benefit to doing this: you can ⌥ alt -click on the Spotting layer eyeball icon to reveal the retouching layer only and use this to show how much spotting work had to be done (see the bottom screen shot example where the spotting is revealed against a transparent backdrop). This might be handy if the client starts asking why you have charged so much to work on a picture!

3 Next I wanted to concentrate on retouching the face. To do this I made a marquee selection of the face and neck and used the ⌘ ⌥ Shift E ctrl alt Shift E shortcut to create a new merged duplicate layer above the spotting layer. I then inverted the selection (⌘ Shift I ctrl Shift I) and hit the Delete key to delete the selected area. This left a merged copy of the selected area as a new layer, which I named 'Face retouching'.

4 I now used the brush tool to paint over the pixels on the Face retouching layer. For example, I began by painting with the brush tool in Lighten mode with a low opacity brush (or ideally a pressure-sensitive pad and pen). I sampled a light flesh tone color by ⌥ alt -clicking on the image and then brushed lightly over the darker areas of the face such as underneath the eyes (when using Lighten mode only the pixels that are darker than the sampled color will be replaced). I also switched to Darken mode, which allowed me to sample a flesh tone color to paint the lighter colored pixels darker (It is a good idea to always keep resampling new colors as you paint). It doesn't matter that I overdid the retouching at this stage, as the next step could be used to moderate the level of retouching. The main goal here was to smooth the skin tones and, if necessary, remodel the light and shade on the face.

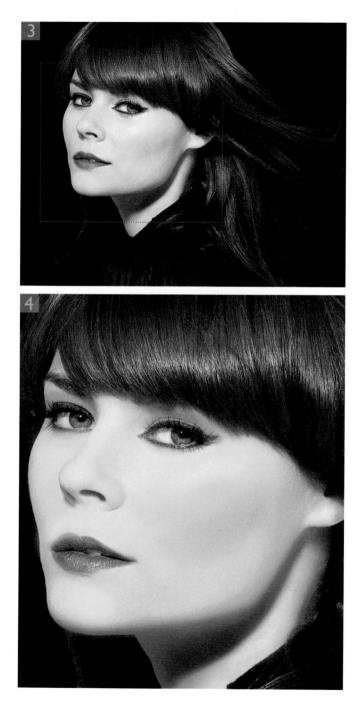

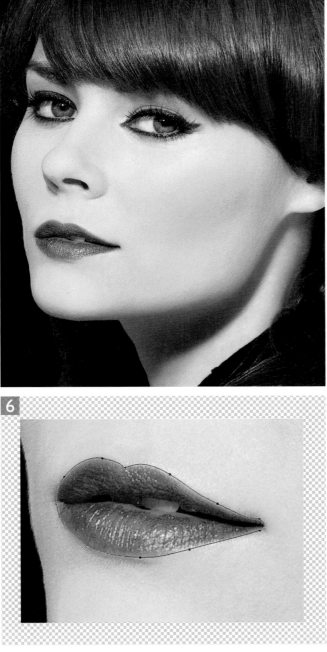

5 Some fashion photographers like the super-retouched look. Others argue that this makes models look more like plastic dolls than real women. It is up to you, but I usually prefer to fade the opacity of the retouched layer. In this instance I reduced the layer opacity to 60%. Doing this allowed more of the original skin texture to show through from the layers below so that the final retouched result looked more convincing. You will notice that I also added a layer mask to the layer and painted with black to hide the areas where the brush strokes overlapped important facial features (don't forget to change the brush blend mode back to Normal!)

6 I next wanted to tidy up the lips. Here I used the same technique as in Step 3, where I made a rough marquee selection of the lips area and used the ⌘ ⌥ Shift E ctrl alt Shift E shortcut to create a new merged duplicate layer above the Face retouching layer. I inverted the selection ⌘ Shift I ctrl Shift I and hit Delete to delete the selected area (this screen shot shows the lips layer viewed on its own). I then used the pen tool to draw a path outline of the lips.

7 I went to the Layer menu and chose Vector Mask ⇨ Current Path to apply the current path as a vector mask (note: the path must be in Add to shape area mode [circled]) and set the Feather in the Masks panel to a 1 pixel radius. I then used a soft-edged brush tool in Multiply mode, with a low opacity, to darken the outer areas of the lips and used the brush in Color mode to fill in some of the lipstick areas just inside the mouth.

8 Once again I used the marquee tool to select the face area and used the ⌘ ⌥ Shift E / ctrl alt Shift E shortcut to create a new merged duplicate layer above the Lips layer, inverted the selection and hit Delete. I then ⌘ / ctrl-clicked on the new layer (which I named 'Liquify work') and chose Liquify... from the Filter menu. As you can see here, I used a few gentle brush strokes with the Warp tool to make the eyes slightly bigger, made the lips a little more symmetrical and straightened the fringe.

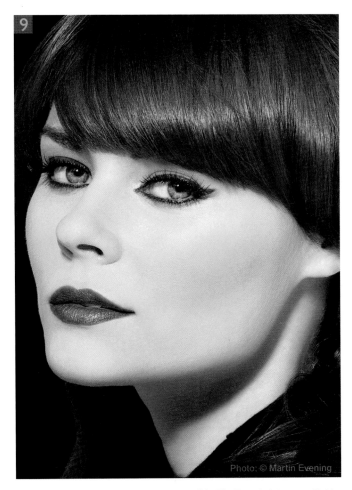

Photo: © Martin Evening

9 Here is the final version showing the results of the Liquify work that was applied in Step 8. I also made a lasso selection of the pupils and added a Curves adjustment to add more contrast and lightness to the pupils only. As you can see, I added a 2 pixel feather in the Masks panel to soften the mask selection edge. The important points to note here are that although the face has been retouched, the skin tones still show the texture of real skin and the layered structure of the master image allowed me to re-edit certain portions of the image as necessary. The Background layer at the bottom remained untouched throughout.

Retouching portraits

Beauty retouching is about enhancing the makeup and the smoothness of the lighting on the face. Portrait retouching requires a fairly similar approach for getting rid of the blemishes and enhancing the skin texture of the subject. Although, overall, I find that portrait retouching requires a more subtle approach, as you don't always want to reduce the lines and wrinkles quite so much when retouching portrait photographs. Not all blemishes should necessarily be removed. Take the case of Cindy Crawford. In the early years of her modelling career, a lot of magazines wanted her mole to be retouched out. Later on, as she became more famous, nobody would dream of removing it because the pictures wouldn't look like they were of Cindy!

It is interesting how there has been quite a backlash in recent years, with many celebrities reacting against pictures where their faces (as well as their bodies) have been retouched out of all recognition. Our friend Greg Gorman is a well-known celebrity photographer and he tells us that he has made a deliberate effort to reduce the amount of retouching that is carried out on the portraits he shoots. Having said that, Greg reckons there are many celebrities who quite like seeing themselves retouched and are happy to believe that's how they really look! Plus many of the magazines simply won't publish photographs that haven't had at least a moderate level of retouching. When Photoshop first came out we saw lots of magazine images where the eyes and teeth were the same white as the paper stock! My gut feeling is that the general public are sick and tired of the over-retouched look and in recent years we have seen magazines tone down the amount of retouching used, or at least use better retouchers. Over the next few pages I have shown an example of a classic portrait where the retouching is more restrained, which if anything requires even more skill to get right compared with the beauty retouching I showed you earlier.

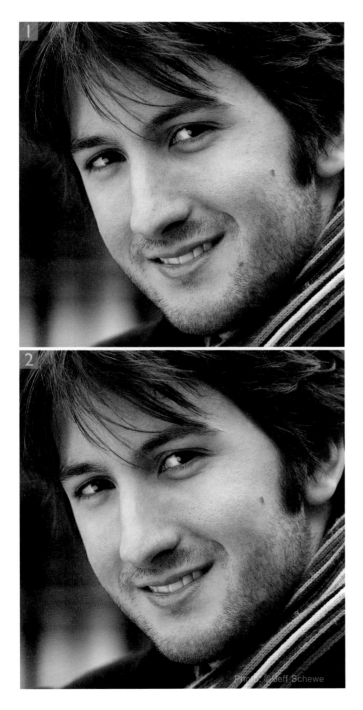

1 This is a portrait of Alex, one of the models used on our Photoshop book shoot, taken by Jeff. Here I wanted to show you the kind of steps that I would typically use to retouch a portrait. These steps are slightly different to the beauty retouching method described earlier because the main objective here was to make the retouching look as completely natural as possible.

2 I began by adding a new empty layer with which to carry out all the initial spotting work using the clone stamp and healing brush tools. If you compare this version with the one above you will notice that I was careful to retouch all the small blemishes and tidy up things like the stray eyebrow hairs and stubble. I didn't remove the mole on Alex's cheek, but I did remove many of the other spots that I felt needed to be retouched.

Photo ©Jeff Schewe

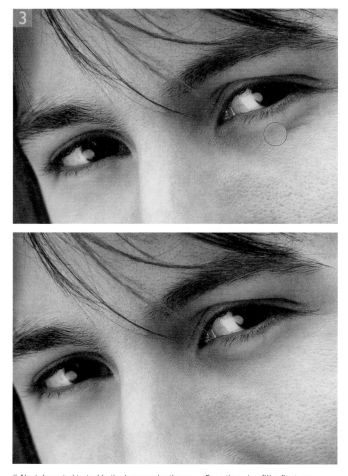

3 Next, I wanted to tackle the bags under the eyes. Even though a fill reflector was used to bounce some light into Alex's face, I felt it would be a good idea to knock these back a little further. To do this, I carried out the Merge copy layer step that was used in the previous retouching example. I used the rectangular marquee tool to select the eyes only and used the ⌘ ⌥ Shift E ctrl alt Shift E shortcut to create a new merged duplicate layer above the Spotting layer, inverted the selection (⌘ Shift I ctrl Shift I) and hit Delete. I now had a merged copy layer of the eyes only at the top of the layer stack. I selected the healing brush and used it to carefully remove the crease line. The trick here is to be very careful choosing where you sample from. In this example I had to make sure that the heal cloned texture correctly matched the surrounding skin texture. Once I had completed the healing brush work, I faded the layer opacity to 70% in order to let some of the bags and crease line show through. This avoided letting Alex look like his face had been pumped full of Botox!

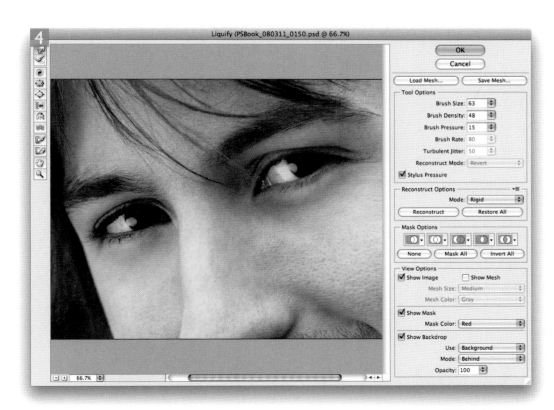

4 I now wanted to open the eyes slightly. If you look closely you can see a reflection of the fill light reflector that was used to bounce more light into Alex's face. The downside of doing this is that his eyes were slightly squinted. To counteract this I repeated the Merge copy layer step, where once again I made a marquee selection of the eyes and used the ⌘ ⌥ Shift E / ctrl alt Shift E shortcut to create a new merged duplicate layer above the 'beneath eyes' layer, inverted the selection and hit Delete. I then went to the Filter menu and chose Liquify... In the Liquify dialog shown here I used the warp tool with a low Brush Pressure setting to gently push the lower eyelids open a little more. It was a very subtle adjustment, but all that was needed to make the eyes look more natural.

5 I now wanted to make Alex's right eye slightly sharper. To do this I used a technique first devised by Bruce Fraser to create a depth of field sharpening layer. The first step was to create a new merged copy layer using the ⌘ ⌥ Shift E ctrl alt Shift E keyboard shortcut. I then double-clicked on an empty space in the layer (circled) to open the Layer Style dialog shown here, where I set the layer opacity to 50%, the blend mode to Overlay and adjusted the Blend If sliders as shown here.

6 I went to the Filter ➪ Sharpen menu and applied the Unsharp Mask filter to the merged copy layer using the settings shown here, followed by the Filter ➪ Other ➪ High Pass filter using a 25 pixel Radius.

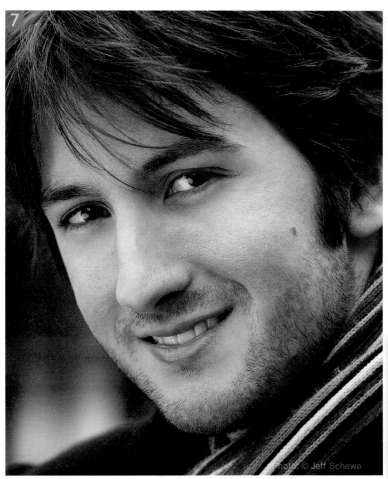

7 Here is the completed photograph. You will notice that I added a Curves adjustment layer to lighten the eye pupils. I added the adjustment layer first, filled the layer mask with black to hide the effect and then painted on the mask with white to reveal the adjustment in the pupils only. As I did this I was careful not to make the catch light reflection any lighter. If you compare this version with the original you'll see quite a transformation compared to what we started out with. Yet I still managed to preserve the skin texture and keep the portrait looking fairly natural.

How to remove reflections from glasses

When you photograph people who are wearing glasses you often have to be careful to watch out for reflections. This isn't always such a bad thing as the reflections can sometimes add to the look of a portrait, but they are usually less desirable when they show a reflection of the studio lighting or are in other ways distracting. In the step-by-step example shown here the reflections aren't at all unpleasant, but I thought it would be useful to show you how one could go about dulling these down in Photoshop. Using the technique described here, it was possible to fade the adjustments made and find the right balance between the uncorrected and corrected versions.

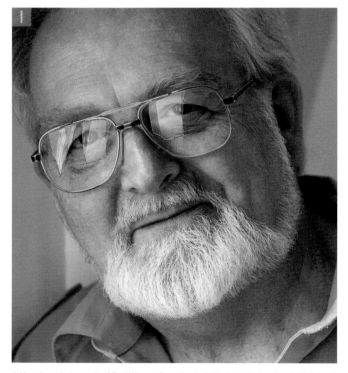

1 Here is a photograph of Rod Wynne-Powell who is the technical editor for this book (shot by Jeff). I began by adding a new empty layer and used this to carry out all the main spotting work. I then selected the pen tool in Path mode and used it to define the outline of the reflections which you can see in the saved path in the Paths panel.

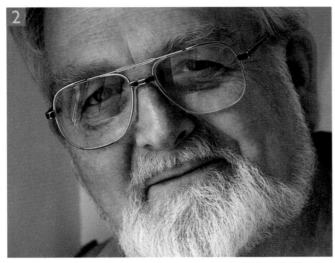

2 I then applied a darkening Curves adjustment layer and, with the path still active, clicked on the Vector path button in the Masks panel (circled). This applied a vector mask to the Curves adjustment masking using the path I created in Step 1 (if the vector mask appears inverted, follow the steps shown on page 110 to invert the Path mode). With the vector mask selected, I also applied a 2 pixel feather via the Masks panel to soften the mask outline. I then clicked on the pixel layer mask and used the brush tool to paint with black. This allowed me to further fine-tune the Curves adjustment masking.

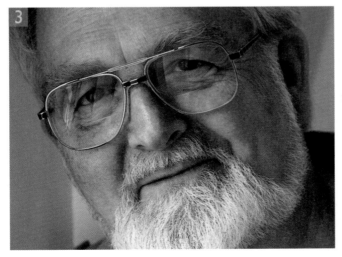

3 The previous step left the eyes looking rather shaded. To address this, I added a further Curves adjustment – this time one that lightened the image. I filled the pixel layer mask with black and used the brush tool with white as the foreground color to paint on the layer mask and effectively dodge the areas inside the glasses to make them lighter.

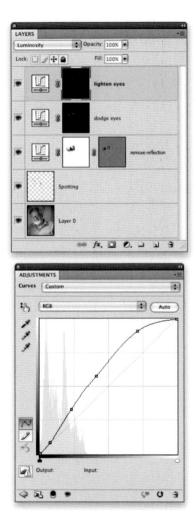

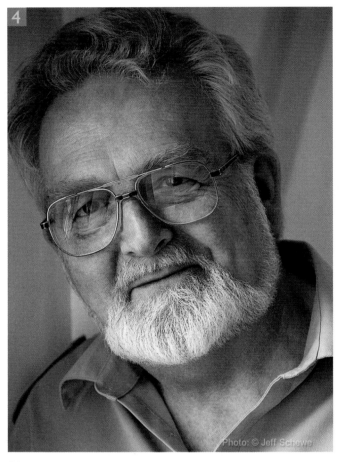

4 Step 3 improved the photograph, but the eyes now lacked contrast. To complete the image, I added another Curves adjustment layer – this time a lightening adjustment that brightened the eyes. I filled the layer mask with black and used the brush tool with white as the foreground color to paint on the layer mask. My aim here was to mainly lighten the whites of the eyes, while preserving the darkness in the pupils.

How to create a sparkle brush shape

If you click on the Brush Presets item in the Brushes panel or view the Brushes panel in a non-expanded view (shown in Figure 3.7), you'll usually see a small thumbnail list of the different brush preset shapes that are available for use with the brush and other painting tools in Photoshop. You will also find even more brush presets can be loaded via the panel fly-out menu. However, if you want to, you can create your own custom brush preset designs by following the instructions shown here for creating a highlight sparkle brush preset. Once you name a brush preset, it will become appended to the current brush presets, but to make sure that the brush shape remains permanently saved choose Edit ⇨ Preset Manager, select the brush or brushes you have just created and choose Save Set...

Figure 3.7 This shows the non-expanded, list view for the Brushes panel.

1 The first step was to go to the Options panel for the brush tool and select a small (10 pixel) soft-edged brush. I then went to the Brushes panel and checked the Shape Dynamics, where I set the Control options to Fade and I also set the Minimum diameter to 4%. Having done that, I checked the brush preview shown at the bottom of the panel and returned to the Control options, where I adjusted the number of fade levels so that the brush preview smoothly tapered from a full size brush (on the left), to a minimum size brush (on the right).

2 I was now ready to create a new custom brush shape. To begin with, I created a new image document that was 600 x 600 pixels in size. I chose View ⇨ Rulers, double-clicked the ruler guides to set the units to Percent and added two guides at 50% on the horizontal and vertical axis. I then selected the brush tool (using the settings shown in Step 1), clicked on the centre point, held down the *Shift* key and clicked at the top of the image. This drew the first line. I then repeated this step to produce the initial sparkle shape shown here.

3 I then copied the Background layer (⌘ J ctrl J), set the new layer blend mode to Multiply, went to the Edit menu and chose Free Transform. I rotated the layer 45°, scaled the transform to make the layer smaller and clicked *Enter*. I then increased the brush diameter to 70 pixels and clicked once on the center point using 100% opacity and 100% flow in the Tool options for the brush tool.

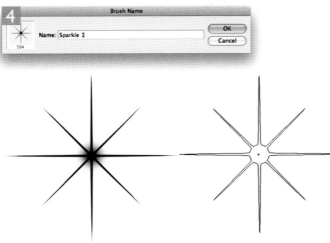

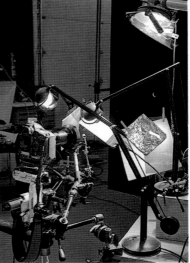

4 To create a new brush preset I first made sure that the guides had been cleared or were hidden. This is important, because you won't be able to create a new brush if the guides are visible. I went to the Edit menu and chose Define Brush Preset. This opened the dialog shown here, where I gave the new brush a name and clicked OK. On the right you can see the brush cursor for the new 'Sparkle 1' brush preset.

Figure 3.8 This shows the studio set that was used to photograph the diamond ring photograph shown in Step 4. You will notice that the camera was mounted on a view camera support. This made it easier for Jeff to adjust the focus, because he could keep the ring and focus setting on the lens static and smoothly adjust the camera distance relative to the ring.

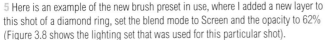

5 Here is an example of the new brush preset in use, where I added a new layer to this shot of a diamond ring, set the blend mode to Screen and the opacity to 62% (Figure 3.8 shows the lighting set that was used for this particular shot).

Vanishing Point

The Vanishing Point filter provides a modal dialog in which you can define the perspective planes in an image and then use the tools available in Vanishing Point to carry out basic retouching work that will match the perspective of the picture. You can make a selection within the Vanishing Point preview area and clone the selection contents within one or more predefined plane areas. You can paste the contents of a selection and align it in perspective with the target image, plus you can apply the stamp tool in Healing or Non-healing modes, or paint with the paint brush in perspective.

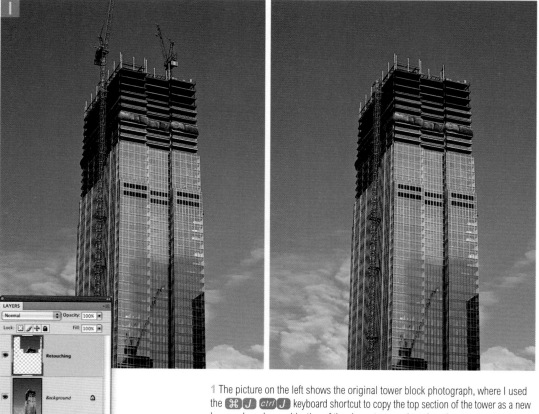

1 The picture on the left shows the original tower block photograph, where I used the ⌘ J ctrl J keyboard shortcut to copy the top section of the tower as a new layer and used a combination of the clone stamp and patch tool to remove the cranes from the top of the building.

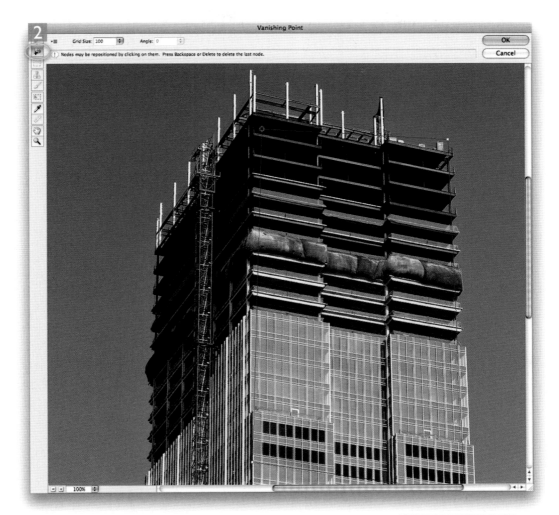

2 I was now ready to complete the construction work in Photoshop. To start with, I added a new empty layer and named this 'Vanishing point layer'. I then went to the Filter menu and chose Vanishing Point..., which opened the dialog shown here where I used the create plane tool (circled) to define the first plane of perspective on the tower. To do this, I clicked on the edge of the front face of the building and then placed the cursor on the other side, and then at the top, and used the perspective lines of the building to guide me to match the first perspective plane shown here. You may find it helps to hold down the \boxed{X} key as you do this, since this will temporarily enlarge the preview to twice the current magnification.

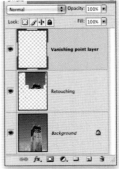

3 After I had defined the initial perspective plane I used the edit plane tool (circled) to fine-tune the placement of the plane handles. I find that in most cases it is necessary to edit the plane corners to match the perspective; this is especially important since how you define the first plane can have a significant impact on other planes you create relative to the first. For example, in this screen shot I held down the ⌘ *ctrl* key as I dragged on the middle handle (circled in red) and dragged a new plane out from the first. Vanishing Point always understands how to create further planes based on the first plane that you draw. Once you drag a new plane out in the way that I describe here, it may not always match the second plane perspective exactly – in which case you can always edit the corner handles as necessary. However, if the second plane definition exceeds certain limits, the plane outline will first turn red and then yellow, as a kind of warning.

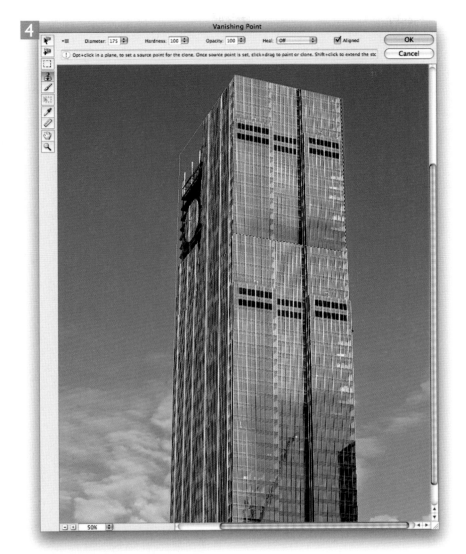

4 This screen shot shows the Vanishing Point retouching in progress. Here, I
used the marquee selection tool to select the front side of the building and ⌥
alt-dragged to move a cloned copy of the selection further up the front of the
building (matching the perspective). I then selected the stamp tool, adjusted the
brush settings to get a hard-edged brush and, with the Heal mode switched to 'Off',
I cloned sections of the building to cover up the crane scaffold and the unbuilt
sections of the tower. The stamp tool works exactly the same as the clone stamp
and healing brush: you use the ⌥ alt key to sample where to clone from and,
as you can see, the stamp tool always shows an overlay preview.

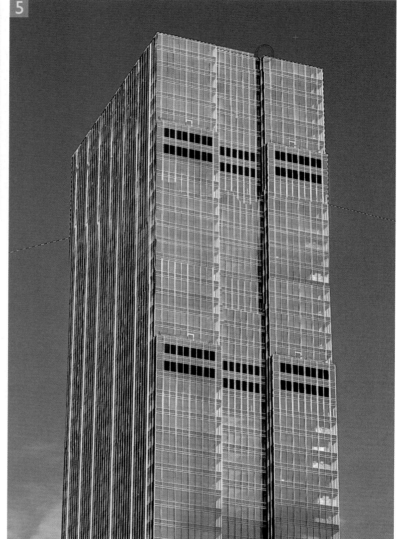

5 This shows the photograph almost at the completion stage. I now needed to tidy up some of the outer edges. To do this, I used the pen tool to define a path outline for the outside area at the top of the building and then used the stamp tool to copy from parts of the sky to produce a clean outline.

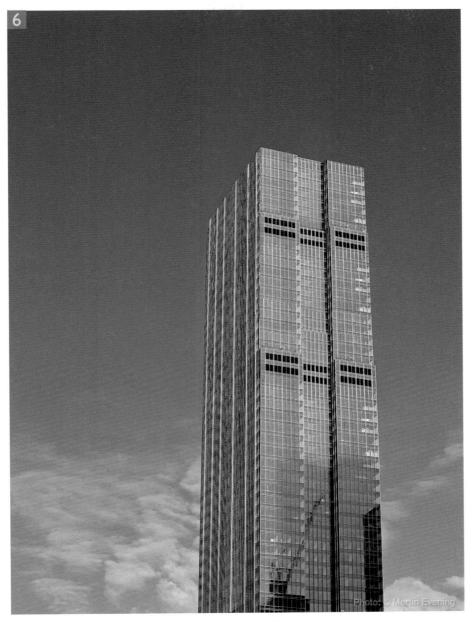

6 Here is the completed photograph where I did take the image into Vanishing
Point one more time in order to clean up the joins on some areas of the building.
To do this, I used a smaller sized stamp tool brush, which was again applied with
the Heal options switched off.

Rendering options

People have long asked for angled guides in Photoshop. With Vanishing Point, you can now create an empty new layer, launch Vanishing Point, use the create plane tool to create a perspective plane and go to the Vanishing Point options menu (circled in Step 2) and choose 'Render Grids to Photoshop'. This will draw the guides shown in the preview on the empty layer. Likewise, you can use the Render Measurements option to do the same with the recorded measurements.

Vanishing Point planes and measurements

With Vanishing Point you can also drag off new planes using a custom angle. In the example below, the room interior had a sloping wall and, as you can see, I was able to adjust one of the planes to accurately follow this angle. So long as you get the initial plane description completely accurate, you should find that the consecutive planes will match the remaining perspective planes in the scene. When you clone or copy objects in Vanishing Point you will notice that you can paint or paste continuously around the corners of a plane (as shown in Step 3). If you happen to have the extended version of Photoshop, you can make a calibration measurement along a line on one of the planes and from this make further measurements of objects on associated planes. So for example, in Step 2 I was able to create a calibration measurement based on the known height of a room, and from that work out the distances and sizes of all other objects in the room.

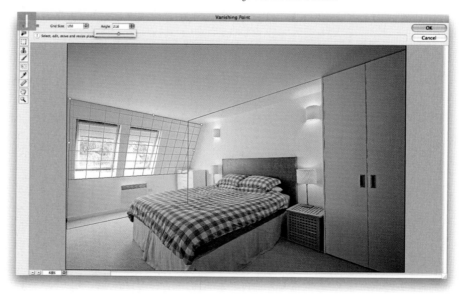

1 With Vanishing Point you can, as in the previous example, use the create plane tool to define the perspective planes for a photograph such as the room interior shown here. In this example I held down the ⌘ ctrl key as I dragged on the middle handle to create a new plane and then adjusted the Angle amount to create a plane that matched the angle and perspective of the sloping wall.

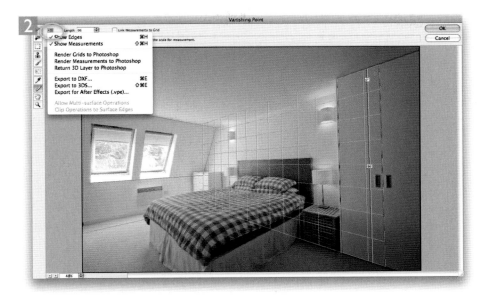

2 The measurement tool in Vanishing Point can be used to make comparative measurements in a perspective plane. Since I knew the height from the floor to the ceiling, I was able to select the measure tool and draw a measurement line along the vertical axis and enter a unit value that corresponds with the known height of the room.

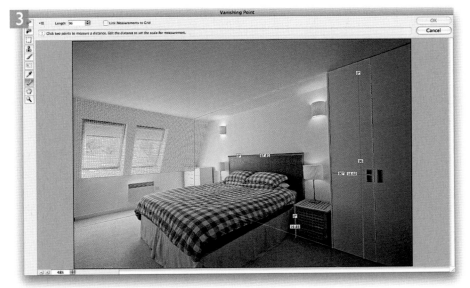

3 Once I had done that I could use the measurement tool to calculate other measurements relative to the first measurement.

4 I now wanted to show how you could use Vanishing Point to add a wallpaper pattern to one of the walls. I opened the wallpaper image shown here and used ⌘A ctrl A to select all, followed by ⌘C ctrl C to copy the selected contents. I also added a new layer so that the following Vanishing Point editing work would be added to this layer.

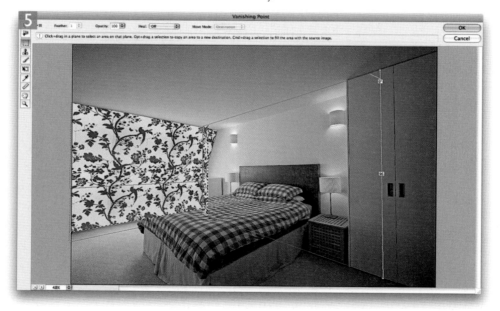

5 I opened the Vanishing Point dialog again and then used ⌘V ctrl V to paste the copied wallpaper image contents into the image. As I dragged the pasted wallpaper selection, the contents aligned to the perspective planes defined in Vanishing Point. I then clicked OK to apply.

6 Having done that I temporarily hid the new wallpaper layer and created a mask outline for the far wall, which is shown here as a Quick Mask overlay.

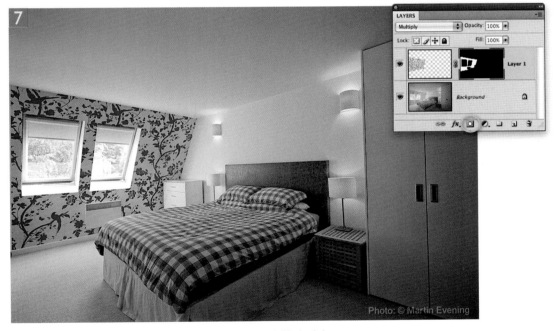

7 To create the final version shown here, I made the wallpaper layer visible, loaded the Alpha 1 channel as a selection and then clicked on the Add layer mask button in the Layers panel (circled) to convert the selection to a pixel layer mask. I also set the layer blend mode to Multiply so that the wallpaper layer blended more realistically with the shading on the wall.

Editing objects in 3D

Those of you who have been using Photoshop for a long time may recall a Photoshop plug-in called the 3D Transform. It was introduced in Photoshop 5 and basically it allowed you to define objects (preferably cube-shaped objects) and transform them in three dimensions. It was a rather crude tool, but was considered quite progressive at the time. More recently it has been possible to edit photographs in perspective using Vanishing Point, but one of the little things that you may not have been aware of is the fact that you can export the planes that have been defined in Vanishing Point as 3D layers.

This tutorial shows how you can now use Vanishing Point to prepare an image as a 3D object before fine-tuning its position in another image. The perspective shift in this example is quite extreme yet, with some careful adjustment of the 3D controls and post-placement retouching, it can be possible to achieve a fairly convincing finished result.

1 The object of the steps shown here was to take this scene of an empty room interior and add the cabinet image (shown on the left), which had been shot in a separate location, and overcome the problem of how to match the perspective of the cabinet with that of the room interior.

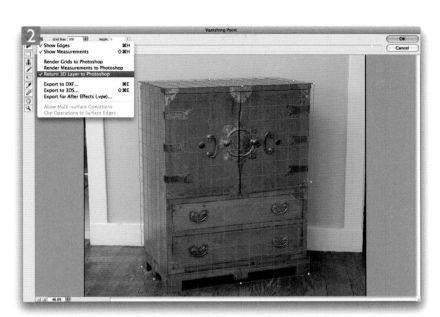

2 The first step was to select the photograph of the cabinet, go to Filter ⇨ Vanishing Point and define the planes of perspective. Once I had done this for the three planes, I went to the Vanishing Point options and checked 'Return 3D Layer to Photoshop'. I then clicked OK to process the selected planes as a 3D layer.

3 Here is the new 3D layer that has been added to the layer stack. The important thing to note here is that the planes defined in the previous step needed to be dragged far enough to include all of the cabinet. Also, when one of the 3D tools is selected in the tools panel, such as the 3D rotate tool, you'll see the 3D navigation widget shown here.

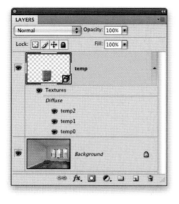

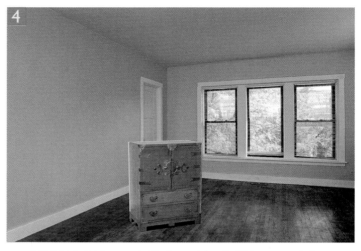

4 Next, I selected the move tool to drag and drop the 3D layer across to the room interior photograph.

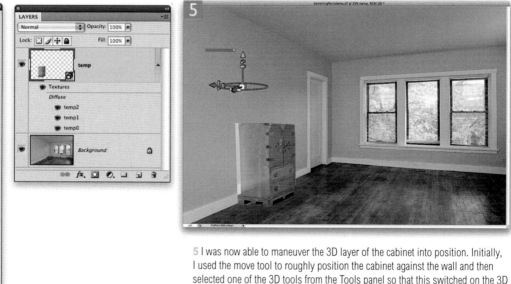

5 I was now able to maneuver the 3D layer of the cabinet into position. Initially, I used the move tool to roughly position the cabinet against the wall and then selected one of the 3D tools from the Tools panel so that this switched on the 3D navigation widget shown here. If you look closely you will see a small magnifier icon. You can drag on this to scale the navigator to make it bigger (as shown here in the screen shot). Now comes the tricky bit of aligning the perspective of the cabinet with the room interior scene. Here I could have used the various 3D tools to select a specific 3D plane to manipulate. The other option was to click on the 3D navigator widget control, which allowed me to manipulate the scale, rotation and panning in each of the three planes.

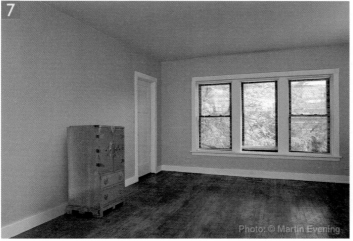

6 This shows the cabinet after I had fine-tuned the 3D controls to get it placed as accurately as possible against the wall. Once it was in place I used the pen tool to draw a vector path around the outline and then clicked on the Add vector mask button in the Masks panel to convert this to a mask.

7 In this final version I did a few extra things to make the new placement of the cabinet look more convincing. To start with, I added a new layer beneath the 3D cabinet layer, set the blend mode to Multiply and painted with dark sampled colors to add shadows below and behind the cabinet. I then added a darkening Curves adjustment layer above the 3D cabinet layer to darken the left side panel. I used the vector mask created in Step 6 to clip the adjustment to the cabinet layer and painted on the pixel layer mask with black to prevent the Curves adjustment from affecting the front of the cabinet.

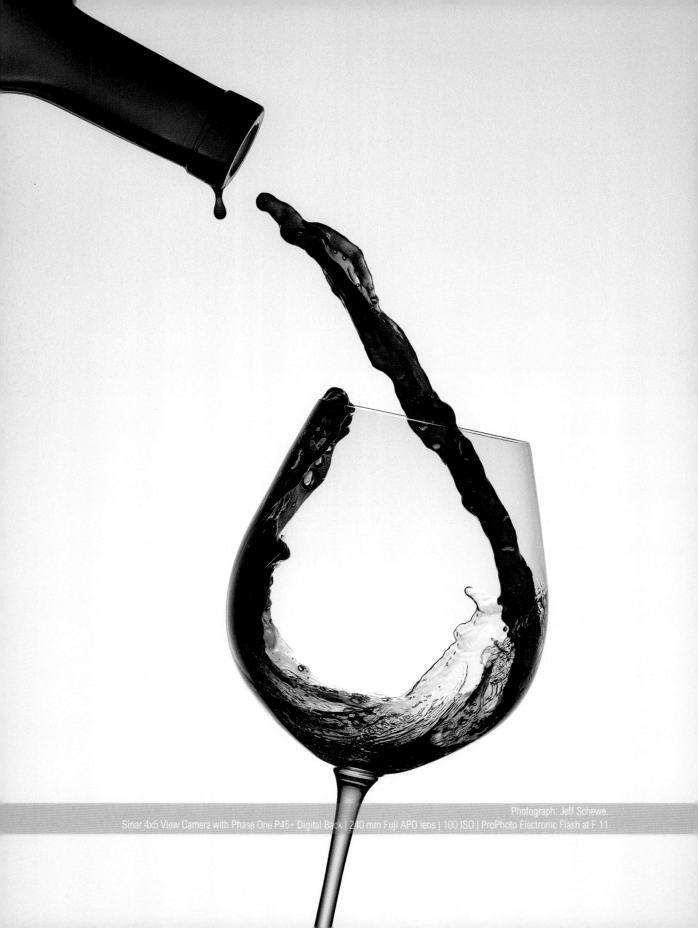

Masking and compositing

How to combine images and solve tricky problems

I n this chapter we wanted to look at some of the various masking and compositing techniques that we have both utilized over the years. This is one of those areas where Photoshop has evolved to provide a useful array of tools that can help you to produce convincing blends in your composite images. Of course, it is not all down to Photoshop. It often matters that you get the photography right to begin with. The techniques shown here should provide you with ideas and inspiration for how to become a master retoucher using Photoshop.

Figure 4.1 The two top shots were done on location at the Case dealer. The sign was done in Photoshop and the sunset was from studio stock.

Compositing work

Creating a realistic composite

In a perfect world where sunsets appeared on schedule and clients really do read (and send) memos, you don't need to worry about putting together a shot – it all falls into place. But in the real world that rarely happens. This is an example of how the best laid plans go awry and how you can use Photoshop to construct the image you need.

The art director promised me that he had seen the scouting shots of the Case dealer and it would work as a nice dusk shot – and the building even had shrubs (he really liked those shrubs). However, the dealer did not get the memo for clearing out *that* bay of the building. The bay with the shrubs had a Case combine in about a thousand pieces, so we were forced to shoot the big machine around back while we set up the exterior shot for dusk. Oh, and the sign, seems that hadn't been manufactured yet, could I just make that in Photoshop? Sure...

This ended up being a far more complex composite than was originally planned. Figure 4.1 shows the two original shots, the sign element and a sunset I had shot in Montana as stock. The key was to shoot both the interior and exterior shot from the same camera angle and camera height – even taking the steps of measuring the distance and the angles to be accurate. The dusk shot was done first with timing to get the right dusk light. The art director had hoped for a nice sunset (yeah, like that would happen). The inside of the bay was lit while waiting for the outside light to get right and shot later at night – it was a long night too!

Paths showing building outline

Layers showing sky and layer mask

1 The first step was to use the pen tool to draw an accurate path around the building exterior that would be loaded as a selection, saved as a channel and then into a layer mask for the sky layer. When the sky layer was brought in I resized it to fit the full width of the image. You'll note in the Background layer that I had to add more canvas to the top in order to fit the layout. The sky covers that addition.

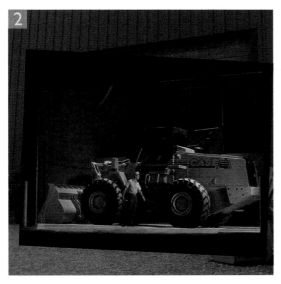

Layers showing detail of the two layers

2 To avoid working with the entire document when doing the center detail work, I used a process described on page 176 and worked on this section of the image separately. Even after careful measurements when shooting, I still needed to do a bit of Free Transform work to get the interior shot sized and positioned. Rather than apply a layer mask to this layer I made a duplicate of the Background layer and moved it to the top of the layer stack and masked it (as you'll see in the following step).

Door outline channel

Layers showing Door overlay layer

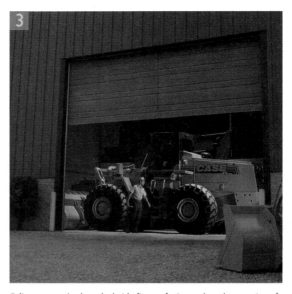

3 It may seem backwards, but I often prefer to overlay a layer on top of something and then use a layer mask to reveal what's underneath. I find it more expedient to work this way. The layer mask was done using the pen tool to create an outline of the door opening, with some softening done in the foreground to allow some of the warm light to spill out. Not enough in this case, which leads to the next step.

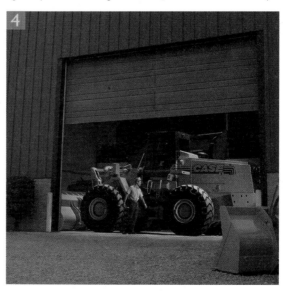

4 In order to get more warm light extending out of the doorway, I added a layer copied from the background, lightened it and added a warmer color balance.

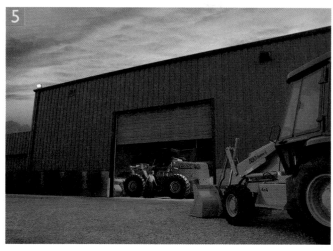

5 Going back to the main image, I dragged and dropped the three sub-layers (I didn't bother with the Background layer) and added them to a layer group named 'Center'. Since I had added a new sky to the photo and the original reflection in the tractor's glass window was of the 'as shot' sky, I needed to fix that.

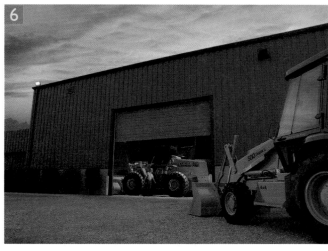

Layers showing Reflections group of 2 layers

The window glass channel

6 I copied the far upper left portion of the sky and made it into a new layer. I then used Edit ⇨ Transform ⇨ Flip Horizontal (since the reflection was a 'mirror image' from that portion of the sky). For the window glass channel, I used the pen tool to create an accurate outline of the glass in the window and loaded the channel as a selection to create the layer mask. You'll note a second reflection was added – since the shiny parts of the cab also reflected the original sky, I repeated the process by duplicating the flopped sky and used a different layer mask created using Color Range.

Case logo in Illustrator

Photoshop's Paste options for paths

Paths panel ⇨ Make Selection dialog

The three channels

7 This is where it started to get complicated. The art director gave me an Illustrator file with the Case logo. In Illustrator, I selected the paths and copied them. Back in Photoshop I chose Path from the Paste As options (see the Paste options). I transformed the paths to fit on the sign background I had previously made (based on a loose 'description' by the client). Then I loaded the paths as a selection and created a mask channel. Well, three channels to be precise: one for the text, one for the colored bar and a third that I blurred to create an outline glow to make the sign look like it was lit from behind. You'll note that I cut the Case logo into two separate channels because the logo had different fill colors.

8 This the final sign already outlined ready for compositing into the main image.

9

Perspective lines path

9 Before I could position and size the sign, I had to know what sort of perspective I would need. I accomplished that by creating two-point perspective lines using the building as a guide for the Vanishing Points. I created the perspective lines using the pen tool (which can go outside the boundaries of the canvas) while the image was zoomed way out. Theoretically, I could have done a vertical set of perspective lines as well. But I had built the original sign with a keystone built in and would make that final adjustment by eye.

IO

Sign layer targeted with the Perspective lines layer also visible.

10 I used the Stroke path with brush to paint white lines on a separate layer to use as a guide for sizing and positioning. I then targeted the Sign layer and used Edit ⇨ Transform ⇨ Free Transform to size and position the sign.

11 I needed three adjustment layers to make final tone and color corrections to the composite. The first adjustment was to tone down the overhead door which appeared lighter than the side of the building. I used a Curves adjustment to darken just the door.

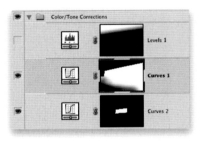

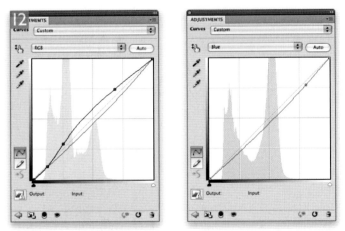

12 The second adjustment was to lighten the front of the building as well as the tractor. I used a layer mask to keep the adjustment off the sky and painted the area of the gravel out as well. In addition to the tone adjustment (above left) I also targeted the blue channel to reduce blue and warm up the color balance. Since the building was shot with basically a white sky, the building had looked too cool.

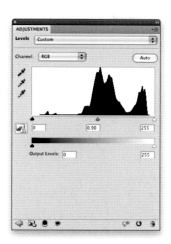

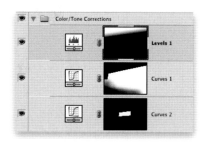

13 The last adjustment was to darken the sky using a gradient from the upper left. Very little of the sky needed to be darkened and I only darkened it slightly by shifting the Levels gamma slider to 0.9.

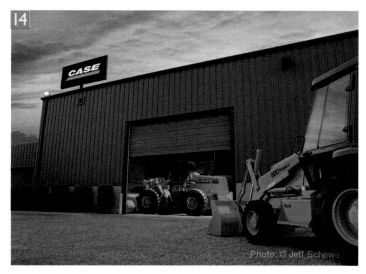

14 This was the final composite: eight pixel layers, three adjustment layers and a final overall midtone contrast boost. The final imaging took about three days' work including scanning the original film (35 mm), building the sign, searching for the stock sky and compositing the various layers. The art director was pleased (and a bit amazed). The only thing I haven't mentioned was the job was actually for two versions of the final image. You see, the job was to do the exact same image with the Case Construction (shown above) as well as the regular Case Tractors. That meant two signs, two exterior shots and two interior shots. Two times the work and two times the billing (even though it wasn't two times the hours since I could reuse pieces)

Third-party plug-ins

Most serious composite work is usually carried out against a plain backdrop. For example, the Ultimatte Advantedge software (www.ultimatte-software.com) requires that you shoot your subject against a blue or green backdrop. However, Vertus Fluid Mask (www.vertustech. com) is different in that it can do a very good job of cutting out images from busy background scenery.

Matchlight software

Professional studio photographers may be interested in looking at the Matchlight system where you can place a special disk in a location scene and the software will be able to interpret the camera angle and lighting you need to use in the studio to match the outdoor location. For more information go to: www.gomatchlight.com

Masking hair

If you are a people photographer and use Photoshop to create montage images, you will appreciate how difficult it is to successfully mask hair. There is always a lot of discussion on the various Internet forums about this particular subject, so I know it is something that will interest photographers and Photoshop artists. The problem most people have is how to get rid of the trace pixels around the edges of the hair, as these are always a sure giveaway that a picture has been composited badly. What follows on pages 150–157 is a hair masking technique that has served me well over the years, which you can apply using Photoshop without the need for any extra plug-ins.

The first thing I should point out here is that for this method to work, your model or subject must be photographed against a white or light colored backdrop. Now, I know a lot of people come up to me at seminars and ask how they can adapt this technique to work with ordinary images shot against busy backgrounds. Well, it won't always work so well with such images and if this is your goal, then you'd be better off using a dedicated masking plug-in such as Vertus Fluid Mask (see sidebar). The point here is that if you know you are about to create a cut-out composite image, then you must shoot your subject with this in mind. Some plug-ins require that you shoot the subject that's to be cut out against a blue or green screen. Similarly, this technique works best if you shoot against a white backdrop. As I say, it can work with backdrops that aren't pure white, but you'll just be making the task a lot harder for yourself.

How it works

This method revolves around making use of the existing color channel contents – by copying the information which is already in the image and modifying it to produce a new mask channel. So instead of attempting to trace every single strand of hair on a mask with a fine-tipped brush tool, you can save yourself a lot of time if you make use of the information that's already contained in the color

channels and use this to define the finely detailed edges. However, you may still find that the pen tool is useful for completing the outline around the smooth broad outline of the neck, shoulders and arms of the model's body. I've not shown how to do this here because I didn't want to make the following steps too complicated. If you do need to use the pen tool you can do so to define the areas that need to be included in the mask, then convert the vector path to a selection and fill with black.

The main message I want to convey here is that it is always worth exploiting the channel content as much as you can as a shortcut for building an accurate mask that is based on the actual image content. As I show in the following tutorial, the tools I find useful here are the Apply Image command for building initial contrast by blending a channel with itself or with a second channel. Another great tip is to change the Paint brush blend mode to Overlay blend mode when editing a black and white mask channel. In recent years, I have even found that the Shadows/Highlights adjustment, and in particular the Brightness and Contrast sliders, can be used to further improve the mask contrast.

Getting the different elements to match

This should go without saying, but in order to create a successful composite you do need to make sure that the photographs you are about to combine all match in terms of camera angle and height, the focal length of the lens and, above all, lighting. It doesn't matter how good you are at Photoshop, if you can't get these things right from the start you'll never be able to produce a realistic-looking composite.

The camera angle and focal length matter most when you are working with wide-angle shots. If you are combining photographs that have been shot with a longer focal length lens there is a much greater margin of error. The lighting doesn't always have to be exact, but if you wish to merge a photograph taken in the studio with an outdoor scene, you will probably need to use a lot of top light and possibly include a direct spot to simulate sunlight.

Keep the mask edges soft

Retouched photographs won't look right if they have 'pixel-sharp' edges. A mask that's derived from a vector path will always be too crisp, even if it is anti-aliased. To create a more natural-looking result you should always use a soft-edged mask instead. This is where the Refine Mask dialog comes in handy because it allows you to use the Radius, Contrast and Feather sliders to control the softness/hardness of the mask edges.

1 The following steps describe how I would go about photographing a model with a view to adding a new backdrop later. I normally plan my shoots so that I always photograph the subject that is to be cut out against a white background, as this is the best way to mask the fine hair detail. In this example the background is not completely white, but there is certainly enough contrast between the hair and the backdrop for me to use the following technique to create a cut-out of the model and place her against a new backdrop image.

2 I began by looking at the individual color channels and duplicated the one that contained the most contrast; in this case I decided that the Blue channel had the most contrast between the hair and the background. I duplicated the Blue channel by dragging it to the New Channel button in the Channels panel. This created the new Blue copy channel, which is the one shown active here.

3

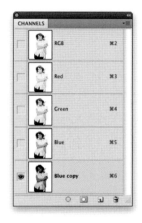

```
                  Apply Image
  Source:  Hairmasking.psd        ⬍
                                          ( OK )
  Layer:   Merged              ⬍
                                          ( Cancel )
  Channel: Blue copy         ⬍  ☐ Invert
                                          ☑ Preview
  Target:  Hairmasking.psd (Blue copy)

  Blending: Multiply          ⬍

  Opacity: 100   %

  ☐ Preserve Transparency
  ☐ Mask...
```

3 To increase the contrast in the Blue copy channel I went to the Image menu and chose Apply Image. Here, I let the Blue copy channel blend with itself using the Multiply blend mode, which effectively darkened the channel. You could just as easily use a Curves adjustment at this stage instead, but the main reason why I prefer to use Apply Image here is because you can sometimes choose to blend other color channels with the copy channel. For example, you might like to try blending the Green channel with a Blue copy channel. As well as using Multiply, you might also like to experiment with using the Overlay blend mode.

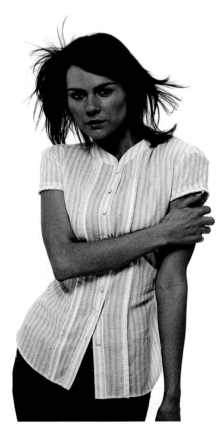

151

4 I now wanted to increase the contrast to create a silhouette mask. To do this I used the paint brush tool set to Overlay mode and toggled between using black and white as the foreground color. When using the Overlay blend mode, as you paint with white, paint is only applied to the light colored pixels and, as you paint with black, paint is only applied to the dark colored pixels.

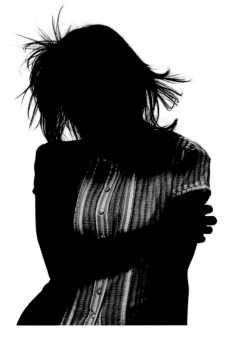

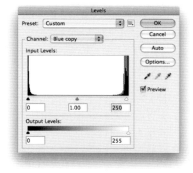

5 The Overlay blend mode is therefore useful when painting on a mask because you can paint quite freely using a large pixel brush to gradually build up mask density around the outline of the subject, but without accidentally painting over the light areas. I continued to paint, taking care not to build up too much density on the outer hair strands (one can switch to Normal blend mode to finish the mask). I also prefer to paint using a pressure-sensitive Wacom™ pen and tablet, with the pen pressure sensitivity for Opacity switched on in the Brushes panel Other Dynamics options. Finally, I applied a direct Levels adjustment to boost the contrast slightly.

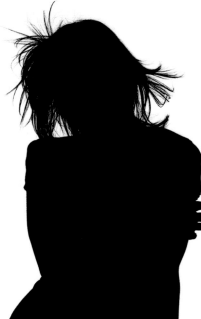

6 It was now time to add a backdrop photo. I opened up a new photograph of a salon interior, selected the move tool and dragged the backdrop image across to the model image window. This added the backdrop as a new layer. I kept the Layer 1 active, chose Edit ⇨ Free Transform and dragged the handles to scale the backdrop layer so that it filled the bounds of the underlying layer. When I was happy with the transformation I clicked OK.

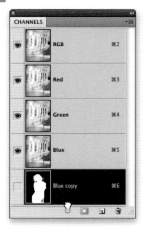

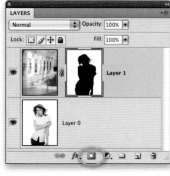

7 I dragged the Blue copy channel to the Load Selection button in the Channels panel and then clicked on the Add Layer Mask button (circled) in the Layers panel to convert the active selection to a pixel layer mask.

153

8 This last step applied a layer mask to the salon backdrop layer, which basically punched a hole through Layer 1 and allowed the photograph of the model to show through from below.

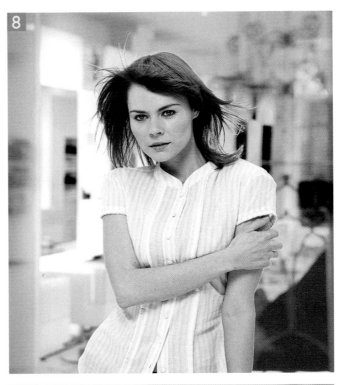

9 For this next step I set the layer blend mode to Multiply, which effectively 'projected' Layer 1 on top of the Background layer. As you can see, it is not a bad mask, but there are still some areas where we have white edges showing around the outline of the hair. The initial layer mask had worked reasonably well, but could still benefit from some fine-tuning.

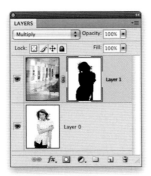

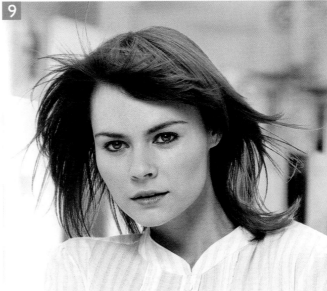

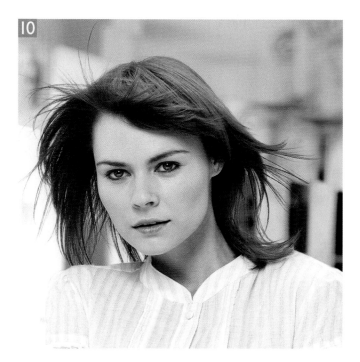

10 Next, I made sure that the layer mask (not the layer image thumbnail) was selected and clicked on the Mask Edge... button in the Masks panel to open the Refine Mask dialog shown here, where I clicked on the Standard mask view (circled) to show the transparency of the mask. I also needed to hide the marching ants that appeared on the screen by using ⌘ H ctrl H. Here, I began by setting the Contract/Expand slider to +50%, which effectively choked the mask. I know this sounds back to front, but remember that the mask that's used here was hiding the selected layer and I therefore needed to 'expand' the mask in order to shrink the size of the hole. Basically, you simply drag the Contract/Expand slider left or right to see which setting works best. I then adjusted the Radius to smooth the edge transitions, and then the Feather to help keep the mask edge looking soft.

At this stage you can see how the edges of the mask looked more convincing and I was now getting a more convincing blend for the loose strands of hair against the backdrop image.

Refine Mask help

There is a Description section at the bottom of the Refine Mask dialog that helps explain what each of the controls does.

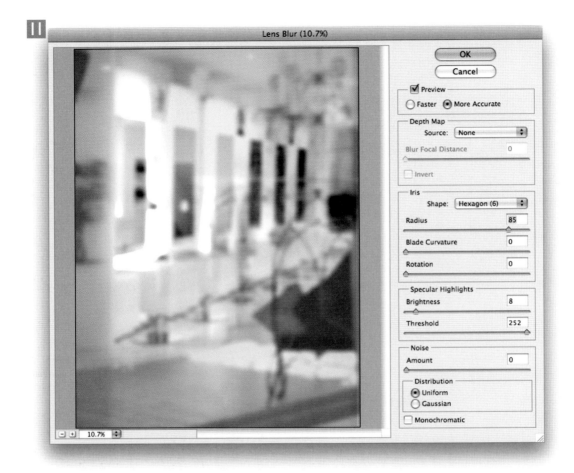

11 I thought the backdrop image would look more convincing if I made it appear more out of focus. To do this I clicked on the image thumbnail in Layer 1, went to the Filter menu, and chose Blur ⇨ Lens Blur. The most relevant sliders here were the Radius slider for the Iris (this sets the blur amount) and the Brightness and Threshold sliders, which determine how much the highlights will burn out. I used the settings shown here and clicked OK.

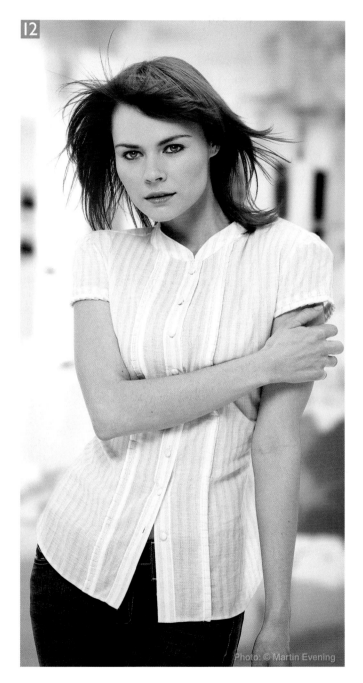

Photo: © Martin Evening

12 Here is the completed image in which you can see a full length view of the model against the backdrop, with just a few further modifications made to the picture. For example, I carried out some basic beauty retouching on the face and added a lightening curves adjustment that was clipped to the background.

In the photograph you see here, I used one pass of the Refine Mask to achieve the best modification of the mask. Overall, I reckon the mask looked pretty good, but there were a few areas along the lower half of the model's left arm where I would probably want to improve the mask.

If I wanted to be really precise here I could refine the mask edges with two applications of Refine Mask. To do this, I would go to the History panel and create a Snapshot of the current Refine Mask state. I would then undo the last Refine Mask step and reapply Refine Mask, but this time adjust the settings for, say, the edges of the arm, then take another snapshot. Having done that, I would select the history brush and sample from either of the two snapshot history states to paint along the edge of the subject. As I say, it shouldn't always be necessary to go to such lengths, but it is possible to blend two different Refine Mask treatments should you need to.

Figure 4.2 This shows the Layers panel view for the masked image along with the Masks panel below.

Refine Mask command

Photoshop CS3 saw the introduction of the Refine Edge command, which allowed you to refine the selection edge before you converted it into a mask. However, it always made more sense to me to apply the selection as a mask first in CS3 before I selected Refine Edge. In CS4 the ability to edit the mask in situ is now made more obvious. If a pixel layer mask is active, you simply choose Select Refine Edge... or click on the Mask Edge button in the Masks panel to open the Refine Mask dialog.

The controls in Refine Mask include everything you need to modify a layer mask edge. The initial preview may confuse you because the default view shows the 'on white' backdrop display. Why this should be the default I don't know, but if you click on the Standard preview button (circled in Figure 4.2) you'll see a transparent view with marching ants active. All you have to do then is use the ⌘ H ctrl H shortcut to hide the ants so that you can preview the mask properly and start editing the mask edge as shown in Figures 4.3–4.9.

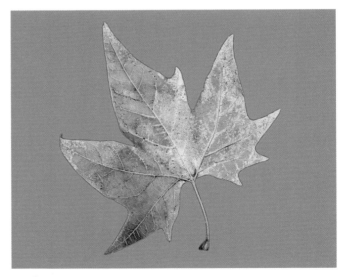

Figure 4.3 To apply a Refine Mask adjustment make sure you have a pixel layer mask active, then click on the Mask Edge button that's circled in the Masks panel. Here you can see the default settings that are applied when you first open the Refine Mask dialog.

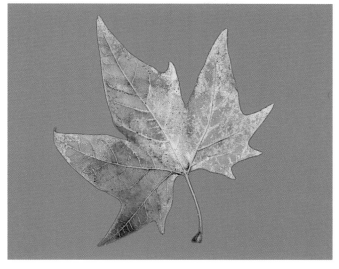

Figure 4.4 The default settings use a 1 pixel Radius. As you increase the Radius this will allow you to improve the edges in areas of soft transitions, but this may also lead to portions of the underlying layers showing through. However, you can address this by adjusting the Contrast slider below.

Figure 4.5 The Contrast slider can be used to make soft mask edges crisper as well as help remove artifacts along the edges of a selection. In this example, I applied a 50% Contrast adjustment in order to give the mask outline shown in Figure 4.4 a harder edge.

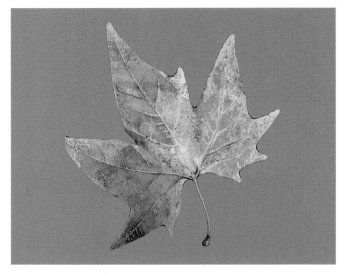

Figure 4.6 The Smooth slider can be used to help smooth out jagged selection edges. You don't normally want to set the Smooth setting too high, but if you do so, for whatever reason, increasing the Radius can help restore some of the edge detail.

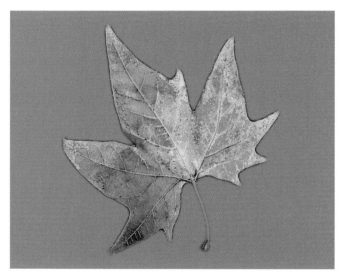

Figure 4.7 Increasing the Feather amount uniformly softens the edges and can help produce a softer-edged mask. You can sometimes use the Feather slider in conjunction with the Contrast slider to fine-tune the mask edge appearance.

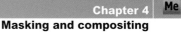
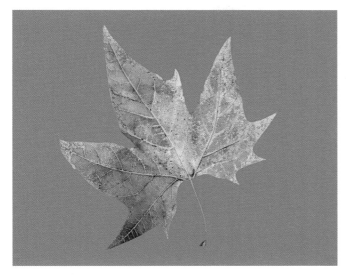

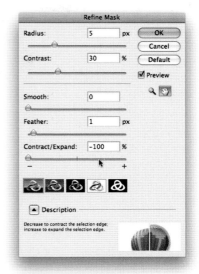

Figure 4.8 The Contract/Expand slider acts like a choke control for the mask and works just like the Maximum and Minimum filters by shrinking or expanding a selection. In the example shown here I dragged the slider all the way to the left to shrink the mask edge so that it masked the layer more tightly.

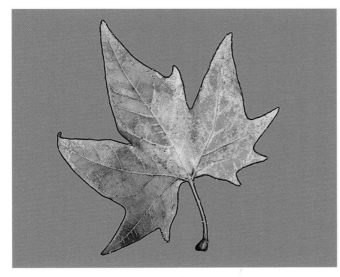

Figure 4.9 In this example I dragged the Contract/Expand slider all the way to the right in order to widen the mask so that it didn't mask the edges so tightly. Very often you will find it useful to adjust the Contract/Expand slider first before you use the other sliders. Remember, with some layer masks the mask reveals the outer area and, in these circumstances, the Expand/Contract slider behavior is reversed.

The history of history

The History feature was added to Photoshop 5 by Mark Hamburg who had been tasked to add multiple undo. Mark had been influenced by seeing a demo I had done of Globe Hands and used this as inspiration for the History feature. Mark got a patent in his name and was named Silicon Valley Software Inventor of the Year (in 1999). I got a Photoshop feature designed just for me – A fair trade in my opinion.

Snapshot painting

A different way of compositing

It's often said that those who forget history are doomed to repeat it. I'll alter that a bit and say that those who forget history are doomed to use layers. The History feature of Photoshop is a powerful and severely underutilized tool that can radically alter the way to do digital imaging.

The proof that using history can be radical is the fact that the Globe Hands image was done in 1994 using Photoshop version 2.5 – well before Photoshop even had layers. The way of working is very different, but the results cannot be duplicated using layers. To understand how to use history requires a bit of learning and practice, but once learned can be deployed for a range of imaging needs – as long as you don't forget history is there.

The Globe Hands image (Figure 4.11) is a composite of two original scans from 4 x 5 film (Figure 4.10) as well as containing substantial retouching for the globe and some image warping for the hands. But before I get too far into the technique, I need to point out that this image was done back when computers could only hold megabytes of ram, not gigs. As a result of the early computer limitations, I used a process where I selected a smaller portion of the image and sliced it out to do the heavy work, only replacing the subsection after the imaging was completed.

Figure 4.10 The original hand scan (left); the original globe scan (middle); the retouched globe layer.

Figure 4.11 The final image after compositing, retouching, final tone and color adjustments and the addition of a rough-edged frame.

Remembering the old times

In the past, Photoshop's primary limiting speed factor has been ram access. Photoshop CS4 can access up to 4 gigs of ram (Mac) and whatever the motherboard can address (Windows as a 64-bit binary). When I first started using Photoshop, it was a struggle to use a paltry 64 megabytes of ram. Hence the use of techniques to minimize the size of the images being loaded into Photoshop.

Slicing an image

Photoshop used to have a plug-in called Quick Edit that would allow you to specify a subsection of an image to open and then save the manipulated sub-image back into the full image file. What follows is the manual way of carrying out that same type of function, but with some added benefits. Note that this does take practise and attention to detail so that you can put things back together correctly in the end. But the technique still offers benefits.

The first step is to decide what section of an image you wish to use as the subsection image. Create a marquee selection (Step 1) and then convert that into a path. Be sure to save the path in the full image before proceeding. For the Globe Hands image, the CENTER-DETAIL path would be turned back into a selection before cropping to the selection and then saving the cropped file as CENTER-DETAIL (Step 2). This new file would then be used for all the warping and snapshot painting.

Image warping

Prior to beginning the snapshot painting, I altered the shape of the two hands (see Steps 3 and 4). Even though I had the fellows wrap their hands around a cue ball that was mounted on a long rod running through the background, their hand shapes weren't round enough.

After duplicating the background to a new layer and renaming it, I added a new layer named 'circle' that was the size and shape I wished to warp the hand to match (Step 2). I warped the hands using Liquify and allowed the circle layer to show as a guide. Using the forward warp tool I gently pushed sections in or out to get a more rounded shape. The hands didn't need to be perfectly round – that would have looked odd. The aim was to get them 'rounder' without making it look like I did anything to them. That's one of the keys to image manipulation – doing something so that the end results don't look like you did anything!

1 I drew a marquee selection in the center of the image that defined the area to be used for the main image manipulation. In the Paths panel I clicked on the Make work path from selection button. I suggest naming paths with a consistent and descriptive name so you'll remember what the path is intended to do.

2 After I had saved the cropped image, I named it 'HAND-DETAIL' and duplicated the Background layer and renamed it 'Hands-unwarped'. It didn't really matter what the name was (I was going to rename it anyway) but it was important to have a descriptive name so in drop-down menus (such as in Liquify) I could be assured of knowing what layer was doing what.

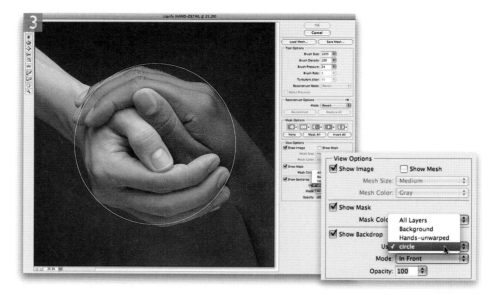

3 The first step was to go to the Filter menu, choose Liquify and activate the Circle layer so it showed as a visible guide for where the hands needed warping.

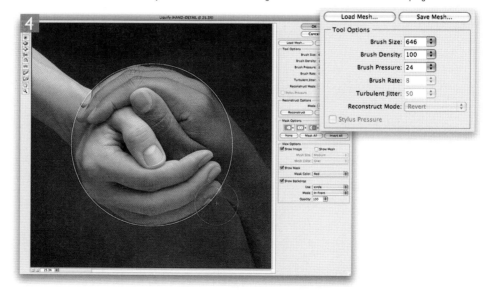

4 The rest of the warping was done using various sized brushes to gently push and prod the shape of the hands into a more rounded shape. One of the keys to successfully warping images in Liquify is to first have a high enough resolution image to work with and, secondly, not to try to do too much. In this case, the amount of warp was sufficient to round out the hands to receive the globe image.

History basics

Before you can really make full use of history as a creative tool, you need to understand some of the fundamentals and how the different options work. In this particular example, I also had to do some preparatory work prior to actually doing the snapshot painting. I suppose the first thing to realize is that there is a relationship between layers and how those layers are used when creating snapshots. For the Globe Hands image, I prepped the HAND-DETAIL image so as to have the proper layers in place before making snapshots (see Figure 4.13).

First, though, is a explanation of the different options found in the History options – they have an important role in using history successfully. To access the History options, select the menu item from the fly-out menu (Figure 4.14).

The Allow Non-Linear History option allows you to go back in time and to use a history event without wiping out things you've already done (see Figure 4.12). If you are a sci-fi fan and understand the 'grandfather paradox' this means you can go back in time, kill your grandfather and you won't cease to exist. If you don't understand this, you can leave this unchecked (but I like to use it and so should you). The next checkbox makes sure that when you click on the Create new snapshot button (Figure 4.15), you'll get the full New Snapshot dialog (which is really important).

You can choose to have a new snapshot created when saving (I consider this marginal in usefulness). This option will do a full document snapshot when you save. The last option – Make Layer Visibility Changes Undoable – I actually find confusing so I don't use it.

Figure 4.13 The HANDS-DETAIL image (a subsection of the main image) had three layers: the Background image of the warped hands, the warped hands outlined as a separate layer and the globe layer sized and positioned for placement.

Figure 4.14 In the History panel, I selected the fly-out menu for the History options which brought up a dialog box allowing the selection of various options.

Figure 4.15 Unless you check the Show New Snapshot Dialog by Default option, clicking this button simply makes a new snapshot of the Full Document, which is not useful for our purposes.

Figure 4.12 By default, the checkbox for automatically creating the first snapshot is checked. I suggest checking the additional checkboxes shown above.

Figure 4.16 When properly prepared, there will be a snapshot named 'Globe' that has all layers merged into one and a separate snapshot named 'Hands' which is a snapshot of only the hands floating on their own layer. The snapshot that will be used for any history function is selected by clicking in the active snapshot column. In this figure, Globe is active and will be used for filling and painting from history.

Making snapshots

In order to use snapshots, you first must create them and be sure of what is contained in them. Not all snapshots are created equal (nor are they all useful for snapshot painting). There are three flavors of snapshots: Full Document, Merged Layers and Current Layer. Of these, I'll only use the Merged Layers and Current Layer flavors. They do substantially different things and offer very different results. The Current Layer option (Figure 4.17) only stores the currently targeted Photoshop layer. This is useful when you want to be able to fill or paint using history to return to the state of that layer when you made the snapshot.

However, for creative purposes, the Merged Layers flavor (Figure 4.18) is far more useful – this is the only version that allows you to paint or fill from different layers. You'll note that on the preceding page, all three layers were currently visible (Figure 4.13). So, when I did a Merged Layers snapshot, I was able to take the image data from the globe layer and blend it into the warped hands layer. If you've never used this snapshot option, you may never have discovered this important feature – blending the results of multiple merged layers into the targeted layer using history.

Figure 4.17 For the Hands snapshot, we need to make sure the warped hands layer is the current target. This snapshot will be of the hands before we do any blending.

Figure 4.18 For the Globe snapshot, we need to create the snapshot using the Merged Layers option. It doesn't matter what layer s the current target, all visible layers will be included in this snapshot.

The channels

I won't dwell on how I made the actual selections and turned them into channels to be used later. Figure 4.20 shows the Channels panel and the variety of channels created prior to starting the snapshot painting. Obviously, I needed an area to fill into – that's what the Globe paste channel provided (Figure 4.19). I also needed to treat the highlights and the shadows of the hands image differently.

The Globe paste channel was made by combining the Hands Outline channel with a circular marquee selection. The Hands Highlights and Hands Shadow channels were made using Color Range selections on the Hands layer. The Finger details selection was made using the pen tool and drawing around the fingers and then inverting the resulting channel after turning the path into a selection.

Snapshot painting is fundamentally different from layers in that you don't use a layer mask: you use a selection to constrain where the snapshot painting is blended. So preparing the selections accurately before you start the blending is critical. On the other hand, you do have infinite flexibility when snapshot painting in that you can always return to where you started by simply using the prepared snapshots. But clearly defining where the fill or painting occurs is the job of really good masks.

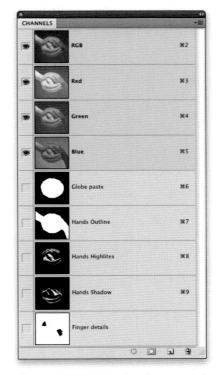

Figure 4.20 The above channels were created using a variety of techniques.

Figure 4.19 For this example, I used the Load Selection dialog box. I usually just ⌘ *ctrl*-click directly on the channel icon to load the selection. In this figure, I loaded the main channel (the Globe paste channel) as a selection. This was the active selection for the first few snapshot painting steps.

169

Contents Use: drop-down menu

Blending Mode: drop-down menu

Figure 4.21 The Fill commands will be set to History and a variety of blending modes will be used.

The blending

If you've never tried this process before, it can seem rather intimidating and complicated. But take heart, it's really not that hard once you grasp the functions of the snapshots and how to use history. It's important to remember that if you've properly created your snapshots of Merged and Current layers, you can interactively blend back and forth to achieve the results you wish. So, it's not like you'll really ruin anything if you make a mistake.

To start the process, the targeted layer is the Warped hands layer and the Globe layer is no longer visible. It really has served its purpose once the Merged Layers snapshot has been created but it's still useful to keep, in the event you need to remake a snapshot. The first steps will use the Fill command found under the Edit menu although you can also use the keyboard command of ⌘ _Delete_ (_ctrl_ _Delete_ for Windows) to directly access the Fill command. Only after the fill series of adjustments are done will we start using the history brush to paint with.

The crucial setting in the Fill command is to make sure that the Contents drop-down menu is set to History as shown in Figure 4.21. All of the blending was done using the History option in the Fill dialog or by using the history brush when doing actual brush-based painting.

The other thing to keep in mind is that there will be a variety of blending modes used while working towards the final look. The primary modes are: Color, Multiply, Screen, Overlay and Luminosity. When needing to return to a previous state, the Normal mode is used. Creatively, the Multiply, Screen and the Overlay combo is used the most. Multiply adds to the existing image by darkening based on the fill content. Screen lightens by the fill content and Overlay is a hybrid of both in that it lightens by the fill content above level 127 and darkens below level 127. So, it lightens the lights and darkens the darks.

You'll also note that the opacities are almost always on the low side with nothing ever done at 100% opacity. Subtlety is important in the blending.

1 With the selection active, I used the Fill command and filled using a Color blend mode. Here I chose a 50% opacity.

2 This shows the image after applying the Color blend fill. Next, I used Multiply with a 33% opacity. The numbers for opacity are not an exact science. Much of the blending is based on a feeling (which takes time to develop). Remember, you have Multiple undo (the whole reason for the History feature) and you can always re-blend from the other snapshot.

171

3 By using the Multiply mode, the whole Globe paste area had grown darker (which was to be expected). To bring back lightness, I used the Overlay blend mode which screens above level 127 and multiplies below level 127. This lightened the lights and darkened the darks.

4 At this stage, the color and texture were growing towards the effect I wanted, but the luminosity had continued to get darker. To regain the original luminosity, I changed the History source to be the Hands snapshot and filled at 33% opacity with luminosity.

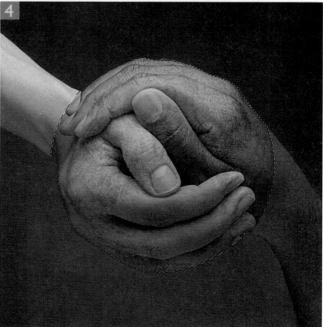

5 After filling in from the Hands snapshot, the History source was changed back to the Globe snapshot after loading the Hands Highlights channel as a selection.

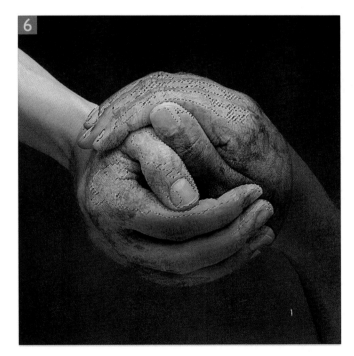

6 After loading the Hands Highlights selection, I filled from the Globe snapshot using Screen (to lighten) again with a 33% opacity.

7 Here, the Hands Shadow selection had been loaded and the blending mode had been changed to Multiply to darken the shadow area by filling in from the Globe snapshot.

8 The overall look was starting to get finalized, but there was an area on both wrists that required special attention. Prior to working on these areas, it was useful to grab the state of the image blend as it existed at this moment. So, it was time to take another snapshot of the Current Layer which would add a fourth snapshot in the History panel. This snapshot was used to re-blend the current state in the event that the next step removed too much detail.

9 The time had come to do some brush work. The Finger details selection had been loaded and the history brush tool selected using a Normal blend and 25% opacity. To return the original skin color and blend in the outer circumference of the Globe blend, the Hands snapshot had been set as the source for history. The Finger detail selection would therefore only allow snapshot painting in the areas away from the fingers.

10 In this step, the Combo snapshot was selected as the History source and I painted back in some of the area I over-painted using the Hands snapshot. This is the interactive nature of snapshot painting that allows going back and forth between blend states by using the various snapshots as the source. While the whole image was looking pretty good, the last step was to zoom in and do some detail work to bring up the contrast and small textural detail in the image.

11 In these last stages, it's typical to bounce back and forth between the snapshots and blend out the final look of the color and texture. Selecting the Hands snapshot will return the area more towards the Hands snapshot, while setting the Globe snapshot will bring more globe back into the image. If either produces undesirable results, you can revert to the stage of the image where you made the Combo snapshot. In the final two figures you see the progression of the small detail being brought out. You should be warned that this process can be, well, addictive. At some point you need to call a halt and decide that enough is enough.

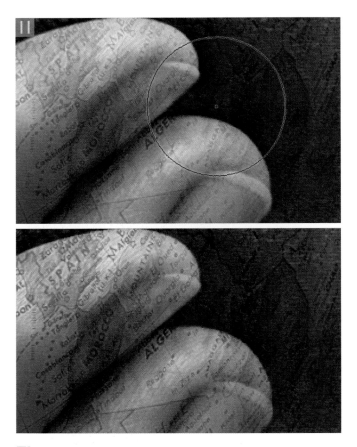

The wrap up

As you can tell from the preceding steps, this process is not for the faint at heart. However, the creative potential is simply too strong to ignore. There are some limitations to using history and snapshots – for example, history and snapshots are live only while your image is open in Photoshop. Once you save and close the image, all history steps and snapshots are lost. You can recreate them if you need (as long as you have the requisite elements saved as layers). You can also save out snapshots as discrete image files that can be reopened and added back into the final file as temporary layers to remake snapshots as needed. The final step in the HAND-DETAIL image is to return the results back into the main image.

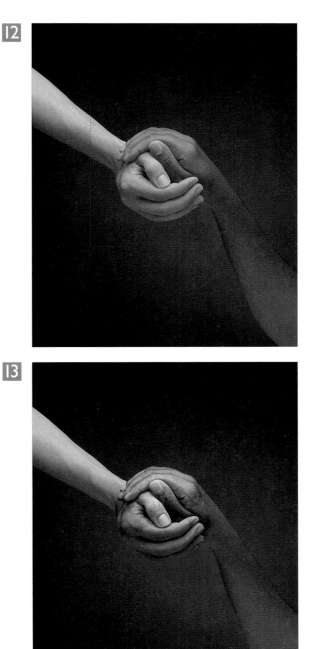

12 After saving the HANDS-DETAIL image, the original full image was reopened and the CENTER DETAIL path was loaded as a selection (⌘ ctrl clicking loaded the path as a selection). The final HAND-DETAIL image was flattened (and closed without saving to preserve the layered image file) and, with the selection active, I chose Edit ⇨ Copy and pasted the clipboard contents into the selection. By default, Photoshop automatically pastes into the exact center of an active selection so as long as the pasted content and the selection were identical in size, I would have made a seamless assembly.

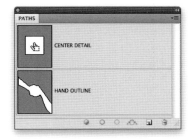

13 Pasting in the HAND-DETAIL image resulted in an exact pixel for pixel match. At this stage some final image adjustments were made to punch up the overall color and contrast and add the rough-edged frame around the final image. The end result is the appearance that the globe is painted onto the hands.

177

Extended only

As with the tourist removal and layer stack noise removal techniques, this is yet another Photoshop technique that is only available to customers who have the extended version of Photoshop CS3 or CS4.

Range stacks blend mode

The Maximum stacks blend mode worked well when blending this particular series of images, but you may also wish to try the Range blend mode which preserves slightly more detail in the extreme highlights.

Combining images

The best way to combine exposures

There are a number of traditional photographic shooting techniques that rely on the use of multiple exposures to produce a single blended exposure image. For example, a lot of still-life studio work is created using multiple exposures and architectural photographers may use this technique to blend one shot of a building at dusk and another taken at night when the lights are all switched on in the building. In most cases you can successfully blend photos using the Normal or Screen blending modes. However, there are some assignments where you may like to try using the method described here, in which I used the Maximum stacks blend mode to add together ten separate exposures of a firework display, but without losing the contrast and definition of the original single exposure shots.

1 This Bridge window view shows an edited selection of photos that I wished to blend together to create a single, merged firework photograph. First, I selected all of the images displayed here, went to the Tools menu and chose Photoshop ⇨ Load Files into Photoshop Layers...

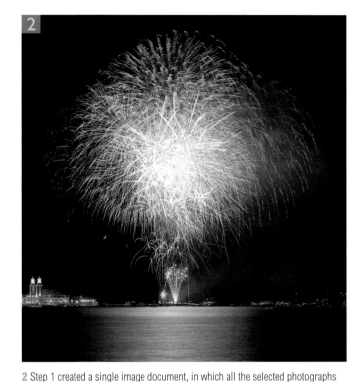

2 Step 1 created a single image document, in which all the selected photographs were all placed as individual layers. There was no need to align these layers as they had all been shot using a tripod. At this stage it was interesting to see what would happen if I set the blend mode on each layer to Screen mode. This is one way to produce a blended composite image and the advantage of this approach is that you can quickly check what the image would look like when certain layers are hidden. The downside is that we end up with a photograph that looks rather misty and where the firework trails are lacking in detail and vibrance.

3 I reset the blend mode back to Normal again for all the layers, then went to the Layer menu and chose Smart Objects ⇨ Convert to Smart Object. This step created a single Smart Object layer.

4 Now that I had converted the layered image to a Smart Object, I went to the Layer menu again and chose: Smart Objects ⇨ Stack Mode ⇨ Maximum.

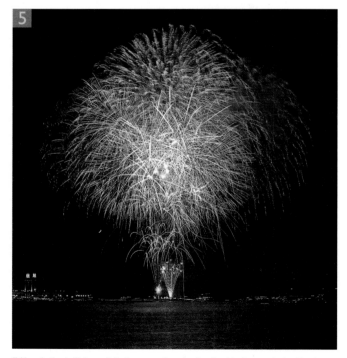

5 Here is the initial result that was produced using the Maximum stacks blend mode. As you can see, this blend method produced a merged composite image that had better detail and contrast compared with the Screen blend mode method.

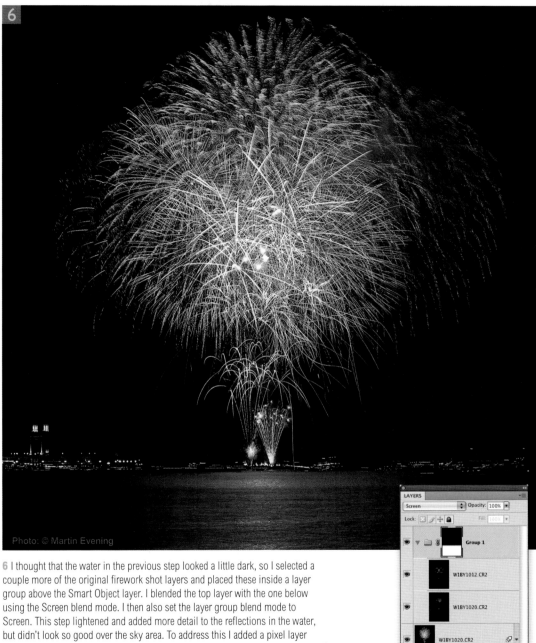

Photo: © Martin Evening

6 I thought that the water in the previous step looked a little dark, so I selected a couple more of the original firework shot layers and placed these inside a layer group above the Smart Object layer. I blended the top layer with the one below using the Screen blend mode. I then also set the layer group blend mode to Screen. This step lightened and added more detail to the reflections in the water, but didn't look so good over the sky area. To address this I added a pixel layer mask to the layer group and applied a black to white gradient which hid the top half of the layer group.

Cheating a mask

Do you really need to spend ages creating a mask in Photoshop? If you are a still-life studio photographer, the answer may be staring you in the face. Here I wanted to give you one example of a situation where a table top studio setup can allow you to cheat at creating a mask by simply turning off the foreground lights and making an additional exposure with a digital camera, and using the silhouette image this creates as the basis for a mask. As long as you are using a digital camera to capture the two exposures, and the camera is mounted on a tripod, the mask created here will be completely pixel accurate. And believe me, as much of a fan of the pen tool as I may be, the thought of using it to outline something like this fan would keep me awake at night.

1 This shows the raw files of the fan opened in Camera Raw. In order to maintain the exact pixel for pixel relationship of these two shots, it was super-critical to make sure the crop for all the processed images was exactly the same. In this step I've got both images selected and clicked on the Synchronize button. In the resulting dialog I selected the Crop option only to synchronize with and then clicked OK.

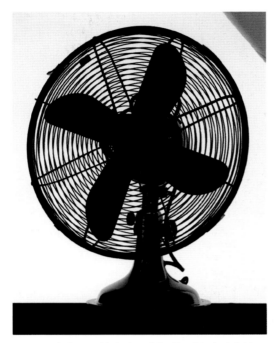

2 Here you can see the image with the front light off and the back light on, opened and converted to grayscale. Since I was only working with this image in order to create a channel, there was no reason for me to work in color here. I did need to do a Curves adjustment to lighten up the background, but without lightening the shadows too much.

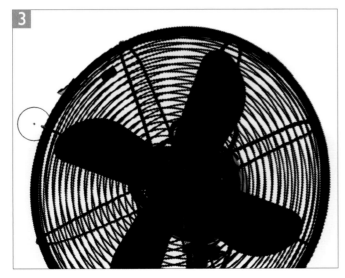

3 I then zoomed in a bit and loaded the grayscale channel of the image itself as a selection and painted around the fan to improve on the mask and eliminate as much tone as possible in the white areas. You'll note that prior to loading the selection I had already painted out the upper right corner that had the fill reflector card showing. Since that was a broad area far enough from the fan itself, I didn't need to worry about working with a selection. You'll also note that inside the fan's circular cage, the base still had some tones that would need to be knocked out. Rather than trying to paint these out by hand, I needed to fix that in the next step.

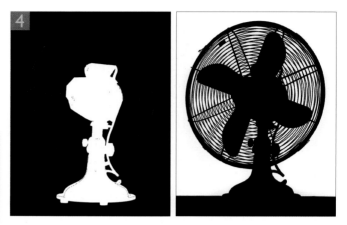

4 In order to accurately fix the base, I did create a path that followed the contour of the base exactly. That path was turned into a channel (above left) and the original channel loaded as a selection. I then loaded the Base outline channel, inverted it and set it to Intersect with Selection. This bit of 'Channel Chops' work resulted in the figure on the upper right. I also used the Base outline to clear the horizon line and outline the fan base. The next step shows how I copied the edited channel into the main RGB image of the fan.

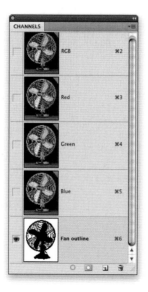

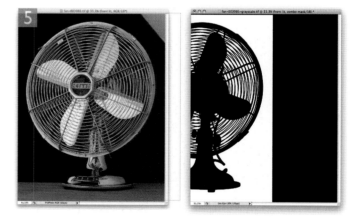

5 Using the move tool, I dragged and dropped from the grayscale image (on the right) to the RGB image (on the left). It was important to hold down the _Shift_ key once I had started the drag. Adding the _Shift_ key while dragging instructs Photoshop to do a pin registered drop so the pixels will line up exactly. The Channels panel on the far left shows how the Fan outline channel had been added to the color image in registered position. Before using it as a layer mask, it was necessary to invert the channel mask using the ⌘ _I_ ctrl _I_ keyboard shortcut.

6 In this step I zoomed in (after inverting the channel) to work on some of the residual areas that needed fixing. This often happens with 'shiny things' that catch a bit of reflection, but it still beats using the pen tool!

7 For this final composite, you can see the main fan layer used the fan outline as a layer mask (after the base had been added to the channel). I also added a second fan layer in the composite – the original backlit image (in color) that I made the mask from. This second fan image added a bit of tonality at the very base of the fan. The rest of the layers included image adjustments, shadows and a color tint layer to colorize the background.

Masking an object with a path

Martin and I both wish there was some sort of magic tool that could be used to make beautiful masks at the snap of a finger, but we've tried them all and usually fall back on the pen tool to create a path when something must be very accurate. Because the pen tool has sub-pixel accuracy, no pixel-based selection can ever be as accurate. So, we are both very good at making paths in Photoshop. It's kind of the mark of a true craftsman if you are good at doing this and pretty much guarantees a mask will end up 'perfect'.

The following steps are from a job I wished to check I hadn't had to do as a composite with a studio shot – February in Chicago would have been a real nice time to go down and do a shoot on a cruise ship. Alas, there wasn't enough budget to do that so I did research on exactly what the shot would look like if done for real, and Figure 4.22 is what I came up with.

Figure 4.22 The sky image (left) was a personal stock image (which I charged stock rates for the client to use) and the image on the right was shot in the studio (in February) lit to make it appear to be outside. I did try real hard to use a blue-screen attempt at knocking out the blue background but it didn't work.

Set to Paths mode

Pen Options

Figure 4.23 For me, it's important to work with the Pen options set to Rubber Band mode. This means that once you place a point, the next point you place will have a line behind the cursor that shows you where the path will be drawn, before it's actually drawn by placing the next point. This gives you the ability to predict what the resulting path will look like before dropping that next point. The other thing you need to be sure of is that the pen tool is in Paths mode. This will result in a path being drawn instead of a Shapes layer.

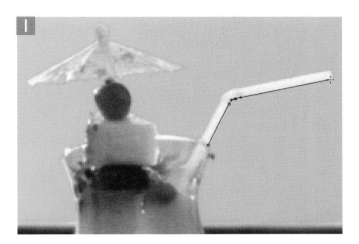

1 The first step was to create a new path and then zoom way in. I prefer to draw paths when zoomed in to at least 200% in order to get a very accurate view of where the path will end up. I was also able to decide what will end up in or out of the final outline. Here I started with the drink in the man's hand and began placing points. The cross-hair shows where the point will be placed and the line behind is the 'Rubber Band' showing where the path will be placed once I had clicked (see Figure 4.23).

Figure 4.24 Using the direct select tool (shown top) I clicked on the path. Note that you can use the keyboard shortcut of ⌘ ctrl with the pen tool selected to get the direct select tool. I then clicked on the path (bottom) where I could move the point ever so slightly to improve the outline of the final path.

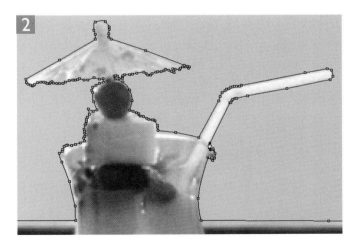

2 Fast forward to the end and I was ready to make the last point and complete the path. While completed, the path may still need fine-tuning in some places. Figure 4.24 shows zooming in and adjusting the path. The pen tool offers extremely accurate placement of what will eventually become a channel and then be converted to a selection for use as a layer mask. Those steps come next including the use of the Focus path shown in Figure 4.25.

Figure 4.25 These are the two paths created. The main outline path was for creating an eventual layer mask and the Focus path was created to modify the final outline mask to add an apparent falloff of the depth of field to the Guy in Chair layer mask shown in Step 4.

187

New Path...
Duplicate Path...
Delete Path

Make Work Path...

Make Selection...
Fill Subpath...
Stroke Subpath...

Clipping Path...

Panel Options...

Close
Close Tab Group

Make Selection

Rendering
Feather Radius: .8 pixels
☑ Anti-aliased

OK
Cancel

Operation
◉ New Selection
○ Add to Selection
○ Subtract from Selection
○ Intersect with Selection

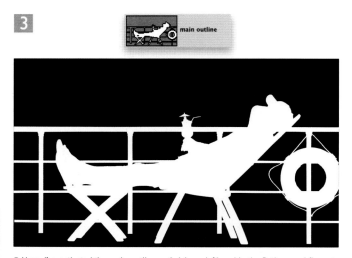

3 main outline

3 Here, I've activated the main outline path (above left) and in the Paths panel fly-out menu chosen Make Selection. In the Make Selection dialog I set the Feather Radius to 0.8. I've learned that while you can always soften up a channel, it's very difficult to accurately harden the feather. So, I always tend towards a sharper feather and adjust it afterwards as I did in the next step.

Gaussian Blur

OK
Cancel
☑ Preview

− 100% +

Radius: 2 pixels

4 Focus path

4 After doing the main outline path, I created a new path that would give me areas where I could apply additional blurring. This was needed to give the feeling of depth of field falloff. I turned the Focus path – which included all of the areas behind the guy in the chair – into a selection and used a 2 pixel radius Gaussian Blur to slightly soften the channel.

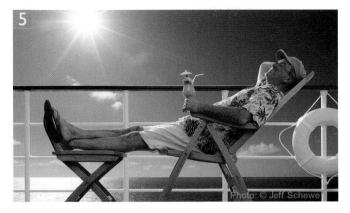

5 After turning the final channel into a selection and making the section into a layer mask, I dragged the Guy in Chair layer onto the sky Background layer and positioned and resized it to fit.

Lens Flare applied to the Background layer

Lens Flare reapplied to the black layer

6 While the composite in Step 5 was close to complete, it needed something atmospheric to help integrate the foreground and background. Since there was already a bit of lens flare I decided to do more. I created a new layer filled with black and set to a Screen blend mode. I wanted to put the lens flare on its own layer and using screen meant that it would lighten the composite only in those areas above black. However, the Lens Flare filter has a problem when previewing a black layer – you can't see the layers underneath. So I use a trick. First, I apply the filter on a layer where the preview will be able to guide me, then immediately undo it. Then I retarget the layer in which I want to apply it and use ⌘ F ctrl F to reapply the last used filter. There you have it – lens flare on a black layer (set here to 50% opacity).

189

Smart Objects

Smart Objects can be made from pixels (as this example will demonstrate), vector art and even a Camera Raw image opened as a Smart Object. Any 'object' that needs the ability to adjust size and rotation without the normal limitations of layered images is an excellent candidate for Smart Objects.

Working with Smart Objects

It should be noted that some of my best friends are art directors, so don't take it as a slam that I mention that one of the more frustrating aspects of dealing with them is that they have this annoying habit of changing their minds. For digital imaging that can cause real problems. When doing a traditional multi-layer composite, the resizing and rotation of a layer can cause image degradation. Positioning and sizing an object has to be a precise operation because if you use Free Transform to make a layer smaller and then find out you actually need it back at the original size (or bigger) you basically have to start over. The way to deal with this situation when doing a complex composite is to make those layers into Smart Objects. Smart Objects are embedded image objects that allow resizing, rotation and other select editing without actually changing the pixels in the object. The image layers are actually treated as a separate file embedded within the master file. You can't do all editing on the Smart Object, but you can open the original layers as a temporary file, do pixel level editing there and then save the changes back into the Smart Object – the changes auto-update in the image in which the objects are embedded. It's easier to show than explain, so let's see an example. This tutorial will be using the following shots of electronic widgets in Figure 4.26 (I really don't know what they are, I just shot them) that were outlined and put on a colored, textured background.

Figure 4.26 The original shots were done on 4 x 5 color film and scanned. Care was taken to finesse the lighting individually – hence the reason for shooting them separately. The background image was of a plastercast of texture airbrushed to achieve the color and with cast shadows and light highlights.

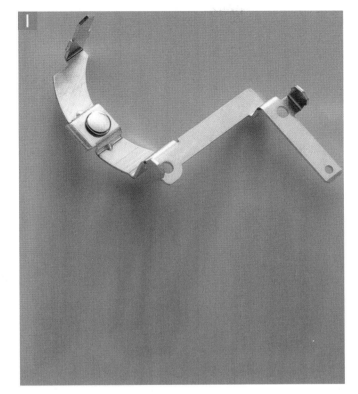

1 The first step in this process is to prepare the image for both outlining and adding cast shadows. The image above has been retouched at least as far as spotting and cloning is concerned. The overall color (of the object) is good. You'll note that the crop was wide enough to provide a hint of a natural shadow. This is important as the real shadow will be the basis of the created shadow. I used a path to create an outline and turned the path into a selection and used ⌘ J / ctrl J to make it into a new layer.

2 The next step, after using the pen tool to create a path of the natural shadows, was to turn the path into a selection. After making the selection, I added a new layer under the object as shown in the Layers panel on the right.

3 After filling the selection with black, I added a gradient in Quick Mask to add a mask for blurring. The Quick Mask was turned into a selection and then saved as a channel. The initial blur I wanted to use was Lens Blur and I wanted to have a gradation over which the blurring would be applied.

4 The main function in the Lens Blur filter was to run the Radius all the way up to 100 and to be sure to select the gradient as the Depth Map. This allows the filter to be applied in a way to help simulate a more natural blur to the cast shadow using the gradient to map the falloff of the blur.

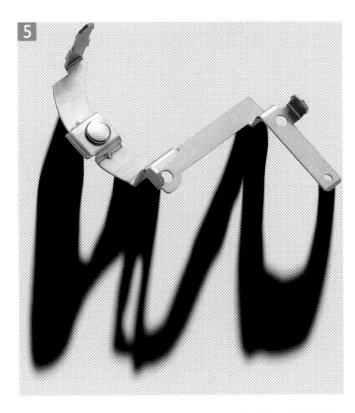

5 The falloff of the gradation needed an additional tweak. For this I used Motion Blur to make sure the slightly less than perfect-drawn path's shadows soften even more. The angle was selected to mimic the natural lighting direction and the amount to provide a directional blur. After the blur, the overall opacity was reduced to 50%.

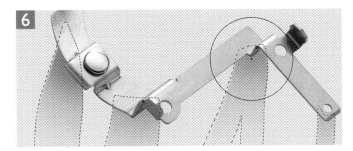

6 A new layer was added and, using the main shadow's opacity loaded as a selection (to keep any painting within the blurred main shadow), I added a second shadow layer to paint in a 'close shadow' that would help ground the object and keep it from looking like it was floating.

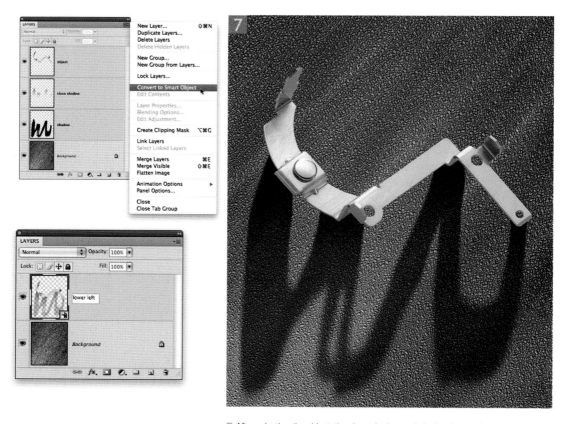

7 After selecting the object, the close shadow and shadow layers, they were all dragged and dropped into the background image. As you can see, the scale was incorrect, but before resizing the layers I needed to convert all three layers into a single Smart Object. Once converted into a Smart Object, I could resize, rotate and reposition them any way I (or the art director) wished. To resize, just select the Smart Object and do a Free Transform. While it transforms the object, it doesn't alter the object's pixels. The figure on the lower left shows the three layers collapsed into a single Smart Object (which I'm in the process of renaming).

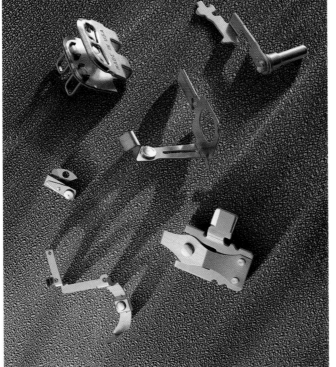

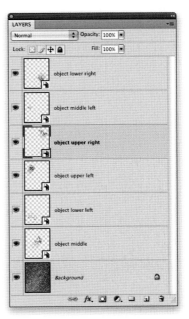

8 This is what the final composite looked like after adding all six of the objects onto the background. The layer stack with the named layers as Smart Objects is shown on the right. In a perfect world, this would be the finished piece but, don't you know, the art director decided that the upper right widget needed work. Smart Objects to the rescue! I just double-clicked the upper right object to edit it.

9 When you open a Smart Object for editing, you are presented with this dialog shown above. Read it and understand it before proceeding. What it basically means is that Photoshop will open the embedded object in a new window and allow you to do whatever edits you need to do. Once that is finished, you must save the document without doing a Save As, otherwise the link will be broken (which is really bad).

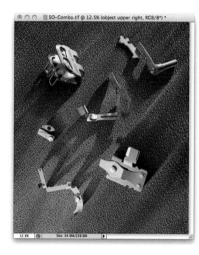

10 With the combined image still open, the upper right Smart Object was opened as a separate file showing it's own layers and allowing a tone tweak to the widget. I used the object's transparency mask to create a layer mask for the Levels adjustment. Once the tweak was done, I saved the file without doing a Save As. Once saved, the adjusted image showed up in the main image with the updates displayed.

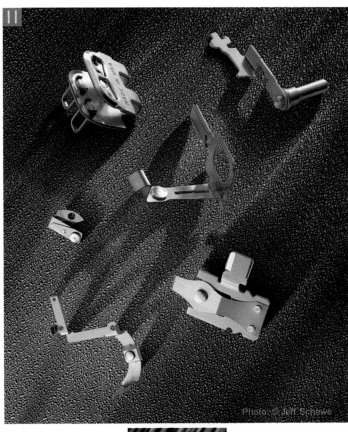

11 After saving the modified Smart Object, the edits are updated in the main image. After working on all the Smart Objects, I also did some overall adjustments. I added Vibrance and Hue/Saturation adjustment layers as well as a pair of graduated Curves adjustments. The final layers were tone adjustments just above the Background layer to lighten and darken areas in a streaked pattern. In order to create them, I created a new channel, chose Filter ⇨ Render ⇨ Clouds, adjusted the density and ran a Blur ⇨ Motion Blur filter. I loaded the channel as a selection and filled with white for the lightening layer, and then inverted the selection and filled with black for the shadowing layer.

Adding atmospherics

I used to shoot a lot of tractors for Case (I never shot for Deere but shot a Deere on this assignment). The ad was to promote a head to head shoot out between Case and John Deere tractors. The company was doing various events around the country and I was assigned an event in Arizona to shoot while both tractors with drivers would be available. The events were being videotaped and made available to smaller dealers and tractor buyers – hence the ad for the video.

We had arranged to have the tractors and drivers very early in the morning, not long after sunrise. We had equipped the drivers with radios so the art director and I could give the drivers instructions about position and speed. I don't know if you've ever driven a tractor (I have) but they don't turn on a dime and they don't go real fast. They're like slow lumbering beasts but the intent of the ad (note in Figure 4.27 the headline changed) was to imply a race, with the Case tractor the winner. Try as we might, we just couldn't get both tractors in the right place at the right speed with the right amount of dust flying. This was clearly a job for Photoshop (something the art director and I both presumed we would need to do anyway).

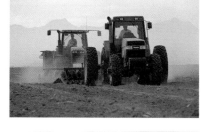

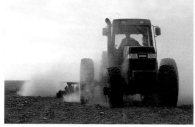

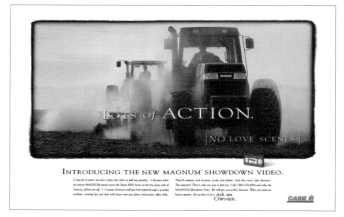

Figure 4.27 Top left is a scan of the actual layout. Below that are the two component shots that were chosen from several hundred frames of 35 mm film shot, and above is the final image as used in the ad.

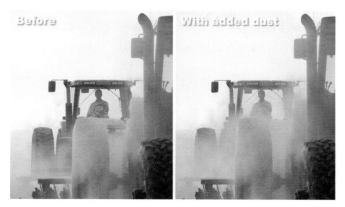

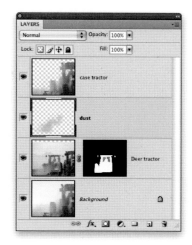

Figure 4.28 This figure shows the composite with and without the dust added. The dust added a sense of 'atmospherics' that helped integrate the two images.

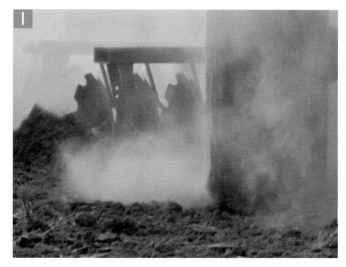

1 The first step was to actually study what the real dust looked like in the shot where the tractor was stirring up lots of dust. This is an important step because before you can add something you need to really understand what it is you are adding. The dust has a sense of motion to it and reacts to its surrounding. So, just painting in with an airbrush would have made it look more like smoke, rather than dust caused by the tractor. Close study actually gave me the clue what tool to use: the Clouds filter. So rather than try to paint with a custom brush, I would paint through a selection.

2 I created a new grayscale document, added a new channel named 'dust' and used Filter ⇨ Render ⇨ Clouds to produce a random 'cloud' pattern. But, in reality, I duplicated the dust layer and reran the filter to get a second iteration of the Cloud filter (no two are ever the same) and used the Cloud copy, loaded as a selection, to modify the first dust channel. This allowed me to lighten or darken certain areas, but through the effects of a Cloud-based selection.

3 I needed to make further modifications. I used Filter ⇨ Noise ⇨ Add Noise to break up the pattern and then ran a very gentle Gaussian Blur to soften the noise.

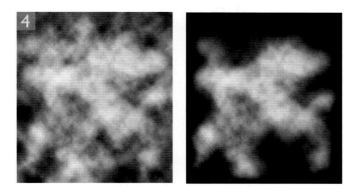

4 Prior to bringing the dust channel into the main image, I needed to modify the perimeter of the channel to make sure there would be no hard-cut lines when painting through the mask. I painted all around the edges and selectively darkened some areas to give more of a feeling of tendrils of dust.

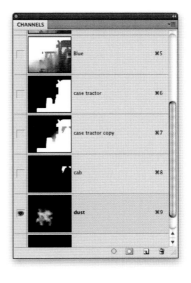

5 I copied the dust channel to a new channel in the two-tractor combo image and clicked to make it visible as well as the RGB image's Green channel. That way I could see the dust channel over the image for position and size. I rotated and sized the dust area of the channel where I needed to add the most dust in the composite.

6 With the dust channel loaded as a selection, I started painting with a lowered opacity. It's ok to play when you are doing this – the feeling of the atmospherics needs to build up as a process. I could always use the eraser tool to lighten up the effect.

7 In this step, I selected the marquee tool to take the active selection and move it to a different region. Once moved, I did more painting to build up more dust in different areas.

8 The next step was to select the erase tool to reduce some of the areas where the dust effect got too strong. I could also have used a layer mask and painted into the mask with black to remove the excess dust. Also, remember that a dust mask can be useful for erasures – you don't need to only use it for painting through.

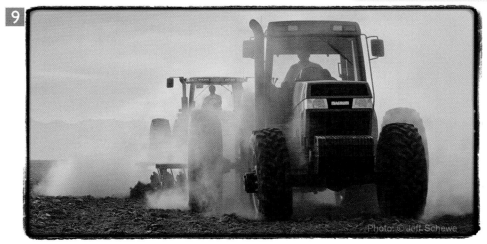

9 This shows the final composite with tone, color and retouching as well as the addition of the 'cut-out negative carrier' look as a border around the image. Also note the addition of a midtone contrast layer to punch up the tractor contrast.

Simulating the effect of motion

Photography is still often called upon to give a sense of motion and, aside from actually shooting something flying through space, the effects that imply motion usually require some pretty substantial work in Photoshop. In this example, actually shooting the glass flying wasn't really an option. In Figure 4.29, you can see the two original shots and the final result – glass flying as though a sledgehammer has broken the glass. Yes, I did have to break some glass to do this effect but, rather than trying to shoot it, I imaged the effect of motion.

The background image was shot with a static hammer showing through a broken pieces of glass with frosted type placed prior to breaking it. The glass was held in place in a wooden frame. Pieces of glass from the same break (and a few extras – I had lots of broken glass to choose from) were suspended on wire via hot-glue and shot under the same lighting as the main shot. The ability to shoot element shots under the same lighting conditions is critical to having a convincing final composite.

The original background shot.

The pieces of glass shot.

The final composite image shot.

Figure 4.29 The original shots were done on 4 x 5 color film and scanned. The main shot was done first and the glass pieces were positioned so the final assembly would match the lighting of the main shot.

Embossing the word

Prior to doing the motion effects, the first job in the imaging is to emboss the word CIPROFLOXACIN onto the hammer's front face. I have no idea what the word means, that's not my job. The image was done for a pharmaceutical firm so I guess it's the name of a drug. The letters were imported as paths into Photoshop and positioned over the face of the hammer, then a selection was made and turned into a channel. Then channel operations (chops) were used to offset multiple channels and create the effects of the emboss.

Emboss vs. Deboss

Note that the following steps are being used to show how to do an emboss. The exact same steps can be used to make a deboss; the primary difference being the direction of the offset and reversing the lighting directions. These steps show an 'innie' but the 'outie' is pretty much the opposite.

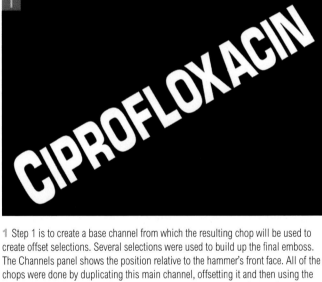

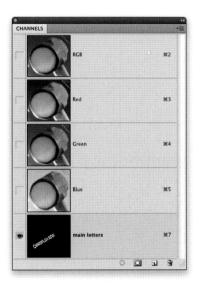

1 Step 1 is to create a base channel from which the resulting chop will be used to create offset selections. Several selections were used to build up the final emboss. The Channels panel shows the position relative to the hammer's front face. All of the chops were done by duplicating this main channel, offsetting it and then using the Load Selection dialog and picking the correct channel source and operation. It was important that all chops were done on duplicate channels, not on this main channel, because I would always need this channel to constrain the other channels against.

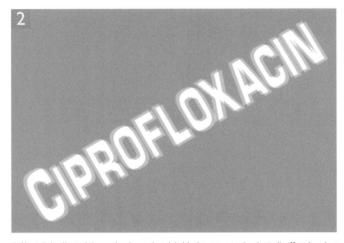

2 Next, I duplicated the main channel and (with the move tool selected) offset it using the arrow keys to nudge it into position. It's useful to click the display eyeball for both channels so you can see the relative positions. The copy channel is being offset down and to the right, and will become the cast shadow of the emboss.

3 I retargeted the main channel and loaded it as the selection. Then, using the Load Selection dialog (cropped for clarity), I set the selection load to be the Main letters copy channel, selected the Invert option (because I needed the selection inverted prior to the operation) and set the Operation option to Intersect with Selection.

4 This is the result of the preceding step. You see the result of the offset selection intersecting with the original main channel. This is the critical result of the channel operations. Once I get the correct result (which depends entirely on correctly setting the Load Selection dialog) I save that as a new channel.

5 This is the saved channel that will be used to create the shadow that gives the emboss its shape. Variations on this operation could be a slight blur on the copy channel to give the impression of softer light or varying the offset to indicate a deeper or more shallow emboss. The main channel will be used to give a sense of overall darkness, the shadow channel used to indicate depth and the final touches would be highlights used to add realism and light. The steps used to create the highlights channels are the same as shown here but with the channel offset up and to the left.

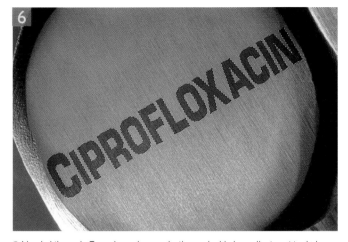

6 I loaded the main Type channel as a selection and added an adjustment to darken the area of the hammer face as the base for the type. I used a Levels adjustment to darken the midpoint and also darken the output levels. Since the brushed pattern of the metal was pretty consistent, I had no need to do an offset of the pattern. If the texture had had a discernible pattern, I would have copy/pasted an offset of the pattern to help indicate depth.

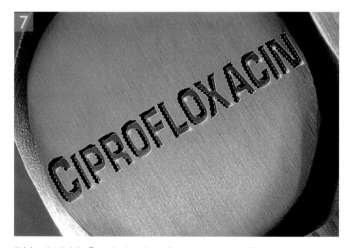

7 I then loaded the Type shadow channel as a selection and did another tone adjustment to make the shadow area even darker. The amount of changes you make is a matter of taste and experience. There really are no absolute numbers here, just a 'feeling' that makes it 'look' right.

8 Rather than do another adjustment layer, I added a new layer set to Screen blend mode then loaded one of the highlight channels as a selection and filled it with white. I had made two separate highlight channels with slightly different softness edges to get a feeling of both a softer light and a harder light hitting the face of the hammer. I actually used the lighting on the hammer itself as a guide to how to create the highlight channels.

9 You can see that the results of the previous highlights having been added. But the last step needs hand work. Using a new layer also set to a Screen blend mode, I zoomed way in and lightly applied soft brush strokes at the corners where highlights would naturally concentrate. This hand work is needed because the emboss needs a sense of reality that chop often fails to introduce. It's the hand work that gives spontaneity and a more believable result. The Layers panel shows the Stack created for the emboss.

Adding motion

To do this final composite, the shot of the broken glass had to be outlined to create individual pieces. And, yes, that is a chore. The best solution (although not the fastest) was using the pen tool to create individual paths that were then turned into a selection. I'll save you from those gory details!

The key to giving a sense of motion in a still image is to use a step and repeat process to give the feeling of movement and then add speed lines (with highlights giving a clue to the direction of the movement). It's not hard but is tedious, so try not to be in a hurry!

1 I selected a piece of glass to work on from the outlined glass image and copy/pasted it as a new layer to the main image. I used a layer mask to remove the solid portion of the blue interior of the glass so the background could show through. Without the mask, you would not see the background of the letter showing through and the glass piece would appear opaque. After positioning the glass, I created paths to give myself a direction for the movement and for scaling. Ultimately I would also use the paths to paint the speed lines with.

2 I duplicated the glass piece layer and moved it underneath the original layer. Then I used Edit ⇨ Free Transform to both move and resize the layer smaller. I used the guidelines for position and size. I knew that once I got all of the step and repeat layers combined I would still need to go back and fiddle with the exact positioning, but the guidelines gave me a good starting point.

3 After the sizing and reposition, I needed to readjust the layer mask to keep the second layer from showing through the original layer. Here, you can see I had partly painted away the offending parts on the second layer's mask.

211

4 At this stage, I had followed the previous steps to add five additional copies of the original layer. I wanted to start making position adjustments but, rather than have to go to the Layers panel, I used the keyboard command to select the target layer. With the move tool selected, a *ctrl* (Mac) or right-mouse click on the area showed a context menu of the current layers with data under the cursor. It was then a simple task to select which layer to target.

Un-linking the layer mask.

5 To aid in the sense of movement, I gave each of the layers a small dose of Motion Blur. But there's a problem: if a layer has a linked layer mask, for some reason the ability to fade the filter is disabled. (Don't ya just hate that?) To work around this limitation I unlinked the pixel layer from the layer's mask so I could run the filter and then fade the results. I used a 15 pixel distance Motion Blur with an angle to match the layer's direction of movement. After running Motion Blur I set the Fade Opacity to 40%. I then continued the blurring and fading on the remaining four copy layers.

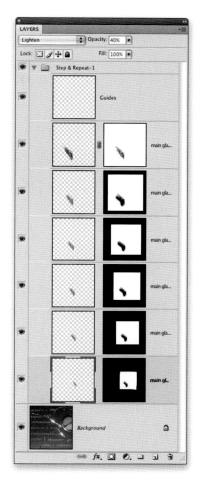

6 Prior to painting in the speed lines, I adjusted each of the step and repeat layers' opacity to go down as the layer got further away. The second layer's opacity was set to 80% and the last layer's opacity was set to 40%. This gave the layers a feeling of disappearing and aided in the sense of the main layer coming forward.

7 The step of painting the speed lines required some preparation. I wanted the brush size to fall off as the line was painted. That required changing the Brush Tip Shape Dynamics. I adjusted the brush's Shape Dynamics Size Jitter to Fade to a maximum of 27% of the starting size. Then I adjusted the Other Dynamics Opacity Jitter also to Fade @ 25% for the starting opacity. I then adjusted the overall Brush Opacity to just 10% so I could build the effect up gradually. The last stage was to select the correct path to use to stroke along. I'm a poor 'painter' so, wherever possible, I use a path to make sure I paint straight lines!

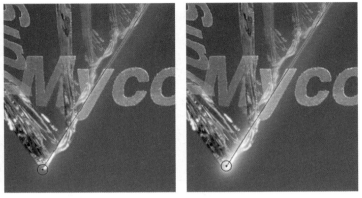

8 The process of painting the guidelines really was a buildup of multiple low opacity strokes performed by starting with a larger brush size, stroking, reducing the size and stoking again. I started large and adjusted the size smaller as I built up the effect. Since I was using a 10% starting opacity and I had got the brush size and opacity set to fade, it took multiple strokes to build up the effect.

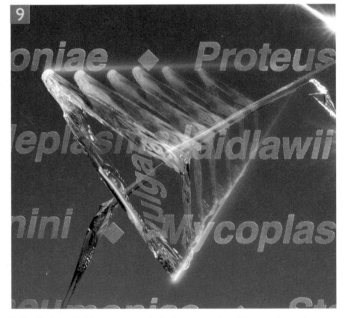

9 The final step in this process was to do the same series of steps on the center speed line and then apply a layer mask to adjust the overall falloff of the lines. And yes, this entire series of steps was repeated for each and every single piece of glass (a total of 18 pieces). Hey, that's why we make the big bucks — the willingness to do what it takes to do a convincing and realistic image manipulation (and bill by the hour for it).

Figure 4.30 The final composite required umpteen hours of work (I really don't know how long it took but the invoice was for 12 hours of imaging) and almost 90 layers (counting the embossing).

Enabling Lens Blur as a Smart Filter

Smart Filters are mainly intended for use with value-based filters only and are not intended for use with filters such as Lens Blur. However, it is still possible to enable Smart Filters to work with the Lens Blur filter. Go to the File ⇨ Scripts menu in Photoshop CS4 and choose Browse… This opens a system navigation window and from there you will want to use the following directory path: Adobe Photoshop CS4 folder/Scripting Guide/Sample Scripts/Javascript and select: EnableAllPluginsforSmartFilters.jsx Once you have located this script, you can click Load or double-click to run it, which will then show a Script Alert dialog. If you wish to proceed, click 'Yes'. The Lens Blur as well as all other filters will now be accessible for use as Smart Filters.

Adding Lens Blur

One of the disadvantages of using smaller format digital cameras is that you often end up with a much greater depth of field than you would get when using a large format plate camera such as a 5 x 4 Sinar. We know a lot of still-life photographers rather like this large format look, so in the technique steps shown here we wanted to show how you can use the Lens Blur filter to simulate a shallow depth of field effect in which only the main subject appears to be in a plane of sharp focus.

The Lens Blur filter is really useful should you wish to add convincing-looking blur effects to your photographs. What's different about the Lens Blur filter is that rather than simply blurring the pixels (which is what the Gaussian Blur filter does), it applies an adaptable iris-shaped blur and also allows you to control the way the highlights burn out.

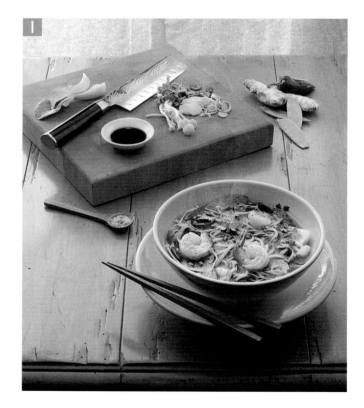

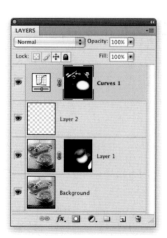

1 Here you can see the photograph that we started with, where we had so far added a few retouching layers to improve the appearance of the image.

2 In this step we added a new Alpha 1 channel via the Channels panel, switched on the channel visibility and selected the gradient tool in reflected gradient mode. With white as the foreground color, we clicked roughly on the center of the soup bowl and dragged with the gradient tool down to the bottom of the photograph. This added the reflected gradient mask shown here as a Red channel mask overlay.

3 We then used the pen tool to draw a Pen path outline of the soup bowl and chopsticks (note: when drawing with the pen tool, we did so in the Add Path mode). Once the work path was complete, we converted this to a new path and then dragged the path to the Load path as a selection button (circled). We then selected the Alpha 1 channel to make it active and chose Edit ⇨ Fill to fill the selected area with white. The only other thing we did at this stage was to deselect the selection and lighten the mask slightly using a Curves adjustment.

217

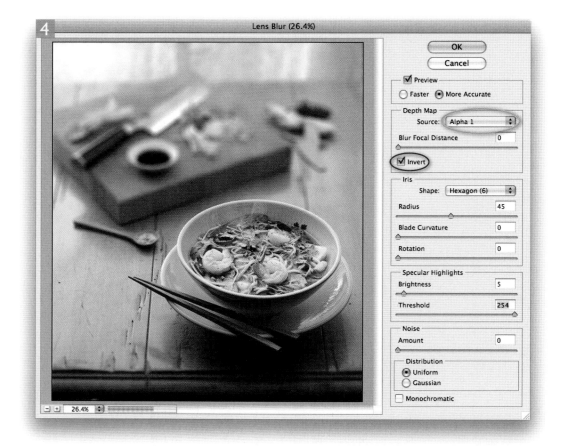

4 We were now almost ready to apply the Lens Blur effect, but first we selected all the layers in the Layers panel and chose Filter ⇨ Convert for Smart Filters. This converted the multi-layered image into a Smart Object, showing a single layer with a Smart Object icon in the bottom right corner of the thumbnail. There are a lot of slider controls in the Lens Blur filter dialog, but the ones that matter most are the Radius slider (which controls the amount of Lens Blur) and the Specular Highlights sliders, which determine how the highlights blow out in the brightest parts of the photograph. We also wanted to make use of the mask that was created in Steps 2 and 3, so we selected the Alpha 1 channel as the Depth Map source (circled in green) and left the Blur Focal Distance at the zero setting. This is how we achieved the shallow depth of focus effect you see here in the preview window. We also inverted the mask (see checkbox circled in red) so that the white portions of the Alpha 1 mask now protected the image from becoming blurred, while the black portions of the mask became the most blurred and the gray mask tones allowed varying degrees of blur across the photograph.

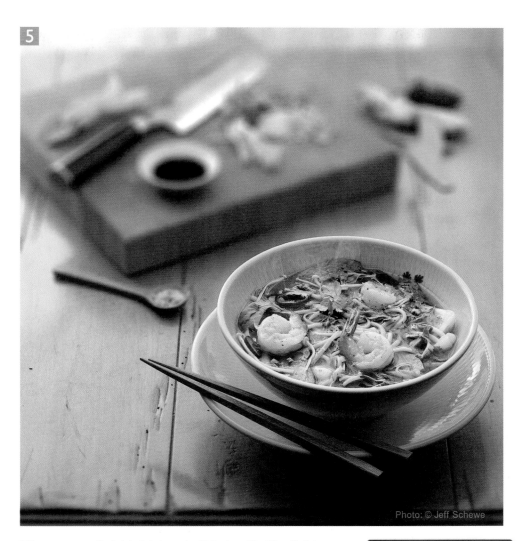

5

Photo: © Jeff Schewe

5 Here you can see the finished photograph with the Lens Blur filter effect shown as a Smart Filter in the Layers panel. It was now possible to edit the Lens Blur filter settings by double-clicking the Lens Blur filter item (circled), which would then reopen the Lens Blur filter dialog shown in Step 4 and allow us to re-edit the filter settings.

Scheimflug Principal

Named after Austrian army captain, Theodor Scheimpflug, it's a geometric rule describing the plane of focus, where the lens plane and the film plane are intentionally altered out of parallel using camera movement to achieve an optimum plane of focus for the subject.

Extending the depth of field

Photographers have always faced the problem of a limited depth of field. You can stop down the lens, but you need either more light or a slower shutter speed. You can use a view camera and try to use the Scheimpflug Principal, or you can use Photoshop CS4 to assemble multiple captures and blend them to achieve photographically impossible depth of field. Focus stacking, cool huh?

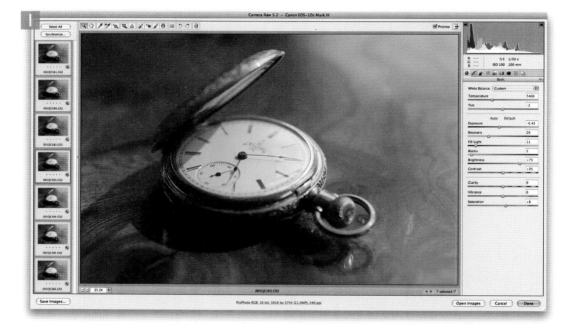

1 The digital captures shown above were all shot with a 100 mm macro lens at F/2.8 on a Canon EOS 1DsMIII while locked down on a tripod. They were brought into Camera Raw to optimize the settings – primarily to lighten the midtones and preserve highlight detail with Recovery. After syncing all the settings, I clicked the Done button. Back in Bridge, with the same images still selected, I went to the Tools ⇨ Photoshop menu in Bridge and chose Load Files into Photoshop Layers.

2 After Photoshop has loaded all the raw files as individual layers, some initial alignment had to be done prior to blending the layers. In the Layers panel I selected all of the layers.

3 With all of the layers selected, I went to the Edit menu in Photoshop and chose Auto-Align Layers. Since the images were shot with varying planes of focus, this changed the watch size slightly on each capture layer. The Auto-Align command resized the images and aligned them based on the content of the individual images. This step was required prior to blending them together for focus stacking.

4 The Layers panel on the left shows the result of the Auto-Align processing. You can see the top images were resized down and have transparency around the edges. Once aligned, the next step was to use the Auto-Blend Layers command (also found in Photoshop's Edit menu). This brought up the dialog box shown above. The Blend Method chosen for focus stacking was Stack Images and I also needed to check the Seamless Tones and Colors option. This kicked in the command's logic to try to achieve an optimal blending. It does a pretty good job overall, but will usually need a bit of help after the blend.

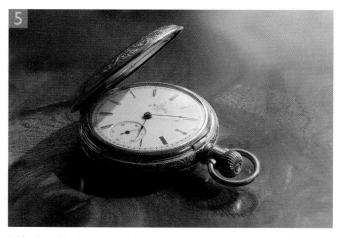

5 After Auto-Blend had done its business, the results were quite good. The processing produced layer masks that selected the sharpest portions of the layered images. There are usually a couple of things wrong. First, since the layers have been resized, it's typical to see uneven blends at the edges. This can be fixed by cropping, but the other problem takes some hand work (see next step).

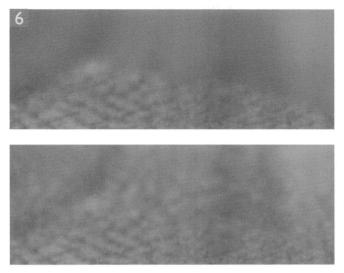

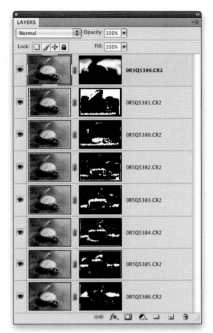

6 To manually fix the out-of-focus issue shown above (the other common problem), I copied the bottom layer, moved it to the top and repainted the layer mask to soften the transition. The final image below had minor spot healing to retouch some of the watch imperfections (I left some because it's a nice patina) and I applied a touch of midtone contrast increase.

Figure 4.32

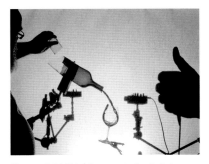

Figure 4.31 This shows a studio shot view of the wine pour setup, snapped at the same moment as the main shot wine pour used here.

Merging studio exposures

Martin asked me whether I knew how to do a pour shot. I laughed and said, yes (it's what I used to do for a living). So when Martin visited Chicago for some shooting for this book, we decided to do a wine shot that would be composited to create an 'impossible shot'. We shot it using a Phase One P45+ back on a Sinar 4 x 5 view camera using high-speed ProPhoto electronic flash to freeze the motion (Figure 4.31). The flash duration was about 1/10000 of a second. We used a laser trigger release so the wine being poured would trigger the flash.

The 'impossible' aspect of the final image is that wine being poured out of a bottle doesn't end nicely. It sort of dribbles out to nothing. As a result, the challenge was to not only get a great pour but enough element shots so the final composite could be pieced together from multiple components (see Figure 4.32).

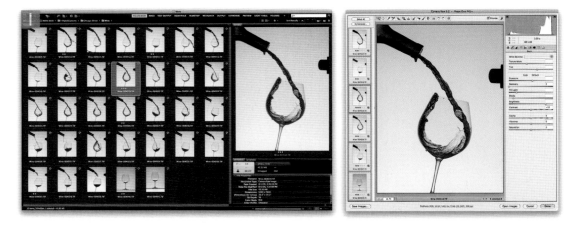

1 I opened the ranked captures from Bridge in Camera Raw filmstrip mode to adjust the basic parameters of the raw files. I used Camera Raw's Batch Save to process the raw images saved out as PSD files. This is an important consideration because the Phase One raw format saves raws with a .tif extension. So, if you open a Phase One raw and resave it as a TIFF, you will save over the raw file if it's saved to the same folder. Normally I use TIFF files, but for this project I figured it would be safer to use PSD. Note that I also saved the files out to a folder named 'Processed' so the raws would remain separate (just in case). Figure 4.32 shows the final composite showing 13 layers.

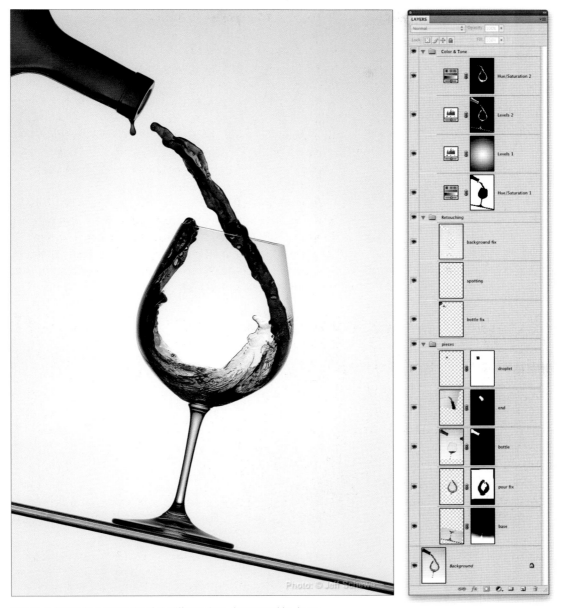

Figure 4.32 The final composite of six different shots, three retouching layers and four adjustment layers. The final image was 19" x 29" @ 300 PPI. The layered file was 1.29 gigs while the flattened TIFF was 378 MBs. This large final size was without any upsampling and suitable for a large print or poster.

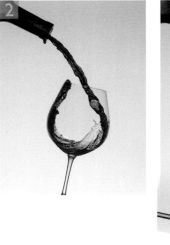

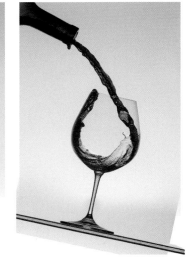

2 After opening the base image, I expanded the canvas and added the image of the full glass cropped to only a portion of the image. The base had to be shot separately because I needed to be able to clamp the pour glass into a fixed place — which of course was not very photogenic.

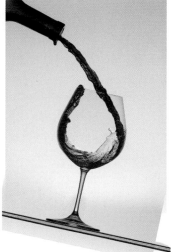

3 I added a second pour shot because the original had an odd thin area inside the glass. Rather than try to retouch it, I just used a second pour. I used a Difference blend mode so I could see the position of both layers while I transformed the second pour shot. On the right is the layer with a layer mask.

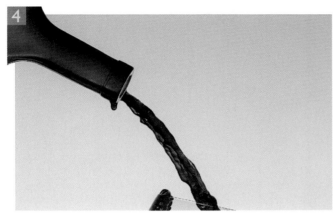

4 I picked an earlier shot that had no wine coming through the bottle (a mistake actually that was nevertheless useful) and positioned it to cover the bottle in the base image that had wine coming through.

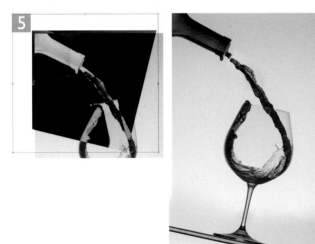

5 If you look back at the Bridge view of all of the images you'll see I had shot some various trigger delays, giving me both early and later shots of pours. Originally I wanted to get an 'ending' pour where the wine ended in mid-air, but that's not the way pours end. So I took an early shot where the wine was just coming out of the bottle and rotated and repositioned it to look like a pour end. I also used a Difference blend mode to aid in the position.

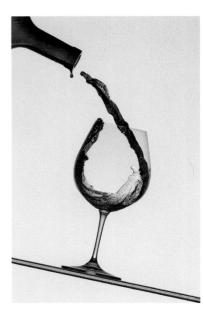

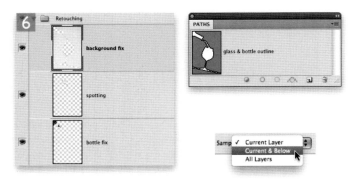

6 I needed three separate layers for the various retouching tasks. At the bottom of the retouching Stack was a retouching layer specific for the bottle replacement. I used a separate layer for all the other wine- and glass-related retouching. Some were done with the healing brush and some with the clone stamp tool. In both cases, I chose to use the Current & Below option (from the tools Options bar) for the sampling. The last part of the retouching was to paint in the background fix. This was done using an outline mask to keep the painting off the glass and bottle. To create the outline mask, the pen tool was used to create a path of the wine, glass and bottle. This outline was also used for the layers masks on the adjustment layers.

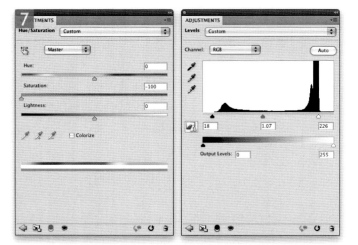

7 Using an inverted glass and bottle outline selection, I added a Hue/Saturation adjustment layer to eliminate any color cast in the background. Using a minus saturation adjustment was far easier than trying to neutralize the cast using Levels or Curves. The Levels adjustment shown here was used to lighten the center based on a circular gradient added to the layer mask.

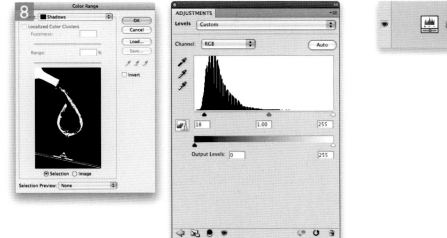

8 The next adjustment was done to pin the black to a good black. When I processed the original images through Camera Raw, I didn't know how the images would end up going together. So, I processed them a bit flat knowing I could punch things back up in Photoshop later. Here, I used Color Range choosing the Shadows selection option to create the mask.

9 The last step was to adjust both the color and density of the wine. I'll be honest — we didn't pour the 'good stuff'. The wine we poured was actually a mix of several bottles purchased for about $4/bottle and was recycled between pours. I used noted wine expert Greg Gorman to help me 'adjust' the color to be a good color for a pinot noir, which was appropriate for the glass we shot.

Figure 4.33 When you change the size of an image, the layer styles will not adjust proportionally. If it is important to retain the exact scaling, choose Layer ⇨ Layer Style ⇨ Scale Effects and enter a scale percentage that most closely matches the percentage change in image size.

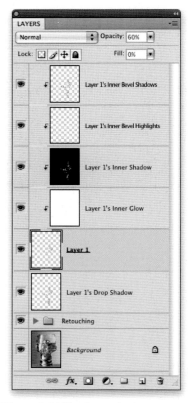

Figure 4.34 Many layer styles (but not all) can be deconstructed into a series of layers. Choose Layer ⇨ Layer Style ⇨ Create Layers. Here is an example of how the layer style applied on page 234 would look if it were broken down into constituent pixel layers.

Layer Styles

With Layer Styles you can link various sorts of layer effects to any of the following kinds of layer: a type layer; an image layer; or a filled layer masked by a vector mask or layer mask. A layer style can be made up of individual layer effects and these effects can be accessed via the Layer menu or by clicking on the Add a Layer Style button at the bottom of the Layers panel. Layer styles can be applied individually or as a combination of effects to create a layer style, and these can be saved by clicking in the empty space area of the Styles panel. As with adjustment layers, layer styles always remain fully editable.

When you add a new layer style, the Layer Style dialog opens to let you adjust the settings and create the desired layer effect. After you add a layer style an italicized *fx* symbol will appear in the layer caption area, and next to that a disclosure triangle. When you click on this disclosure triangle, an indented style effects layer will appear below containing an itemized list of the individual layer styles used to create the master layer style; this allows you to control the visibility of the individual effects.

Layer styles are not directly scalable. So if you resize an image, the layer effect settings will not alter to fit the new image size; they will remain constant. However, if you go to the Layer menu and choose Layer Style ⇨ Scale Effects, you'll have the ability to scale the effects up or down in size (see Figure 4.33).

If you need to work with real layers, you can rasterize a layer style by going to the Layer menu and choosing Layer Style ⇨ Create Layers. This action will deconstruct a layer style into its separate components, placing the newly created layers in a clipping mask above the target layer (see Figure 4.34). You can deconstruct most layer style effects in this way, but be warned that with some layer style effects the rasterized layers won't always produce an identical-looking effect.

Over the next few pages we'll show how we went about using a 'water drops' layer style to add extra water droplets to a still-life photograph of a glass.

How to add extra water drops to a glass

Here is an example of a photograph where we wished to add some extra droplets of water that matched those already on the glass. To do this, we added a new empty layer with the Layer Style settings shown over the next two pages applied to the layer and set the Fill opacity to zero. The Layer Style settings used here were originally outlined by Greg Vander Houwen, but you may want to do what we did here and adjust some of the following Layer Style settings to suit the requirements of each individual shot.

Figure 4.35 This shows the studio setup for the glass shot shown here. You'll notice that we used a monorail camera setup with a Phase One back to capture the main image. Shown also is the airbrush that was used to add some of the original water drops to the glass.

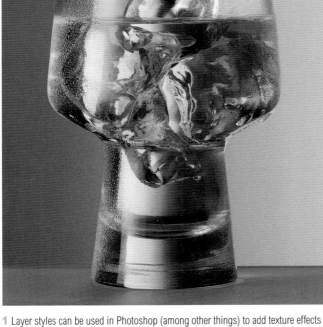

1 Layer styles can be used in Photoshop (among other things) to add texture effects to a picture. You will find the 'water drops' layer style used here on the DVD. To load this style on your system, simply double-click the layer style and Photoshop will automatically add this layer style to the Styles panel (See Figure 4.36).

Figure 4.36 The Styles panel.

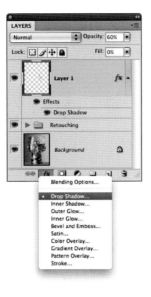

2 The first step was to create the water drops layer style effect. We began by adding a new empty layer where the Fill was set to 0% and then went to the Layer Style menu to add a Drop Shadow layer. First we set the drop shadow opacity to 50% with a Distance of 1 pixel, a Spread of 4 pixels and a Size of 1 pixel. We applied a global light angle of 120° and selected a Cone contour for the Drop Shadow edge.

3 We next clicked on the Inner Shadow style, set the blend mode to Color Burn at 15% opacity, using a Distance of 7 pixels.

4 We then clicked on the Inner Glow style, kept the blend mode set to Screen, raised the opacity to 82% and clicked on the color swatch to change the Inner Glow color to white. In the Elements section we selected the Softer option, using the Edge method, with a 0% Choke and a 5 pixel Size. In the Quality section we created a custom contour shape like the one shown here and set the Range to 68% and Jitter to 0%.

5 Lastly, we clicked on the Bevel and Emboss style. Here we selected the Inner Bevel style with a Chisel Soft technique, using a depth of 500%. We used the Up direction with a Size of 3 pixels and 4 pixels Soften. For the Shading we used the default Gloss Contour shape and blend modes, but set the Highlight Opacity to 100% and the Shadow Opacity to 70%.

6 After we had created the layer style we then needed to create a custom brush setting to paint the water droplets with. Here we selected a small standard, round brush shape with a hard edge. We then went to the Brushes panel and clicked on the Shape Dynamics section, linked the pen pressure with the size of the brush and raised the Size Jitter (the randomness of the brush size) to 80%. We clicked on the Scattering option and set the Scatter and Count Jitter to the maximum settings allowed. We chose this combination of settings in order to produce a random droplet effect when painting with the brush.

7 Here is how the Layers panel looked after all the layer style options had been added. To save this style, we clicked on the Create new style button in the Styles panel and named it 'Water drops'.

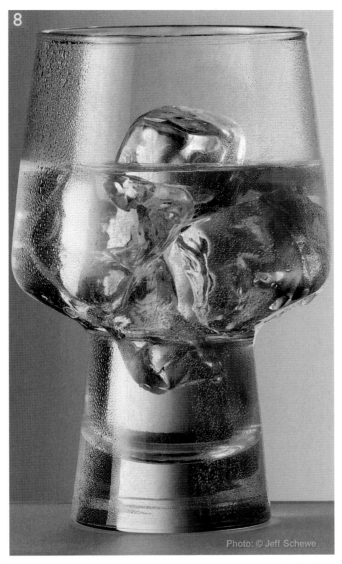

Photo: © Jeff Schewe

8 We were now ready to start painting on the empty new layer. As we painted with the brush tool, we were effectively able to paint using the layer style effect and produce the fine droplets of water that you see added here. The layer opacity had to be adjusted to fine-tune the density of the water droplets. You will note that in Step 3 we reduced the layer opacity to 60%, which was done to produce softer looking water drops. To create variable density droplets, we added two further layers – one at 40% and the other at 15% opacity – and painted on these separately, thereby creating a more realistic buildup of water droplets.

Editing layer styles

Double-clicking the layer, or anywhere in the layer style list, will reopen the Layer Style dialog.

Layer what?

The Photoshop User Guide and Help menu sometimes describe the individual layer styles as layer effects, even though the Layer menu, Layers panel and Layer Style dialog refer to them as 'layer styles'. It is unfortunate that Photoshop uses mixed terminology and, naturally, this can lead to confusion, but, basically, layer styles and layer effects are one and the same thing.

Copying layer styles

Layer styles can be shared with other layers or files. Select a layer that already has a style applied to it, go to the Layer ⇨ Layer Styles submenu and choose Copy Layer Style, then select a different layer and choose Paste Layer Style from the same submenu. Alternatively you can ⌥ *alt* drag on the *fx* icon to copy the entire layer style from one layer to another. If you don't wish to copy the complete layer style, you can just ⌥ *alt* drag to copy just a single style effect from one layer to another layer in the same image.

How to remove edge flare

Layer styles are mostly used to create special effects for logos and type, but in the following steps I thought I would show you a photographic application for the Inner Shadow layer style. Here I wanted to show how you can compensate for edge flare on an object that's been isolated from the backdrop. Just bear in mind that the subject will need to be cut out from the backdrop first before you apply the layer style.

1 A layer style can be applied to an image, shape or type layer by mousing down on the Add a Layer Style button in the Layers panel. When you add a new layer effect, an italicized *fx* icon appears next to the layer name in the Layers panel.

2 In this example I added an Inner Shadow layer style in order to counteract the lens flare that was visible around the edges of the photograph. First I set the Angle to 90° (in order to match the direction of the overhead lighting used in this photograph). I then set the Multiply blend mode Opacity to 50% and the Distance to 30 pixels, the Choke to 10 pixels and the Size to 70 pixels.

3 This combination of settings proved sufficient to reduce most of the edge flare in the photograph. You will notice in the Layers panel below how the layer style appears indented in the Effects list associated with the current layer. To re-edit the settings, all you have to do is double-click the layer style in the list. You can also toggle showing and hiding individual effects by clicking on the eyeball icon next to each effect.

Photo: © Martin Evening

Chapter 5

Cooking with Photoshop

Taking your Photoshop skills to the next level

We are now ready to show you what you do in Photoshop to push the boundaries a little and become a true Photoshop expert. As with some of the earlier techniques, it is not just about what you can do in Photoshop to enhance your photos – some of what we describe here, such as the Photomerge techniques, requires some planned shooting beforehand. The main message in this chapter is to show you just a few of the ways you can use Photoshop as your digital darkroom.

Camera settings

Before you shoot a set of panorama photographs, set the exposure setting to manual so that the exposures are all consistent and make sure that the white balance setting also remains the same (although if you shoot raw, you can apply a single white balance in the Camera Raw processing later).

Blend Images Together

When the Blend Images Together option is selected Photomerge looks for the optimal borders between each image layer, color matches these layers and applies a layer mask. When Blend Images Together is turned off, a simple color match blend is performed. This allows you to edit the layers individually before you apply the Edit ⇨ Auto-Blend Layers... command.

Photomerge

Photomerge can mainly be used to stitch photographs together to create panoramic compositions. There are other programs that can do this with varying degrees of success, but I would say that the Photomerge feature in Photoshop has now evolved to become one of the best panorama stitchers out there. The biggest change in CS4 is that the complex interactive layout dialog option has been removed and instead you are offered a choice of layout options, of which Auto is usually the best one to choose.

There are four main ways to use Photomerge. You can go to the File ⇨ Automate menu in Photoshop and click on the Browse button in the Photomerge dialog (circled in Figure 5.1) and select a folder of images, or browse through the folders on your computer to add specific photos. Or, if the images you wish to merge are already open in Photoshop, select the Open Files option. The easiest way though is to select the images you wish to merge via Bridge and then choose Tools ⇨ Photoshop ⇨ Photomerge. This also pops the same Photomerge dialog as

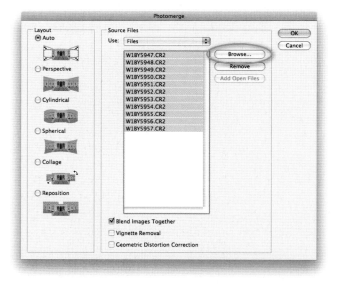

Figure 5.1 If you use the File ⇨ Automate ⇨ Photomerge... command in Photoshop, or choose Tools ⇨ Photoshop ⇨ Photomerge... in Bridge, you will see the Photomerge dialog shown here.

shown in Figure 5.1, where you can select the appropriate layout and blending options to create a Photomerge composite in one single step.

Alternatively, in Photoshop you can choose File ⇨ Scripts ⇨ Load Files into Stack... This opens the Load Layers dialog shown in Figure 5.2 where you can, again, manually select the photos you wish to process. When you click OK, this creates a single image in which all the selected photos are added as layers. Or, if you are in Bridge, you can simply to go to the Tools menu and choose Photoshop ⇨ Load Files into Photoshop Layers... This too creates a single layered image, but without having to show the Load Layers dialog. Whichever method you choose, once the layered image is opened in Photoshop you can then choose the Edit ⇨ Auto-Align Layers... option to select the desired layout blend mode (see Figure 5.3) followed by the Edit ⇨ Auto-blend Layers... option to carry out the blending step. By breaking the Photomerge process down into three separate steps, this allows you to experiment more easily with the different layout and alignment options before you choose to blend the layers.

Photomerge photography tips

For optimum results, you should aim for a 25–40% overlap between each photo. The focal length and focus should remain constant; do not attempt to zoom in or out as you are taking photographs. As you take your series of pictures rotate the camera in gradual steps aiming to pivot the rotation around the center of the lens and try to prevent the camera lens axis shifting too much. You can do this by hand-holding the camera but, to get the best results, you could consider using a tripod head like the Pan head from Manfrotto™ which, when used with the angle bracket clamp, will let you center the rotation accurately around the center of the lens axis. The captured photos will then align more easily in Photomerge.

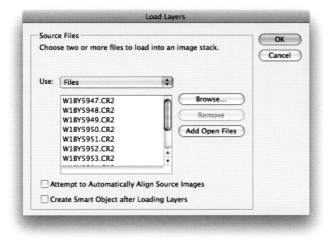

Figure 5.2 If you choose File ⇨ Scripts ⇨ Load Files into Stack... in Photoshop, or choose ⇨ Photoshop ⇨ Load Files into Photoshop Layers in Bridge, you will see the Load Layers dialog shown here. Select the files that you wish to load as layers and click OK. With this dialog you also have the option to automatically align the source photos, but if you are going down this route it makes more sense to apply the Photoshop Edit ⇨ Auto-Align Layers option separately.

Lens Correction options

The Lens Correction options will in most cases help you achieve better panoramic images. The Vignette Removal applies exposure compensation to the edges of any images that have darkened corners. This is a common problem with certain wide-angle lenses, although you can also correct for this in Camera Raw directly before you carry out a Photomerge or auto-alignment. The Geometric Distortion Correction can compensate for barrel or pincushion lens distortion, but will add significantly to the Photomerge processing time. If you are blending images that were shot with a 'recognized' fisheye lens, Photomerge switches on the Geometric Distortion option automatically (see page 240).

Basically, if you know which Photomerge layout mode and Lens Correction options you need to use, it is always easier and quicker to apply Photomerge directly as shown in Figure 5.1. If you are unsure as to which settings would work best it can advantageous to use the indirect Load Files into Stack (also referred to as 'Load Files into Photoshop Layers in Bridge') method, since this allows you to open the images first before you decide which Auto-Align method to use. For example, you can use the Photoshop or Bridge method to open a selected number of files as Photoshop layers in a single image. In Photoshop you can then choose Edit ⇨ Auto-Align Layers and select a layout and lens correction option to see what kind of panorama alignment this produces. If you're not pleased with the outcome you can simply undo the Auto-Align step, select Auto-Align Layers again and choose a different one instead. Once you feel you are on the right track you can then select the Edit ⇨ Auto-Blend Layers option (shown in Figure 5.3) to apply the Panorama blend method. This allows you to complete the Photomerge alignment and blending.

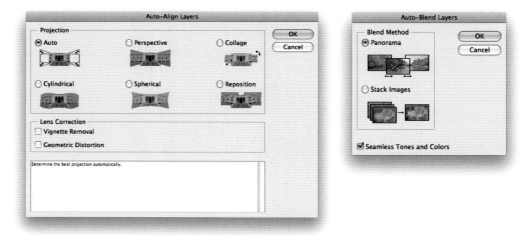

Figure 5.3 If you want to align the layers in a layered image you can do so by choosing Edit ⇨ Auto-Align Layers. This opens the dialog shown here on the left, where the Projection/Layout and Lens Correction options are identical to those found in the Photomerge dialog in Figure 5.1. You can choose a combination of settings and click OK to apply the desired alignment. Afterwards, you can choose the Edit ⇨ Auto-Blend Layers option and select the Panorama blend method.

Resizing the source images

When you create a panorama image you will end up with a photograph that is considerably bigger in size than the individual photographs used to build the panorama. This was not such a concern when digital cameras could only capture small size pictures anyway, but these days we often find it necessary to scale the individual source images down in size so that the resulting panorama doesn't end up being too over-sized. If you are working from raw file originals, one way to do this is to go to the Workflow options in Camera Raw (Figure 5.4), change the file opening size and click Done to apply the new size setting to the selected photos. Do this and the individual photos will open smaller and the Photomerge processing will consequently happen a lot quicker.

Auto-Blend Layers

Auto-Blend Layers analyzes all the selected layers and masks the layers such that each area of the final composite is defined by a single portion from each individual layer. The layers themselves are cut out using a jagged outline that masks the edges of each layer element. This will usually produce a composite free of overlapping picture elements and fuzzy sections. We always keep the Seamless Tones and Colors option checked as this helps improve the blend smoothness between the layers.

Figure 5.4 The Camera Raw workflow options can be found at the bottom of the Camera Raw dialog. Click on the blue, underlined text to open the Workflow Options dialog and change the Size settings to apply a smaller or bigger file opening size. Remember to click on the Done button in Camera Raw when you are finished to apply this new setting to the selected photos.

File size limitations

If you find the Photomerge process stalls during the processing, this is probably because the individual files are too big and are thus preventing Photomerge from working successfully. You either need to install more RAM memory or work with smaller files. It may also be because you have the Geometric Distortion Correction option checked, which can make big demands on the file processing.

A simple, one-step Photomerge

I thought I would start with a simple example of how to create a Photomerge image. The Auto layout option is usually the best choice to select here, as it analyzes the source images first and tries to work out in advance which layout method (Perspective, Cylindrical or Spherical) will produce the best-looking panoramic image. Although the Auto option gets it right most the time, it doesn't always manage to guess correctly. So here's a tip. If you are combining a series of images to produce a landscape panorama, the Cylindrical layout method will always keep the horizon line level in the picture. This is the layout method I select when I know it's the best one to use.

1 I began by opening Bridge and made a selection of the photographs that I wished to merge into a panorama. If you are working from raw files, you may at this stage want to open these pictures up in Camera Raw and make sure that the Camera Raw settings are synchronized across all the images. In addition to this, it can be a good idea to check the Workflow options (mentioned on page 243) to set the file opening size of each image to an appropriate individual size (if you attempt to merge a series of full-size digital captures, you can end up with a really huge panorama image file). Once I had done that, I went to the Tools menu in Bridge and chose Photoshop ⇨ Photomerge....

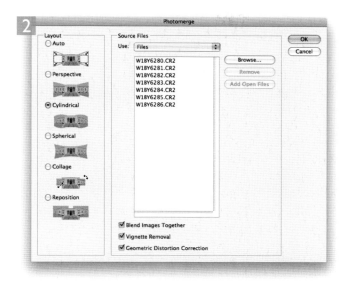

2 Here is the Photomerge dialog, showing the photos selected in Bridge as the source files for the Photomerge. I selected the Cylindrical layout option and checked all the options at the bottom: Blend Images Together, Vignette Removal and Geometric Distortion Correction, then clicked OK to build the panorama.

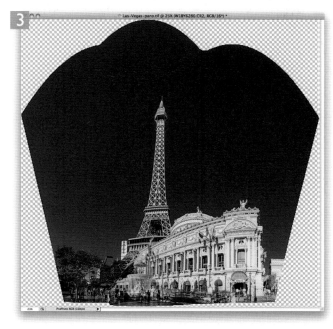

3 Here is the completed panorama in which the selected images have been merged together and blended, with layer masks applied to each layer.

4 Lastly, here is a cropped view of the merged panorama, where I cropped the photograph and then flattened the layers to leave me with a single layered composite merged from the original seven photos.

A three-step Photomerge

The Photomerge command works pretty well almost every time and is essentially carrying out a three-step process in which the first step is to add all the images as layers in a Photoshop document before auto-aligning the individual layers. The final step is to carry out an Auto-Blend operation in which the layers are aggressively masked.

The following tutorial shows an alternative approach in which the Auto-Align and Auto-Blend Layers steps are carried out separately, one step at a time. By breaking the Photomerge process down into separate steps, you can have more control (should you need it) over how the images are merged together.

1 I began by making a selection of 20 photographs in Bridge that were part of an overlapping sequence of pictures to be blended as a Photomerge panorama.

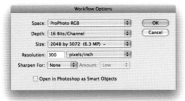

2 I adjusted the Camera Raw settings and synchronized these settings across all the selected photos and clicked Done to apply the changes. To keep the final image size manageable, I clicked on the Workflow options in the Camera Raw dialog and reduced the individual image sizes to 2048 x 3072 pixels. Next, I went to the Tools menu in Bridge and chose Photoshop ⇨ Load Files into Photoshop layers... This opened the selected photos as layers in a single Photoshop image.

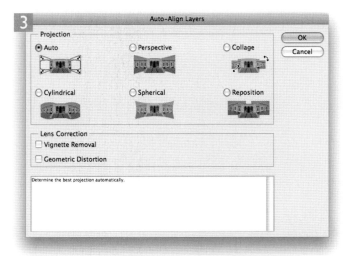

3 Next, I went to the Edit menu in Photoshop and chose Auto-Align Layers... This opened the dialog shown here, where I selected the default Auto Projection option and clicked OK.

Carry out a low-res test first

If you have a large selection of medium-sized images, these can take a while to process. If you want to see a quick preview of how such a Photomerge will look, I suggest you run the Photomerge command with the Camera Raw Workflow options set to the smallest size possible. Once you are satisfied with the way the panorama is looking, repeat the command, but at a larger pixel size.

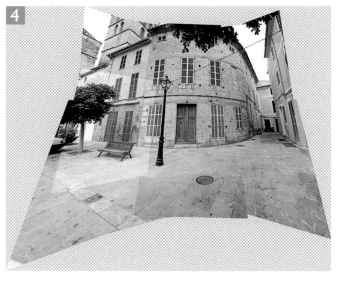

4 Here is the auto-aligned, photomerged image without the layer blending. As you can see, the layers are all fully visible and it is easy at this stage to make changes to the individual layers.

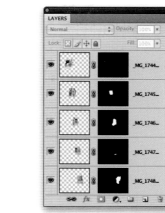

5 I then selected the Edit ⇨ Auto-Blend Layers command where I selected the Panorama blend method and Seamless Tones and Colors. Auto-Blend Layers intelligently analyzes the image and masks the individual layers to produce a composite in which the layers are all masked out like pieces of a jigsaw puzzle.

6 Here you can see how the panorama composite looked after I had applied the Auto-Blend Layers step. Next, I wanted to correct the perspective, but before I did that I thought it would be a good idea to convert the blended layers into a Smart Object. By doing this I could preserve this version of the image in its current state. I therefore went to the Layer menu and chose Smart Objects ⇨ Convert to Smart Object. This converted the multi-layer file into the single layer file you see here with a Smart Object icon in the bottom right corner.

How much to correct?

You can of course fine-tune the perspective to the point where the horizontals and verticals are almost perfectly aligned to the grid. In my view it sometimes looks more natural to let the verticals converge slightly.

7 I then went to the Edit menu and chose Free Transform (⌘ T ctrl T) and held down the ⌘ ctrl key as I dragged on each corner handle to correct the perspective of the image

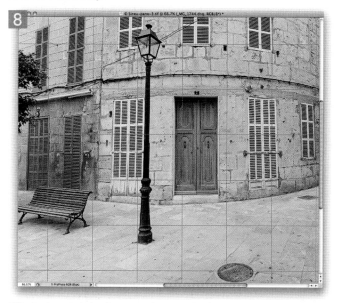

8 The best way to judge the perspective correction for an image such as this is to make the Gridlines visible. You can do this by going to the View menu and choosing Show ⇨ Grid, or using the ⌘ ' ctrl ' keyboard shortcut. Here is a close-up view of the image in 'mid Free Transform' mode, where you will notice that the outline of the door frame aligns neatly with the lines of the grid. Once I was happy with the perspective correction, I clicked Enter to OK the transform.

Delete or Hide?

In the crop tool options panel you will notice that you have the option to Delete or Hide the cropped portion of the image. If you wish to preserve the trimmed areas of the picture, then I recommend choosing the Hide option.

9 All that remained was to crop the photograph to trim the edges. To do this I selected the crop tool and carefully marqueed the image to select the area I wanted to crop to.

10 Here is the final version of the photomerged image.

Extreme wide-angle Photomerges

Another thing that's new in Photoshop CS4 is that you can use Photomerge to successfully align and merge photographs that have been shot using a fisheye or extreme wide-angle lens. These types of photographs were previously impossible to join together.

Photomerge features support a limited number of fisheye lenses and can tailor the Photomerge alignment to the known optical characteristics of these particular lenses. Basically, Photomerge reads the lens EXIF metadata in the source files and if it detects a lens that is supported will auto-select the Auto layout and Geometric Distortion options to create an optimal Photomerge. We've tested this and it works very nicely with the Canon 15 mm fisheye lens. However, if the lens you use is not one of those supported, you may need to do things slightly differently.

1 I began in Bridge by selecting a series of nine photographs that had been shot of the interior of the Colosseum in Rome. These pictures were all photographed using a 12 mm focal length lens which, although an extreme wide-angle lens, was not one of those optimized for Photoshop CS4 Photomerge processing. No matter, I could still use Photomerge in CS4 to blend these images into a single panorama. I could have used the Tools menu in Bridge to select the Photoshop ⇨ Photomerge option and applied the Photomerge in one go, but I was uncertain as to which Photomerge settings to use. So for this reason I chose Tools ⇨ Photoshop ⇨ Load Files into Photoshop Layers...

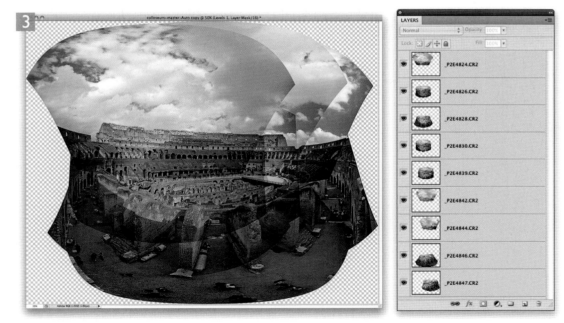

2 Once I had opened the images from Bridge and loaded them as a layer stack, I went to the Edit menu in Photoshop and chose Auto-Align Layers... When using fisheye or extreme wide-angle lens source images, it is usually recommended that you select Auto, as well as the Geometric Distortion Lens Correction option, but in this instance I found out through trial and error that it was better to leave the Geometric Distortion option switched off.

3 Here is how the composite panorama looked after I had applied Auto-Align Layers in Auto layout mode (without Geometric Distortion correction).

4 Once I was happy with the way the panorama composition looked after applying the Auto-Align Layers step, I was ready to go to the Edit menu in Photoshop and choose Auto-Blend Layers. I selected the Panorama blend method with the Seamless Tones and Colors option also checked.

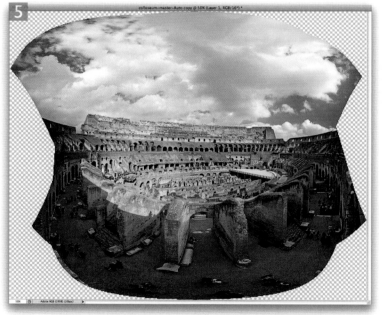

5 Here you can see how the panorama composite looked after I had applied the Auto-Blend Layers step. As in the previous examples, Auto-Blend Layers was able to successfully blend the tones and colors across all the layers and apply a layer mask to each layer so that each area of the final composite was defined by a single portion from each individual layer.

6

Photo: © Martin Evening

6 Here is a bigger version of the final composite, in which I merged all the layers into a single layer and cropped the photograph. I didn't want to crop it too tightly, so I allowed some of the transparent background to show in the bottom corners. I then added a new empty layer and used a combination of the clone stamp tool and healing brush to fill in the corners.

Filter effects

How to create a fisheye lens effect

There was a time when fisheye lenses were expensive and bulky items. I remember a camera company salesperson telling me that they had only sold two of their most expensive fisheyes that year, one of which was to a rich business man who wanted it turned into a novelty desk lamp! These days fisheye lens optics are a lot more compact, but you still need to pay good money for a lens that can take sharp photos, free of lens aberrations. In the following technique I show how you can simulate an extreme 180° fisheye lens effect, by using Photomerge to join a series of individual photos into a 360° panorama, and use the Polar Coordinates filter to simulate the appearance of a 180° fisheye lens effect. To reproduce the steps shown here, you will need to use a moderate wide-angle lens to shoot a sequence of pictures that captures a complete 360° view and aim for a 25–40% overlap between each frame.

1 To carry out this technique I shot a series of photographs that captured a full 360° panoramic view. The camera was mounted on a tripod so that I could easily pan the camera in small steps and keep the camera position level. I shot these photos with a moderate wide-angle lens and used a manual exposure setting so that the exposure value was consistent across all the frames. Here you can see the photos selected in Bridge ready to be opened. If you are working from raw originals you may want to go to the Workflow options in Camera Raw (see page 243) and reduce the output size so that you don't end up with too huge a panoramic image. Having said, this technique does involves quite a bit of pixel stretching. If your computer is up to the task of creating a large Photomerge composite, it might be worth processing the photos at the full size and then reduce the image size at the end if necessary.

2 I went to the Tools menu in Bridge and chose Photoshop ⇨ Photomerge. This opened the dialog shown here where I selected the Auto option and checked the Blend Images Together and Vignette Removal options. Be aware that checking the Geometric Distortion Correction option will add to the Photomerge processing time and, in any case, shouldn't always be necessary to build a successful panorama composite.

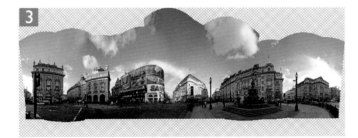

3 Here is the result that was produced using the above Auto layout Photomerge settings. As you can see, there was an overlap at either end and this allowed me plenty of scope to crop the image.

4 The next step was to flatten the image, make any necessary tonal or other image corrections and crop the photograph so that the left and right edges more or less matched exactly.

5 I then went to the Image menu and chose Image Size... The photograph needed to be made square, so I deselected the Constrain Portions checkbox, made sure that the Width pixels value matched the Height value and clicked OK.

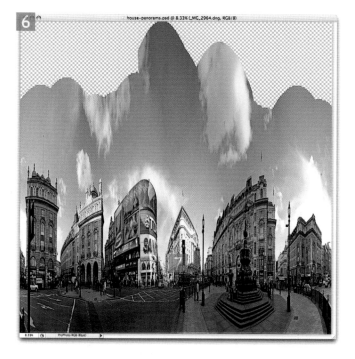

6 Here is how the photograph looked after it had been stretched to make a square image. I then needed to convert it to 8-bits per channel mode (because the Polar Coordinates filter only works on 8-bit images).

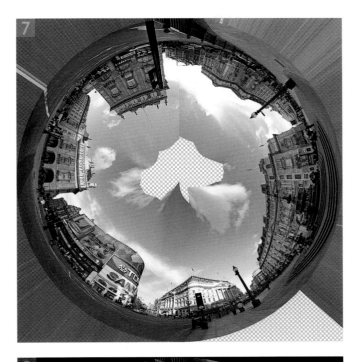

7 Next, I went to the Filter menu, chose Distort ⇨ Polar Coordinates and clicked on the Rectangular to Polar option. This filter dialog has a small preview and I needed to click on the minus button a few times to see a scaled preview of how the image would look after I had applied this filter.

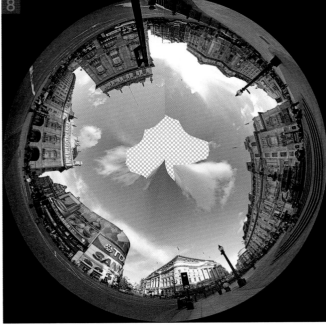

8 The image now looked dramatically different from the original Photomerge panorama, but the stretched edge pixels were a bit of a distraction. To make this fisheye effect look more photographic I selected the elliptical marquee tool and dragged from the top left corner to the bottom right corner with the *Shift* key held down. I then chose Select ⇨ Invert selection, added a new empty layer and filled the selected area with black.

259

Photo: © Martin Evening

9 There was one major flaw still and that was the hole left in the middle of the picture. To address this I added an empty new layer, selected the brush tool, sampled a blue sky color and painted on the layer to cover up the gap in the center.

How to create an aerial fisheye lens effect

Music fans of a certain age (especially those who liked prog rock) may remember the band *Yes* whose cover artwork would often feature the imaginary planet worlds of Roger Dean. This simple adaptation of the fisheye effect shows a simple way you can transform a panoramic photograph into an aerial fisheye view of a scene. I would definitely regard this as a novelty effect, but it is nonetheless a fun experiment to carry out and you never know when a client will ask you to come up with a quirky approach to a brief.

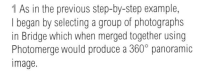

1 As in the previous step-by-step example, I began by selecting a group of photographs in Bridge which when merged together using Photomerge would produce a 360° panoramic image.

2 I flattened the image, cropped the skyline tightly and used the Image Size dialog to stretch the photograph and make a square image (see Step 5 on page 258). The crucial difference here is that I then went to the Image menu and chose Rotate Canvas ⇨ 180°. This prepared the image for the final step.

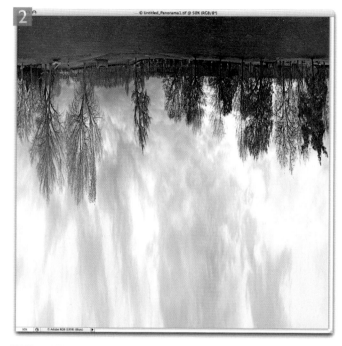

3 I went to the Filter menu, where I chose Distort ⇨ Polar Cooordinates and once again I clicked on the Rectangular to Polar option. This produced the finished result shown here, where all I did was to crop the photograph slightly and use the healing brush and clone stamp tools to retouch out the single join line that ran from the top to the center of the photograph.

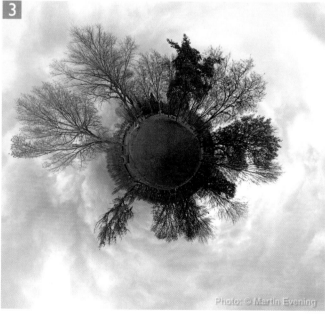

Photo: © Martin Evening

Working with Liquify

Liquify is Photoshop's answer to warping and distortion of photographic images. It's a free form tool that takes some practice to become proficient at using, but the results really can't be accomplished in any other manner.

It's probably good that I casted an actor and not a model for this shoot (and that he had a sense of humor). The intent of the ad was to characterize the fellow in the ad as a true wimp – somebody who routinely get's walked over by everybody. As you'll note in Figure 5.5, even the original shot has a lot of 'wimp' going on, but the art director wanted to push the concept to the max. That's where Photoshop's Liquify tool came in very handy.

The original image was shot on 120 mm transparency film and scanned. The angle and position was designed to give a foreshortened perspective and to keep the natural shadow. The first step was to create a path, make a selection and outline the image of the guy to its own layer.

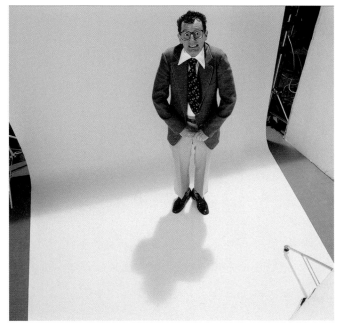
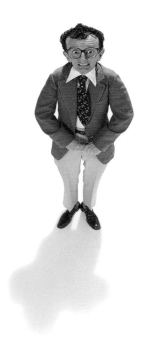

Figure 5.5 The image above was the original shot for 'Wimpy Guy'. The image on the right shows the result of the warping and some wardrobe modification.

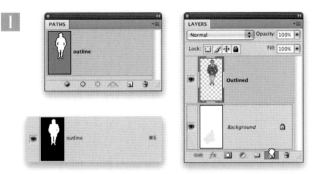

1 I outlined the guy using the pen tool, made a selection and saved it as a channel. Since I was going to be warping the guy, I didn't bother using a layer mask but simply loaded the selection and made a new layer via copy (⌘ Shift J / ctrl Shift J). That put the guy on a new layer and cut him from the background leaving the shadow on the Background layer.

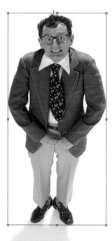

2 For the next step I duplicated the Outlined layer and renamed it Sized. I then used Edit ⇨ Transform ⇨ Free Transform (⌘ T / ctrl T) and did a non-proportional resize to shorten the guy even further than what could easily be done in Liquify. Since Liquify is much more of a free form brush-based tool, doing this step there would have been difficult, not to mention tedious.

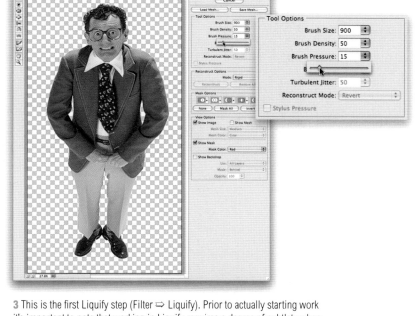

3 This is the first Liquify step (Filter ⇨ Liquify). Prior to actually starting work it's important to note that working in Liquify requires a degree of subtlety when pushing and prodding the image pixels. I tend to work with a low brush pressure and build up the effect gradually. You'll also note that I duplicated the Sized layer and named it 'Warped'. That's the layer that is targeted for Liquify. I did this so that I could always fall back on the previous unwarped layer if need be.

Forward warp tool icon

Pucker tool icon

4 The next series of steps involved gently pushing areas of the image into place using the forward warp tool. Above left, I added a stronger slope to the shoulders. Above middle I pushed his pants inwards and on the right I used the pucker tool to bow the legs in.

Freeze mask tool icon

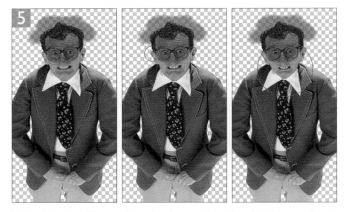

5 After doing the initial overall warping, I zoomed in and used the freeze mask tool to select certain areas (shown in red) where the warp tool would be constrained. In the upper left I applied the freeze. The middle and right figures show additional warping being applied.

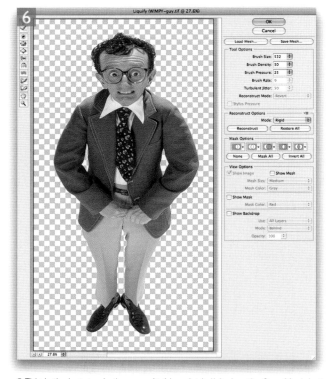

6 This is the last step in the warp. At this point I clicked on the Save Mesh button and saved the warp mesh for later use (if I needed it – better safe than sorry).

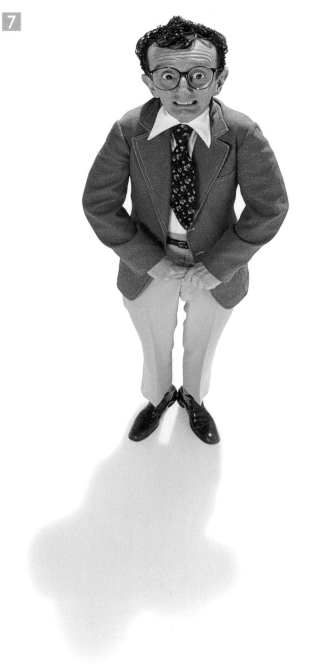

7 The last step was to add a really disgusting color palette to the 'wimp's wardrobe'. The art director wasn't quite satisfied with the original ugly clothing. I used Color Range to quickly select areas in the clothing and applied Color Fills with the blending mode set to Color (or Hue in the case of the Jacket color 2 layer). The tie layer also needed a Curves adjustment layer. As far as the actor was concerned, he didn't really want a copy of the tear sheet since it really didn't look like him any more (actually, I think he thought it made his butt look too big). However he was happy to get an inkjet print of the image before warping and re-dressing him.

The Photoshop diet

You know how it's said that the camera adds ten pounds? Well, this is an easy weight loss program courtesy of Photoshop (and you don't even have to go on a diet).

1 The first step is so easy, you'll kick yourself for not thinking of it yourself. Non-proportional resizing. Simply uncheck the Constrain Proportions option in Image Size and enter in a reduced percent in the Width. This has a very simple ability to slim without any visible clue (as long as you keep to 4–8% maximum).

2 If the first step isn't enough, you can go to further lengths (or widths). The key thing here is to know that unlike most plug-in filters, Spherize actually works well even when a selection is feathered. In this step, an elliptical selection was made around the dancer's tummy and I chose Select ⇨ Modify ⇨ Feather and feathered the selection by 50 pixels.

3

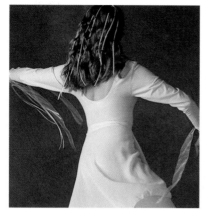

This shows the result of a single pass of Spherize

3 With the feathered selection active, I chose Filter ⇨ Distort ⇨ Spherize and entered a −10 amount and constrained the effect to the horizontal axis only. You can try to do a normal Spherize but this will sometimes draw the effect somewhat too strongly giving a pinched look. Moderation is the key here (similar to your actual diet).

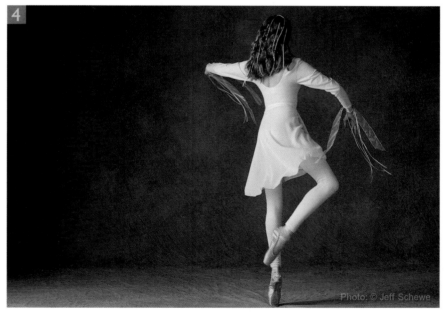

Photo: © Jeff Schewe

4 At this stage, both the non-proportional resize and two passes of −10 horizontal spherize had been applied (I added a second pass by using the ⌘ F ctrl F keyboard shortcut). However, I really must caution against overuse of this effect. You can too easily move from subtle to a cinched waist look that would be outlandish.

269

Moral rights

UK copyright law allows the copyright owner to assert what is known as their moral rights. These include the right to be identified as the author of a work (although this must be asserted and is not automatic), plus the right to object to the derogatory treatment of a work. USA copyright law doesn't include this clause, but the 1990 Visual Artists Rights Act, 17 USC § 106A does give authors 'rights of integrity' which amounts to the same kind of protection against prejudicial distortion of a work.

Content-aware scaling

The Content-Aware Scale feature is arguably one of the more interesting, and some might say, controversial new features in Photoshop CS4. As you can see here, you can use content-aware scaling to radically adjust the aspect ratio of some photographs, but without squashing or stretching important subject matter within the picture. Yes, this may be a contentious tool if used inappropriately and without permission of the copyright holder, but we feel it may prove very useful to design and advertising photographers. For example, most ads and design layouts are required to fit several different aspect ratios such as posters, magazine layouts and web banners. This tool allows you to easily modify a single photograph to fit various aspect ratio layouts.

1 Here you can see the original photograph shot of a harbour entrance. To prepare this photograph for content-aware scaling, I first needed to select all (⌘ A ctrl A) on the Background layer to target the image for transforming.

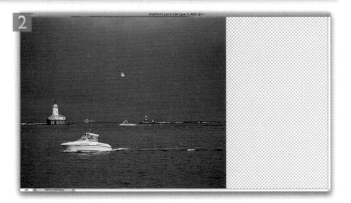

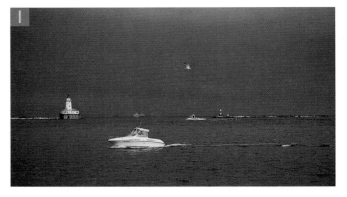

2 I then went to the Edit menu and chose Content-Aware Scale (or I could have used the ⌘ ⌥ Shift C ctrl alt Shift C keyboard shortcut). This applied a bounding box to the image and allowed me to drag the right-hand side handle inwards to compress the picture horizontally. You'll notice in this screen shot how the content-aware scaling feature cleverly compresses all the soft areas of detail, such as the harbour wall and the sea, while preserving the detailed subjects such as the lighthouse and boats.

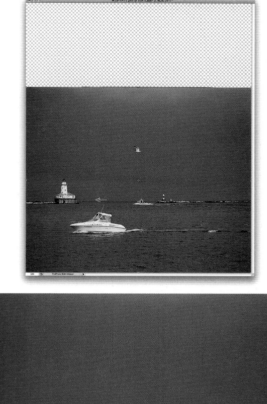

3 After I had applied the first content-aware scale transform I selected the crop tool to apply a crop to the photograph where I dragged the top handle of the crop bounding box upwards and clicked OK, in order to add more canvas area to the top of the picture. I once more chose Edit ⇨ Content-Aware Scale so that I could apply a second transform to the photograph.

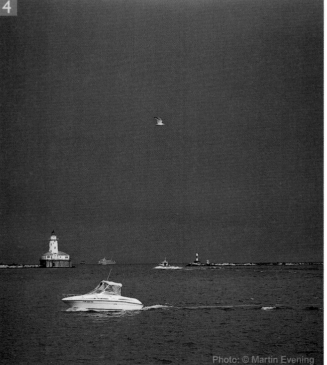

Photo: © Martin Evening

4 Here you can see the result of the second content-aware scale transform, in which I dragged the top handle of the transform bounding box upwards to make the image fill the full height of the picture. What is interesting about this feature is the way that the content-aware scale transform appears to automatically recognize objects where the shape needs to be preserved, while compressing or stretching the areas that are of less importance. You'll also notice in this example how the content-aware scale transform preserved the position of the horizon and stretched the sky only.

Content-aware scaling – another use

Even without resorting to masking, the Content-Aware Scale feature can do remarkable transforms. However, it can also be used to remove things (or people) from a scene. In the example below, a horizontal image has been transformed into a strong vertical proportion. In the second step a mask is used to eliminate the model.

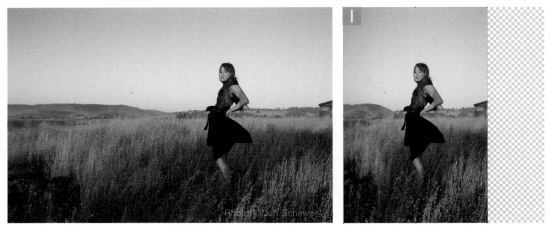

1 To prepare this photograph for content-aware scaling, I first selected all of the layer contents on the Background layer (⌘ A ctrl A) to target the image for transforming. I then went to the Edit menu and chose Content-Aware Scale (⌘ ⌥ Shift C ctrl alt Shift C). I applied a normal content-aware scaling and was able to make the horizontal image into a vertical. This is a case of an extreme scaling.

2 Going back to the original image, I entered Quick Mask mode and created a rough outline using a hard-edged brush. This mask can be used to trigger content-aware scaling to squeeze this portion to remove it (more or less). So, after going to the Edit menu and choosing Content-Aware Scale, I selected the Quick Mask from the tools Options bar drop-down menu before applying the transform.

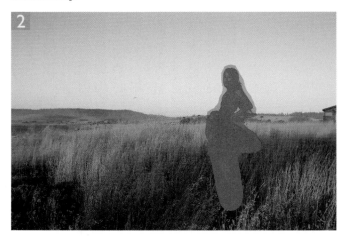

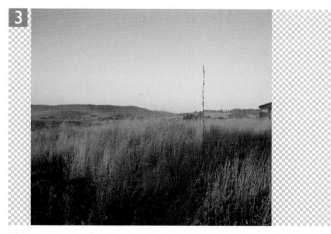

3 I dragged the transform handle on both the left and the right towards the middle. As is often the case when removing objects, a tiny remnant remained that required fixing.

4 After transforming, I created a new layer and used a combination of the healing brush and some clone stamp work to remove these tiny artifacts.

Digital darkroom effects

Advanced black and white conversion

Given the advances of the abilities of Camera Raw and Photoshop to do excellent black and white conversions, you might think that doing a manual conversion would be an anachronism. But there are times when a global conversion from color to black and white is less than optimal and this technique may prove effective. In order to understand the following approach it's important to understand that red, green and blue (RGB) images are, in fact, three flavors of black and white combined into a single composite image. The Red channel is the equivalent to a Kodak Wratten 29 tri-color separation filter. The Green channel is a 61 while the blue is a 47. So with every RGB color image you already have three potential black and white conversions (the basis of this is what Photoshop's Black and White adjustment is based on). With a simple color to Lab conversion you can also access the Lightness channel which brings the total to four (see Figure 5.6).

Figure 5.6 Above is the original RGB color image. Below are the Red, Green, Blue and Lightness channels that can be used for a black and white conversion.

The Red channel

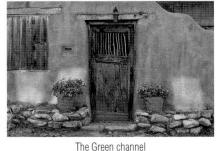

The Green channel

The Blue channel

The Lightness channel

1 In order to get the color channel information into a grayscale document I duplicated the original color image (on the left) and converted the copy (on the right) to grayscale using the Image ⇨ Mode ⇨ Grayscale command. In this step I targeted the Red channel of the original color document and chose Select ⇨ Select All (⌘ A ctrl A). I then copied the channel to the clipboard (⌘ C ctrl C).

2 Next, I targeted the grayscale copy image and pasted from the clipboard (⌘ V ctrl V). This took what was the Red channel and pasted it as a grayscale layer. I named this the 'red' layer (so I could keep track of which channel the layer was from). I added a Hide All layer mask by holding the ⌥ alt key and clicking on the new layer mask icon. I repeated the process for each subsequent channel/layer pairing, including the Lightness channel. To get the Lightness channel I converted the RGB image to Lab using the Image ⇨ Mode ⇨ Lab Color command. From this point, it was merely a matter of deciding which layer had the best black and white image data on it and painting into the layer mask with white to make it visible. The layer stack shows the current Background layer which is the Photoshop default grayscale conversion. For those interested, Photoshop's default conversion is a calculation based upon blending approximately 30% of the Red channel, 60% of the Green channel and 10% of the Blue channel. Using that as a basis, I could decide what percent of which channel would end up giving the optimal conversion — and the advantage is that I could do so locally with layer masks. But wait...there's more!

3 The image above had the final layer blending via layer masks shown in the layer stack. The one area where the layer blending failed to provide an optimum conversion was in the numbers on the door. Since I still had the color image open, I could use Select ⇨ Color Range to select the color of the numbers.

4 Using Color Range on the color image, I selected the door numbers. I used a high fuzziness setting and also used the new Localized Color Clusters option in Photoshop CS4. With the selection active (left figure) I selected the marquee tool and started to drag the selection. Once I started the drag, I held down the **Shift** key before dropping the selection on the grayscale image (on the right). Holding down the **Shift** key instructs Photoshop to pin register the selection. Since the color and grayscale image had the exact same pixel dimensions, the selection was dropped exactly in the grayscale image where it started in the color image.

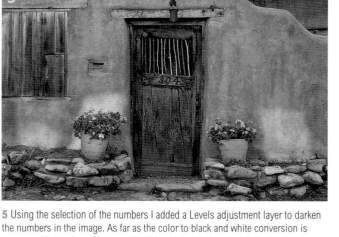

5 Using the selection of the numbers I added a Levels adjustment layer to darken the numbers in the image. As far as the color to black and white conversion is concerned I was done. However, the thing about black and white in the darkroom is that black and white isn't really all about black and white – there is often color toning done to the silver gelatin print. The next and final step is done after reconverting the image from grayscale back to RGB to add color.

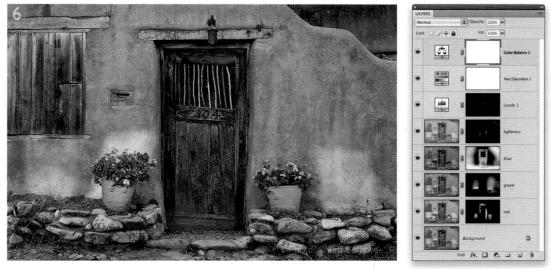

6 This is the final result. I added a Hue/Saturation adjustment layer set to the Colorize option and a hue of 49 (amber) and a Saturation of only 5. The top Color Balance adjustment was used to give the color a split toned look. Using the Highlights tone I adjusted the yellow/blue slider to −7 (warming) then used the Shadows tone to move the yellow/blue slider to +7 (cooling). This split tone is similar to the old sepia tone from the chemical darkroom.

Cross-processing

The cross-processing technique has long been popular among fashion and portrait photographers for distorting the colors in a picture and bleaching out the skin tone detail. There are two basic cross-processing methods: E-6 transparency film processed in C-41 chemicals and C-41 negative film processed in E-6 chemicals.

You can simulate cross-processing effects quite easily in Photoshop and do so without the risk of 'overdoing' the effect or losing important image detail. One way to cross-process an image is to use the Split Toning panel sliders found in Camera Raw working with either a raw, a JPEG or a flattened TIFF image (see Figure 5.7). This is a fast and effective method and the Balance slider gives you that extra level of control whereby you can adjust the bias between the shadow and highlight coloring effects.

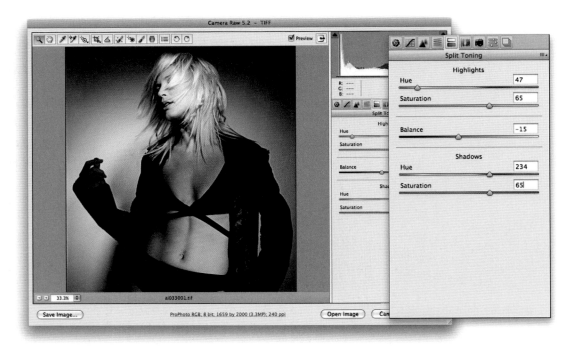

Figure 5.7 Here you can see an example of how to use the Split Toning sliders in Camera Raw to apply a color cross-processing effect to a raw or flattened TIFF image.

The technique that's shown over the next two pages aims to replicate the cross-curve effect you typically get when using a C-41 film processed in E-6. In this example you'll notice how I managed to make the shadows bluer and gave the highlights a yellow/red cast. This is a technique that I have adapted over the years so as to make it more flexible. As with all the other coloring effects described in this chapter, the main coloring adjustments are applied as adjustment layers using the Color blend mode. This helps preserve the original luminosity, but if you want to simulate the high contrast cross-processed look then use the Normal blend mode instead. In addition to this, you might want to consider deliberately increasing the contrast in the RGB composite channel as well (this will also boost the color saturation). You may also wish to experiment with using different color fills and layer opacities.

Luminance blending tip

One way to preserve the luminosity in an image is to always set the 'coloring' adjustment layer to the Color blend mode. Some techniques described in this chapter involve a series of extreme image adjustments or multiple adjustment layers. Therefore, if you are not careful you may lose important highlight and shadow detail. One solution to this is to make a copy of the original Background layer and place it at the top of the layer stack, and set the layer blending mode to Luminosity. This will produce the same result as setting a single adjustment layer to Color mode, but by adjusting the layer opacity of the duplicate layer in Luminosity mode you can restore varying amounts of the original image luminance.

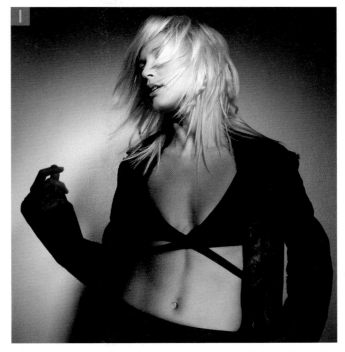

1 Here are the steps used to create a cross-processing effect that simulates C-41 film processed in E-6 chemicals. You can adapt this technique by using different channel Curve adjustments and different fill colors.

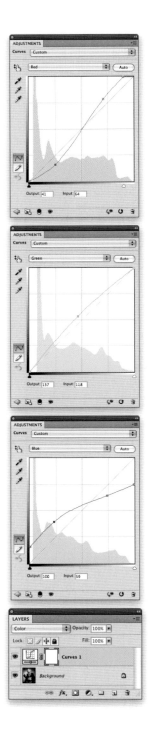

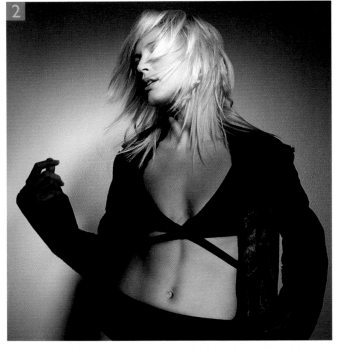

2 I added a Curves adjustment layer that used the Color blend mode and then adjusted the curves in the individual color channels as shown in the screen shots on the left. The Curves channel adjustments added a blue/cyan cast to the shadow areas and a red/yellow cast to the highlights. Because the Curves adjustment layer was set to the Color blend mode, the luminosity was unaffected.

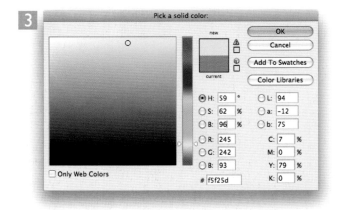

3 I then added a Color Fill layer (which was also set to Color mode), set the opacity to 15% and selected a strong yellow fill color.

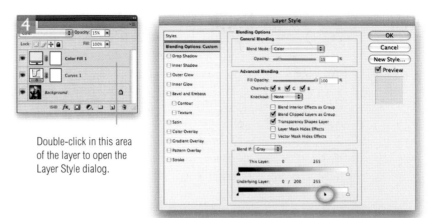

Double-click in this area
of the layer to open the
Layer Style dialog.

4 I then double-clicked the Color fill layer and adjusted the Underlying layer blend options. I ⌥ _alt_-clicked on the Underlying Layer shadow point triangle slider and dragged to separate the dividers, splitting them in two, and dragged the right-hand shadows slider (circled) across to the right.

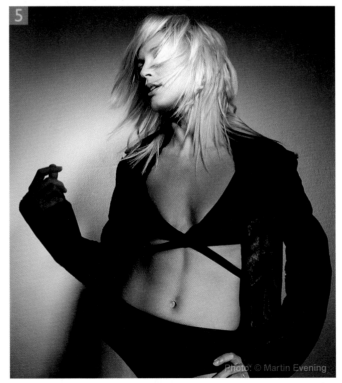

Photo: © Martin Evening

5 Here you can see the finished result in which I had created a transitional blend between the underlying layers and the yellow Color fill layer above.

Lab Color effects

Here is another type of Photoshop cross-processing effect which involves the use of the Lab Color mode to distort the colors in a photograph. This is not a cross-processing effect per se, but this technique can certainly allow you to mess with the colors in your images in some pretty interesting ways. I would suggest that this effect is best applied to medium or high resolution images and that the source image should be fairly free of artifacts. As you will see at the end of this tutorial in Step 7, I found that you can also create some interesting variations if you invert the layers that are used to create the coloring effect.

1 To start with I opened an RGB image and created a duplicate copy by choosing Image ⇨ Duplicate... I then converted the duplicate image to Lab Color mode by choosing Image ⇨ Mode ⇨ Lab Color. The Lab Color image contained a Lightness channel plus **a** and **b** color channels. I went to the Channels panel and selected the **a** channel first.

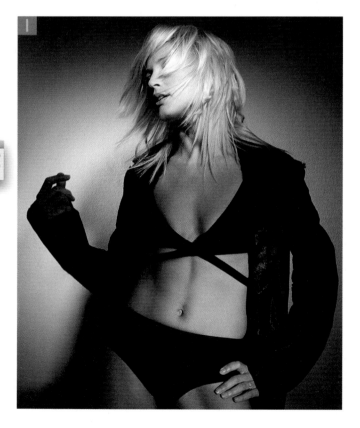

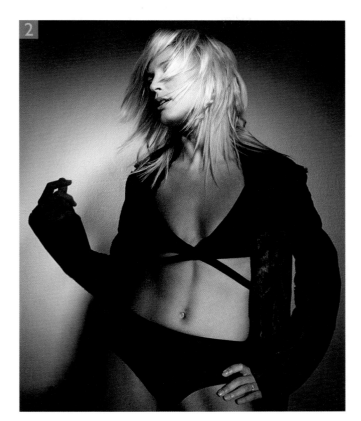

2 I then chose Image ⇨ Adjustments ⇨ Equalize, which expanded the channel contrast of the **a** channel. Next, I clicked on the Lab composite channel in the Channels panel (it is essential you remember to do this so that all three channels are selected again) and copied the enhanced image across to the original image as a new layer. You can do this by choosing Select ⇨ All, then copy and pasting the image contents. Or, you can select the move tool and drag the Lab image across to the original RGB version image. Make sure that you hold down the *Shift* key as you do so, as this ensures that the layer is centered when you let go of the mouse (there is no need to worry about the color mode mismatch. Photoshop automatically converts the file back to RGB mode again as you copy the data). I set the blend mode for the Lab copied layer to Color and set the layer opacity to 30%.

3 This Lab coloring technique can sometimes generate ugly pixel artifacts, so I chose Filter ⇨ Blur ⇨ Surface Blur and applied a 5 pixel Radius Blur using a Threshold of 100 Levels. This blur filter treatment softened the image of course but, because the new layer was added using the Color blend mode, the blur simply smoothed the color information on this layer, which had no adverse effect on the detail since it did not alter the luminance.

283

4 I returned to the Lab copy image and went back one step in the History panel to the point where I had just converted the duplicate image to Lab mode. I now selected the **b** channel and once again applied an equalize image adjustment and copied the newly enhanced composite Lab image across to the original RGB version of the image.

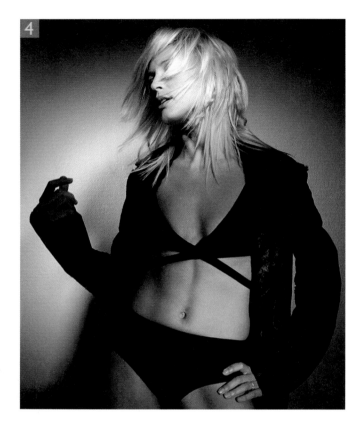

5 The new layer appeared as Layer 2 in the layer stack and I once more set the blend mode to Color, the opacity to 30% and applied the same Surface Blur filter treatment to the newly added image layer.

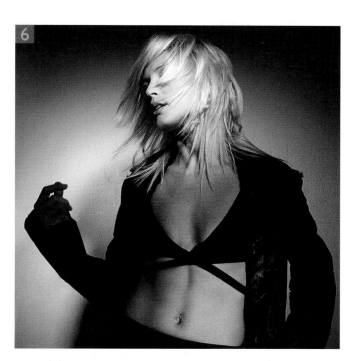

6 Here is the finished result. As you can see, when using the Lab Color cross-process method you end up with two brightly colored, semi-transparent layers. The fun starts when you adjust the relative opacity of each of these two layers to obtain different coloring effects.

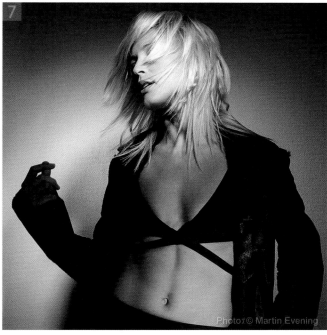

7 In a further twist, I applied an Image ⇨ Adjustments ⇨ Invert adjustment to both of the coloring layers. This allowed me to produce yet more interesting color variations.

285

Black and white infrared film

Black and white infrared film emulsions are predominantly sensitive to infrared radiation. Vegetation in particular reflects a lot of infrared light which is beyond the scope of human vision. Hence, green foliage will appear very bright and almost iridescent when captured on black and white infrared film.

Simulating black and white infrared film

I first invented the black and white infrared technique some ten years ago when I was asked to come up with different ways to convert a color image to black and white. I initially started out with a Photoshop method, which relied on the use of a Channel Mixer adjustment to boost the Green channel in the grayscale mix. Since then I have had the opportunity to make various improvements and more recently I have found that the Lightroom and Camera Raw approach now offers the best approach when creating the black and white infrared look. This is especially true now that you can apply a negative Clarity adjustment, which simulates the soft glow look that is so typical of black and white infrared photography. The following steps were all carried out using a raw capture file. To get the best results I suggest you work with a raw original, but you could use the same steps described here to process a JPEG or flattened TIFF image.

1 I chose this particular photograph to work with because it contained a lot of green foliage and was therefore an ideal subject for the black and white infrared treatment.

2 I began by adjusting the White Balance. Here, you can see that I adjusted the Temperature slider to make the image warmer and dragged the Tint slider all the way to the left in order to exaggerate the greens.

3 I then went to the HSL/Grayscale panel and checked the Convert to Grayscale box. I applied a manual Grayscale Mix adjustment, where I raised the Yellows and Greens to +100 and set the Aquas to +75. This adjustment created a black and white conversion that lightened the green, yellow and aqua colors.

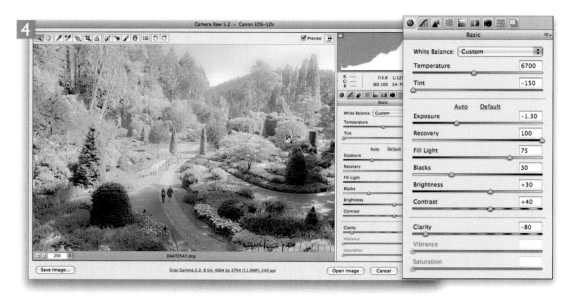

4 I now needed to go back to the Basic panel and make some corrective adjustments to the Exposure, Recovery, Fill Light, Blacks, Brightness and Contrast sliders. More importantly, I applied a negative Clarity adjustment, which created the soft glow effect that is so typical of black and white infrared photographs.

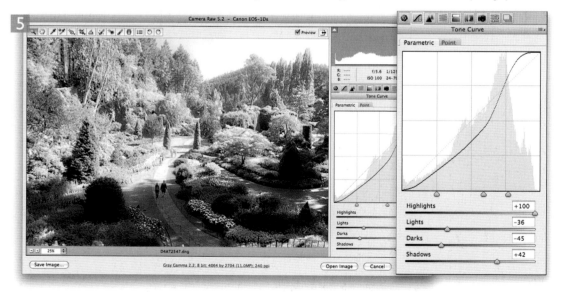

5 I then went to the Tone Curve panel and applied the parametric curve shape shown here, where I steepened the curve shape in the highlights in order to increase the highlight contrast.

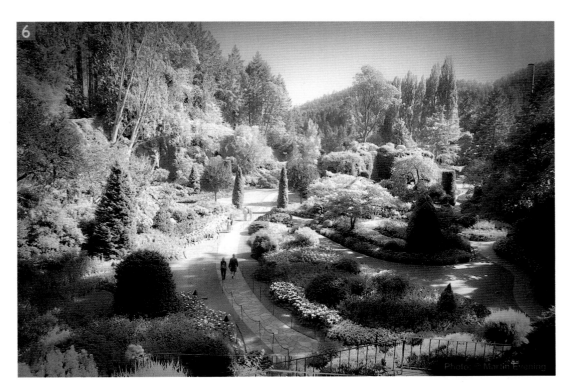

6 To produce the final photograph seen here, I went to the Lens Corrections panel and added a post-crop vignette to darken the edges of the photograph and then went to the Split Toning panel to apply a color toning effect.

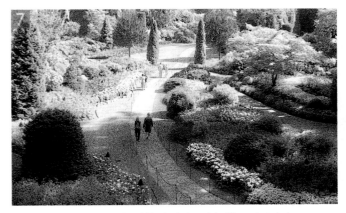

7 Lastly, to get the grainy infrared film look, I used the film grain technique described on pages 78–79 to add a grain layer above the Background layer.

Origins of solarization

This original photographic darkroom technique is associated with the artist Man Ray, in which the print paper is briefly fogged towards the end of its development.

Black and white solarization

Here is another Photoshop technique that has evolved into one that can now be done using Camera Raw. Ideally, you should use this method to edit raw originals, but it can also be made to work with JPEGs or flattened TIFFs.

The original Photoshop method was quite simple: you applied a Curves adjustment, clicked on the pencil button to switch to Draw mode and created an inverted V-shaped curve. The Camera Raw method is similar. In the example shown here, I went to the Point curve editor in the Tone Curve panel, added three points to the curve and dragged the top right point down to the bottom right corner. This allowed me to create the inverted V shape shown in Step 4. The best thing about using Camera Raw to solarize an image is that when you revisit the Basic panel you can readjust the main sliders there which allows you to further modify the solarization effect. You will notice here that I opened the Camera Raw processed image as a Smart Object, which allowed me to create two versions of the original master and then blend the two together using a pixel layer mask.

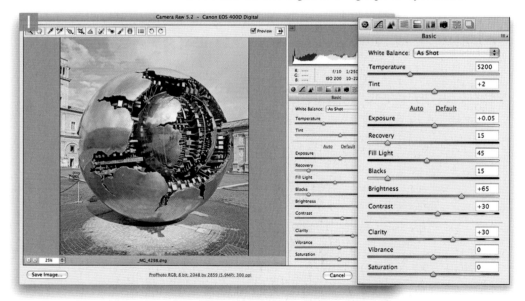

1 As with the previous example, this technique was carried out on a raw original photograph, although you could get this to work equally well using a JPEG or flattened TIFF image.

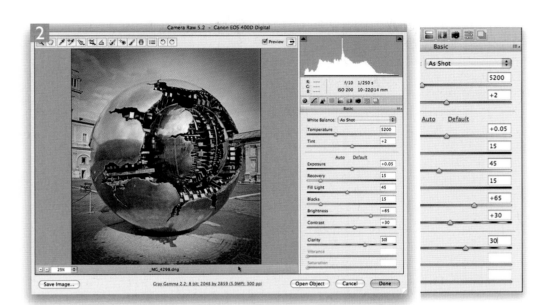

2 I began by converting the photograph to black and white and adjusted the HSL/
Grayscale and Basic panel settings to achieve an optimum grayscale image from
the color original. When I was happy with these settings I held down the *Shift* key
to change the Open Image button to Open Object and clicked to open the photo as
a Smart Object in Photoshop.

3 On the left is a Layers panel view of the Camera Raw Smart Object layer. I made
a copy of this layer by going to the Layer menu and choosing Smart Objects ⇒
New Smart Object via Copy. Note that you can also access this menu item by
right-mouse clicking on the Smart Object layer and selecting New Smart Object
via Copy from the contextual menu (Mac users who don't have a two-button mouse
will have to hold down the *ctrl* key to access this menu). I made sure that the copy
Smart Object layer was now selected so that the following steps were applied to
this layer only.

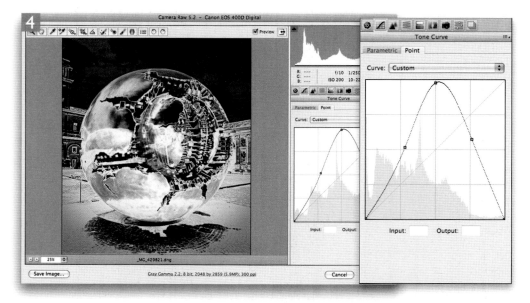

4 I went to the Tone Curve panel, selected the Point curve editor option and made the inverted 'V' curve shape you see here to create the solarized look.

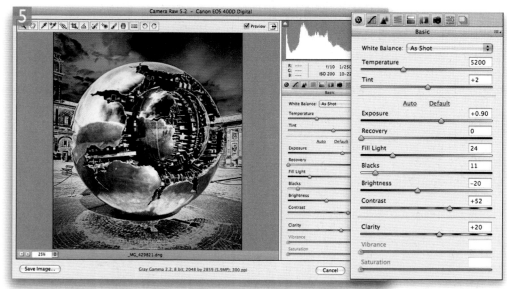

5 I then switched to the Basic panel and adjusted the tone controls to further modify the effect. This is where using the Camera Raw controls really gives you the edge, as adjusting the Exposure, Recovery and Fill Light sliders can make an enormous difference to the solarized effect.

Photo: © Martin Evening

6 At this stage I now had two Smart Object layers of the same source image in the layers stack. I had processed the lower Smart Object layer as a normal black and white conversion and had processed the upper layer using the Solarized settings shown in Steps 4 & 5. I added an empty pixel layer mask to the upper layer and painted on the mask with black as the foreground color to hide portions of the solarized version and reveal the non-solarized version on the layer below. A further benefit of the Camera Raw Smart Object approach was that I could continue to edit the individual Camera Raw settings on each of the Smart Object layers.

Figure 5.8 Here you can see the lighting setup used to capture the photograph shown below.

Hand-coloring a photograph

One way you can colorize a photograph is to set the brush tool to the Color blend mode and set the foreground color to the color you wish to paint with. But here is a hand-coloring technique that was originally devised by Jim Divitale as an ultra-flexible way to paint items a specific color. The way this works is that you pick a foreground color and then add three Color fill layers of this same color, but using three different blend modes: Color, Overlay and Multiply. Color essentially colorizes the image, the Overlay blend mode applies color to the image, but also adds contrast and, lastly, the Multiply blend mode adds color depth by adding color and darkening at the same time.

1 This photograph was shot using a standard beauty light setup (see Figure 5.8), and shows the model with her normal hair color. In the following sequence of steps I want to show you how I was able to change her hair color using a precisely measured sample hair color swatch as guidance.

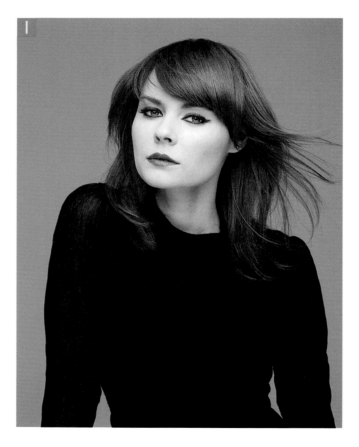

2 For this first step I used an X-Rite Eye-One spectrophotometer to take a series of measurements from selected hair color swatches in a hair color guide book.

3 I used the X-Rite Eye Share software to record the measurements made with the Eye-One device. I took several measurements of the desired hair color sample and clicked on the resulting sample swatch colors in the Eye Share interface to calculate the best average color reading (the color readouts were given in Lab values [circled below]).

4 I then opened the Color Picker in Photoshop and entered the (rounded up) Lab Color values in the Lab coordinates boxes (circled). It isn't absolutely necessary that you go through the pre-step of measuring the color swatch values with a spectrophotometer. The following steps will work just as well if you simply resort to guessing the color here. Once I was happy with the settings I clicked OK to make this the new foreground color.

5 Next, I went to the Swatches panel and rolled the cursor down to the bottom of the list, where you'll notice how the icon changed to a paint bucket icon. I clicked here to add the foreground color as a Swatch preset, where I named it using the color reference from the hair swatch book in Step 2. Saving special colors like this in the Swatches panel can save you time if you need to reference such colors again.

6 At this particular point, you might find it helpful to record the following steps as a Photoshop action. This way you'll find it quicker to set up all the layers in future without having to do so manually. The first step here was to click on the Add adjustment/fill button in the Layers panel (circled) and add a new Color fill layer using the current foreground color.

7 I then dragged the Color fill layer to the New Layer button in the Layers panel to make a copy and dragged again to make a second copy. I set the uppermost Color fill copy layer to Color mode @ 50% opacity. I clicked on the middle layer and set the blend to Overlay mode @ 25% opacity and, lastly, I went to the original layer at the bottom and set the blend mode to Multiply @ 10% opacity. In the screen shot shown here you'll notice that I renamed the layers, indicating the layer blend mode and opacity percentage. It is by no means essential that you do this, but if you are recording these steps in an action it may help if you identify the layers in this way.

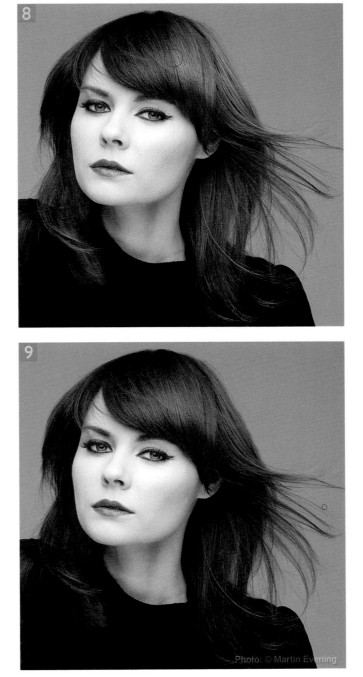

8 I *Shift*-clicked to select all three Color fill layers and chose New Group from Layers... from the Layers panel fly-out menu (or use the ⌘ G *ctrl* G shortcut). I then *alt*-clicked on the Add a Layer Mask button in the Layers panel to add a pixel layer mask filled with black, which hid the layer group contents. (if you have been recording these steps as an action, you can now press the Stop button to end the recording). After I had completed these steps I was able to paint with white on the layer group's layer mask to simultaneously reveal all three layers in the group.

9 Here you can see the finished result after I had finished painting on the pixel layer mask to define the outline of the hair. The blend and opacity modes I suggested using for the three layers are a good starting point. When you try this method out on your own photographs you may well want to adjust the opacity settings (as required) for the subject you are coloring.

Photo: © Martin Evening

297

Coloring an object

It's not at all unusual for the color of things to be wrong even when the overall color is fine. So, the ability to alter or add color to an object is useful. In this case the image was prepared for a paper company that wanted to promote themselves as 'chameleons' in the paper biz (hey, we don't get to control the ad concepts). So the mandate was to use examples of their paper: fine writing paper, cardboard and even brown wrapping paper and a chameleon. So, I hired a chameleon wrangler, made a model with paper and did the shots to combine. When working with animals, I have found it's a really good idea to want the animal to do what it does naturally (it's real hard to keep it from what it wants to do). For this assignment I shot the chameleon first, selected the best image and built the set around where the chameleon would be placed, as shown in Figure 5.9. The coloring on the lizard would be done in Photoshop.

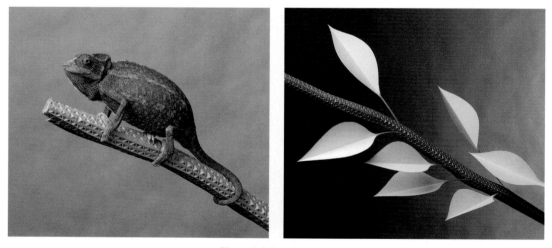

Figure 5.9 These are the scans of the original 4 x 5 film shots. The chameleon's name was Fred and, when placed on the set, naturally assumed the color of the cardboard (which was a good thing because he was green when he was first removed from his box and that would have been more work to fix). The image on the right shows the set that was built after picking the main image. The 'leaves' were placed strategically to allow putting Fred on the 'branch'.

1 The first step was to composite the lizard (Fred) in place. Well, actually there were a lot of steps prior to getting to this stage such as creating a path around Fred and various retouching done on the two scans. But this is where we're starting from here. The layer stack shows the three layers that made up the shadows plus Fred.

2 The next step was to create the channels. The path of the chameleon was turned into a selection and saved to make the channel on the left. The channel was duplicated and the channel on the right was hand-painted to reveal only the areas where the color would be added later.

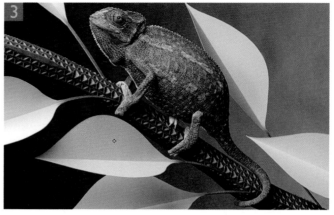

3 The Lizard color mask channel was loaded as a selection using Select ⇨ Load Selection and the eyedropper tool was selected to choose the color to fill. The client wanted to use a color close to the writing paper so I sampled an area to arrive at the color. I then added a Solid Color fill layer from the layers panel icon using the foreground color that had just been selected.

4 The color fill layer's blending mode needed to be set to Color so that it only altered the color of the underlying image. The color blend mode contains both the hue and the saturation information (it's actually a combination of both) but not luminance. Filling (or painting) using a color blend is the trick to changing the color of an object. You can do it radically as in this example or you can paint or fill it in with a low opacity for more subtle effects.

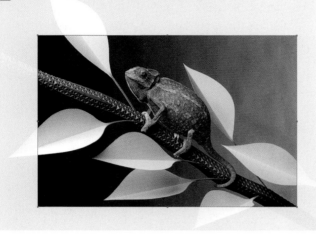

Double-click on the channel icon for the options

5 Here the color fill has been accomplished. A slight Levels adjustment layer was put on top to tweak the color of the fill. This step shows a trick I use when dealing with art directors who have a habit of changing their minds (and sometimes the layout): non-destructive cropping. Rather than actually crop the image pixels (until the last moment), I use a channel with the channel options set to a color of white and an 80% opacity (sometimes it's at 100%). The advantage is that you can see the whole image and the live area but only crop at the end. You can even transform the size and the location (don't rotate – that doesn't work) then simply load the Crop channel as a selection and chose Image ➩ Crop.

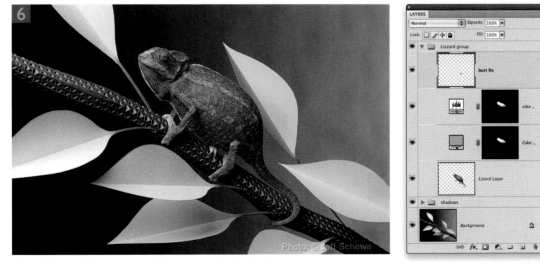

6 This shows the final composite, coloring, crop and butt fix. Fred had an 'issue' that had to be addressed by retouching on a separate layer.

Coloring effects using Match Color

The Match Color adjustment is available from the Image Adjustments menu and is mainly designed to allow you to match the colors in one image with those in a source image. For example, if you have two separate shots of an important product where the colors need to match, you can use Match Color to get these to match exactly. However, you can also use the Match Color adjustment in a creative way to sample colors from a source image and apply these to a completely different image. This technique can produce interesting and sometimes unusual-looking results.

In Step 2 you will notice that I used the Equalize command to balance out the Match Color sample image before I saved the statistics. This will help you achieve a statistics file that can be used as a colorize adjustment, but without disrupting the tonal balance of the destination images. However, you may still need to make further adjustments in the Image Options section, using the Luminance, Color Intensity and Fade sliders.

If you are interested in using this technique then you should perhaps consider creating a library of Match Color statistics settings. Open up a bunch of images and save out different Match Color settings which you can use on other images.

1 To demonstrate the following technique, I opened a photograph where the colors in the original scene were fairly muted.

2

blue-yellow cobbles.sta

2 Next, I needed to create a Match Color settings file. To do this, I opened the sample image shown on the right and chose Image ⇨ Adjustments ⇨ Equalize. This step was done to ensure that the tones ended up more evenly distributed. You don't have to apply this step, but it can help you produce a better Match Color statistics file. I then chose Image ⇨ Adjustments ⇨ Match Color and clicked on the Save Statistics... button (circled) to save as a Match Color statistics setting.

3

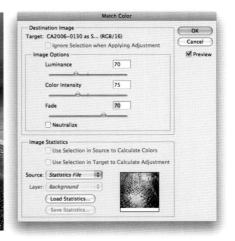

3 I opened the image shown in Step 1, chose Image ⇨ Adjustments ⇨ Match Color again and clicked on the Load Statistics... button and selected the previously saved Match Color setting. I then fine-tuned the Match Color settings. I set the Luminance to 70%, the Color Intensity to 75% and the Fade to 70% and clicked OK to apply the adjustment.

Match Color auto adjustments

The Match Color image adjustment can also function as an auto color correction tool for images that have a heavy color cast.

In the following tutorial you'll see how Match Color can be very effective at removing a deep blue/cyan cast from an underwater photograph. You can always try using the Image ⇨ Adjustments ⇨ Auto Color adjustment in Photoshop to remove such casts, but Match Color's ability to neutralize tricky subjects is usually more impressive. It's not just the fact that a Match Color neutralize is generally more effective, but you also have the ability to use the Image Options sliders to moderate a Match Color neutralize adjustment. For example, if you use Match Color to auto-correct images with heavy casts this can result in images that have less overall saturation. You may therefore sometimes want to adjust the Color Intensity in the Match Color Image Options section in order to compensate for the lost saturation. In addition to this you can also adjust the luminance of the image and fade the overall adjustment.

1 The Match Color image adjustment is a useful image correction tool in its own right. In this extreme example, I used the Match Color adjustment to remove the strong blue/cyan cast seen in this photograph taken by Jeff in his scuba diving days!

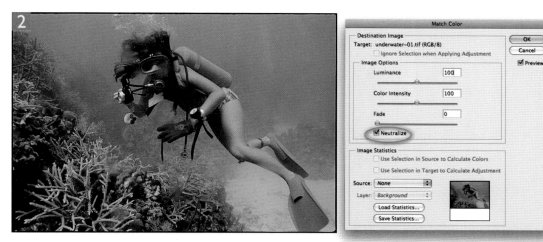

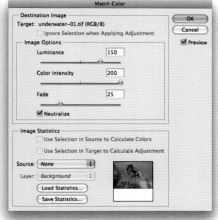

2 To do this, I went to the Image menu, chose Adjustments ➪ Match Color and checked the Neutralize option (circled). This helped remove most of the color cast in the photograph.

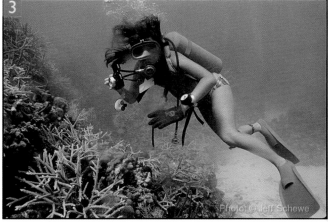

3 Step 2 did quite an impressive job of removing most of the deep blue color. However, I felt that it would be useful to moderate the adjustment slightly. First of all I raised the Luminance to +150%, which essentially lightened the photo. Since the photograph had now been neutralized, there wasn't an awful lot of color saturation left in the image so for this reason I raised the Color Intensity to +200%. Lastly, I moved the Fade slider slightly to the right in order to fade the neutralize adjustment and restore a little more of the original color. The final result is a picture that still looks like an underwater photograph, but with more of a neutral color feel and perhaps a little closer to how Jeff perceived the original scene when he shot this picture.

Using Camera Calibration to distort colors

The Camera Calibration panel in Camera Raw is really intended for fine-tuning the color calibration of a camera and getting the Camera Raw processed colors to match as closely as possible to the colors in the original scene. However, one of the interesting things you can also do with the Camera Calibration panel is to deliberately mess up the colors in an image to create unusual color effects!

To achieve the result you see here I mostly adjusted the Hue and Saturation sliders in the Camera Calibration panel, taking the sliders to their extremes. If you want, you can link these adjustments with further modifications to the Temperature and Tint White Balance sliders in the Basic panel, not to mention the Split Tone panel controls as well. Once you find a calibrate setting that you are happy with, and would like to reuse on other images, it is a good idea to save it as a custom setting.

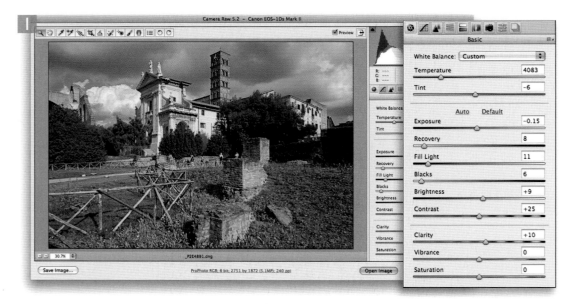

1 This shows a normal version of a raw image that had been opened up in Camera Raw, where all I had done so far was to set a Custom White balance in order to achieve neutral-looking colors and had adjusted the other settings to achieve a corrected tone balance.

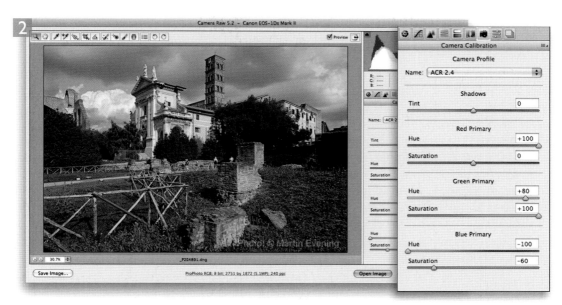

2 In this version I went to the Camera Calibration panel and adjusted the sliders as shown here to produce a color infrared type look.

3 Once I was happy with the Camera Calibration adjustment I clicked on the Presets panel and then clicked on the New Preset button (circled) to save the setting as a Camera Calibration only preset, which could now be accessed again in future.

ProPhoto RGB editing

For any technique that involves using tone and color adjustments, the RGB space of the source image will always have a bearing on the final outcome. Such differences may often be so slight as to be unnoticeable, but not so when big changes are made to the image. This particular technique was devised for use with the ProPhoto RGB space, because only ProPhoto RGB was able to handle the huge color shifts applied in Step 2 before converting these into the tamer luminosity tone adjustment shown in Step 3. If you were to use sRGB or Adobe RGB, Step 2 would cause a lot of the color information to be clipped early on. You could modify the settings used here to achieve a similar result when working with smaller gamut RGB spaces, but for best results I suggest you use ProPhoto RGB throughout.

Demo Action

The steps shown here are available as an action: CS4 Nocturnal, which is available from the Chapter 5 folder on the DVD.

Nocturnal effect

There is a film by the French film director Francois Truffaut called *La Nuit American* (known in the English speaking world as *Night for Day*) where the title of the movie is based around the use of a photographic filter designed to make daylight footage resemble a moonlit night scene. In all my photographic career I never did manage to work out the elusive combination of filters used to pull off this trick, but I was recently inspired to see if a similar type of effect could be achieved directly in Photoshop.

In creating a simulation effect such as this, I needed to work out exactly what makes a scene look like it has been shot at night as opposed to day? There was certainly more to this than dimming down the exposure. First of all I had to take into account the way our human vision is compromised in low light conditions. Our eyes are less able to gauge colors and we therefore perceive everything as being more monochrome. We tend to think of moonlight as being blue in color, but the color temperature of moonlight is actually around 4125 K, which is actually only slightly cooler than a tungsten halogen light and certainly warmer than normal daylight. But the reason why we perceive moonlight to be blue is because of *Purkinje's phenomenon*, which describes how in low-level lighting conditions red/yellow colors appear to become less luminous and green/blue colors appear to become brighter. It is these shifts in our human visual response combined with the dimmer lighting conditions that contribute to the way we perceive night-lit scenes differently to a daylight scene.

Preserving the pixels

This technique also teaches an important lesson about the use of the Color blend mode to blend coloring adjustment layers such as the blue curves coloring layer I applied in Step 5. Doing this produced a cleaner histogram compared with leaving the coloring adjustment layer set to Normal blend mode.

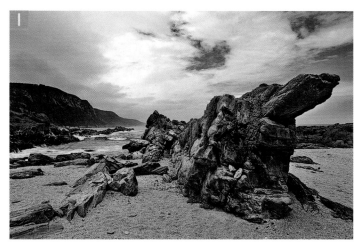

1 I started here with a normal color photograph in ProPhoto RGB and began by adding a Channel Mixer layer. Any photograph will do, but not all pictures will look convincing as a nocturnal image. Ideally, I suggest you begin with an image that is in 16-bits per channel mode since this technique involves a fair amount of pixel stretching.

2 In the Channel Mixer settings I set the channels as follows. In the Red channel I set Red to 0, Green to +100 and Blue to 0. In the Green channel I set Red to 0, Green to +200 and Blue to −100. In the Blue channel I also set Red to 0, Green to 0 and Blue to 200. This combination of settings produced the false-color look seen here.

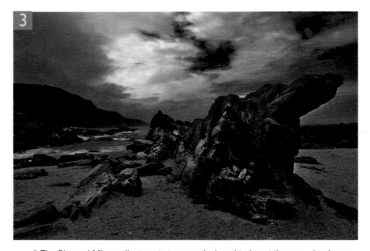

3 The Channel Mixer adjustment step was designed to boost the green luminance in the scene. The coloring effect was interesting but not exactly the look I was after here, so I set the blend mode of the Channel Mixer layer to Luminosity. Next, I added a Curves adjustment layer in Normal mode that darkened the scene to make the photograph look more night-like.

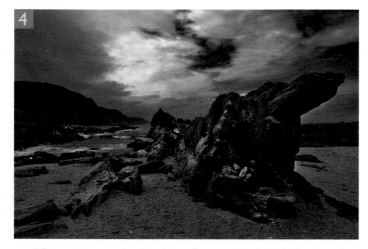

4 The next step was to knock back the yellow saturation. I added a Hue/Saturation adjustment layer, set the Yellows Saturation to −60 and the layer blend mode to Color. I then held down the *Shift* key, clicked on the Channel Mixer layer to select all three adjustment layers and chose Layer ⇨ Group Layers (⌘ G ctrl G).

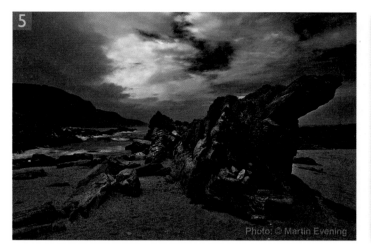

5 Finally, I added a Curves adjustment layer to the top of the layer stack (above the Layer Group) and adjusted the red and blue curves (as shown here) to create a blue/cyan cast. I set the blend mode of this layer to Color and reduced the layer opacity to 50%. The reason I did this was because it gave me the freedom to tweak the coloring effect strength. You probably won't see much difference in the appearance of the image, but you'll see why this is important in the following step.

6 A series of adjustment layers can cumulatively stretch the pixels in the base image and create spikes and gaps in the image histogram. However, there are ways that you can mitigate such losses. On the left is a layer stack in which I followed all the stages up to Step 5 and left the final Curves layer in Normal blend mode. As you can see, the 8-bits per channel image histogram is quite choppy. On the right, I set the layer blend mode to Color and overlaid the histogram using this blend mode over the Normal mode histogram, and highlighted the difference in green. Note how this histogram has fewer spikes. If you apply these steps to a photo that is in 16-bit mode, you will see even fewer spikes and gaps in the final histogram.

Preserving colors with ProPhoto RGB

Over the last ten years, the advice on which is the best RGB color edit space to use has shifted. Initially, most experts suggested you use Adobe RGB, but in recent years opinion has changed and we now advocate you use the ProPhoto RGB as your edit workspace.

There are two main reasons for this. Firstly, many inkjet printers now have color gamuts that are typically wider than the Adobe RGB space. Therefore, by choosing ProPhoto RGB as your edit space you can make full use of the gamut of the printer, especially when it comes to reproducing shadow colors on glossy printing paper. Secondly, because ProPhoto is a wider gamut space, it is better suited for carrying out pixel calculations where the calculated pixel values may end up extending beyond the boundaries of a smaller gamut color space. Using the last tutorial image as an example, we can see how the ProPhoto RGB space offers extra headroom with which to make some big pixel shifts, whereas a smaller gamut space will simply clip the pixels that extend beyond the gamut limits.

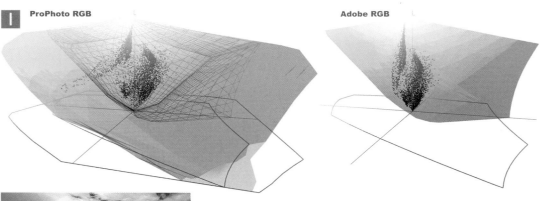

1 These 3D diagrams allow us to compare the use of the ProPhoto RGB and Adobe RGB edit spaces. The pixels in the photograph on the left are shown here plotted to their RGB coordinate positions in each color space. You will notice that the Pro Photo RGB space does not constrain the pixels in any way and that the pixel colors in the ProPhoto RGB version extend beyond the gamut limits of the Adobe RGB space, which is represented here (for comparison purposes) as a wire frame diagram within the ProPhoto RGB space gamut.

2 ProPhoto RGB L Adobe RGB L

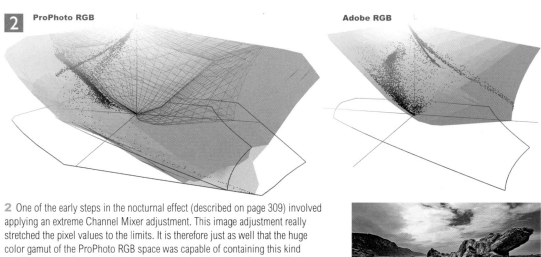

2 One of the early steps in the nocturnal effect (described on page 309) involved applying an extreme Channel Mixer adjustment. This image adjustment really stretched the pixel values to the limits. It is therefore just as well that the huge color gamut of the ProPhoto RGB space was capable of containing this kind of adjustment and preserved the color and tonal relationships between all the individual pixels. If the Adobe RGB color space was used to edit the image, the Channel Mixer adjustment simply clipped most of the colors because the gamut was simply not big enough to allow Photoshop to calculate such an extreme adjustment.

3 ProPhoto RGB L Adobe RGB L

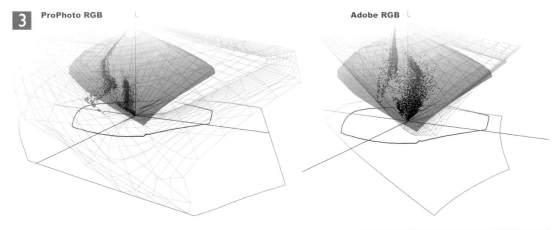

3 Although the nocturnal effect applied an extreme color adjustment at the beginning, the pixel values were later squeezed back again to produce a more muted-color look in the finished image. You can't see the differences too clearly in these 2D representations of the 3D gamut shapes, but there was a substantial blue hue shift in the Adobe RGB edited version. What mattered most of course was which version would print best? For this last step I switched the color gamut profiles to wire frames and overlaid the color gamut of a glossy paper print profile. In the ProPhoto RGB example you will notice that although some blues are beyond the gamut of the printer, more color detail is preserved in the shadows.

Softening the focus

Fog effect

A quick way to soften the focus in a photograph is to duplicate the Background layer and use Filter ⇨ Blur ⇨ Gaussian Blur to blur the image. You can then use the method described here to modify the soft focus effect. You can reduce the Smart Filters opacity as necessary to restore more of the original image sharpness and, if you paint on the Smart Filters layer mask, you can fill or add paint to the mask and apply the soft focus effect selectively.

1 Here is a woodland forest scene that is in fact an HDR blend, converted to a low dynamic range image. The first step was to go to the Filter menu and choose Convert for Smart Filters. This changed the Background layer into a Layer 0 layer with a Smart Object icon in the bottom right corner.

2

2 I then went to the Filter menu again, chose Blur ⇨ Gaussian Blur and used an 8 pixel Radius. It didn't matter too much which setting I applied here, since a Smart Object layer will allow you the flexibility to re-edit the filter settings any time you want.

3

Photo: © Jeff Schewe

3 Here you can see the Layers panel with the Gaussian Blur Smart Filter layer. To produce the soft focus lens effect seen here, I double-clicked on the Gaussian Blur filter blending options (circled), changed the mode to Screen and reduced the opacity to 70%. Screen is ideal if you want the blow-out soft focus look. Otherwise, try using the Lighten mode instead.

Figure 5.10 Here you can see the lighting setup used to capture the photograph shown here.

1 To demonstrate this technique, I started with a black and white studio portrait. As in the previous example, I went to the Filter menu and chose Convert for Smart Filters to convert the Background layer to a Smart Object layer.

2 I then went to the Filter menu and chose Blur ⇨ Gaussian Blur. I entered a 20 Radius Blur here, but again the amount doesn't really matter since one can re-edit the blur setting at any time.

Diffused printing effect

Here's a variation of the previous technique that can be used to simulate a traditional darkroom diffuse printing effect. As I mention at the end, it is best to do this with an image that is in 16-bits per channel.

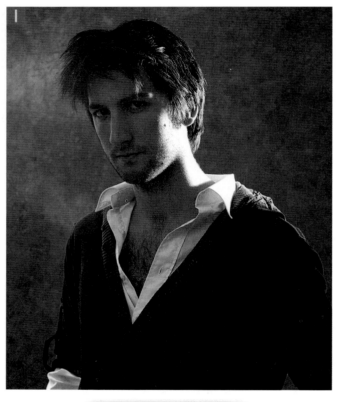

3

3 I followed this by double-clicking the blending options icon (circled in Step 2) and set the mode to Multiply. As you can see, choosing Multiply really darkened the image. You could try lowering the opacity so that the image doesn't end up quite so dark or you could try using the Darken blend mode at around 50%, which will also produce a gentler effect.

4 In this example, I left the opacity at 100%, then went to the Image menu and chose Adjustments ⇨ Shadows/Highlights using the settings shown below. Now the Multiply blend mode and the Shadows/Highlights adjustment are in some ways cancelling each other out here, but if the image you are editing is in 16-bits per channel you should still end up with a smooth histogram.

Photo: © Martin Evening

Adding progressive blurs

Sometimes an overall blur isn't what's called for in an image. I like to add multiple blur layers and use a layer mask to paint in or out the blur effect. It's quick and easy to do as in this example. Here, I shot Martin's daughter Angelica with her grandmother Hannah in the background. The shot is nice but the visual complexity of Martin's office is a distraction. Figure 5.11 shows the original shot.

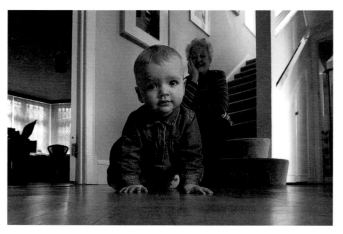

Figure 5.11 The original shot of Angelica with the camera on the floor.

1 I duplicated the Background layer and used Filter ⇨ Blur ⇨ Box Blur at a radius of 15 pixels. I then made a Hide all layer mask by holding the ⌥ *alt* key, and clicked on the Add Layer Mask button. This way I could paint the blur in, not out.

2

2 Using a very large brush while zoomed out, I painted with white into the layer mask. I did a little touch-up work in the center area by painting with a smaller brush set to black to remove some excess blur effect. I then repeated the entire process of duplicating the Background layer and adding another blur layer with a Box Blur of 30 this time. I prefer the Box Blur to regular Gaussian Blur because I like the bokeh (the out of focus look) it produces. It's also a lot quicker than using the Lens Blur (and simpler, I like simple).

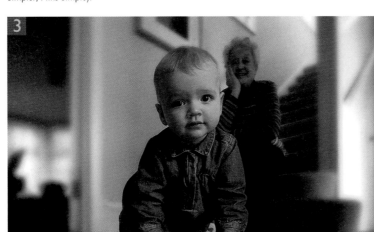

Photo: © Jeff Schewe

3 This is the result with the multiple blurs added. Note that the second blur layer's mask cuts down on the opacity of the second blur. The blur 1 layer mask also shows the close work done to keep the blur effect off Angelica and Hannah. The final version here is slightly cropped to hide the bathroom door on the right and a bit more of Martin's messy office (even if it is blurred down).

Image border effects

Adding a border to an image

Here is a simple two-step technique for adding a new border to an image in Photoshop. For the following steps I used a scan of a black and white photograph that had a typical Polaroid™ border.

For those who don't know, the Polaroid company used to make black and white instant print film such as Type 55 or Type 665. The tear off portion contained a usable negative, which when stripped from the positive print after processing needed a bath of 18% sodium sulphite to remove the black coating on the back and other gunk. The border picture below shows the characteristic edges that you would get when making a darkroom print from such a Polaroid negative. I mention all this in case you feel like creating your own 'real' border images. Polaroid no longer manufacture the instant print films that they were once famous for, but if you hunt around you may still be able to get hold of old supplies of this material. Otherwise, feel free to use the sample image that is supplied on the DVD, or you could try using any other type of border such as the Clouds filter border effect demonstrated on pages 324–325.

1 I began here with the photo on the left, which was the picture I wanted to apply the border effect to, plus a second photograph which was a scan made from a print of a Polaroid™ processed border.

2 To prepare the Polaroid border image, I selected the rectangular marquee tool and carefully dragged inside the border area to define the inside area and, with white as the foreground color, used `⌥` `Delete` `alt` `Delete` to fill the selection area with white. This cleared the inside area of the border frame and prepared it for use later in Step 4.

3 I now selected the main photograph and set the foreground/background color to the default setting so that white was the background color. I expanded the window size to show more of the canvas surrounding area. I then selected the crop tool and dragged to first select the whole of the image. I then held down the `⌥` `alt` key as I dragged on a corner handle to expand the crop size. This was a quick way to expand the canvas area of an image, while keeping the crop centered. I then hit `Enter` to apply the crop.

4 I now had the main photograph (with a white border) plus the expanded Polaroid border scan open in Photoshop. I selected the move tool, clicked on the border image and dragged it across to the other photograph. As I did so I held down the *Shift* key so that the border image was placed as a new layer, centered in the image.

5 I then changed the blending mode of the Polaroid layer to Multiply to merge the border layer with the underlying Background layer. Because the central portion of the layer was filled with white, this part of the layer (and any other white areas) appeared transparent. Once I had done this, I selected the Edit ➪ Free Transform to scale the border image layer so that it neatly overlaid the image below.

6 To remove the surplus border I went to the Image menu and chose Trim… I used the settings shown below to trim the image size based on the Top Left Pixel color (although Bottom Right would have worked just as well). Lastly I added a Curves adjustment layer that was clipped to the border image layer. I adjusted the color channels in this Curves adjustment so that it colored the border image layer to create a warm sepia color tone that matched the colors in the underlying photographic image.

Difference Clouds

The Difference Clouds filter has a cumulative effect on the image. Applying it once creates a cloud pattern based on the inverse color values. Repeating the filter produces clouds based on the original colors and so on, as the filter effect builds up more cloud contrast.

Adding a Clouds filter border

The Clouds filter is available from the Filter ⇨ Render submenu and can be used to generate a cloud pattern that fills the whole image (or selected area), based on the foreground and background colors. The cloud pattern alters each time the filter is applied, so repeated filtering (using ⌘ F ctrl F) will keep producing a fresh cloud pattern. If you hold down the ⌥ alt key whilst applying the Cloud filter, the effect will be magnified.

In the example shown here, I made use of the Clouds filter to generate a rough-edged border effect. The beauty of this technique is that the border edge will be different each time you apply this series of steps.

1 I opened an image, added an empty new layer and chose Select ⇨ All, followed by Select ⇨ Modify ⇨ Border, and entered a pixel value that was large enough to create a suitable-sized border.

2 I then feathered the selection by a much smaller percentage. In this example I created a 40 pixel border selection and feathered it by 7 pixels. I reset the foreground/background colors, went to the Filter menu, and choose Render ⇨ Clouds.

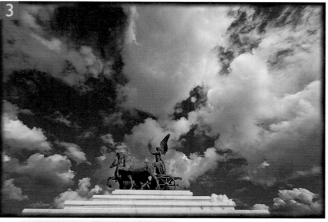

3 I added another empty new layer and, with the selection still active, filled the selection with black and set the layer blend mode to Multiply.

4 I then deselected the selection, merged the two layers, changed the blend mode of the merged layer to Multiply mode and applied an extreme Levels adjustment that hardened the border edges. As you can see, this combination of steps produced the rough-edged border effect shown here. As I mentioned at the beginning, the outcome will be different each time you apply these steps. Don't forget that you can also record this as a Photoshop action, although the Border selection width and Feather Radius will need to be adapted for different-sized images.

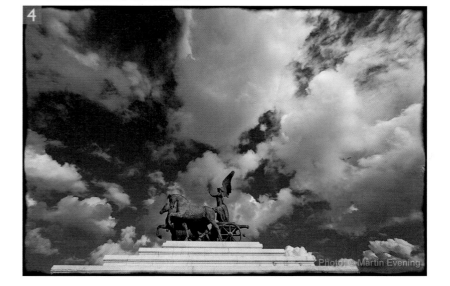

Photograph: Martin Evening.
Jeff Schewe portrait | Canon EOS 1Ds MkIII | 40 mm | 1600 ISO | f3.2 @ 1/40th

Photoshop output

Tips and advice on inkjet and CMYK print output

I t is all very well getting your photographs to look good on screen as you retouch them in Photoshop, but as far as most photographers are concerned it's how the final print looks that matters most. Getting from screen to print should and can be easy, providing you are using a well-maintained, color managed workflow. Most of the basic tips and advice on printing are contained in Martin's main *Adobe Photoshop CS4 for Photographers* book. What this chapter does is to provide additional tips and advice on setting up an inkjet printer, as well as instructions on how to make custom profiles, how to soft proof in Photoshop, plus how to create CMYK proof prints.

Fine-art printing

Inkjet printers

Inkjet printers now dominate the printing market and are especially popular with photographers who are using Photoshop. Inkjet printers come in all shapes and sizes from small desktop devices to huge banner poster printers that are the width of a studio.

The first inkjet devices were manufactured by IRIS and designed for commercial CMYK proof printing on a limited range of paper stocks. It was largely due to the experimentation of country rock musician and photographer, Graham Nash, that the IRIS evolved to become an inkjet printing device suitable for producing fine-art prints. This costly venture began in the early nineties and was to revolutionize the world of fine-art printing, thanks to these pioneering efforts. The IRIS printer stopped production in 2000 and its successor is the IXIA from Improved Technologies. The IRIS/IXIA is still favored by many artists, but in the last decade companies like Epson, Hewlett-Packard (HP), Canon and Roland have developed high quality wide-format inkjet printers that are suitable for large format printing, including fine-artwork applications.

The revolution in inkjet technology began at the high end with expensive wide-format printers, but the technology soon diffused down to the desktop. Epson was one of the first companies to produce affordable high quality desktop printers and has retained its lead in printer and consumables technology, always coming out with new and better printers, inks and papers, although companies like Canon and Hewlett-Packard are now beginning to regain their slices of the printer market with printers to rival Epson's continuing dominance.

How inkjet printers work

Inkjet printers work by spraying very fine droplets of ink as the head travels back and forth across the receiving media/paper. The different tonal densities are generally created by varying the number of evenly-sized individual

droplets. Epson were one of the first to use variable-sized droplets to avoid the appearance of widely-spaced and noticeable fixed-size dots in the highlights; now most of the other manufacturers have followed suit, so that the higher dot density in highlights gives much smoother tones. Inkjets typically do not have a regular arrangement of their color dots, so more closely follow the results of stochastic printing in the Litho world. The latest Epson Stylus Pro models use eight, or now ten, color inks and these are capable of producing an even smoother continuous tone output. The Epson 4800 printer in my office uses additional light black, light light black, light cyan and light magenta inks to render the paler color tones. The print output is therefore very smooth because there is no discernible dot dithering in the lighter areas. But more significantly, the K3 inks are capable of reproducing richer colors than can sometimes be seen on most LCD computer displays.

Inkjet printers are used for all sorts of printing purposes. An entry-level inkjet can cost as little as $100 and is suitable for anything from office letter printing to outputting photographs from Photoshop. And you don't have to spend much more than a few hundred dollars to buy an A4 or A3 printer that is capable of producing photo-realistic prints.

Although inkjets use CMYK inks or CMYK plus the additional inks (such as those mentioned above), they work best when they are fed RGB data. This is because a lot of these printers use Quartz rendering (Mac) or GD (PC) drivers as opposed to PostScript. These print drivers can't understand CMYK. So if you send CMYK data to the driver it will convert the data from some form of generic CMYK to RGB before converting the data again to its own proprietary CMYK color. Later on in this chapter we will discuss how it is possible to use an inkjet printer to produce acceptable guide prints for CMYK press color matching. For example, if you perform the color management in Photoshop and disable the printer color management, it is also possible to produce what is known as a cross-rendered CMYK guide print from an RGB file, using the Proof Setup dialog to specify a CMYK space to proof with.

Output through a RIP

Some standard print drivers may use a mix of inks to print dark colors. But a good photo RIP like ColorBurst™ will use proper black generation (GCR) control to minimize color shifts in prints.

Hewlett-Packard Z series

The Z series printers include two 12-ink color models. These printers have an incredibly wide color gamut which is achieved by the addition of red, green and blue inks.

Epson 900 class printers

At the time of writing, Epson has just started shipping their new 10-color 7900 and 9900 series printers. Jeff has been using a late beta unit and is impressed with the gamut and D-max of the new UltraChrome HDR inks to the extent that the choice of color workspace in Photoshop is more important than ever if you are to make the most of this latest breed of printer. Only ProPhoto RGB can take advantage of the full range of colors these printers can achieve.

The ideal inkjet

Your first consideration will probably be the print size and how big you need your prints to be. Most desktop inkjet printers are able to print up to A3+ (13" × 19"), while the Epson 3800 can print up to 17" × 35" in size. The wide-format printers like the Epson 9900 can print up to 44" wide and the Hewlett-Packard printers as wide as 96" (the Hewlett-Packard Z series also has built-in X-Rite calibrators that can help maintain closed-loop color accuracy). Wide-format printers are suitable for all commercial purposes and are particularly popular with fine-art photographers who need to produce extra-large exhibition quality art prints. These bigger printers are designed to be freestanding and therefore require a lot of office space.

Photographic print quality

Almost any inkjet printer can give you acceptable print quality, but some printers are definitely more suited to photographic quality printing than others. The Epson Stylus Pro range of printers are marketed as a good choice for photographic print output because they use specially formulated inks and print with six or more ink colors, which can yield superb results. Printers like these, and others, can also be adapted to take third-party inks that are specially formulated for black and white or fine-art printing. The Epson 3800 printers are suitable for fine-art printing with longevity and have an extra light black ink, which also makes this an almost ideal printer for black and white work (as is the more robust Epson 4880, which offers bigger ink cartridges). In recent years, Hewlett-Packard has ramped up its range of photo printers. For example, the PhotoSmart 9180 is simple to set up and also features a built-in calibration device.

Image preservation

The longevity of an inkjet print will be determined by a variety of factors. Mostly it is down to the combination of the inks and media that is used to produce the print, followed by the environment in which a print is kept or

displayed and whether it has been specially treated to prevent fading. Light remains the biggest enemy though. If prints are intended for long-term exhibition, then you have to make sure that you use a suitable ink and paper combination, and that the prints are displayed behind UV filtered glass and sited so they are not exposed to direct sunlight every day.

The premium glossy and semi-gloss paper is a popular choice for photographers as these papers match or exceed the quality of a normal photographic print surface, and the print longevity when used with Epson 4880 is estimated to be close to 100 years. A lot of photographers and artists have enjoyed experimenting with various fine-art paper stocks. When these are combined with the right types of ink, it is possible to produce prints that can be expected to last even longer.

If you are printing to black and white and use the Advanced Black and White Epson print driver (which is available on the higher-end models such as the 2880), this will print the photos using just the black, light black and light light black inks with minor amounts of cyan, magenta or yellow. Essentially you are making prints with pure carbon pigments and the estimated lifetime for these types of prints is up to 300 years.

Inks and media

To start with I recommend that you explore using the proprietary inks and papers that are 'officially' designated for use with your printer. Firstly, it should be pointed out that the manufacturing engineers have designed these ink and paper products expressly for their printers and, secondly, the printer companies will usually supply canned profiles which these days are often very accurate. Therefore, if you stick to using proprietary inks and papers at the beginning there are fewer variables for you to worry about when you are learning how to print from Photoshop.

There are two types of inks used in inkjet printers. Dye inks were once the most popular because they were capable of producing the purest colors. But the dye molecules in

Wilhelm Imaging Research

Henry Wilhelm has conducted much research into the various factors that affect the permanence of inkjet prints. The Wilhelm Imaging Research website contains print permanence reports for several printers. Henry has also co-authored a book, *The Permanence and Care of Color Photographs: Traditional and Digital Color Prints, Color Negatives, Slides, and Motion Pictures*, which offers a definitive account on the subject. For more information go to: www.wilhelmresearch.com

Optimizing the printer

Neil Barstow is a UK-based color management consultant who offers a CD containing a manual and test files to help you optimize your printer settings. For more information on this and his UK-based color consultation services, go to: www.colourmanagement.net Our good friend and colleague Andrew Rodney is also a color management expert based in the USA and is the author of *Color Management for Photographers* from Focal Press. Andrew consults and also makes custom printer profiles. For more info, see: www.digitaldog.net.

Branded consumables

The inkjet manufacturers like to sell their printers cheaply and then make their profit through the sales of proprietary inks designed for their printers. If you care to read the small print, using anything but the manufacturer's own inks may void the manufacturer's guarantee.

such inks were also known to lack stability. This meant they were prone to deteriorate and fade when exposed to prolonged intense light exposure, high humidity or reactive chemicals. Pigment-based inks have a more complex molecular structure and as a result are less prone to fading. But pigmented inks have traditionally been considered less vivid than dye inks and have a restricted color palette (the color gamut is smaller).

Some modern inks use a hybrid combination of dyes and pigments. The specially formulated pigment-based ink and paper combinations will produce bright prints that also have exceptional image permanence. When using the correct paper and inks, the life expectancy is predicted to be over 100 years and may be as long as 200 years with certain paper combinations.

Third-party inks

When ordering ink supplies you need to make sure that the cartridges are compatible with the printer and, if using a custom profile, are of the same type. While it is possible to use third-party inks in some printers, we tend to take the view that the ink technology is often just as important as the printer hardware itself and it may prove a false economy to switch to using non-branded inks.

Inkjet economies

Ink cartridges don't come cheap and once you get into serious print making, you will soon get through a lot of expensive cartridges. I don't recommend you economize by buying ink refill kits as these are very messy to use. In the long run it can work out more economical if you buy a printer that uses single ink cartridges with higher ink capacities (don't forget there are some places where you can recycle your used cartridges).

Building a custom printer profile

These days it is much easier to rely on the canned profiles that ship with most of the current inkjet printers (or at least this is true of the Epson printers that we are most familiar with). There are two key reasons for this. Firstly, now that the printer hardware is more consistent in quality, it is possible to build a profile using one printer and have it work well for every other printer. Secondly, the profiles that are supplied are of better quality anyway. You'll also find that third-party media suppliers such as Hahnemuehle (www.hahnemuehle.com) and Innova (www.innovaart.com) are able to supply ICC profiles for their paper products with various printers.

Should you feel the need to create your own custom profiles for non-regular ink and paper combinations then you might want to consider having custom printer profiles made. If you don't have the necessary profiling hardware and software, the most obvious thing to do is to contract the work out to a specialist service provider such as colourmanagement.net in the UK or www.digitaldog.net in the US. If you wish to build your own custom profiles, then you'll need to purchase something like an X-Rite Eye-One or Color Munki device plus the necessary software to read the measured spectral data from which a profile can be built. Whichever approach you choose, you'll need to know how to correctly print a test target image.

Printing a printer test target

The next series of screen shots leads you through the steps to follow when printing out a target like the one shown in Figure 6.1. The important points to bear in mind here are that you must not color manage the target image. The idea is to produce a print in which the pixel values are sent directly to the printer without any color management being applied. The patch readings are then used to build a profile that will later be able to convert the image data to produce the correct-looking colors. The remaining Print dialog settings should be saved so that the same print settings can be applied as when you printed the test target.

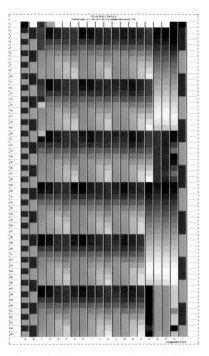

Figure 6.1 Here is an example of an X-Rite color target which is used to construct an ICC color profile. The print outputs are then measured using a reflective spectrophotometer and a profile built from these measurements. All you have to do is make a neutral path print, as shown on the following pages. A third-party profiling service will be able to supply you with the test chart and printing instructions. You mail the color management service provider a print and they will email a printer profile back to you.

Installing custom printer profiles

The custom printer profiles should be saved using the following locations: Library/ColorSync/Profiles folder (Mac OS X), Windows XP/System/Color folder (PC). For Windows Vista just right-click on the profile and choose Install.

1 Open a test chart file like the one shown in Figure 6.1. Such files are included as part of any print profiling package or can be supplied to you by a color management service provider. This file will have no embedded profile and it is essential that it is opened without making any conversions and is always printed at the exact same print size dimensions. If it is necessary to resize the ppi resolution, make sure that the Nearest Neighbor interpolation mode is selected.

2 Next, go to the File menu and choose Page Setup. Here, you'll need to make sure that you select the correct printer device and select a media paper size that is big enough to print the target without having to rescale the image. When you have done this, click OK (see also Figure 6.2 for the Mac tip on centered printing).

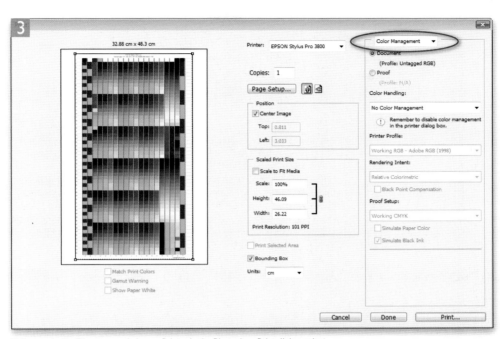

3 Now go to the File menu and choose Print... In the Photoshop Print dialog select the Color Management options (circled). The print space should say Document: (Profile: Untagged RGB). The idea here is that you want to create a print output of the unprofiled data without applying any printer color management. In the Color Handling section, select the No Color Management option. If you set the Page Setup correctly in the previous step, the target image should fit within the printable area shown in the preview. It is very important that you don't scale the image and that it remains at 100%. When you have done this click the Print... button.

Figure 6.2 To make sure your prints are centered, on the Mac go to the Page Setup menu and choose Manage Custom Sizes from the drop-down menu... In the Custom Page Sizes dialog check out the margin width for the bottom trailing edge margin for the selected printer. If you want your prints to be centered when printing landscape or portrait, adjust all four margins to the same dimension and save this as a new paper size setting and add 'centered' so you can easily locate it when using the Page Setup dialog.

335

Mac Presets drop-down menu

4 In the Mac OS X Print settings section upper left (Vista is shown on the right), choose the appropriate media type and in the Color Settings section choose No Color Adjustment. In this example, I was building a profile for the Hahnemuhle rag smooth fine-art paper, so I selected Ultra Smooth Fine Art Paper as the Media Type. In the Printing preferences for the PC print dialog you would select the same Media Type, then click on the Custom mode button and the Advanced button (circled above), and also choose No Color Adjustment.

However these settings are configured, they should now be saved as a named preset (in this example I named it as 'HMrag-3800-2880'). This same setting should then be used whenever you make a print using the custom profile.

5 The target print should stabilize before it can be measured and a profile built (this means leaving it for the inks to dry properly). The profile that's generated can be used with your printer, using the same ink sets and with the same media/paper type and print settings as were used to generate the printed target. The custom printer profile must be installed in the appropriate operating system ColorSync profiles folder. When you go to the Print dialog always choose Photoshop Manages Colors and select the custom profile as the Printer Profile.

6 When you go to the system Print dialog make sure you select the same preset setting that you saved when creating the target print (on a PC you need to click on the Save Settings button to get to the dialog shown here) and that's it. Once you have established and saved the print settings and installed the printer profile correctly you only need to follow these two steps each time you make a print.

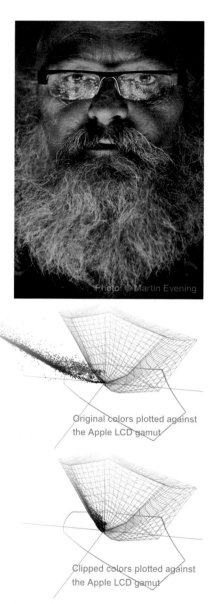

Original colors plotted against
the Apple LCD gamut

Clipped colors plotted against
the Apple LCD gamut

Figure 6.3 In this photograph I shot of Jeff,
the vibrant colors contained in the ProPhoto RGB
master far exceeded what could be displayed on
the gamut of an Apple LCD monitor (represented
here by the wire frame shape). This is an example
of where even a calibrated display cannot show
the full color potential of an image in print.

Getting the most from your printer profiles

There is no such thing as a perfect color management
workflow. Allowances will always need to be made for
a small margin of error, but if you follow the guidelines
carefully you should attain impressive results even from
a modest desktop printer. To fully appreciate the printed
results you really need an accurate light viewing box
to view the prints correctly. Some inkjet prints can take
a while to dry after they come off the printer. A print
produced on older Epson printers can at first look quite
green in the shadows, but after a few hours the ink colors
will stabilize and the green cast eventually disappears. This
is why you are sometimes advised to wait at least 24 hours
before measuring your printed target prints.

Then there is the issue of what is incorrectly described
as 'metamerism' (the correct term is metameric failure).
This refers to the phenomenon where when viewing under
different lighting conditions, the ink dye/pigment colors
will respond differently. This problem can be particularly
noticeable when a monochrome image is printed using
color inks. Although the color management can appear
to be working fine when a print is viewed under studio
lighting, if this environment is changed, and the print is
viewed in daylight from a window, the print can appear
to have a green cast. There was an example of this with
the early Epson Ultrachrome 2000 printer where the
pigment-based ink suffered from this green shift in daylight
problem, but the latest Ultrachrome printers have now
managed to resolve this problem.

Even despite all your best efforts to produce a perfect
profile, you may just find that a specific color on the
display does not match exactly. I sometimes see this
happening with the skin tones in a portrait. Although I
usually obtain a perfect match with a specific ink and paper
profile combination, the printed result is sometimes just
a fraction out on an item of clothing or in the skin tones,
but every other color looks just fine. This could indicate
that it is time to recheck the monitor calibration, or it could
be that you need to adjust the printer profile. If you know
what you are doing it is possible to tweak profiles using a

program like X-Rite's ProfileMaker Pro™. Another reason why there may be a difference in the colors seen is that the color gamut of the printer is not as large as the gamut of the display on which you are viewing the image (see Figure 6.3).

Display gamut versus printer gamut

It is important to understand that what you see on the monitor display is always going to be a selective view of the colors actually contained in the image. A great many computer displays are effectively sRGB devices, while even the Adobe RGB gamut screens such as the Eizo CG301W and NEC LCD3090 30" monitors may not be able to accurately display every color that your printer can print (although we still recommend these as the best tools for soft proofing). There was a time when this didn't matter so much but some of the latest inkjet printers, such as those made by Epson and HP, have color gamuts that well exceed the limits of the average computer display. There is not much you can do to predict the color output of those colors that exceed the gamut limits of your monitor. If some of the colors you see in an inkjet print don't match those you see on the monitor, and you are confident you have color managed everything effectively, this most likely points to the fact that the monitor isn't able to display some of the colors that will actually show in print (see Figure 6.4). You can't really do anything about this other than invest in a good quality, large gamut monitor. But just be aware that what may appear to be color errors don't necessarily point to a failure in color management

Soft proofing via the display

More often, the colors you see on the screen may appear brighter than those you see in print because the tonal contrast range of the display is greater than what you see in print; this can have the opposite effect of making the print image appear duller in comparison to the image displayed on the monitor. The solution to this is to use soft proofing in Photoshop to simulate the output characteristics of the print output device on the monitor display, as well as CMYK conversions destined to go to the press.

Original colors plotted against the inkjet print gamut

Clipped colors plotted against the inkjet print gamut

Figure 6.4 These two color gamut diagrams really follow on from the Figure 6.3 example because they show the actual colors in the original ProPhoto RGB image plotted against the wire frame gamut of a glossy inkjet printer profile. Here you can see that while many of the ProPhoto RGB colors are still beyond the gamut of the print output, the print can still reveal much richer blues and shadow detail than can be revealed on the calibrated Apple display. As you can imagine, it's not possible to show in the book the colors that a modern inkjet printer can reproduce, but there was quite a difference.

If you are editing an RGB image and go to the View ⇨ Proof Setup menu you'll see a list of proofing options. If you select Working CMYK this will allow you to soft proof an RGB image using the current CMYK space established in the Edit ⇨ Color Settings dialog (using the default rendering intent). If you choose the Custom... option this opens the Custom Proof Condition dialog shown in Figure 6.5, where you can select any output profile that's available from your system color profiles folder and use this to simulate the tone and color output characteristics of the print device on your monitor, using different rendering intents.

You can then save a custom proof setting as a '.psf' file in the Users/Username/Library/Application Support/ Adobe/Color/Proofing folder (Mac OS X) or the Program Files/Common Files/Adobe/Color/Proofing folder (PC). This saved proof setting will then be appended to the bottom of the list in the Customize Proof Condition dialog,

Figure 6.5 Use the View ⇨ Proof Setup menu to select the device or color space you wish to soft proof with, whenever the Proof Colors command ⌘ Y *ctrl* Y is applied. If you click on Custom... this will take you to the Customize Proof Condition dialog, where you can select the profile of your printer or CMYK print output. In this example, I selected a custom CMYK profile for the book printers who are printing this book.

which means that you can quickly access the settings
needed for simulated proof printing via the Proof Setup
Preset menu in the Print dialog.

You don't have to keep returning to the Customize Proof
Condition dialog. Once you have established a custom
proof setting you can preview the colors in this space by
simply choosing View ⇨ Proof Colors, or use the keyboard
shortcut ⌘ Y ctrl Y to toggle the preview on and off.
This keyboard shortcut makes it very easy for you to
switch from Normal to Proof viewing mode. The document
window title bar will also display the name of the proofing
space after the color mode such as: *RGB/Working CMYK*.

Display simulation options

Once you have established a proof setup and you select
the Proof Colors option from the View menu, Photoshop
takes the current display view and converts it on-the-fly
to the destination color space selected in the Proof Setup.
The data is then converted back to the RGB monitor space
to form a preview using the relative colorimetric rendering
intent and with black point compensation switched on.
In simple terms, the image you see on the display is
effectively filtered by the profile space selected in the
Customize Proof Condition dialog.

The Proof Colors view provides you with an advance
indication of how a file might reproduce after it has been
converted to the print output space. The Proof Colors
view may make the monitor image appear muted, but it
does more accurately reflect the appearance of the final
print output. However, the image on the screen will still
be optimized to the full contrast range of the display. This
is where the Simulate Paper Color and Black Ink options
come in (Figure 6.6). These allow you to achieve a more
accurate simulation, one that takes into account the color
of the paper and the black ink density. The Simulate Paper
Color option simulates how the whites in the image will
appear, by simulating the color of the paper on the screen,
and will use an absolute Colorimetric rendering to convert
the proof color space data to the monitor space; it also

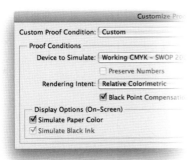

Figure 6.6 The Display Options in the
Customize Proof Condition dialog allow you
to achieve more authentic on-screen previews
that take into account the fact that density of
the black in the final output is less black than
the maximum black you see on the computer
screen. When the Simulate Paper Color option is
selected the screen image will simulate both the
color of the paper stock and the black ink color.
It is important to note here that while the Proof
Condition settings for the Rendering Intent and
Black Point Compensation have a bearing on
a proof print output, the Simulate Paper Color
and Black Ink options will only affect the screen
preview.

Preserve numbers

You use the Customize Proof condition to
preview how a document will look before
it has been converted to another color
space. The Preserve Numbers option can
be useful for proofing how a CMYK file
in a specific space will print if sent to a
known CMYK space. By preserving the
numbers you can simulate how a file will
print before you consider reseparating it.
If the destination space is in the same
color mode as the source space (i.e. RGB
or CMYK), the Preserve Numbers box
allows you to preview how an image would
look without a profile conversion.

Inkjet paper optical brighteners

The optical brightener additives contained in many of today's inkjet papers can also bring about quite a noticeable shift in the way a print is perceived under different lighting conditions. If there is a high amount of UV light present the whites will look much brighter, but also bluer compared to a print that has been made using a paper stock such as GMG Premium Proofing papers, which are ideally suited for CMYK proof printing and viewed using controlled lighting with a color temperature of 5000 K.

auto-selects both the color of the paper and the black ink color density. However, the Paper Color simulation only works if the profile used is made on the actual paper stock used for printing, and only if this paper doesn't have too much optical brightener in it (otherwise the results will look bluish on screen – see side panel). Turning these options on are, in effect, the 'Make My Image Look Really Bad' buttons. Why? Because a computer display may have a 700 to 1 contrast ratio while a print may only have 200 to 1 ratio. Since white will be white and black will be black, the only way to predict the impact that the lowered contrast ratio will have is to make the image look dull and flat. It's accurate mind you, but it is disappointing unless you know how to use it. So I follow Bruce Fraser's advice and try looking away from the display just prior to checking these press simulation settings – that way I don't see the image die.

The Simulate Black Ink option simulates on screen the actual black density of the printing press by turning off the black point compensation in the conversion from the proof color space to the display color space, thus simulating the 'ink on paper black'. Checking both these options allows you to see, as accurately as possible, an on-screen representation of how an image will look when printed. Figure 6.7 shows the results of having the Display Options on and off.

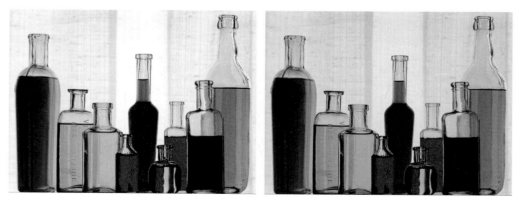

Figure 6.7 On the left is the soft proofed image using the PFP-Medium-GCR proof setup with the Display Options for Paper White and Ink Black off. The figure on the right has the options for both turned on.

Color proofing for press output

If you are supplying digital files for CMYK halftone reproduction, then you will want to obtain as much relevant information as you can about the press, paper stock and print process that will be used to print a job. If the pre-press people you are communicating with are cooperative and understand what you are asking for, they may be able to supply you with a suitable proofing standard ICC profile, or they can provide you with information about the printing inks and other specifications used for the press. Go to the Edit ⇨ Color Settings ⇨ Working Space ⇨ CMYK ⇨ Custom CMYK dialog and enter these settings as described in the previous chapter. Once you have saved this as a CMYK setting you can convert your RGB image to this custom CMYK color space and save it as a TIFF file.

A CMYK file on its own is not enough to inform the printer how it should be printed. It is standard procedure to supply a targeted CMYK aim print or proof along with the image, as this will provide a guide as to how you expect the picture to reproduce in print within the gamut of the specific CMYK print process. The term 'contract proof' is used to describe a CMYK proof that has been reproduced using an approved proofing device. These include the Epson x880 series with a good proofing RIP like the ColorBurst™ RIP. Kodak Approval™ is still much used, and perhaps to a lesser extent DuPont™ Chromalin™. Inkjet printers are essentially taking over the proofing industry, as many press houses move to Computer to Plate (CTP) technology, thus eliminating the need for film at the proofing stage. The contract proofing devices benefit from having industry-wide recognition and, if the proof that accompanies the file is generated using an approved contract device, a designer can use an aim print to pass off a job to the pre-press company handling the repro. A proof print is more likely to be accepted as a valid target print representing the colors that are achievable on the press.

Realistic proofs

When you supply a CMYK proof you are aiming to show the printer how you envisage the picture should look in print. A proof is a print that has been produced using the same color gamut constraints as the halftone CMYK process. That way the printer will have an indication of what colors they should realistically be able to achieve. However, you should not confuse a really nice fine-art print with maximum gamut made from an RGB file as a realistic proof. The colors in such a print simply can't be reproduced on press. Only a cross-rendered CMYK proof will represent a reasonable expectation of what the image will look when printed.

Contract proof versus aim print

The term 'aim' print most justly describes the appropriateness of a standard profiled inkjet output, when used as a guide for the designer or pre-press person who is determining how the colors in an image will reproduce when using CMYK inks on the actual press.

Rendering Intent grayed out

When Proof is selected as the source space, the Rendering Intent will be grayed out and the Black Point Compensation automatically switched off. This is because Photoshop will use the Rendering Intent that is applied in the custom proof setup.

CMYK proofing with an inkjet

Even a humble inkjet printer is capable of producing 'targeted' CMYK prints that can be used as 'aim' prints or even as contract proofs (if produced via a RIP), because it is possible to simulate the restricted CMYK gamut of the press via the Photoshop Print dialog. Figure 6.8 shows the Photoshop print dialog for a ProPhoto RGB image. When the Proof option is selected as the print space, the Proof Setup is invoked below and the default Proof Setup will use the current CMYK workspace. The Photoshop Manages Colors option should be selected so that you can select a printer profile for the printer. In the Proof Setup you can then also select a saved Customize Proof Condition preset for the print process you wish to simulate (which includes the chosen Rendering Intent) and use the two checkboxes below to simulate the press conditions, using: Simulate Paper Color and Simulate Black Ink.

Simulation and Rendering Intents

The aim here is to produce a print that simulates the output of a CMYK proof printer. We are configuring the Photoshop print dialog settings to utilize the Customize Proof Condition settings (which will already include the device to Simulate and the Rendering Intent) and then applying a further profile conversion from this proof setup space to the printer profile space. Photoshop makes it easy for you to select the right options so that you don't have to do anything more than decide whether you wish to simulate the black ink appearance only or simulate the paper color as well (in which case the Simulate black ink will be checked automatically anyway). So by clicking on one or more of these buttons at the bottom, you can instruct Photoshop to work out for you how the data should be converted and sent to the printer to achieve the desired press simulation.

When Simulate Paper Color is selected, the whites may appear duller than expected. This does not mean the proof is wrong, rather it is the presence of a brighter white border that leads to the viewer regarding the result as looking inferior. To get around this try adding a white border to

the outside image you are about to print. When the print is done, trim away the outer paper white border so that the eye does not get a chance to compare the dull whites of the print with the brighter white of the printing paper used.

When you hit the Print button, the same routine should be followed as usual. If you are using Photoshop to manage the colors, the system print settings should have the color management switched off and the Print Settings should match the paper type used, or you should select the saved print preset that was created for use with the custom printer profile.

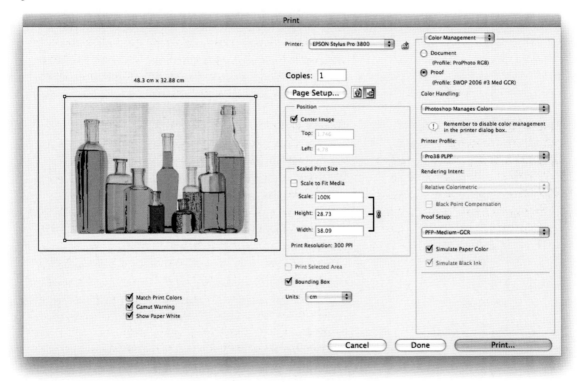

Figure 6.8 Here, the Print dialog is configured for making a cross-rendered simulated CMYK print. The options for Match Print Colors, Gamut Warning and Show Paper White are selected, but there's not much you can do about the result. Ideally you should take care of that in soft proofing. After hitting Print, you would need to select the system print preset setting that matches the selected printer profile.

What flavour of CMYK?

Often photographers are simply told 'give me a CMYK file' but not all CMYK files are really equal. For magazine repro using a web press in the US, Photoshop's default CMYK profile is ok. It really is, but one can do a bit better. If the image is intended for small run sheetfed printing, the problem gets a bit more difficult. You can try to get an ICC profile from the printer (good luck) or, the alternative is to have a client specify exactly what proofing system will be used. If you can determine that, then you can separate for the proof and not the press. I have required that clients provide the exact proofing system that will be used on purchase orders before accepting a job. Since I have profiles for pretty much every proofing system out there, I can both soft proof and do the final RGB to CMYK conversions for the actual proof.

CMYK output

Preparing files for output

Any RGB image destined for CMYK halftone reproduction will need to be converted to CMYK by somebody, at some time. The big question is by whom? The photographer? The art director or designer (we doubt that), or the pre-press or printer that will be doing the output? The 'best' answer to the question is whoever can do it in an optimal manner. This could be the photographer or the printer. The circumstances really dictate who will be the most likely.

If the photographer is shooting an assignment where their job is to turn over many images that will end up being selected by somebody way down the road, the odds are it won't be the photographer. Optimizing images for RGB to CMYK conversion takes time and effort to do well. So, unless the assignment is for a few select final images the pre-press provider or printer will probably do the CMYK conversions.

If you are a photographer who can control the final selection of images in concert with the art director or designer, and get paid to do imaging and final conversions, then you would probably be the best person to do the conversions. You know what the image is supposed to look like and optimizing the RGB images and doing the CMYK conversions isn't really all that hard. It does take some effort and technique. First and foremost is knowing how to use soft proofing to predict what the image will look like and knowing how to take steps to improve the CMYK conversion. That's what we'll try to get across in this section.

The first thing we'll tell you is that it's wise that you never show your clients what your RGB images look like. Since it's a look they'll never be able to get on press, you really should only show them the images after you've already turned on CMYK soft proofing. You can defer the Display options for paper white and black ink as you wish, but you really should not let them fall in love with the RGB colors from the beginning.

The second thing we'll tell you is that the old Gamut Warning under the View menu is pretty much useless for optimizing CMYK conversions and may actually lead you astray. It has some limited usefulness – most notably as a front end to the ability to select out of gamut colors using Color Range as shown in Figure 6.9. The problem with this approach is that you don't know how much out of gamut a color or tone will be, just that it's out of gamut. It also doesn't show you what the result will look like. For this reason we don't suggest using Gamut Warning but instead suggest learning how to use soft proofing instead.

We've already talked about using the Customize Proof Condition dialog and how to configure it for your use. The following series of steps shows how to use it to optimize a colorful ProPhoto RGB image for CMYK. There are some hard limits in doing this in the book. For one thing, we can't show you what the ProPhoto RGB image actually look like because the book is, of course, CMYK. So, the steps show the 'relative' relationship between ProPhoto RGB and the CMYK conversion we are using for the book separations, which were provided by Chris Murphy, co-author of *Real World Color Management*. More info about Chris is on his website www.colorremedies.com however, we will make the original ProPhoto RGB file as well as the CMYK conversions available on the DVD so you can see for yourself how the images were optimized and try it for yourself. The other thing we need to tell people is that the graphic arts industry varies considerably by country and region. Martin has experience in the UK and Jeff in the US, but every country's printing industry operates by slightly different rules and practices. You really need to get to know your own printing industry's expectations and how best to provide them with the optimal CMYK images for their process.

The other thing is that what we'll show and tell you is what works for us. There's no guarantee it'll work for everybody in every situation. The best thing to do is communicate with your client and their printers, and gain experience of your own.

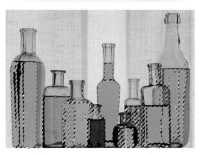

Figure 6.9 The Gamut Warning command is not really suggested. It's primary usefulness is as a method of making a selection based on the out of gamut color in Color Range (middle figure above). The problem of what to do to address the Gamut Warning still remains. Should you reduce the color saturation to the point where the warning essentially goes off, you'll end up with a very weak CMYK image as shown in the bottom figure.

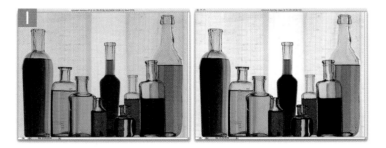

1 I'll start by opening the RGB image and making a duplicate. Above, the original ProPhoto RGB image is on the left with soft proofing already turned on. I chose to use Relative Colorimetric as the rendering intent. The copy without soft proofing is on the right. This image is a temp image used to provide a guide to what the image should look like. It will never match the color and dynamic range of this copy because the CMYK gamut is so small and halftone repro is such a lowered contrast range process. But I needed something to aim for.

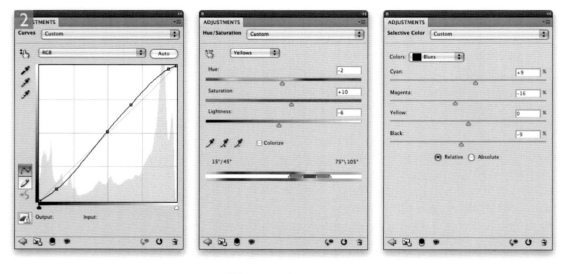

2 To properly address both the color and contrast range of the CMYK limitations, I needed to use three sets of adjustments. The important Tone Curve adjustment is shown above. In addition to the Curves adjustment, I made a Hue/Saturation adjustment to tweak the overall saturation of the image up and individually adjust the Yellows to –2, Hue, +10 Saturation and a –6 Lightness. The other important color was the Blues where I did a –7 Hue, +14 Saturation and +13 Lightness. The final Selective Color adjustment (the only adjustment for RGB files that gives CMYK controls) tweaked the Blues again as well as Black increases in both the Neutrals and Whites drop-down options. Selective Color is a critical tool for doing CMYK style correction on RGB images.

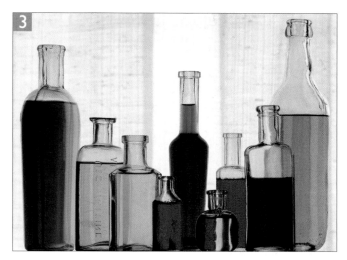

3 The above image is the actual CMYK file made from the original ProPhoto RGB image without doing any soft proofing tweaks. It looks 'ok' but is flat with dead blues.

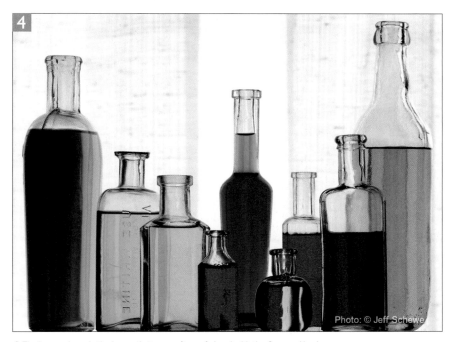

Photo: © Jeff Schewe

4 The image above is the image that was soft proofed and with the Curves, Hue/ Saturation and Selective Color adjustments added. You can see the impact that the adjustments had. No, it doesn't look as 'bad' as the soft proofed image in Step 1. Remember, all we can actually show here in the book are 'relative' differences.

Delivering files for output

You might think that simply saving a CMYK file and giving it to the client is sufficient. It would be in an ideal world, but we live in the real world. You need to take some extra steps to ensure that your carefully prepared CMYK files don't get screwed up.

1 I use Convert to Profile rather than simply doing a mode change. Why? Because Convert to Profile allows explicit confirmation on the profile being used and the Rendering Intent (which I determined should be Relative Colorimetric). When saving, I use the TIFF file format and choose not to embed a profile. Why? Embedding a CMYK profile might lead a printer to do something and most of those things will be wrong. By not embedding the profile, I ensure that the printer will just use it without doing anything (like ignoring the embedded profile or converting to some other profile).

2 The next thing I do (because clients almost always ask that we also supply RGB files) is that I take the CMYK image and reconvert it back to RGB. Why? Well, we never give clients layered ProPhoto RGB images because most people don't know how to use color management and ProPhoto RGB looks pretty bad unless you use the embedded profile (very dark and green). So, I use the fact that the CMYK image has already undergone the worst color change of its life and preserve that CMYK gamut when converting back to RGB. In this case I used sRGB, but depending on the client I might be inclined to give them Adobe RGB. You'll note I have included the sRGB profile in this file – you really don't want any untagged RGB files around!

Schewe-DVD

3 The last step is to burn a DVD (or CD if the files are small enough) for delivery to the client. The DVD always has a License-ReadMe file outlining use. Why a DVD? Because while expediency may demand a file be uploaded or transmitted via the net, a file delivered in that manner may be altered or otherwise changed (read screwed up) by somebody downstream. If that file is considered your contractual 'deliverable' then it becomes a difficult situation trying to prove exactly who screwed up the file since it has no provenance. By requiring the physical delivery of a read-only media as the final deliverable, you can always have the client refer back to the DVD as proof of the state of the file when delivered. This has saved me in several situations where the blame game was being played, and my client actually appreciated the fact they had a physical file that represented the state of the file prior to giving it to the pre-press provider. It actually saved the client some time and money by being able to prove that neither myself nor the client had screwed up the file.

Is CMYK for you?

As you can see, there's more to making a good CMYK image file than just doing an Image ⇨ Mode ⇨ CMYK Color command in Photoshop (although, truth be told, that's the way a lot of people in the graphic arts treat the conversion). Is it worth all the time and hassle? Only you can say... but even if you decide you would rather simply provide sRGB or Adobe RGB files and let the client or the printer deal with the problem (we still don't think you want to give ProPhoto RGB images out), you can still take steps to make sure the images you provide are still the best suited for CMYK conversion down the road. You still need to evaluate the images under relevant CMYK soft proofing conditions and make adjustments for the impact of the CMYK conversion later.

One aspect of the CMYK question is one of economics. Clearly doing the conversions for free would not be good business – a topic we'll address in the next chapter. But there is an economic incentive to do the work if you can do it well (and be well paid for the work).

Process color limitations

A four-color process mix can be used when printing larger sans-serif type using large point sizes, but not when printing fine type and line diagrams as the slightest misregistration could make the edges appear fuzzy when printed. This is one example of where the use of spot colors is to be recommended.

Spot color channels

Spot colors can be added to images as part of the graphic design when you need to add a specific process color in addition to the standard CMYK printing inks. Photoshop is able to simulate the effect of how a spot color will reproduce in print and how a special color overlay will interplay with the underlying image. Spot colors include a wide range of industry-standard colors. The colors available can include those found in the CMYK gamut, but also a whole lot more that are not, including metallic 'specials' (manufacturers' printed book color guides are an accurate reference for how the color will print). Spot colors are mostly used where it is important that the printed color conforms to a known standard, and for the printing of small point size type and graphics in color.

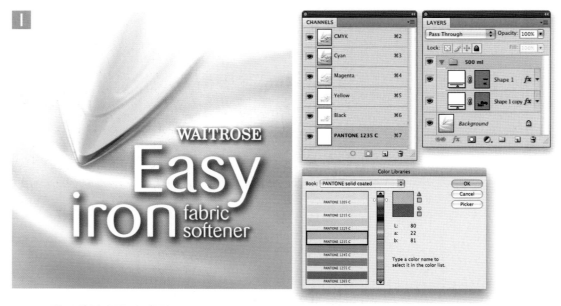

1 A Spot color channel is used to add a fifth color to a CMYK file. This master image contained some shape layers based on artwork supplied by the designer, to which I added a drop shadow effect. To add the Spot color channel, I went to the Channels panel fly-out menu and chose New Spot Channel... which popped the New Spot Channel dialog. I clicked on the swatch color to open the Color Picker and then clicked on a button marked Color Libraries. A quick way to select a known Pantone reference color is to rapidly type in the Pantone reference number.

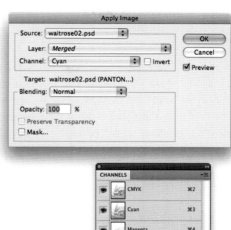

2 I wanted to use the new spot color to add color to the fabric, but not the iron. I drew a path to define the area outside the iron, made an inverse selection and feathered the selection. I activated the new Spot channel and used Image ➪ Apply Image to blend the selected Cyan channel contents into the Spot color channel using a Normal blend.

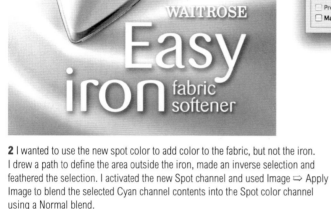

3 Meanwhile, with the selection still active in the Cyan channel, I used ⌥ *Delete* *alt Delete* to fill the selected area with white. I then did the same thing in the Magenta channel as well. There now remained a CMYK full color image of the iron, but the fabric and lettering outside of the iron was now using the yellow, black and spot color channels only. To preview all of the color channels combined, I clicked on the composite channel and the Spot color channel eyeball icons. The client wanted the drop shadow lettering to predominantly use the spot color ink. I therefore had to make an inverted selection of the iron in the Black channel and apply a Levels adjustment to substantially lighten the lettering in the Black channel. Here is a screen shot of the image which shows the final result after I had basically taken the image information from the darkest channel (the Cyan channel) and copied this over to the new Spot color channel.

Photograph: Laurie Evans. Designer: Richard Lealan. Client: Waitrose Limited.

Preparing screen shots for publication

When I first started publishing books on Photoshop I was keen to make sure that the screen shots on the printed page looked as good as possible. Using the knowledge I had then about CMYK reproduction, I was able to devise some special techniques for preparing screen shot images so that they would all look as good as possible in print. I have been using these methods for over 12 years now, but here for the first time I can share the information as a Photoshop output preparation technique.

Scaling dialog screen images

Let's start with the simple stuff first. Screen dialog captures are usually too small to be reproduced at 100% on the page and the dialog text will be barely readable unless you scale these up in size to, say, at least 135%. They can look too big at 200% and the ideal is probably somewhere between 150% and 180%. It is possible to do this in Quark or InDesign, but the problem here is that when you enlarge images this way you can sometimes end up with jagged edges. If the original screen dialog image has a resolution of 300 pixels per inch and it's enlarged to 150% on the page layout, then the pixel resolution effectively becomes 200 pixels per inch. In the case of photographic images, 200 pixels per inch is a little on the edge of what the desired resolution should be for magazine or book reproduction, but just about acceptable. In the case of screen shot images, the sharp lines will soon break down.

The solution to this is to play safe and make the screen dialogs bigger in Photoshop. You can achieve this by using the Image Size dialog to enlarge the pixels by 200% using the Nearest Neighbor interpolation (see Figure 6.10). This interpolation method enlarges the pixels precisely without introducing any anti-alias smoothing. The net result is that straight line edges are extended accurately and you end up with files that reproduce more sharply on the page. There is no need to sharpen of course. All you have to do is set up a Photoshop action to do the following: set the image resolution to 300 pixels per inch (without resampling)

and then resize the image to 200% document width (using Percent), with Constrain Proportions and Resample Image checked.

What I usually do is write a complete action (Figure 6.11) that also includes an Image ⇨ Trim... command (to remove surplus pixels around the edges of the screen dialog) as well as a Convert to Profile step in which I convert the screen shots from the screen capture RGB space to sRGB. Why sRGB and not Adobe or ProPhoto RGB? Unless you are using an Eizo or high-end NEC display, the monitor space is probably closer to sRGB than anything else, so it makes sense to convert to a standard RGB space that has the same kind of color gamut. Lastly, I add a step that saves out the file as a TIFF image.

Figure 6.10 This shows the action steps normally recorded for preparing a screen shot dialog ready for placement in a page layout as an RGB master, before it is converted to CMYK. The key steps are as follows: convert to sRGB and trim the image of any surplus pixels. Go to Image Size and set the resolution to 300 pixels per inch (no resampling). Go to Image Size again and resize to 200% using Nearest Neighbor interpolation. Lastly, perform a Save command using the TIFF format.

Figure 6.11 This shows the Image ⇨ Image Size dialog. To resize screen shots, set the Document Size to 200% and the Resolution to 300 pixels per inch with the Constrain Proportions and Resample Image checked. It is also important to set the interpolation method to Nearest Neighbor.

Creating a droplet to process screen shots

The action steps recorded in Figure 6.10 can now be converted to a droplet so that you can then simply drag and drop screen shot files to the droplet and they'll be automatically converted to TIFF RGB images. To create a new droplet, go to the File ⇨ Automate menu and choose Create Droplet (see Figure 6.12). Click on the Choose... button to locate the folder where you wish to save the droplet, name it and click Save to return to the main Create Droplet dialog. In the Play section the currently selected action will be shown listed, so there is no need to change anything there. In the Destination section, click on the Choose... button and locate the folder where you would like to save the processed screen shots to (usually in the same folder as where you save the droplet). Beneath that is the Override Action 'Save As' Commands option. This must be checked because the action you are using for the droplet contains a Save as TIFF step and you'll need to override the Save destination used when the action was recorded.

Figure 6.12 This shows the Create Droplet dialog.

Max Black generations

Screen shot interfaces usually contain a large amount of gray. It is therefore important to make sure that the gray elements are printed as neutral as possible. A standard CMYK conversion will use a certain percentage of cyan, magenta and yellow ink combined with the black plate to produce the gray colors. The problem here is that if there is any color drift in the press during a print run, this will show up in the predominant gray colors. To address this, we can use a custom CMYK conversion where the GCR Black generation is set to Maximum (see Figure 6.13). If you do this, the CMYK conversion uses the black plate only to generate the neutral gray colors and none of the cyan, magenta and yellow. If you study the channels shown in Figure 6.14, you can see how the channel makeup of a Max Black generation CMYK separation compares to a standard CMYK conversion. The net result is that no matter how much the colors drift during a print run, the dialog gray colors will always print gray because only the black plate is being used to print the gray colors.

Dot Gain and Ink limit settings

The settings described in Figure 6.13 show how to set a Maximum Black GCR setting. Don't forget that you will also need to know from the printer what the dot gain should be, plus which Ink Limit settings to use.

Scaling the image previews

This step is optional, but if you intend using a screen shot image large on the page at close to the 200% scaled size, and the screen shot contains a large image preview, it can be a good idea to replace the 200% scaled preview image with an actual pixels scaled image. What I sometimes do is to locate the original image and place it as a layer then scale the image so that it matches the underlying preview image.

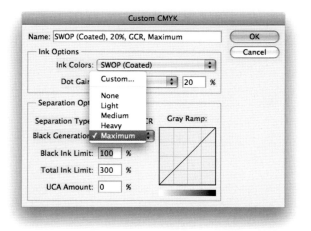

Figure 6.13 To create a Maximum Black GCR generation separation setting, go to the Edit menu and choose Color Settings... Then go to the Working Spaces section, mouse down on the CMYK menu and choose Custom CMYK... Make sure the GCR button is checked (and not UCR), then go to the Black Generation menu and choose Maximum. Once done, click the OK button. You can now save this as a custom Color Setting and name it something like 'Maximum Black GCR'.

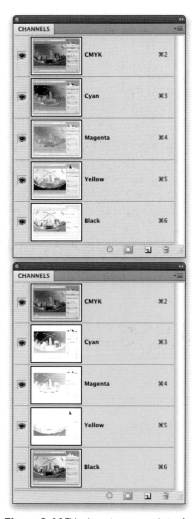

Figure 6.14 This shows two screen shots of the Channels panel after a CMYK conversion. The one on the top shows the result of a Medium Black generation CMYK separation. You will note how the gray colors are generated using a combination of ink from all four plates. The Channels panel on the bottom shows the outcome of a Maximum Black generation GCR separation. You will notice here how all the gray colors are printed from the black plate only and a minimal amount of color information is printed using the CMYK plates.

Recording a Max Black separation action

The next step is to set up another action, this time to record a conversion to a Maximum Black generation CMYK space. Once you have configured a Max Black GCR custom CMYK setting in the Photoshop Edit ⇨ Color Settings, you should save this as a new custom Color Setting (Figure 6.15). You can then record selecting this setting as part of an action, but don't forget to also record resetting the Color Settings to the normal default at the end (Figure 6.16).

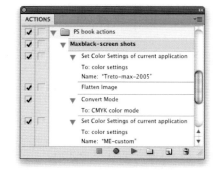

Figure 6.15 This shows the Color Settings with the Maximum Black GCR separation saved as a custom setting that can be called as part of an action.

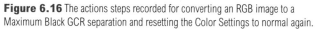

Figure 6.16 The actions steps recorded for converting an RGB image to a Maximum Black GCR separation and resetting the Color Settings to normal again.

Dual CMYK conversions

Maximum Black generation separations work great with standard dialog shots but if you convert a photographic image using a Max Black separation, the results will look terrible in print and you'll end up with photos that have dull, lifeless shadow detail. So, when converting dialog screen shots that contain large preview images the ideal solution is to carry out a dual CMYK conversion in which the dialog components with all the gray interface are converted using a Max Black separation and the image content area is converted using a Light or Medium black generation separation. This is a tricky technique to carry out although, as you can see, the process can be automated to a certain extent by recording these steps as a Photoshop action.

1 We start here with a screen shot in which the screen capture image I used for this step-by-step contained a large image preview. So far all I did here was to follow the steps described earlier. I scaled the screen shot to 200% using Nearest Neighbor, trimmed the white surround area and converted the capture image to sRGB.

2 I now wanted to record the following steps as a Photoshop action. I created a new action called 'Dual CMYK separation' and clicked the Record button. I then went to the Image menu and chose Duplicate... This created a copy version of the opened screen shot image.

3 With the duplicate image selected, I now needed to optimize the CMYK conversion for the photographic image. To start with I wanted to sharpen the image for CMYK print output. You can use whatever method you prefer here. You could apply an Unsharp Mask filter, but in this instance I chose to use the PhotoKit Sharpener plug-in to apply a half tone sharpening. Now, because the image has been enlarged to 200% and the chances are it will be placed at around 75% on the page, the best sharpening setting to apply here was one for a 350 line screen. I applied the Photokit Sharpening effect, which as you can see added a layer group above the Background layer.

4 I then flattened the image, opened the Color Settings and selected a saved preset for converting photos to the appropriate CMYK setting for converting normal photographic images. I clicked OK and then converted the image to CMYK.

5 With the Duplicate image still selected (which don't forget must be flattened), I chose Select ⇨ Select All, followed by an Edit ⇨ Copy command and closed the Copy image document without saving.

6 This left just the original screen capture image document. I again opened the Color Settings and this time selected a preset for applying a Maximum Black generation separation conversion, clicked OK and converted the image to CMYK.

7 I now had just the original screen capture document open and used the Edit ⇒ Paste command to add the duplicate screen capture image as a new layer. This popped a warning dialog alerting me to the fact that the pixels I was about to paste were in a different CMYK space. If I selected Convert Colors I would end up converting the pasted pixels to the Maximum Black GCR generation CMYK space. The correct option here was to choose Don't Convert and preserve the numbers, since the whole point of this technique is to create a single CMYK image that is made up of two separate CMYK conversions.

8

8 We now come to the tricky bit. At this stage I had recorded all the action steps up until the point where the normal CMYK separation version overlaid the Maximum Black GCR separation version as a new layer. Now is a good point to insert a pause into the action so that when replaying the action steps you get a chance to interact with the image before continuing with the final action steps.

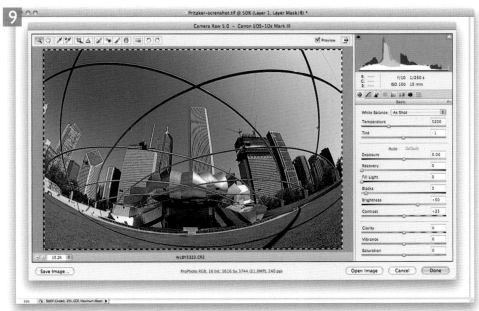

9 Here is the part that has to be done manually. When replaying the action, I would at this stage need to select the rectangular marquee tool and drag carefully to select the exact outline of the image preview. It is crucial to make the selection as accurate as possible and define the image area precisely to the nearest pixel. As I say, this step is not something that you would record as part of an action and, after inserting the Stop shown in Step 8, you would continue recording the action as directed over the page in Step 10.

10 To complete the action steps I recorded clicking on the Add Layer Mask button (circled), which would add a layer mask based on the marquee selection that revealed the selected area and hid everything that was outside the selection area. All I had to do then was to choose Layer Flatten Image and record resetting the Color Settings back to the normal default settings I would normally use, and then click on the Stop button to end the recording.

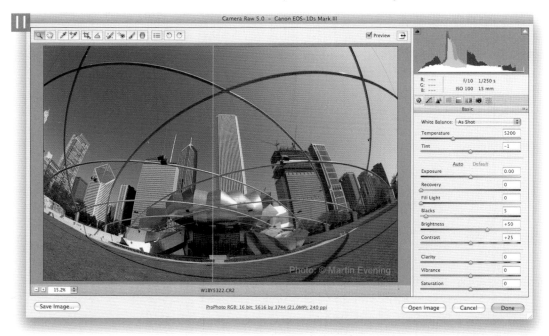

11 For this last step I created a CMYK separation where the left half shows how the screen capture image would reproduce using a dual Max Black plus Medium Black GCR separation (left) and how it would look using a Maximum Black GCR separation only (right). I have no idea how these will print. If the press is running accurately, the dialog colors may appear neutral in the left half, but if not you'll see a color cast. But you should see a definite decrease in image quality with the Maximum Black GCR separation on the right.

12 ACTIONS

▼ **Dual CMYK separation**

Duplicate first document

▼ PixelGenius Toolbox

Toolbox Items: Toolbox Item list
Toolbox Item
Module: "PhotoKit Output Sharpener 2"
Set: "Halftone Output Sharpeners"
Effect: "175lpi Coated 350 ppi"
Without Merge Results

Merge Visible

▼ Set Color Settings of current application

To: color settings
Name: "PP photos_medium black"

▼ Convert Mode

To: CMYK color mode

▼ Set Selection

To: all

Copy

▼ Close

Saving: no

▼ Set Color Settings of current application

To: color settings
Name: "PP screen capture_max black"

▼ Convert Mode

To: CMYK color mode

▼ Paste

Anti-alias: none

▼ Stop

Message: "Use Marquee tool to select p..."
With Continue

▼ Make

New: channel
At: mask channel
Using: reveal selection

Flatten Image

▼ Set Color Settings of current application

To: color settings
Name: "ME-custom"

Book resources

If you want to learn more about printing from Photoshop, I can recommend some further reading: *Mastering Digital Printing* by Harald Johnson is a comprehensive title that does a good job of covering the subject of printing in extensive detail; *Real World Color Management* by Bruce Fraser, Chris Murphy and Fred Bunting; and also *Color Management for Photographers* by Andrew Rodney. These are the industry bibles on the subject of color management and printing.

12 This shows the final list of Action steps that were recorded in the previous steps. As before, you can convert this action into a droplet where you can then simply drag and drop a prepared RGB screen shot image to the droplet and let Photoshop process the image automatically. All you have to do is follow the Stop prompt and apply a marquee selection to define the preview, before hitting the Continue button to complete the final few action steps.

Chapter 7

Minding your own business

Suggestions on how to use Photoshop in your business

For a business to prosper there must be a profit, for if you don't turn a profit you won't be in business for long. Artists have historically been poor business people in part because there is an assumed conflict of interest – if you do what you do for love how can you put a price on it? But that's exactly what you must learn to do. Ironically, the real value of your work has little to do with how difficult it was to do and more to do with how much perceived value it has by others. That is the key to understanding how to profit by doing what you love to do. And don't be afraid to put a high price on what you do, there's nothing wrong with being a business person as well as an artist. It's what we do...(and we love it, right?)

Adding value to your images

Digital images, on their own, certainly have value. But with extensive keywording and captioning, the same image is potentially far more valuable. Many people think of metadata (data about data) as merely an organizational aid, without realizing how much value can be added to the image. Our good friend and colleague, Seth Resnick, strongly advocates extensive keywording and, just as importantly, captioning of the image. Seth does this primarily because he's so anal but also because he depends on the stock sale of images where metadata is an asset. So, for him and many others competing in that industry, adding metadata is a must.

The image shown in Figure 7.1 has 35 keywords (about average for a well-keyworded image) and has almost 150 words in the caption (called 'Description in Bridge CS4', but we still think of it as a caption). Seth has boasted of having images that needed over 100 keywords for completion. We rarely go that far.

How do you keyword? One of the best tips from Seth is first write the caption (the story) and remember the who, what, when, where and why of journalism. When you write the story, many of the keywords will come from the story itself. Be sure to list word variations and alternative spellings, such as color and colour. Use gerunds (verbs that function as nouns) and participles rather than verbs, such as *running* rather than *run*. Try to use the plural rather than the singular form of a word unless the plural spelling is different than merely adding an 's', in which case add that word as well. Some keywords can be conceptual attributes, but use these very sparingly because overuse will make them useless – everybody thinks their own work is 'beautiful' so *beautiful* as a keyword is pretty useless.

Above all, be consistent in your approach and, if you are a poor speller, keep a dictionary handy. There's nothing quite so embarrassing as misspelling a keyword for the world to see. Using a 'controlled vocabulary' is critical; for more information, see the website run by photographer David Riecks (www.controlledvocabulary.com).

A look at the Marina Towers from Wacker Street in Chicago. In the foreground a boat can be seen on the North Branch of the Chicago River. The view is looking North between Dearborn Street on the left and State Street on the right. On the far right you can see Trump Towers under construction. Trump Towers has been called Trump's Folly in the Chicago media. Marina Towers is called Marina City and construction was started in 1959 by architect Bertrand Golberg and completed in 1963 for a cost of $36 million. The apartments were original rental apartments which were converted to condominiums in 1977. The two towers are each 65 stories (including 5-story elevator and mechanical plant and penthouse). The buildings are listed as being 587 feet (179 meters). The Marina City towers are considered the first urban post-war high-rise residential complex in the US.

affluence; apartments; architects; architecture; Bertrand Golberg; boat travel; boat docks; boats; bridge; building boom; Chicago; Chicago Landmarks; Chicago River; Chicago River North Banch; City of Chicago; Cook County; commercial building; condominiums; construction; construction cranes; Dearborn Street Bridge; Downtown Chicago; famous buildings; fisheye lens; high-rise; Illinois; Marina Towers; Near North Side of Chicago; North America; river; State Street; Trump International Hotel & Tower; Trump Tower; Trump's Folly; United States

The keyword and caption detail

Figure 7.1 This figure shows an image I shot in Downtown Chicago (which is one of the keywords) being displayed in Bridge CS4. Note that the background has been made white for the purposes of this figure.

Identifying your images

It used to be pretty easy to stamp slides with your name and copyright info but doing so with digital images isn't so straightforward (although arguably easier). But for your own sake please be sure to properly embed metadata in the IPTC schema (which stands for International Press Telecommunications Council). While we are still in the relatively early days of extensive metadata development, it's a viable method of identifying your work.

You can add metadata using direct text entry in Bridge CS4 or in the File Info panel (see Figure 7.2) in Bridge or Photoshop (or the other applications in the suite – they all support IPTC now). But that's really the slow and inefficient method. We like to use Metadata Templates. Adobe has souped up the XMP (which stands for Extensible Metadata Platform) support in all of their CS4 applications and well they should, since Adobe initiated this free metadata standard. It is based on XML (Google it) and is the basis of the World Wide Web.

Orphan works

An orphan work is a copyrighted work whose owner is unknown or impossible to identify. The US Copyright Office has been working to address the issue (which is a real problem) and new legislation governing orphan works is to be introduced that may make it easier for potential infringers to claim they could not identify or find the owner and thus escape some of the penalties of copyright infringement. Without commenting on that issue we will say it now becomes even more critical that copyright holders avail themselves of the current metadata opportunities and never send out any digital images without having embedded your copyright notice as well as contact information in the file.

The .xmp file icon

Figure 7.2 This figure shows the File Info panel that contains the metadata of the Marina Towers image. Notice that I have marked the status as Copyrighted and added the digital copyright notice – the two most important metadata properties of identification.

File organization methods

The old days of filing cabinets with slide pages are long gone. These days, all of the image organization happens in the computer. If you have good organizational skills and take advantage of using metadata, organizing images is not impossible (just tedious). Jeff does not rename his original image files: he has adopted a logical folder naming convention and relies upon keywords and other metadata to organize his work as shown in Figure 7.3.

Figure 7.3 Jeff organizes all captures in an enclosing folder ~Digital Captures and uses upper level folder names such as Events, Portfolio, Studio Shoots and Travel Shoots for the main structure. The Chicago-Shoot was the project shot for this book. You'll note the raw file is still a .CR2 file. Jeff only converts to DNG when he has to deliver a DNG file. All delivery files are renamed with Bridge and the original raw file name is preserved in metadata.

Martin's approach is similar to Jeff's except when it comes to client job work, where everything is renamed using a standard naming convention where the abbreviated client name is followed by the capture date (using the YYMMDD format), followed by a four-digit serial number (see Figure 7.4). There are several reasons for adopting this approach. By choosing a regular renaming scheme, it can become easier to identify files by client name and date (it is important to be consistent in the client naming of course). Four digits is usually enough to cover all the numbers of shots that he might shoot for a client in any year. Martin will start from zero for the first shoot of the year and keep the numbers running consecutively for all subsequent shoots with that client. It is important to carry out such renaming as soon as the files are brought into the computer. So, if a client selects a particular photo via the screen, the name that's referenced is one that stays with the file forever. By including the client name in the renaming scheme this reinforces 'ownership' of the file name. One of the problems Martin found in the early days of shooting digital was that if you didn't rename the

Figure 7.4 This shows the file renaming method one might apply using the Tools ⇨ Batch Rename... feature in Bridge.

images, clients would often rename them for you. There was one client who would ask for prints to be made from 'hairshine-blonde.tif' or some other descriptive name that had been applied to the original retouched images. It all got very complicated trying to work out which exact shots they were talking about!

This is just one way of renaming. In *The DAM book*, Peter Krogh suggests renaming everything with your name first rather than the client's. This kind of naming scheme immediately makes it clear who is the copyright holder before the image is opened. Peter also suggests using the embedded filename instead of allocating a four-digit serial. The reason being that if all your jobs are renamed starting from 0001, your files will all end up renamed within the same low number range. If you use the embedded numbers, very few of the filenames will end up being identical. Hence, if a client can only give you the last four digits you should be able to do a filename search and figure out which image they are referring to.

Figure 7.5 Me sitting at the temporary home of my old Mac G4 running System 9.2 and Retrospect 4.2. I was restoring image files from as far back as 1993 for this book that were stored on DAT tape.

Archiving issues

Backing up is not archiving!

Archiving is really the process of long-term conservation and preservation. While you do want to do weekly or daily backups, that process does not ensure long-term viability and availability. In film days we used to worry about film lasting decades or centuries, but with digital the process is complicated by film formats, operating systems and hardware that goes out of date and ceases to be supported. Unfortunately, at the moment the bad news is that there are no good long-term archiving solutions for digital photography. The good news is that major institutions such as the National Archives in the US and UK are studying the problem, but there isn't any good news to report yet. The best advice we can offer about this issue is to maintain multiple copies on multiple media in multiple locations and get into the habit of updating and migrating as new technologies become available.

By multiple media we include tape, hard drives and burnable media like CD or DVD. The long-term prospects of this media are not good. I used to archive first on DAT then AIT tape until suffering enough media problems that gave it up. However, I do still have all of the old DAT and AIT tape archives and for this book I had to resort to pulling up original image files from as early as 1993 (see Figure 7.5). To do so I had to set up an old Mac G4 that I kept around for this purpose. The figure shows me loading a DAT tape while running Retrospect 4.2 and Mac OS 9.2. I've been unable to find SCSI cards that allow me to use the old SCSI DAT drive on any current machines and current DAT drives have problems reading old media that they didn't write.

But the problem going forward is worse than it was back then. Back in the film and scan days, only selected images were actually scanned and you always had the film to fall back on. Now, with digital capture, all of the originals are digital objects that must themselves be preserved. And for long-term considerations the file formats themselves need scrutiny.

Shortly before Adobe shipped the original Creative Suite (CS), Bruce Fraser and I were warned by the then Adobe engineer Mark Hamburg (who has since left Adobe) that the Photoshop 'native' file format, PSD, wasn't under Photoshop's control anymore and suggested we switch to using TIFF. The Tagged Image File Format was originally developed by Aldus with input from a few other companies. Ironically, Adobe inherited the format when it acquired Aldus and has done a reasonably good job of moving it forward (although not of updating the TIFF 6 spec). But if you want to store processed image files for the long term, we suggest TIFF because it is publicly documented.

But that's for processed files – what about original raw files from a camera? For that we support Adobe's DNG (Digital Negative) file format specification. Adobe has essentially 'given' the file format to the industry and even gone to the extent of offering it (for free) to the ISO for use in an upcoming TIFF-EP specification update (TIFF for Electronic Photography). Ironically, Adobe had already granted the ISO the right to use TIFF in their TIFF-EP specification and it's that spec that pretty much all of the major camera makers such as Nikon and Canon use. Yet the camera makers so far have refused to adopt any standard (their use of TIFF-EP is unofficial so they are free to diverge from the spec if they so choose, and they do).

For the long-term preservation and conservation of digital photography we simply must adopt raw file format standards. While traditional chemical photography originals can be accessed from the 1800s, there's a real question whether digital photography since the beginning of this millennium will be so enduring. The United States Library of Congress has studied long-term conservation of digital objects and has identified seven major factors that impact long-term digital preservation and conservation (see sidebar). All of the current proprietary raw file formats (except DNG) violate most, if not all, of these factors. We therefore encourage our readers to support DNG, and wherever possible have your voices heard by the camera makers that proprietary, undocumented raw file formats need to be eliminated.

The seven sustainability factors

Disclosure:
Refers to the degree to which complete specifications and tools for validating technical integrity exist and are accessible to those creating and sustaining digital content.

Adoption:
Refers to the degree to which the format is already used by the primary creators, disseminators, or users of information resources.

Transparency:
Refers to the degree to which the digital representation is open to direct analysis with basic tools.

Self-documentation:
A digital object that contains basic descriptive metadata and incorporates technical and administrative metadata relating to its creation and early stages of its life cycle; will be easier to manage and monitor for integrity and usability and to transfer reliably from one archival system to its successor system.

External dependencies:
Refers to the degree to which a particular format depends on particular hardware, operating system, or software for rendering or use and the predicted complexity of dealing with those dependencies in future technical environments.

Impact of patents:
Patents related to a digital format may inhibit the ability of archival institutions to sustain content in that format.

Technical protection mechanisms:
Content for which a trusted repository takes long-term responsibility must not be protected by technical mechanisms such as encryption, implemented in ways that prevent custodians from taking appropriate steps to preserve the digital content and make it accessible to future generations.

The DAM book

If you want to find out more about image management using Adobe Bridge and iView, we highly recommend that you read *The DAM book, Digital Asset Management for Photographers* by Peter Krogh, ISBN: 978-0596100186.

RAID

RAID which stands for Redundant Array of Independent Disks is often thought of as some sort of magic bullet. Not really. RAID level 0 stripes data across multiple drives for speed at the expense of safety. If you lose one drive you lose all your data. RAID 1 (mirrored arrays) is safer but slower. RAID 5 and 6 use one or more of the drives for parity to rebuild the array should a drive fail. But they are sometimes proprietary processes and if you lose the RAID hardware, you can't read the drives so it's only a risk reduction strategy. NAS, or Network Attached Storage, is catching on and the units often use RAID 5, but even gigabit Ethernet is much slower than fast eSATA drives and you are at the mercy of the network and it's built-in embedded OS usually running a Windows variation that may not support AFP (Apple File Protocol) connections.

Backing up your data

When managing your digital images, the most important thing is to make sure you have a backup procedure in place that can be relied upon in the event of a disaster, such as a hard drive failure or theft of a computer. If you don't have too big an image library, this could be achieved quite simply by having a single hard drive connected to the computer that you can back up your files to. At a more advanced level, you could invest in a mirrored RAID storage system where the data is mirrored across two or more drives of equal capacity. If one of the drive units were to fail, the data is protected on the backup drive so you can simply replace the defective drive and the data is mirrored across to the replacement drive again. But be warned that mirroring the data in this way is still not entirely foolproof. However you choose to back up your data, the following points should be borne in mind.

Scheduled backups are most important because it is useful to have a buffer between the contents that are on the current working drives and the backup versions. It is all too easy to delete a file or discover you need to revert to an earlier version of a file. If you make a mistake on a mirrored RAID system, the mistake will soon be mirrored to the other drive. But if you also maintain a copy on a separate backup drive system, there should always be a recent backup copy of the data ready for you to access. As a Macintosh user, Martin likes using the Chronosync utility (Figure 7.6) to make regular backups of his computer files. It's a fairly easy program to use and can automatically cross-reference the files on your computer drives with those on the backup drives to auto-synchronize the two. Jeff, on the other hand, has been using Retrospect® from EMC® – originally for writing to tape drives and more recently for doing incremental nightly scheduled hard drive backups using scripts. Jeff has used the searching function of Retrospect extensively either by date or enclosing folder naming.

Where do you store the backup data? If you keep the backup data on separate hard drives, it is not too difficult

Figure 7.6 Chronosync™ from Econ™ technologies (www.econtechnologies.com) is an indispensable tool for carrying out data backups.

to keep these backup drives stored in a safe location away from the computer, such as in a fireproof safe or off-site somewhere. One approach is to use two additional drives for every drive you wish to back up. That way you can keep one backup drive at the office, the other at a separate location and keep swapping the two backup drives. For absolute security, some people back up all their data over a fast Internet connection to a remote server. In the writing of this book, the InDesign files and images were constantly backed up to a remote server and updated files obtained by each author. This allowed Martin and Jeff to work remotely and, given their time zone differences, Jeff would be ending his day by uploading files to the server for the start of Martin's workday. A simple email was used to alert each other to the updated files rather than trying to email actual files.

Hard drives can provide storage space that is fast, cheap and high capacity. But they can still be vulnerable to things like a virus attack. It may take a while to burn copies of your data to CD or DVD but while such media may not be completely infallible, your data won't be vulnerable to virus attacks.

DVD storage

Recordable DVD drives have become increasingly popular and are often supplied as standard with some computer models. Recordable DVD discs are capable of storing 4.7 GB of data. But again, to be realistic, I would knock that figure down to something more like 4.3 GB as the actual amount of data you can store on a disc. The only problem with a DVD (or CD) disc is that if it gets damaged you lose everything and that might mean losing a hefty chunk of valuable data. So don't rely entirely on DVD as a backup method. Recordable discs also have a finite life-span. And who is to say if DVD, or the new Blu-ray standard, will not be superseded by some other form of recordable media requiring a different type of hardware device to read the data? Furthermore, if you archive raw camera files without converting them to the DNG format, will you always have the software to interpret these? In this industry a lot can happen in a matter of just a few years. For example, does anyone now remember Syquest disks? We are hoping that Blu-ray may end up as a viable medium but we certainly hope you didn't back up to HD DVD, the standard Toshiba was promoting that died in early 2008. But then we still don't know about the long-term viability of the media.

Fingerprint plug-ins

Software solutions have been developed to provide better data protection and security, giving suppliers of electronic data the means to identify and trace the usage of their intellectual property. These systems apply an invisible 'fingerprint' or encrypted code that does not spoil the appearance of the image but can be read by the detection software. The code must be robust enough to work at all usage sizes: from screen size to high resolution. They must withstand resizing, image adjustments and cropping. A warning message should be displayed whenever an image is opened up, alerting the viewer to the fact that this picture is the property of the artist, and a readable code embedded from which to trace the artist and negotiate a purchase.

Two companies have produced such encryption/detection systems: SureSign by Signum Technology and Digimarc by the Digimarc Corporation. Both work as plug-ins for Photoshop. They will detect any encrypted images you open in Photoshop and display a copyright detection symbol in the status bar alongside the file name. You have to pay an annual usage fee to Digimarc to register your individual ID (check to see if free trial period offers are in operation). Anyone wishing to trace you as the author, using the Photoshop Digimarc reader plug-in, will contact their website, input the code and from there read off your name and contact number. SureSign provide a unique author code plus transaction number. In my opinion, the latter is a more adaptable system.

Image protection

Anyone who fully understands the implications of images being sold and transferred in digital form will appreciate the increased risks posed by piracy and copyright infringement. The music industry has for a long time battled against pirates duplicating original disks, stealing music and video sales. Digital music recordings on CD made this problem even more difficult to control when it became possible to replicate the original flawlessly. The issue of piracy is not new to photographers and image makers, but the current scale of exposure to this risk is. It includes not just us Photoshop geeks, but also anyone who has their work published or is interested in the picture library market.

To combat this problem, the first line of defense had been to limit the usefulness of images disseminated electronically by (a) making them too small in size to be of use other than viewing on a screen and (b) including a visible watermark which both identified the copyright owner and made it very difficult to steal and not worth the bother of retouching out. The combination of this two-pronged attack is certainly effective but has not been widely adopted. The World Wide Web contains millions of screen-sized images, few of which are protected to this level. The argument goes that these pictures are so small and degraded due to heavy JPEG compression, what possible good are they for print publishing? One could get a better pirated copy by scanning an image from a magazine on a cheap flatbed scanner. Shopping is now replacing sex as the main focus of interest on the Internet, so screen-sized web images therefore do now have an important commercial value in their own right. Furthermore, the future success of digital imaging and marketing will be linked to the ability to transmit image data. The technology already exists for us to send large image files across the world at speeds faster than DSL. Once implemented, people will want to send ever larger files by telecommunications. The issue of security will then be of the utmost importance.

How to make money with Photoshop

How much are you worth?

Creative workers and, in particular, freelancers, often have difficulty in working out what they're worth and how they should go about charging for the services they provide. Retailers sell goods, taxi drivers sell cab rides, while bankers look after our money. At the end of the day an employee is simply selling their time, and their worth is calculated based on how much their work skills profit the employer. OK, in the case of investment bankers, they screw up the economy and look to the tax payer to bail them out of difficulty but, as far as many workers are concerned, they are essentially all selling their time.

The problem a lot of freelancers have is that they fail to take into account how much time and money is required to run a business. They fall into the trap of confusing freelance income rates with the rates of pay given to full-time employees. There is a big difference. If you work for a company, you cost your boss a lot more than your take home pay check. A company has to provide its workers with premises to work from, light and heating, computer equipment, plus maybe even a subsidized canteen – Not to mention all the other side-benefits such as a company pension contributions and sickness benefit. So, when you start out on your own and become your own boss you have to take responsibility for all these added expenses. On top of this you have to fill lots of other roles such as finance director, marketing manager, bookkeeper and coffee maker. So, when calculating how much you need to charge you first need to work out how you are going to fulfill all these tasks on top of doing the actual work you set out to do as a freelancer.

Let's start with the assumption that you will work a basic 40-hour week. I know most freelancers work a lot more hours than this, but we need to begin with a sensible business projection that allows us to compare the way you work as a freelancer with the way most other employees are expected to work. Here's how things should break

Finding an agent

Some people argue that having the right agent can make a tremendous difference to a career. An experienced agent can help nurture creative talents and provide an umbrella that allows the artist to get on with doing what they do best, while the agent takes care of managing the job bookings and ensures that you get paid the best rates, often asking for more money than you might dare ask yourself. For advertising work, having an agent makes good sense. The fees are substantial enough that everyone usually gains from this type of arrangement. The downside of having an agent is that some agencies will say yes to any kind of job, even if it pays below the market rate. From the agent's point of view, an editorial commission that pays only $150 is still worth $30 to them plus $30 booking fee. Editorial bookings are usually the simplest ones for them to manage, as all they have to do is pick up the phone and take the booking. The freelancer meanwhile is the one who has to do all the work, in order to make themselves $120!

down. If you want to be realistic you should expect to spend half that time working on freelance commissions and the other half working on all the other jobs that are part and parcel of running a self-employed business. So, you might typically only be able to spend 20 hours on average per week working on paying commissions, while the other 20 hours will be spent doing everything else. You don't believe us? Well, think about it for a second. In the early years you will need to spend at least one day a week sitting down to make calls to make appointments to show your work and going out to see prospective clients. When you get commissioned, you will be asked to send your portfolio in again or spend time making a presentation to the client. There will be day-to-day telephone calls to deal with. There will be invoicing work to do as well as bill chasing. Then there are meetings with professionals such as bank managers, accountants and lawyers. What about training? You need to allow time to catch up with the latest news from the forums and attend seminar events to learn more about Photoshop. In fact, shouldn't reading this book count as work? Here is a brief summary of some of the things you might spend time doing:

• Self-promotion: making appointments
• Advertising/website
• Client telephone calls
• Creative research/email forum activities
• Office administration
• Bookkeeping and accounts
• Business meetings
• Seminars and training

If you estimate that you'll spend 20 hours a week on average per week working on commissions, this works out at 1000 billable hours per year. Therefore, if you add up all your likely annual business costs, you can add on to this how much salary you would like to earn, then simply divide this figure by 1000 to calculate what your hourly rate should be. Now, we do realize you'll be offered jobs

where the rate offered is a set fee that pays less than this rate, but at least you can use this as a guide to work out what you should be earning. Like most freelancers, you'll probably end up working a lot more than 40 hours per week which is fine, as long as you are doing so to earn a better living. The above calculation is also based on an individual setting themselves up from scratch as a sole trader. Once you become more established you can afford to allocate some of the job responsibilities to a personal assistant but then, of course, you'll have to factor in the costs of employing someone and that too will affect how much your hourly rate should be! Here is a brief summary of things that your freelance fees will need to pay for:

- Rent of business premises
- Heating and lighting
- Equipment costs
- Insurance
- Telephone
- Office supplies
- ISP service, including server hosting fees
- Travel
- Training expenses
- Professional fees
- Pension, income protection and health insurance.

Your rate is your rate

Once you have worked out your daily and hourly rate, we recommend you stick firmly to it. You have worked out what you should charge based on the minimum amount you need to earn in order to keep your business ticking over, plus what premium you think your skills are worth, and it is therefore in your best interests to hold firm and not waver on that. However, there will come lots of times where you'll be asked to work for less than the going rate. There is a real simple question that you can ask yourself before you take on any job: is it a job for the portfolio or a job for the bank? Most the time the answer will be it's one or the other. You either want to work on a job because

Editorial rates

Editorial magazines probably offer the lowest rates of pay. In fact, there are a lot of fashion magazines that expect you to work entirely for free, in return for a credit. As we point out, this type of work is only worth doing if it offers a good market place with which to show off your skills and helps you get good published work for your portfolio. We advise you to keep this in mind before taking on these kinds of jobs. We know lots of people who have got sucked into the cycle of working on endless free editorial jobs, where they don't even particularly enjoy the work that they are asked to do.

you reckon it will be a nice job to work on and look good in your portfolio, or you want to do the job because it's a chance to earn some decent money. The best jobs are the ones that provide good money as well as artistic freedom, but you definitely want to avoid cutting your rates to do jobs that pay you less money than you are worth, or need to live on, plus do nothing to raise your profile. The reality for some people is that when times are tight you have to swallow your principles and do anything to keep the cash flow ticking over but, whatever you do, be on your guard against those clients who are willing to take advantage. In our experience, the clients who pay the least are the ones who also take the longest to pay (it's true). If you do agree to work for less than the standard hourly rate, then here's a tip. Never agree to charge less. If you simply invoice the lesser amount, the client will see this as the rate you charge for everything. Instead, you should propose to charge your normal rate, but offer a special discount on the invoice for whatever reason seems appropriate. That way you make it clear from the start what your rate should be and that the client is getting a special discount this time only. Clients like this kind of arrangement because ultimately they get the saving they wanted and, not only that, they feel good because they see the saving shown to them on the invoice. They'll also have more respect for you and are reminded of how much your services are normally worth. When it comes to getting more work from the same client the starting point for your quote will be the standard day rate, rather than the lesser amount you actually charged, and you can therefore negotiate from a position of strength if they come back to you with offers of more new work.

How to bill for digital

With the advent of digital capture, clients are under the delusion that everything should be cheaper, right? Hey, pixels are free (once you've bought that $8K camera and that $5K computer system and all the other stuff you have to have in order to capture those 'free pixels'). No, in fact while there may be less direct costs with digital compared

to the old film and processing days, there are actually much higher indirect costs in the equipment needed. So, how can you possibly consider giving your digital services away for free? But it's not up to us to tell you what to charge. Just the factors to consider when you do decide.

Seth Resnick makes out a good case for charging a flat fee for all digital work. He'll offer a breakdown whose à la carte totals are more than what he expects to charge and a flat fee that is what he actually wants to charge. Most clients choose the flat fee but he's happy to charge by the service. Jeff on the other hand likes to break things down to their elemental costs. If something costs him something, somewhere, he wants to have an actual price for that cost and pass it along to the client. In Figure 7.7 you'll note that he is proposing to charge $1.25 per capture made. Sure, there will be four shots with 200 captures/shot and the total price would be $1000 but when priced at $1.25 it doesn't seem so high. You'll also note that he is charging for CMYK separations and proofs, burning to DVD (he would charge for digital transmission if needed) and even for storing the files. Figure 7.7 shows Jeff's estimating software built on FileMaker Pro, which he uses for all jobs.

Whatever you do decide to charge, just know that as a good business person you are expected to charge something because if you don't the implication is that there's no value attached – and clients ultimately expect value and will pay.

Figure 7.7 This is a sample estimate prepared (in jest if you can read the description) showing an example of how to charge for digital. It should be noted that Jeff is not suggesting you actually charge these rates – these are not Jeff's real rates – they are simply an example of how you might break down the charges to a client. When breaking down the charges, be prepared to explain and, if need be, defend them. Clients fully expect to have to pay for value (sometimes they just like real cheap prices) so you need to be prepared to educate them on the value attached to what you charge.

Index